Luciano Cheles

THE STUDIOLO OF URBINO – AN ICONOGRAPHIC INVESTIGATION

Luciano Cheles

The Studiolo of Urbino
An Iconographic Investigation

1986
DR. LUDWIG REICHERT VERLAG · WIESBADEN

CIP-Kurztitelaufnahme der Deutschen Bibliothek

Cheles, Luciano:
The Studiolo of Urbino
an iconograph. investigation
Luciano Cheles.
Wiesbaden: Reichert, 1986.
ISBN 3-88226-276-1

© 1986 Dr. Ludwig Reichert Verlag Wiesbaden
Den Druck des Textes und der Tafeln besorgte die MZ-Verlagsdruckerei GmbH in Memmingen.
Printed in Germany.

For P. Y.

CONTENTS

ACKNOWLEDGMENTS

This monograph has benefited from the assistance of many. I owe my greatest debt to Dr. Thomas Puttfarken, who supervised the postgraduate thesis on which it is based, in the Department of Art of Essex University. For much advice and criticism, I am also grateful to Mr. Jules Lubbock, Dr. Erika Langmuir and Dr. Elizabeth McGrath. I owe special thanks to Professor Martin Kemp, who kindly glossed the full text of my thesis and the new material I submitted to him. Of the many colleagues and friends who responded to my requests for information, I am especially indebted to Dr. Cecil Clough, Virginia Tenzer, Amy Schwarz and Verina Jones. For their assistance with regard to the Latin texts, I must thank John Creed and Keith Sidwell of the Department of Classics and Archaeology of Lancaster University. I am also most grateful to the *Soprintendente* of Urbino, Professor Paolo Dal Poggetto, for allowing me to visit parts of the Palace normally inaccessible to the public, as well as generously sharing his expertise on the Urbino Renaissance with me, and to *Architetto* Giovanni Venturini of the *Soprintendenza* of Perugia, for enabling me to see the room in the Gubbio Palace that originally housed the *studiolo*, while restoration was in progress. Thanks are also due to the contributors to the 1982 conference on Federico da Montefeltro (held in Urbino and Gubbio) who made their papers available to me prior to the publication of the Proceedings. They are specifically mentioned in the notes, as are the names of other people who kindly assisted me in various ways. Finally, I am most grateful to my friend Ronnie Ferguson for reading the final draft of the manuscript and polishing my non-native speaker's English.

Though my debts in the preparation of this monograph are considerable, it goes without saying that final responsibility for its contents is entirely mine.

The writing of the definitive draft of this study would not have been possible without a special leave of absence. I wish to express my gratitude to the Research Committee of Lancaster University for supporting it with a grant.

University of Lancaster (G.B.)
October 1985

INTRODUCTION

Urbino was a quiet provincial town when, in 1444, Federico da Montefeltro (1422–1482)[1] took over the rule of the small state in the Apennines' hinterland, of which it was the main centre. By the late 1460's, thanks to his initiative, it had become one of the most distinguished cultural centres of the Renaissance.

Federico, the illegitimate son of count Guidantonio da Montefeltro, was destined for a traditional military career. A series of circumstances led him to acquire instead an education and experience of life far more wide-ranging than that of his half-brother Oddantonio, the heir.

At the age of eleven, he was taken to Venice as a hostage, since the Republic had acted as a peace guarantor between Pope Eugene IV and the Duke of Milan, Filippo Maria Visconti, whose ally Guidantonio was. The fifteen months he spent there are likely to have had some impact on his formation, for this city was a sophisticated international trading centre. Following an outbreak of plague, Doge Foscari had him transferred for safety to Mantua, where he stayed at the court of Gianfrancesco Gonzaga. There, for two years, he attended Vittorino da Feltre's prestigious humanist school *Casa Gioiosa*, where the children of the nobility (including the Gonzagas) studied side by side with those from humbler backgrounds. The school did more than establish Federico's humanist ambitions. The educationalist aimed to give his pupils an all-round education that would not be restricted to their intellect. He stressed such values as frugal-living, self-discipline and social responsibility, and treated sport as an essential part of the School's activities. His academic curriculum, the broadest of his time, included, unusually, the subjects of the *Quadrivium* (Astronomy, Music, Arithmetic and Geometry). In this environment, Federico developed a versatility that was to make him the prototype of Castiglione's many-sided man.

He returned to Urbino in 1437, and was sent shortly afterwards to Lombardy with a small army to train in the art of war with the condottiere Niccolò Piccinino, who was involved in a campaign against Gattamelata, the captain Donatello was to immortalize in his equestrian statue in Padua.

Count Guidantonio died in 1443, and was succeeded by the seventeen-year-old Oddantonio. The latter's rule was, however, short-lived. His administrative inefficiency, combined with his cruelty and dissolute life-style, angered the people of his State. In July 1444 he was killed in a conspiracy. Federico, who was in Pesaro at the time, was called in to take over the leadership of the State. His rule established what may be regarded as the Golden Age of Urbino. All contemporary accounts stress his humanity, his justice and his concern for the citizens' well-being – features that contrasted markedly with the brutal and devious attitudes of most of the leaders of the time.

Like all rulers, Federico was eager to secure a legitimate successor. His union to Gentile Brancaleoni (he had married her in 1437) was childless. In 1459, two years after her death, he married Battista Sforza, daughter of Pesaro's ruler Alessandro Sforza. After bearing eight daughters, Battista gave Federico the much-awaited son in 1472. The boy was named Guidobaldo, in honour

[1] The biographies of Federico are numerous. Among those written in his own time, the principal ones are: Ser Guerriero DA GUBBIO, *Cronaca 1350–1472* (G. MAZZATINTI ed.), Città di Castello, 1902; Pierantonio PALTRONI, *Commentari della vita et gesti dell'illustrissimo Federico Duca d'Urbino* (W. TOMMASOLI ed.), Urbino, 1966; Vespasiano DA BISTICCI, *Le vite* (A. GRECO ed.), Florence, I, 1970, pp. 353–416; II, 1976, pp. 447–8; Giovanni SANTI, *Federigo di Montefeltro duca di Urbino. Cronaca* (H. HOLTZINGER ed.), Stuttgart, 1893 (henceforth referred to as *Cronaca*). A fundamental later biography is Bernardino BALDI, *Della vita e de' fatti di Federigo di Montefeltro, duca di Urbino (1604)* (F. ZUCCARDI ed.), Rome,1824, 3 vols. For modern biographies, see esp.: J. DENNISTOUN, *Memoirs of the Dukes of Urbino* (E. HUTTON ed.), London, 1909 (first published in 1851), I, pp. 61–291; R. DE LA SIZERANNE, *Le vertueux condottiere Federigo da Montefeltro*, Paris, 1927 (Italian transl.: *Federico di Montefeltro: capitano, principe, mecenate (1422–1482)* [C. ZAPPIERI ed.], Urbino, 1978); W. TOMMASOLI, *La vita di Federico da Montefeltro, 1422–1482*, Urbino, 1978.

of St. Ubaldo, patron saint of Gubbio, for it was believed that the heir had been conceived by his intercession. She died a few months later, amid general consternation: she had enjoyed a considerable reputation on account of her political ability, exercised in Federico's absence, as well as for her devoutness and erudition.[2]

Fighting remained Federico's profession throughout his life. Indeed, this activity provided the State – which was poor in natural resources and cut off from the main trade routes – with its main source of income. He led armies on behalf of different patrons, sometimes serving opposite sides in succession, but never breaking contracts or agreements, as was common practice among mercenary soldiers at the time. This sense of loyalty, together with his military ability, made him the most esteemed and sought after condottiere of the Peninsula, and led to a number of honours. The most important ones were bestowed upon him in 1474: Sixtus IV awarded him the title of Gonfalonier of the Holy Roman Church and the Golden Rose, and made him a Duke; the King of Naples, Ferdinand I, conferred on him the Order of the Ermine, and King Edward IV of England, the Order of the Garter.

Within his State, Federico's popularity stemmed not only from his benevolent rule, but also from the very large profits derived from his activities as a condottiere, since they enabled him to keep personal taxation at low levels.[3] A considerable proportion of his earnings was invested in patronage. It is believed that from 1468 till his death in 1482 – this being regarded as the peak of Urbino's Golden Age – Federico spent more on patronage than any other prince in Italy. Most of it was devoted to the erection and refurbishing of buildings, and to their adornment.[4] Federico had palaces built in Urbino, Gubbio, Cagli, Fossombrone and Castel Durante (present-day Urbania). The largest and most impressive of all is the one in Urbino; its construction occupied him for the last thirty years of his life.[5]

1

[2] For contemporary accounts on Battista, see esp. Giovanni SABADINO DEGLI ARIENTI, "De Baptista Sforza duchessa de Urbino", in idem, *Gynevera. De le clare donne* (C. RICCI and A. BACCHI DELLA LEGA eds.), Bologna, 1969 (reprint of the 1887 ed.), pp. 288–311; and G. GAUGELLO DELLA PERGOLA, *De vita et morte ill.mae Baptistae Sfortiae Comitissimae Urbini* (A. CINQUINI ed.), Rome, 1905. Other references may be found in E. BATTISTI, *Piero della Francesca*, Milan, 1971, I, pp. 330–2, 509.

[3] On the finances of Urbino, see C. H. CLOUGH, "Sources for the Economic History of the Duchy of Urbino, 1474–1508", *Manuscripta*, X, 1966, pp. 3–27; idem, "Towards an Economic History of the State of Urbino at the Time of Federigo da Montefeltro and of his Son, Guidobaldo", in L. DE ROSA ed., *Studi in memoria di Federigo Melis*, Naples, 1978, III, pp. 469–504. The latter is reprinted, with additions, in CLOUGH's collection of his own articles, *The Duchy of Urbino in the Renaissance*, London, 1981, item III (the collection is hereafter referred to as CLOUGH 1981).

[4] On Federico's patronage, see C. H. CLOUGH, "Federigo da Montefeltro's Patronage of the Arts, 1468–1482", *Journal of the Warburg and Courtauld Institutes*, XXXVI, 1973, pp. 129–44; idem, "Federigo da Montefeltro's Artistic Patronage", *Journal of the Royal Society of Arts*, CXXVI, 1978, pp. 718–34 (reprinted, with additions and corrections, in CLOUGH 1981, items VIII and IX respectively). For the claim that Federico was, in the latter part of his rule, the most munificent patron in Italy, see the former article, p. 129.
On the artistic and humanist background of Urbino in general, see: W. BOMBE, "Die Kunst am Hofe Federigos von Urbino", *Monatshefte für Kunstwissenschaft*, V, 1912, pp. 456–74; A. VENTURI, "L'ambiente artistico urbinate nella seconda metà del Quattrocento", *L'Arte*, XX, 1917, pp. 259–93, and XXI, 1918, pp. 26–43; G. FRANCESCHINI, *Figure del Rinascimento urbinate*, Urbino, 1959; A. CHASTEL, *Art et humanisme à Florence au temps de Laurent le Magnifique*, Paris, 1982 (3rd ed.), pp. 359–72; P. MORACHIELLO, *Programmi umanistici e scienza militare nello Stato di Federico da Montefeltro*, Macerata Feltria, 1972; P. ZAMPETTI, *Federico da Montefeltro e la civiltà urbinate del Rinascimento*, Urbino, 1982; M. G. CIARDI DUPRÈ DAL POGGETTO and P. DAL POGGETTO eds., *Urbino e le Marche prima e dopo Raffaello*, Florence, 1983, Part I, Section I. See also the next note.

[5] On the Palace of Urbino, see: M. SALMI, *Piero della Francesca e il Palazzo Ducale di Urbino*, Florence, 1945; P. RO-TONDI, *Il Palazzo Ducale di Urbino*, Urbino, 1950, 2 vols. (abridged English ed., *The Ducal Palace of Urbino*, London, 1969); G. MARCHINI, "Il Palazzo Ducale di Urbino", *Rinascimento*, IX, 1958, pp. 43–78; idem, "Aggiunte al Palazzo Ducale di Urbino", *Bollettino d'Arte*, XLV, 1960, pp. 73–80; P. ROTONDI, *Francesco di Giorgio nel Palazzo Ducale di Urbino*, Novilara, 1970; L. H. HEYDENREICH, "Federico da Montefeltro as a Building Patron. Some Remarks on the

Federico must have first conceived the idea of this residence around 1450, when his authority in the State, and his reputation as a condottiere became established. There were three major phases of work.

The building erected in the first phase had as its core the so-called *Palazzetto della Jole*, on the east side of the present Palace, facing the Church of San Domenico. It incorporated two older constructions – a connection with the past which was probably intended to suggest dynastic continuity. The architect in charge of the first phase appears to have been the Florentine Maso di Bartolomeo, who, between 1449 and 1451 had built the doorway of San Domenico. This part of the building is impressive for its size, but shows little originality: like its medieval predecessors it consists essentially of a compact block with relatively small windows, while its disposition ignores its natural setting.

The turning point in the construction of the Palace occurred around 1465, when Luciano Laurana was invited from nearby Pesaro, where he was temporarily in the service of Alessandro Sforza, to take charge of the works. It was mostly under his direction that the building became the grand complex in the new idiom which Castiglione was to define as "una città in forma di palazzo". He was responsible for such distinctive features as the airy courtyard, the three-storey loggia overlooking the countryside framed by the two towers, the ducal apartment and the hanging gardens. 2,3

A patent-letter officially engaging him to direct the works on the Palace was issued to Laurana by Federico in 1468. It is worth discussing in some detail for it is revealing of the latter's artistic culture and of his attitude to patronage.[6] The document begins thus:

> Quelli uomini noi giudicamo dover essere onorati e commendati, li quali si trovano esser ornati d'ingegno e di virtù, e maxime di quelle virtù che sempre sono state in prezzo appresso li antiqui e moderni, com'è la virtù dell' architettura fundata in l'arte dell' arismetrica e geometria, che sono delle sette arti liberali, e delle principali, perché sono in primo gradu certitudinis, ed è arte di gran scienza e di grande ingegno, e da noi molto estimata e apprezzata.

The claim that architecture (traditionally regarded as a manual activity) is a liberal art, in fact, the highest of them all, because it is based on the scientific truths of mathematics and geometry, is a statement of belief in the so-called "mathematical humanism". Federico's court had become, from the mid 1460's, a meeting place of mathematically-inclined personalities. Alberti was a regular guest at his household, and seems to have intended to dedicate his *De re aedificatoria* to him.[7] Piero painted in Urbino two of his most complex works, the *Flagellation*, and the *Sacra Conversazione* now at Brera, the dates for both of which are much disputed. Around 1480 he wrote the treatise *De prospectiva pingendi*, which he dedicated to Federico, and the pamphlet *De quinque corporibus regularibus*. Indeed, though he is not recorded in Urbino before 1469, it has been suggested that he may have contributed to the planning of the Palace, for in the interior décor may be found echoes of the ideal architecture he depicted in some of his works (the *Flagellation*, for instance).[8]

Ducal Palace of Urbino", in *Studies in Renaissance and Baroque Art Presented to Anthony Blunt on his 60th Birthday*, London 1967, pp. 1–6 (also in L. H. HEYDENREICH, *Studien zur Architektur der Renaissance: Ausgewählte Aufsätze*, Munich, 1981, pp. 170–9); C. W. WESTFALL, "Chivalric Declaration: the Palazzo Ducale in Urbino as a Political Statement", in H. A. MILLON and L. NOCHLIN eds., *Art and Architecture in the Service of Politics*, Cambridge, Mass., 1978, pp. 20–45; L. BENEVOLO, "Il palazzo e la città", paper presented at the 1982 conference on Federico.

[6] For the full letter, edited by D. DE ROBERTIS and introduced by A. BRUSCHI, see A. BRUSCHI, C. MALTESE, M. TAFURI and R. BONELLI eds., *Scritti rinascimentali di architettura*, Milan, 1978, pp. 3–22. An English translation of the document (based on a preceding edition), is in D. S. CHAMBERS ed., *Patrons and Artists in the Italian Renaissance*, London, 1970, pp. 164–6.

[7] The claim is made by BALDI, *Della vita e de' fatti* cit., III, pp. 55–6.

[8] SALMI, op. cit. On Piero's presence in Urbino, see also BATTISTI, *Piero della Francesca* cit., I, pp. 308–71, 499–522, who however plays down the painter's contribution to the Palace, as well as his impact on that town in general.

The patent also bears witness to Federico's competence in architectural matters, for one learns from it that he chose Laurana after much looking around ("... avendo noi cercato per tutto, e in Toscana massime, dove è la fontana delli architettori, e non avendo trovato uomo che sia veramente intendente e ben perito in tal mistiero ..."[9]), and on the basis of the master's accomplishments as well as his reputation ("... avendo per fama prima inteso e poi per esperienza veduto e conosciuto quanto l'egregio uomo maestro Luziano, ostensore di questa, sia dotto e instrutto in quest'arte ..."). Federico's specialized knowledge of architecture is confirmed by a reliable biographer such as Vespasiano da Bisticci,[10] and has led to the suggestion that the general conception of the Palace may be due to him.[11]

The letter to Laurana also reveals the motive behind the construction of the building. Federico's aim was

> ... di fare in la nostra città di Urbino una abitazione bella e degna quanto si convene alla condizione e laudabil fama delli nostri progenitori, e anco alla condizion nostra.

These lines express a belief in *magnificentia*, the virtue of lavish spending. Like his contemporaries Lodovico Gonzaga, Alfonso V and Francesco Sforza, Federico was aware that large-scale building projects reflected the dignity of the patron. He must also have known that this form of personal ostentation helped enlist the support of the inhabitants, for it instilled in them a sense of civic pride.[12] They benefited too, in tangible terms, since architectural projects provided employment.

Laurana left suddenly, for unexplained reasons, in 1472. He was succeeded around 1474 by another architect of standing belonging to the "rationalist" tradition, Francesco di Giorgio Martini (to whom Vasari wrongly attributes the whole Palace). His are, as is generally agreed, the so-called *Cortile del Pasquino*, on the south side, with its flanking loggias on the northern and eastern sides, the underground reservoirs that watered the hanging gardens through a feeder-pipe system, and the stables on the west front of the complex. He also erected for Federico a number of fortifications, and, most probably, the memorial Church of San Bernardino on the outskirts of Urbino, which is based on an antique sepulchral prototype.

2

[9] The claim that there was not a competent enough architect in Tuscany at the time is endorsed by Howard SAALMAN in his review of the English edition of Rotondi's book: "The Ducal Palace of Urbino", *Burlington Magazine*, CXIII, 1971, p.51.

[10] Aveva voluto avere notitia de' architettura, delle quale l'età sua, non dico di signori ma di privati, non c'era chi avessi tanta notitia quanto la sua signoria. Vegansi tutti gli edifici fatti fare da lui, l'ordine grande et le misure d'ogni cosa come l'ha oservate, et maxime il palagio suo, che in questa età non s'è fatto il più degno edificio, si bene inteso, et dove sieno tante degne cose quante in quello. Bene ch'egli avessi architettori apresso della sua Signoria, nientedimeno nell'edificare intendeva il parere suo, dipoi dava et le misure et ogni cosa la sua Signoria, et pareva, a udirne ragionare la sua Signoria, che la principale arte ch'egli avessi fatta mai fussi l'architettura ...
Le vite cit., I, pp. 382–3.

[11] HEYDENREICH, "Federico da Montefeltro" cit., and BATTISTI, *Piero della Francesca* cit., I, p. 500 note 346. Heydenreich recalls that, in his *Trattato di architettura*, Filarete considers the birth of a building as the fruit of the "marriage" between the patron (to whom he credits the role of conceiver of the general idea) and the architect. On the question of the patron's role in the design of a building, see M. KEMP, "From 'Mimesis' to 'Fantasia': The Quattrocento Vocabulary of Creation, Inspiration and Genius in the Visual Arts", *Viator*, VIII, 1977, pp. 359–60.
The view that the Palace of Urbino was executed following Federico's general instructions is rejected by CLOUGH, who argues that the Prince had neither the time nor the competence to devise such a building. Cf. "Federico da Montefeltro's Patronage of the Arts" cit., p. 141.

[12] On the development of the ethos of *magnificentia*, cf. A. D. FRASER JENKINS, "Cosimo de' Medici's Patronage of Architecture and the Theory of Magnificence", *Journal of the Warburg and Courtauld Institutes*, XXXIII, 1970, pp. 162–70. This virtue is made much of in Giovanni SABADINO DEGLI ARIENTI's eulogistic treatise *De triumphis religionis*, published by W. L. GUNDERSHEIMER in his *Art and Life at the Court of Ercole I d'Este*, Geneva, 1972; see Book V, pp. 50–9, devoted to the "Triumpho e dignità della Magnificentia", and the editor's introduction, pp. 16, 26.

Federico's taste, in spite of the theoretical awareness suggested by the patent, was not consistently "mathematical". He also favoured imaginative styles of immediate effect. Under Laurana, or shortly after he left, the interior of the Palace was decorated in the precious and profuse idiom of Tuscan craftsmen such as Domenico Rosselli, and Venetian ones such as Ambrogio Barocci. The artists he engaged included Botticelli[13], the Fleming Justus of Ghent and, perhaps, the Spaniard Pedro Berruguete.[14] From Flanders came also in 1476 a set of eleven tapestries depicting the Siege of Troy, by Jean Grenier of Tournai.[15] Such eclecticism perhaps suggests an aspiration to see represented in the Palace the best of what was available at the time.[16]

Federico's passion for letters and scholarship in general equalled his interest in the visual arts. He kept regular contacts with the leading humanists of the time – the Tuscan ones in particular.[17] Cristoforo Landino dedicated to him his *Disputationes Camaldulenses* and Marsilio Ficino his Latin translation of Plato's *Republic*. In fact, the book dedications Federico received were numerous; however, like the celebratory poems written in his honour, not all were disinterested expressions of admiration. Through them many scholars sought to attract Federico's attention, in the hope of permanent patronage. They were usually disappointed, for he was reluctant to keep at his court full-time *littérateurs*, as was common practice at the time. The scholars he did employ, relatively few in number, served as tutors, librarians and in other specific capacities.[18]

No expense was spared, on the other hand, in the building up of the library. This was one of the highlights of the Palace. By 1482 it contained more than one thousand manuscripts, over half of which were provided by Vespasiano, who estimated the collection to be worth 30,000 ducats. It was one of the most wide-ranging libraries of the time, and contained, as well as medieval and contemporary texts, virtually the whole corpus of known classics.[19]

Another feature of the Palace that well illustrates Federico's humanist aspirations is the set of twin cubicles on the west side of the ground floor, respectively dedicated to God and the Muses – the so-called *Cappella del Perdono* and *Tempietto delle Muse*.[20] What is most "modern" about them is the 5,6
association of sacred and profane, for it proclaims a belief in the complementary nature of the Christian and pagan traditions. An inscription in the small vestibule that leads to the twin cubicles makes it clear that the association is deliberate: BINA VIDES PARVO DISCRIMINE JVNCTA SACELLA ALTERA PARS MVSIS ALTERA SACRA DEO EST.[21]

On the floor above, occupying an area corresponding exactly to that of the twin cubicles, is the *studiolo*. This is undoubtedly the feature of the Palace that best expresses the Prince's humanist enthusiasm – not only because its very presence implies that the condottiere was also an intellec-

[13] Botticelli's presence in Urbino is not documented, but his hand is evident in the designs of some of the intarsia-work of the Palace. Cf. CHASTEL, *Art et humanisme* cit., pp. 364; and Ch. IV, note 2 of the present monograph.

[14] The controversial issue of Berruguete's presence in Urbino is outlined in Ch. III, note 2, and Appendix B, note 2.

[15] CLOUGH, "Towards an Economic History" cit., pp. 487, 503–4; idem, "Federico da Montefeltro's Artistic Patronage" cit., pp. 725–7, 732–3. It is worth mentioning that the taste for the detailed lifelikeness, which was a distinctive feature of Flemish art, accords well with humanist taste; cf. M. BAXANDALL, *Giotto and the Orators*, Oxford, 1971, Ch. II.

[16] CHASTEL, *Art et humanisme* cit., p. 363.

[17] For Federico's relations with the humanists, see esp. FRANCESCHINI, *Figure del Rinascimento urbinate* cit., pp. 119–47; CLOUGH, "Federigo da Montefeltro's Patronage of the Arts" cit., pp. 133–7.

[18] CLOUGH, ibid.

[19] The library was accommodated in a room to the left of the main entrance, facing the grand courtyard. The manuscripts were taken to Rome in 1657 by Pope Alexander VII, and incorporated in the Vatican Library. On the library of Urbino and its vicissitudes, see: C. H. CLOUGH, "The Library of the Dukes of Urbino", *Librarium*, IX, 1966, pp. 101–4; S. R. HERSTEIN, "The Library of Federico da Montefeltro, Duke of Urbino", *The Private Library*, IV, 1971, pp. 113–28; and L. and M. MORANTI, *Il trasferimento dei 'Codices Urbinates' alla Biblioteca Vaticana*, Urbino, 1981.

[20] On these, see esp. ROTONDI, *Il Palazzo Ducale* cit., pp. 368–82, 468–9 (*The Ducal Palace* cit., pp. 85–93); CHASTEL, op. cit., pp. 370–2.

[21] [Here you see the two small temples divided by just a small space; one is dedicated to the Muses, the other to God]

tual, and because the idea of the studious withdrawal evokes the figure of Petrarch and his classical prototypes,[22] but most of all because, as will be shown in the present monograph, the decorations of the room embody a learned programme.

[22] These points are expanded upon in Ch. I.

Venuta la sera, mi ritorno in casa et entro nel mio scrittoio; e in su l'uscio mi spoglio quella veste cotidiana, piena di fango e di loto, e mi metto panni reali et curiali; et rivestito concedentemente entro nelle antique corti degli antiqui huomini, dove, da loro ricevuto amorevolmente, mi pasco di quel cibo che solum è mio e che io nacqui per lui; dove io non mi vergogno parlare con loro, e domandarli della ragione delle loro actioni; et quelli per loro humanità mi rispondono; e non sento per quattro hore di tempo alcuna noia: sdimenticho ogni affanno, non temo la povertà, non mi sbigottiscie la morte; tucto mi transferisco in loro.

Niccolò Machiavelli[1]

I. THE STUDIOLO OF URBINO:
RECONSTRUCTION, DESCRIPTION AND FUNCTIONS

The study of Federico da Montefeltro in Urbino[2] is the most complete surviving example of an early Renaissance *studiolo*. It is strategically placed on the piano nobile close both to his domestic quarters (bedroom and dressing room) and to his official ones (what are now known as *Sala delle Udienze* and *Sala degli Angeli*). Through its direct access to a loggia, the room enjoys a sweeping view of the surrounding countryside. 2
3, 62

The floor plan is quite irregular, as the doors in the west and south sides are set in deep recesses, and a pier in the middle of the eastern side determines two lateral niches; part of the west side is slanted. 4
If we exclude the recesses, the axes of the floor measure 360×335 cm. The room is lit by a window incorporated in the upper section of the slanted wall.

The walls of the *studiolo* are veneered with illusionistic intarsias to a height of 222 cm. On the upper part of the room, which from this height cuts out the door openings and the niches, originally hung twenty-eight portraits of famous men. The series has recently (summer 1983) been reconstructed *in situ*, in part photographically. 41, 49, 53, 58

II, III, IV

The ceiling, 494 cm. high, is decorated with twenty-four coffered panels depicting a wide range of Federico's devices, titles and emblems. Immediately beneath it, carved on a narrow strip of wood, runs the inscription: 66

FEDERICVS.MONFELTRIVS.DVX.VRBINI.MONTISFERETRI.AC.DVRANTIS.COMES.
SERENISSIMI.REGIS.SICILIE.CAPITANEVS.GENERALIS.SANCTEQVE.ROMANE.EC- II, III, IV
CLESIE.CONFALONERIVS.MCCCCLXXVI[3].

The presence of the famous men in the *studiolo* is well documented. Vespasiano da Bisticci states in his biography of the Prince:

[1] From the letter to Francesco Vettori, dated 10 December 1513; quoted after E. RAIMONDI ed., *Opere di Niccolò Machiavelli*, Milan, 1966, p. 23.
[2] On the *studiolo* as a whole, see: ROTONDI, *Il Palazzo Ducale* cit., I, pp. 332–56, 454–67 (pp. 77–85 of the English ed.); A. BRUSCHI, *Bramante architetto*, Bari, 1969, pp. 75–84 (p. 21 of its abridged English ed., *Bramante*, London, 1977); C. ELAM, *Studioli and Renaissance Court Patronage*, M.A. Dissertation, London Univ., 1970, pp. 19–24; MORACHIELLO, op. cit., pp. 91–102; M. CALVESI, "Vita e morte nello studiolo di Federico da Montefeltro", *Corriere della Sera*, 8 July 1973, p. 13; W. LIEBENWEIN, *Studiolo. Die Entstehung eines Raumtyps und seine Entwicklung bis um 1600*, Berlin, 1977, pp. 83–96, 207–12; CHASTEL, *Art et humanisme* cit., pp. 364–70; F. MAZZINI, *I mattoni e le pietre di Urbino*, Urbino, 1982, pp. 226–41; A. LUGLI, *Naturalia et Mirabilia. Il collezionismo enciclopedico nelle Wunderkammern d' Europa*, Milan, 1983, pp. 38–49, 128–9.
[3] [Federico da Montefeltro, Duke of Urbino, Count of San Leo and Durante, Captain General of the Very Serene King of Sicily, and Gonfalonier of the Holy Roman Church. 1476.]
It is generally believed that 1476 indicates the date of completion of the decorations.

[Federico] mandò infino in Fiandra per trovare uno maestro solenne, et fello venire a Urbino, dove fece fare molte pitture di sua mano solennissime, et maxime in uno suo istudio, dove fece dipingere e' filosofi et poeti et tutti e' dottori della Chiesa, così greca come latina, fatti con uno maraviglioso artificio, et ritrasevi la sua signoria al naturale, che non gli mancava nulla se non lo spirito[4].

Another source is Bernardino Baldi, who writes in 1587:

Oltre la Libreria v'è una Cameretta destinata allo studio, nell'appartamento principale, d'intorno alla quale sono sedili di legno con gli appoggi, ed una tavola nel mezo: lavorato il tutto diligentissimamente d'opera di tarsia e d'intagli. Dall'opera di legno, che così ricopre il pavimento come la muraglia d'intorno a l'altezza d'un uomo o poco più in fino alla soffitta, le facciate sono distinte in alcuni quadri, in ciascuno de' quali è ritratto qualche famoso scrittore antico o moderno, con un breve elogietto, nel quale ristrettamente si comprende la vita di ciascheduno di loro[5].

In 1631, shortly after the death of the last duke of Urbino, Francesco Maria della Rovere, and the consequent devolution of the ducal territories to the State of the Church, the famous men were brought to Rome, together with other works from the Palace, by the legate Cardinal Barberini. The portraits, which were originally arranged in twos, set within a fictitious structure of double compartments, were sawn apart and cut round the edges. After various vicissitudes, fourteen of them returned to Urbino (they are the originals that can now be admired in the study), while the others ended up in the Louvre (these have been replaced in the room with sepia-coloured reproductions)[6].

In spite of the dismemberment and the dispersal of the panels, a reconstruction of the arrangement has been possible. The scholar Laurent Schrader, who saw the portraits when they were still in their place, copied the inscriptions beneath them, starting from Plato and ending with Petrarch, and published them in his *Monumentorum Italiae, qua hoc nostro saeculo et a Christianis posita sunt* (Hemelstadt, 1592)[7]. His sequence provided Walter Bombe with a basis for the establishment of the original scheme. Bombe arranged the twenty-eight portraits in two superimposed registers, placing the first fourteen of the sequence on the first one, and the others on the second. As for the panels' distribution, he allotted the first group of four portraits to the west wall (the section to the right of the window), and the successive groups of four, in pairs, to the north, east and south walls. Bombe pointed out that the relative affinity of size of the panels in each group, and the complementary nature of the residual parts of the illusionistic framework proved that Schrader had copied the inscriptions in the right order. His scheme looks as follows[8]:

[4] *Le vite* cit., I, 1970, p. 384.
[5] *Descrizione del Palazzo Ducale di Urbino*, in idem, *Memorie concernenti la città di Urbino*, Rome, 1724 (facsimile ed., Bologna, 1978), p. 57.
[6] The vicissitudes of the famous men are as follows. Pope Urban VIII donated the paintings to Cardinal Barberini, who bequeathed them to his family. In 1812, fourteen of them were given to the Colonna di Sciarra family, who sold them to the Marchese Campana. These panels were acquired by Napoleon III when the Campana collection was dispersed in 1861. They entered the Louvre in 1863. The remaining fourteen panels were put on public display in the Palazzo Barberini of Rome in 1907. Following an agreement with the Italian State, these pictures found their way back to Urbino in 1934; until their recent re-collocation in the *studiolo*, they were exhibited in the *Galleria Nazionale delle Marche*, which the Palace houses. For a more detailed account, cf. J. LAVALLEYE, *Les primitifs flamands. I. Corpus de la peinture des anciens Pays-Bas méridionaux au 15e siècle. Le Palais Ducal d'Urbin*, Brussels, 1964 (hereafter: LAVALLEYE, *Le Palais Ducal*), p. 85; see also pp. 100–1 for the text of the act of donation of the panels to Cardinal Barberini.
[7] For the full texts of the inscriptions, cf. Appendix A. Because of the panels' mutilations, only the first line of each inscription, which carries the name of the figure, is extant.
[8] The question of the reconstruction was first dealt with by Bombe in "Justus von Gent in Urbino: Das Studio und die Bibliothek des Herzogs Federigo da Montefeltre", *Mitteilungen des Kunsthistorischen Institutes in Florenz*, III, 1909, pp. 111–28 (the scheme here reproduced is based on that on pp. 116–7 of the article). The same arguments and conclusions were later repeated in "Una ricostruzione dello Studio del Duca Federigo ad Urbino", *Rassegna Marchigiana*, VIII, 1929, pp. 73–88; "Une reconstitution du studio du Duc Frédéric d'Urbin", *Gazette des Beaux-Arts*, IV, 1930, pp. 266–75; and

window	GREGORY THE GREAT	JEROME		AMBROSE	AUGUSTINE	MOSES	SOLOMON
	119×70 cm.	117×68 cm.		119×70 cm.	116×62 cm.	115×80 cm.	115×78 cm.
	PLATO	ARISTOTLE		PTOLEMY	BOETHIUS	CICERO	SENECA
	100×76 cm.	100×76 cm.		97×68 cm.	98×67 cm.	102×79 cm.	100×76 cm.

THOMAS AQUINAS	DUNS SCOTUS	PIUS II	BESSARION	ALBERTUS MAGNUS	SIXTUS IV	DANTE	PETRARCH
114×76 cm.	120×76 cm.	116×56 cm.	115×56 cm.	116×56 cm.	116×55 cm.	111×64 cm.	112×64 cm.
HOMER	VIRGIL	EUCLID	VITTORINO DA FELTRE	SOLON	BARTOLUS	HIPPO-CRATES	PIETRO D'ABANO
95×76 cm.	90×74 cm.	95×59 cm.	95×63 cm.	95×59 cm.	95×59 cm.	98×67 cm.	93×60 cm.

Bombe's sequence has never been questioned[9]; nor has the two-tier arrangement of the panels, since, thus placed, they comfortably fill the available wall space. Appropriately, one register (the taller of the two) accommodates together the religious figures[10], and the other the figures from antiquity and the lay humanists. Bombe, however, unwittingly inverted the position of the two rows[11]: the reconstituted "jig-saws" of the mutilated grisaille figures that linked each set of four portraits leave no doubt as to the original position of the registers in relation to each other.

9–40

Far more controversial was the question concerning the possible presence among the portraits of the *studiolo* of a panel (134.4×75.6 cm.), attributed to Justus of Ghent, representing Federico with young Guidobaldo; this was also taken to Rome by Cardinal Barberini[12]. Such a

I

"Een reconstructie van de bibliotheek en van de werkkamer van den hertog Federigo van Urbino", *Historia*, IX, 1943, pp. 193–9.

[9] The one exception is BRUSCHI, *Bramante architetto* cit., pp. 80–1 note 53. Having noted that the articulations of the painted frieze and of the marquetry are out of phase, he concludes that Schrader must have copied the inscriptions in the wrong order. However, it is obvious from his footnote that he has not examined the paintings closely.

[10] Dante's and Petrarch's "intrusion" in the register of the ecclesiastical personalities is explained below, in Ch. III.

[11] Though this error was corrected by the organizers of the Melozzo exhibition of 1938 (cf. L. BECHERUCCI and C. GNUDI eds., *Mostra di Melozzo e del Quattrocento romagnolo*, Forlì, 1938, drawing between pp. 28 and 29), it was often repeated. See LAVALLEYE, *Le Palais Ducal* cit., p. 70.

[12] On this painting, cf. LAVALLEYE, op. cit., pp. 109–27; C. M. ROSEMBERG, "The Double Portrait of Federico and Guidobaldo da Montefeltro: Power, Widom and Dynasty", paper given at the 1982 conference on Federico; G. NEERMAN, "Il ritratto di Federico di Montefeltro e di Guidobaldo e il problema di Pedro Berruguete", in M. G. CIARDI DUPRÈ DAL POGGETTO and P. DAL POGGETTO eds., *Urbino e le Marche* cit., pp. 88–90.

panel synthesizes a dual concept which, as we shall see, recurs frequently in the *studiolo* decorations: that of *vita activa – vita contemplativa*. The Prince is represented wearing his armour and displaying the symbols of his successful military career (the Garter and the Order of the Ermine); yet he is also seated in a relaxed manner, absorbed in his reading, his helmet casually laid to one side. The composition suggests that *buon governo* is the result of military prowess and intellectual pursuits.

That the panel was originally in the *studiolo* seems to be attested by Vespasiano in the already-quoted passage. Yet this "evidence" is not entirely clear: the reference to the portrait of "sua signoria al naturale" immediately follows that to the "filosofi et poeti et tutti e' dottori della Chiesa, così greca come latina", but the "-vi" of "ritrasevi" could apply to "istudio" as well as to "Urbino". It is worth remarking incidentally that the portrait in question need not be identified with that of Federico and Guidobaldo, given that Vespasiano does not refer to the heir. The other source, Baldi, does not mention the double portrait at all.

Bombe excluded the presence of this panel from his reconstruction, noting that only theoretically could it be placed on the eastern wall (the only one wide enough to accommodate it), since the original dimensions (widths) of the eight portraits that hung there did not permit its insertion. He also pointed out that the panel would have struck a discordant note. By this, one presumes, he meant that, granted that the inclusion was possible, the eastern wall would have appeared cluttered up; that the sideways construction of the double portrait would have clashed with the frontal one of the other panels; that the full-length representation of Federico and Guidobaldo would have contrasted with that cut at knee-length of the famous men; finally, that the difference in scale would have upset the general illusionistic effect. The majority of scholars, however, bound by Vespasiano's "evidence" and/or influenced by the opinion expressed in 1950 by the *Soprintendente* of Urbino, Pasquale Rotondi, chose to include the double portrait on the east wall, placing it between the two groups of four portraits[13].

Bombe's exclusion of the double portrait from the *studiolo* could only in part settle the question of harmony, since, on their own, the portraits of Homer, Virgil, Thomas Aquinas, Duns Scotus, Euclid, Vittorino, Pius II and Bessarion would, considering the Renaissance *horror vacui*, have left a blank space of unacceptable proportions on the east wall.

The question of the reconstruction has recently been re-examined by Rotondi[14]. The less mutilated sides of the original double portraits have revealed, following the latest restoration, the presence of lines and strips, which he has convincingly interpreted as remnants of an illusionistic structure of pilasters linking the ceiling to the intarsia basement and grouping the portraits in fours. Now, if we followed the topographic arrangement of the famous men proposed by Bombe, these pilasters would relate asymmetrically to the inlaid structure below. Rotondi, however, has argued that since Schrader recorded the inscriptions without leaving any explicit topographic indications, it could not be taken for granted, as Bombe and all others after him had done, that the sequence of portraits 7,8 began on the western wall. Reversing his own earlier opinion, he has proposed to shift the beginning of Schrader's sequence to the north wall. The new arrangement looks as follows[15]:

[13] See M. J. FRIEDLÄNDER, *Early Netherlandish Painting* (N. VERONEE-VERHAEGEN ed.), Leyden-Brussels, 1968, III, p. 51; ROTONDI, *Il Palazzo Ducale* cit., I, pp. 340, 455–6 note 206; LAVALLEYE, *Le Palais Ducal* cit., attached photomontage; LIEBENWEIN, op. cit., p. 88; WESTFALL, op. cit., p. 37. See also Clough's reconstruction, discussed below. As far as I know, Bombe's opinion was shared only by Guglielmo Pacchioni, whose scheme the organizers of the Melozzo exhibition (cited in note 11) used.

Friedländer actually states that the portrait of Federico and Guidobaldo was on the west wall; he must in fact be referring to the east wall.

[14] "Ancora sullo studiolo di Federico da Montefeltro nel Palazzo Ducale di Urbino", in *Restauri nelle Marche – Testimonianze, acquisti e recuperi*, Urbino, 1973, pp. 561–602 (also in *Studi Bramanteschi*, Rome, 1974, pp. 255–65).

[15] The dimensions given here, more accurate than those provided by Bombe with his scheme (they consist of the average of

NORTH WALL
width: 335 cm.

PLATO	ARISTOTLE	PTOLEMY	BOETHIUS
101.6×68.8 cm.	100.3×68.5 cm.	97.8×66.5 cm.	97×62.9 cm.
GREGORY	JEROME	AMBROSE	AUGUSTINE
114.1×68.8 cm.	117.4×68.6 cm.	118×65.9 cm.	118.4×63 cm.

EAST WALL
width: 360 cm.

CICERO	SENECA	HOMER	VIRGIL
101.3×73 cm.	98.7×78.1 cm.	94.6×76.3 cm.	92×75.2 cm.
MOSES	SOLOMON	THOMAS AQUINAS	DUNS SCOTUS
114.8×73.6 cm.	111.7×79.6 cm.	114.9×76.3 cm.	119.2×75.8 cm.

SOUTH WALL
width: 280 cm.

EUCLID	VITTORINO DA FELTRE	SOLON	BARTOLUS
94.6×58.4 cm.	94.9×63.8 cm.	95.2×58.4 cm.	95.2×58.5 cm.
PIUS II	BESSARION	ALBERTUS MAGNUS	SIXTUS IV
116×51.6 cm.	115.9×56.3 cm.	116.2×53.8 cm.	115.9×56.4 cm.

WEST WALL
width: 160 cm.

	HIPPO-CRATES	PIETRO D'ABANO
window	97.6×63 cm.	96.6×63.4 cm.
	DANTE	PETRARCH
	111.2×64.7 cm.	111.2×57.9 cm.

Rotondi backs his proposal with a series of convincing arguments. He points out that the topographic re-arrangement makes for greater harmony, thanks to the considerable affinity in size of the panels within each wall: the portraits fill their respective walls comfortably and at regular intervals that allow for the insertion of the pilasters. A more satisfactory relationship between the painted structure and the inlaid one also ensues, since the central pilaster of the northern wall and that of the eastern wall fall symmetrically over the niche and the central pier below. The lighting on the portraits and on the illusionistic pilasters of the north and south walls relates logically to the actual source of light of the *studiolo* – the window on the west wall[16]. Rotondi further substantiates his claim by observing that the inscription beneath the ceiling, which in Schrader's transcription immediately precedes the texts of the portraits, begins on the north wall – the one to which he proposes to move the beginning of the sequence. This would support the reasonable assumption that, after copying the inscription surrounding the room, Schrader went back to the original wall to copy the twenty-eight epigraphs.

9–16, 25–32

three measurements and correspond to the original parts of the paintings – i.e. they exclude the wooden strips later added to some of them), are drawn from VERONEE-VERHAEGEN's edition of FRIEDLÄNDER's work, p. 51. They are, in turn, taken from LAVALLEYE, *Le Palais Ducal* cit., pp. 44–5, and from the forthcoming catalogue: R. VAN SCHOUTE, *Le Musée national du Louvre. Corpus de la peinture des anciens Pays-Bas méridionaux au 15e siècle*, II.

[16] The lighting on the portraits and pilasters of the remaining walls is unsystematic. Rotondi argues that the correctly-lit panels were painted by, or under the supervision of, Bramante, and the others by an artist unconcerned by the need to take the real source of light into account; he believes this artist to be Justus of Ghent. Cf. "Ancora sullo studiolo" cit., pp. 593–602 (pp. 261–5 of the later ed.). The question of the authorship of the panels is touched upon in note 2 of chapter IV.

17–24, 33–36

The arrangement excludes the presence of the panel of Federico and Guidobaldo, since, given the dimensions of the portraits of Cicero, Seneca, Moses, Solomon, Homer, Virgil, Thomas Aquinas and Duns Scotus, there is no room for it on the eastern wall. Rotondi adds that X-rays and infrared examination have established that the double portrait was painted after the panels of the famous men: this indicates that it was not part of the original pictorial scheme.

III

Rotondi's reconstruction is also supported by the satisfactory iconographic relations resulting within the frieze of famous men. This aspect will be dealt with in detail in Chapter III; suffice it to say at this stage that the new topography permits the grouping on the northern wall of the four Doctors of the Church: Gregory, Jerome, Ambrose and Augustine.

Only a marginal aspect of Rotondi's reconstruction may be objected to: the suggestion that the double portrait may have been placed on the floor, held upright by a stand. This practice was uncommon in the Quattrocento. Besides, the painting was designed to hang high, as its point of

I

view indicates. Finally, it would have greatly encumbered the tiny room (which probably housed a lectern already), and hidden part of its attractive inlays.

Another reconstruction (the last of the series) has recently been proposed by Cecil Clough[17]. On the assumption that the traditional topographic arrangement of the portraits is correct, and that the panel of Federico and Guidobaldo hung on the east wall, he has argued that the space between the latter picture and the inlaid basement was probably occupied by Piero's *Flagellation*. Clough recalls that, in 1839, Passavant read on this panel the now lost inscription "convenerunt in unum" [they came together]. These words are drawn from the second verse of Psalm 2, to which the *Acts of the Apostles* 4:26 refer (hence the connection with Christ's Passion). The Psalm contains a celebration of dynastic power. Clough remarks that the phrase is also found at the beginning of the second Book of Dante's *De Monarchia*, which deals with the way in which Divine Will manifests itself in history. He concludes that the *Flagellation* lent itself to be placed beneath the portrait of the Prince and his heir because it implicitly expressed the idea that the perpetuation of the Montefeltro rule had divine approval. Clough supports his theory by stating that the *Flagellation* could constitute an indirect celebration of the Prince; he refers to the traditional interpretation of the painting, according to which the fair young man in the foreground depicts Oddantonio, killed in the 1444 plot, whom Federico agreed to succeed in order to ensure the continuation of the dynasty.

Clough's theory is interesting but contradicted by Rotondi's discoveries and sound philological arguments. Even assuming that the old arrangement of the portraits is correct, the *Flagellation*, with its width of 91 cm.[18], would not have fitted in the gap on the east wall (86.3 cm.). Neither Vespasiano nor Baldi of course make any reference to this painting. The inclusion of the 75.6 cm. wide portrait of Federico and Guidobaldo would have been extremely improbable, given that the famous men were originally larger – a point already made by Bombe, as we have seen.

Rotondi's reconstruction, with the exception of the small point already discussed, is so convincing as to be considered definitive, and all iconographic arguments made here will be based on this assumption. Such a view is shared by the *Soprintendenza* of Urbino, which has in fact reconstructed the frieze of portraits according to Rotondi's latest proposal[19]. The double portrait has

[17] "Federico da Montefeltro's Artistic Patronage" cit., pp. 727–34; "Federigo da Montefeltro: the Good Christian Prince", *Bulletin of the John Rylands University Library of Manchester*, LVII, 1984, pp. 335–41.

[18] The panel's height is 67.5 cm. The figures of 23¼"×32" provided by CLOUGH (ibid., p. 733 note 60) are misleading since they correspond, with slight approximation, to the dimensions of the panel's painted area only: 58.3×81.5 cm. The unpainted border is original, and provided a grip to the now lost frame on which the inscription "convenerunt in unum" was probably to be found. See BATTISTI, *Piero della Francesca* cit., II, pp. 49–50, from whom the dimensions of the panel are also drawn.

[19] Unfortunately, the panels have been inaccurately spaced out, both vertically and horizontally. The two tiers of portraits are too close to each other: the arrangement does not leave sufficient room for the missing parts of the inscriptions of the upper tier. On the other hand, the two halves of each double compartment are too wide apart from each other, and

been excluded altogether from the room[20] (it is displayed in the *Galleria Nazionale delle Marche*).

*

The inlays, which, as already noted, completely veneer the lower part of the walls, depict illusionistically mostly the sort of furniture, ornaments and implements one might expect to find in a princely study[21].

If we exclude the east side, the west and south doors, and the narrow area to the right of the west door – all presenting "irregular" designs – the inlays may be divided into three horizontal registers. 49, 58, 53 / V

a) An upper register, consisting of: cupboards with latticed doors ajar or closed containing, amongst other things, books, vessels and scientific instruments; three niches incorporating the Theological Virtues; and two compartments enclosing a full-length portrait of Federico and an organ respectively. The frieze is articulated by a series of roughly equidistant fluted pilasters, headed by composite capitals. 46, 57, 61 / 41, 54

b) A middle register, consisting of ducal *imprese* and one emblem, located immediately beneath each of the already named enclosures. This register is articulated by pedestals decorated with a stylized vegetal design.

c) A lower register, consisting of folding seats placed on a continuous platform. The flaps are hinged on to the lower border of each *impresa* panel. Most of them rest on stands, thus providing a suitable place for the display of a variety of musical instruments and other items; a few lean back thus completely hiding the corresponding *impresa*, but revealing the abstract vegetal pattern of their reverse side. Each stand corresponds to the pilaster and pedestal above, and incorporates a wheel-like design. The front carries a stylized olive branch motif.

The main feature of the east side is the central pier. The upper part of it depicts a loggia overlooking a landscape; on the edge of the sill are a basket of fruit and a squirrel intent on cracking a nut. The recess to the right is illusionistically expanded in depth; there we see depicted a sort of miniature *studiolo*, with a lectern set on a circular table, some books and a sandglass. Part of an inscription is visible: "… CVS.MONFELTRIVS.DVX.VRBINI.MONTISF …". Clearly, it is meant to echo that beneath the ceiling. At the back of the left recess is depicted a compartment containing a suit of armour. The articulation of fluted pilasters is present on this side too. 49 / VII / 49, 52 / 50

The lower part of this wall reproduces asymmetrically some motifs already encountered, such as cupboards and pedestals with vegetal decorations, as well as a few new ones such as stylized laurel branches and some purely abstract designs.

do not allow room for the insertion of the pilasters. The wrong spacing is especially noticeable on the east wall, where the panels of Virgil and Duns Scotus, and of Solomon and Thomas Aquinas incongruously touch each other. II–IV

[20] The *Soprintendente* of Urbino, Prof. Dal Poggetto, kindly informs me that he chose to follow Rotondi's latest arrangement and leave out the portrait of Federico and Guidobaldo after reading my critical survey of the reconstructions: "La decorazione dello studiolo di Federico da Montefeltro a Urbino: problemi ricostruttivi", *Notizie da Palazzo Albani*, X, 1981, pp. 15–31.

The new arrangement has also been endorsed by CALVESI, op. cit., and ROSEMBERG, op. cit., note 1 (who agrees with me that the double portrait could not have been set on a stand on the floor). As far as I know, it has not been refuted by anyone, apart from Clough. It is true that Liebenwein and Westfall refer to the old reconstruction (see note 13, above), but since they make no mention of the new one, we can assume that this has simply escaped them.

[21] For contributions of general interest on the Urbino inlays, cf. A. CHASTEL, "Les marqueteries en trompe-l'oeil des 'studioli' d'Urbin et de Gubbio", *Art et décoration*, XVI, Febr. 1950, pp. 13–7; L. MICHELINI TOCCI, *Le tarsie dello studiolo di Urbino*, Pesaro, 1968; ROTONDI, *Francesco di Giorgio nel Palazzo Ducale* cit., pp. 103–16; M. L. D'OTRANGE MASTAI, *Illusion in Art*, New York, 1975, pp. 72–4; M. FERRETTI, "I maestri di prospettiva", in F. ZERI ed., *Storia dell'arte italiana*, Turin, XI, 1982, pp. 488, 517–24, 577–85.

The left-hand side of the central pier contains a series of real shelves. Its right-hand side incorporates real cupboards, on whose shutters are depicted latticed cupboards containing jumbled-up books.

Of the two doors in the room, that on the west wall, leading to the ducal dressing room, depicts a cage with two parrots, and a clock; that on the south wall, leading to the *Sala delle Udienze*, has latticed motifs. The shutter beneath the window, which gives access to the loggia, is perfectly camouflaged by decorations of the "regular" type described above.

Among the motifs represented on the narrow wall to the right of the west door are a series of drawers, two of the Prince's titles (the Collar of the Ermine and the Order of the Garter), a scroll and some musical instruments.

<div align="center">*</div>

The main purpose of the Urbino study was to provide Federico with a comfortable and secluded environment that might allow him to devote himself to leisurely pursuits of a mostly humanistic type and thus free himself temporarily from the worries of his administrative and political duties[22].

The idea of a *studiolo* is rich in literary implications. The figure of Petrarch (present in the room through one of the portraits) comes to mind: to his example the Renaissance owed the transformation of the monastic ideal of solitude into a secular and literary one. Petrarch withdrew to the peace of the country not merely to seek God, but to analyse himself, stimulated by the reading of his beloved classics and by the intimacy with nature. The idea that *otium* and *solitudo* could be especially congenial to *studium* was inspired in Petrarch first and other humanists later by a number of ancient writers' lyrical descriptions of country villas; these expressed the cult of a contemplative leisure to be spent away form the crowds[23].

Heydenreich has suggested that the Urbino study, in fact the whole Ducal apartment, may have been directly influenced by one of such sources[24]. Pliny the Younger described in one of his letters (that addressed to Gallum, in Book II, xvii of his collection) two quiet areas he had created in his *Villa Laurentinum* to withdraw to in his moments of leisure. Some of their features recall details of Federico's *appartamento*: their diminutive size and the prospect over nature, for instance. Of one of such rooms Pliny notes:

> Parieti eius in bibliothecae speciem armarium insertum est, quod non legendos libros, sed lectitandos capit[25].

Such a cupboard is relatable to the illusionistic ones of Federico's *studiolo*. Heydenreich believes that these correspondences are not purely coincidental: Federico owned a codex with Pliny's letters; the letter in question was also known to Alberti (a frequent guest to the Montefeltro house-

[22] See Machiavelli's quotation prefacing this chapter.

[23] On the humanist idea of studious withdrawal to the country, and the antique sources that inspired it, cf. U. HOFF, "Meditation in Solitude", *Journal of the Warburg and Courtauld Institutes*, I, 1937–38, pp. 293–4; B. RUPPRECHT, "Villa. Zur Geschichte eines Ideals", *Probleme der Kunstwissenschaft*, II, 1966, pp. 210–50; D. R. THOMASON, '*Rusticus*': *Reflections of the Pastoral on Renaissance Art and Literature*, M. Phil. Thesis, London Univ., 1968, esp. Chs. I and II; D. RADCLIFF-UMSTEAD, "Petrarch and the Freedom to be Alone", in A. SCAGLIONE ed., *Francis Petrarch, Six Centuries Later. A Symposium*, Chapel Hill – Chicago, 1975, pp. 236–48; M. O'LOUGHLIN, *The Garlands of Repose*, Chicago – London, 1978. The subject will be taken up when dealing with the landscapes (the illusionistic and the real) that the Urbino *studiolo* opens on to.

[24] "Federico da Montefeltro as a Building Patron" cit., pp. 5–6 (pp. 178–9 of the later ed.).

[25] [in the wall is contrived a cupboard like a bookcase, which contains a collection of such authors whose works can never be read too often.]
Transl. from PLINY, *Letters*, Cambridge, Mass., 1951 (Loeb Classical Library), I, p. 155.

hold, as we have seen), who quotes an extract from it in Book X of his *De re aedificatoria* in connection with the planning of a quiet room.

Both Elam[26] and Liebenwein[27] have played down Heydenreich's claims. Liebenwein is probably correct in suggesting that, rather than providing an exclusive source, Pliny's text merely confirmed the conception of the *studiolo* in the Palace. It is reasonable to suppose that such celebrated precedents as Leonello d'Este's Belfiore study in Ferrara and Piero de'Medici's *scrittoio* in the *Palazzo di via Larga* in Florence (which Federico probably knew, at least indirectly, and which, in turn, might have been inspired by Pliny and/or other classical texts) also had a share in suggesting the idea of a *studiolo* in Urbino, and affecting the nature of its decorations[28].

Finally, inspiration could have come from the pictorial genre of the scholar in his study, which had as protagonists Petrarch and such learned saints as Jerome and Augustine. No specific pictures need to be singled out as possible influences, given the diffusion of the theme, but among the most celebrated examples which antedates our *studiolo* two are worth recalling: the portrait of Petrarch attributed to Altichiero in the *Sala Virorum Illustrium* of the Palace of Francesco da Carrara in Padua (now the University Assembly Hall), and Van Eyck's *St. Jerome*, a picture owned by the Medici, which was to serve as a model for Ghirlandaio's *St. Jerome* and Botticelli's *St. Augustine* in the Church of Ognissanti in Florence[29].

The sumptuousness of the decorations of the room is in keeping with the already-discussed belief in *magnificentia*. Unlike the monk or the hermit who, purely concerned with seeking communion with God, retreated to a bare cell, Federico required a luxurious and worldly environment that, while secluded to permit concentration, would also be comfortable, aesthetically pleasing, and intellectually and morally inspiring; one that would suitably reflect and glorify his taste, aspirations and interests.

The *studiolo* is unlikely to have been used for contemplative activities only. It must also have been shown to illustrious visitors, thus fulfilling a propaganda function. Its very location by the *Sala delle Udienze* seems to confirm this. Indeed, Rotondi has suggested that the *studiolo* was created when its adjacent room began to be used for audiences[30].

[26] *Studioli and Renaissance* cit., p. 20.

[27] *Studiolo* cit., p. 212 note 341.

[28] On the Belfiore study, cf. A. K. EÖRSI, "Lo studiolo di Leonello d'Este e il programma di Guarino da Verona", *Acta Historiae Artium Academiae Scientiarum Hungaricae*, XXI, 1975, pp. 15–52. Piero della Francesca was in Ferrara in 1449, when Leonello's *studiolo* was being decorated, and could have been the mediator of the idea of such a room in Urbino later (cf. ROTONDI, *Il Palazzo Ducale* cit., I, p. 335).
On Piero de' Medici's study, cf. D. HEIKAMP, "Lo 'scrittoio di Piero'", in *Il tesoro di Lorenzo il Magnifico. II.I vasi*, Florence, 1974, pp. 47–51. Federico, who, as has been remarked, had close contacts with Florentine humanist circles, is likely to have seen or heard of the *scrittoio* in the Medici Palace. On the probable influence of this *scrittoio* on Federico's *studiolo*, cf. W. A. BULST, "Die Ursprüngliche Innere Aufteilung des Palazzo Medici in Florenz", *Mitteilungen des Kunsthistorischen Institutes in Florenz*, XIV, 1970, pp. 384–5.

[29] For the rise of the theme of the scholar in the study, and surveys of its representations, cf. A. PÖLLMANN, "Von der Entwicklung des Hieronymus-Typus in der älteren Kunst", *Benediktinische Monatsschrift*, II, 1920, pp. 438–522; A. VENTURI, *L'arte a San Girolamo*, Milan, 1924; A. STRÜMPELL, "Hieronymus im Gehäuse", *Marburger Jahrbuch für Kunstwissenschaft*, II, 1925–26. pp. 173–244; R. JUNGBLUT, *Hieronymus Darstellung und Verehrung eines Kirchenvaters*, Tübingen, 1967; A. CHASTEL, "The Studiolo", in idem, *The Myth of the Renaissance 1420–1520*, Geneva, 1969, pp. 167–9; H. FRIEDMAN, *A Bestiary for Saint Jerome. Animal Symbolism in European Religious Art,* Washington, 1980; B. RIDDERBOS, *Saint and Symbol. Images of Saint Jerome in Early Italian Art*, Groningen, 1984. With the exception of Chastel, these authors deal almost exclusively with Jerome, as this scholar dominated the genre.

[30] ROTONDI, *Il Palazzo Ducale* cit., I, p. 457 note 208. That *studioli* were not inaccessible to others besides their regular occupiers is amply proven. The study of Paolo Guinigi, ruler of Lucca, was renowned enough to be requested by Leonello d'Este in Ferrara (cf. S. BONGI, *Di Paolo Guinigi e delle sue ricchezze*, Lucca, 1871, pp. 27, 48–50). Piero de'Medici's *scrittoio* was described by Piero Parenti, Filarete and Vasari, and its decorations copied by many (HEIKAMP, op. cit., pp.

The combination of inlays and painted panels which we find in the Urbino study was in no way unique. It was commonly adopted for types of rooms as different as tribunals and bedchambers[31]. It appears to have been almost a norm with *studioli*. The study of Nicholas V in the Vatican Palace, that of Leonello d'Este in the Palace of Belfiore, of Piero de' Medici in the Palazzo di via Larga, of Federico in his Gubbio Palace, and of Guidobaldo in Urbino (to name some prominent instances) were all decorated in this way[32]. Though usually complemented by paintings, the woodwork was probably the leading constituent in *studioli* decorations. The reasons for this must have been first of all practical. Studies were meant to be used for prolonged spells, and therefore needed to offer the maximum physical comfort. Now, wood is an ideal material in this sense, for, as Alberti points out in his *De re aedificatoria*, it offers the advantage of insulation from cold and heat[33]. The advantages of wood are also psychological: it is a material that can create, thanks to its warm tones

48–9; E. BORSOOK, "A Florentine 'scrittoio' for Diomede Carafa", in M. BARASCH and L. F. SANDLER eds., *Art the Ape of Nature. Studies in Honor of H. W. Janson*, New York, 1981, pp. 91–6); it is known to have been shown to Ermolao Barbaro among other visitors (LIEBENWEIN, op. cit., pp. 82–3, 206–7 notes 261–4). Isabella d'Este's *camerini* were frequently opened to illustrious guests (C. M. BROWN, "'Lo insaciabile desiderio nostro de cose antique'. New documents on Isabella d'Este's collection of antiquities", in C. H. CLOUGH ed., *Cultural Aspects of the Italian Renaissance – Essays in Honour of Paul Oskar Kristeller*, Manchester, 1976, pp. 347 note 37, 349 note 49).

If it is more than likely that the *studiolo* of Urbino was proudly shown to visitors, the view occasionally expressed that it was not actually used for study purposes is probably extreme. Emanuel WINTERNITZ, for instance, remarks that the real objects would have cluttered up the room, thus upsetting the harmony of the simulated environment. Cf. *Musical Instruments and their Symbolism in Western Art*, London, 1967, p. 120 (the comment actually refers to the Gubbio study, but it could of course equally apply to the Urbino one). The location of the study in close proximity to the bedroom and dressing-room, and the presence of real, carefully-hidden shelves and cupboards suggest that the room did have a practical function. It is worth noting that in a treatise aimed at merchants, written around the middle of the 15th century, Benedetto CO-TRUGLI implies that for functional reasons *studioli* should ideally be situated next to a bedroom:

Et chi si diletta di lettere, non dee tener li libri nello scrittoio comune, dee havere uno studiolo à parte, in più remoto luoco della casa, il quale potendo esser vicino alle camara dove dorme è cosa ottima, e salubre, per poter più comodamente studiare quando il tempo gl'avanza, e questo è glorioso e laudabile essercitio.

(*Della mercatura e del mercante perfetto*, Venice, 1573, p. 86; quoted after C. FRANZONI, "'Rimembranze d'infinite cose'. Le collezioni rinascimentali di antichità", in S. SETTIS ed., *Memoria dell'antico nell'arte italiana*, Turin, I, 1984, p. 307.)

[31] A. SCHIAPPARELLI, *La casa fiorentina e i suoi arredi nei secoli, XIV e XV*, Florence, 1983 (reprint of the one-volume edition of 1908, with a second volume of additions by M. SFRAMELI and L. PAGNOTTA), I, pp. 167–72; M. WACK-ERNAGEL, *The World of the Florentine Renaissance Artist* (A. LUCHS ed.), Princeton, N. J., 1981 (originally published in 1938), pp. 153–67.

[32] The decorations of Nicholas V's study included frescoes by Angelico and intarsia panelling by Niccolò da Firenze; cf. B. BIAGETTI "Una nuova ipotesi intorno allo studio e alla cappella di Niccolò V nel Palazzo Vaticano", *Atti della Pontificia accademia romana d'archelogia-Memorie*, III, 1932–33, pp. 205–14. Those of the study of Belfiore consisted of inlays by Arduino da Baiso, Lorenzo and Cristoforo da Lendinara and others, and of a series of painted panels representing the Muses, of various and partly debated authorship; cf. EÖRSI, op. cit. Piero's *scrittoio* was decorated with perspective inlays and paintings of unknown subjects and authorships (as well as with roundels by Luca Della Robbia depicting the seasons); cf. HEIKAMP, op. cit. For the Gubbio *studiolo* see the next chapter. Guidobaldo's *studiolo* was located in the *Tempietto delle Muse*, which was decorated with inlays of unknown designs and authorship, complemented by eleven panels representing Minerva, Apollo and the Muses of controversial attribution; see note 20 of the Introduction, for an essential bibliography.

[33] Materia praesertim abieginea aut item pupulea si parietem convestieris, erit locus salubrior et bene satis hyeme tepens, aestate vero haud multo erit calens.

[If you veneer your walls with wood, fir or poplar especially, your house will be healthier: quite warm in winter, and not too hot in summer.]

(*L'Architettura* [G. ORLANDI ed.], Milan, 1966, Book X, Ch. XIV, vol. II, p. 981.)

and soft organic texture, a cosy atmosphere congenial to meditation and study[34]. Finally, and more simply, wood is very appropriate because it is normally associated with furniture. When *studioli* were not fitted with real shelves and cupboards, the illusionistic representation of these could be enhanced by employing the very material which they were usually made of.

[34] On the "friendliness" of the wood, cf. R. BARTHES, "Toys", in idem, *Mythologies*, London, 1973, pp. 54–5; and J. BAUDRILLARD, *Le système des objets*, Paris, 1968, pp. 45–6.

Ne già qui degio andar dimenticando
dello admirando suo palazzo altero
nella Città de Ogobio, e del quale
non potrei tanto dir che assai più el vero
non fusse …

Giovanni Santi'[1]

[The Palace was] once renowned […] especially for its jewel of rare
intarsia work, the apartment known as the Gabinetto del Duca, sold a
few years since to Prince Lancelotti of Rome; it is now nothing but […]
the merest empty shell.

Laura McCracken[2]

II. THE STUDIOLO OF GUBBIO

The *studiolo* of the Ducal Palace of Gubbio[3], the second most complete example of a Quattrocento
study, and one dependent on that of Urbino (at least as far as the intarsias are concerned, as we shall
see), deserves detailed attention, since it will be frequently referred to in the course of this investi-
gation.

Gubbio, Federico's birthplace, had belonged to the Montefeltros since 1384. It was Battista Sfor-
za's favourite residence, after her marriage to the Prince in 1460. It is there that, in January 1472,
she gave birth to Guidobaldo, dying shortly afterwards. The Ducal Palace, erected by Federico
between 1474 and 1480 approximately, was perhaps intended to commemorate her and celebrate
the birth of the heir. The building, which was frequently referred to as *Corte nova*, incorporated
the 14th century *Palazzo della Guardia*; it is now known that the architect responsible for at least
part of the design was Francesco di Giorgio Martini[4]

The decorations of the *studiolo* can no longer be admired in its original setting, since the Palace was
stripped of all its furnishing and fittings by its successive owners, after the death of Francesco
Maria II della Rovere in 1631[5]. Like that of the Urbino study, they consisted essentially of paint-
ings, intarsia panels and a coffered ceiling. This is well documented.

67

78–88, 89

[1] *Cronaca* cit., Book XII, Ch. LX, 23–4, p. 121.
[2] *Gubbio, Past and Present*, London, 1905, pp. 145–6. I am grateful to Dr. Clough for this reference.
[3] For general literature on this *studiolo*, cf. P. REMINGTON, "The Private Study of Federico da Montefeltro", *Bulletin of the Metropolitan Museum of Art*, XXXVI, 1941, pp. 3–13; R. PAPINI, *Francesco di Giorgio architetto*, Florence, 1946, I, pp. 137–9, 244, 247–8; C. H. CLOUGH, "Federico da Montefeltro's Private Study in his Ducal Palace of Gubbio", *Apollo*, LXXVI, 1967, pp. 280–7; WINTERNITZ, op. cit., pp. 120–8; CHASTEL, *Art et humanisme* cit., pp. 369–71; ELAM, op. cit., pp. 25–7; LIEBENWEIN, pp. 97–9, 212; C. H. CLOUGH, "Lo studiolo di Gubbio", paper read at the 1982 conference on Federico.
[4] On Gubbio in general, see: O. LUCARELLI, *Memorie e guida storica di Gubbio*, Città di Castello, 1888; McCRAC-KEN, op. cit.; T. JACKSON, *A Holiday in Umbria*, London, 1917, pp. 190–202; E. GIOVAGNOLI, *Gubbio nella storia e nell'arte*, Città di Castello, 1932. An exhibition entitled *Dal Sogno all'Utopia. Gubbio e i Montefeltro* was set up in Gubbio in summer 1983, but no catalogue was published.
On the Palace, see G. MARTINES, "Il Palazzo Ducale di Gubbio: un brano sepolto della città medioevale, un' ipotesi per Francesco di Giorgio", *Ricerche di storia dell'arte*, VI, 1977, pp. 89–99; idem, "Francesco di Giorgio a Gubbio in tre documenti d'archivio rinvenuti e trascritti da Piero Luigi Menichetti", *Ricerche di storia dell'arte*, XI, 1980, pp. 67–70; finally, idem, "La costruzione del Palazzo Ducale di Gubbio: invenzione e preesistenze", and F. P. FIORE, "Francesco di Giorgio a Gubbio", papers given at the 1982 conference on Federico.
[5] Briefly, the vicissitudes of the Palace are as follows. The building was inherited by Vittoria della Rovere, grand-daughter of Francesco Maria della Rovere, and passed on to the Grand Dukes of Tuscany when she married Ferdinand II in 1634. It was sold to the State of the Church in 1763 by Francesco Stefano of Lorraine. It appears to have been used as a hospice for the mendicant friars till 1788, when it was sold at auction to the Balducci family of Gubbio. It was used as a factory for the

The earliest reference to the *studiolo* is in Nicola Cerretani's *Relazione degli stabili della Principessa Vittoria* (1631), an inventory of the items which Vittoria della Rovere was to inherit from the Duke. This mentions, with reference to the first floor of the Palace, "uno studiolo con le scansie intarsiate, e Pitture"[6]. The paintings in question cannot be traced with documentary certainty but, as will be shown later, attempts have been made to identify them.

A second early reference to the study is to be found in the *Relazione sopra il Palazzo della Ser[enissi]ma Duchessa Vittoria in Gubbio*. This document, datable between 1631 and 1659, consists of a detailed survey of the structural conditions of the Palace, complete with an estimate of its restoration costs, and of three well-captioned plans of the floors. In the drawing of the piano nobile, a room marked with the letter "I" is identified as "Gabinetto", i.e. study[7].

69

The paintings of the *studiolo* must have been the first to be removed, since the descriptions of the room that have reached us, all of them 19th century, refer to the woodwork, but make no mention of any other decoration[8]. The woodwork left the Palace in 1875, and eventually found its way to the Metropolitan Museum of New York[9]. There it was exhibited in reconstructed form from 1941 to the early seventies. It is currently being restored and will be placed on permanent display soon.

Cerretani's *Relazione*, the first floor plan attached to the second *Relazione*, as well as the shape and dimensions of the woodwork, have permitted the identification of the room that originally accommodated the *studiolo*. This room which, as we have seen, is located on the piano nobile of the Palace[10], faces south-east; it is set between a spiral staircase in the north-eastern side, and a 14.5×3.00 m. corridor on the south-western side. The plan is quite irregular: its sides measure (beginning from the wall to the left, as one enters the room from the long corridor): 397.5, 205, 402 and 286.5 cm. respectively. The door is set in a recess some 122 cm. deep. A window niche is cut

68

70

manufacture of candles and silk in the first half of the 19th century. The building became a national monument in 1909, but by then it had been despoiled of practically all its decorative woodwork and sculpture (door frames, chimney-pieces, etc.). For a more detailed account of these vicissitudes, cf. CLOUGH, "Lo studiolo di Gubbio" cit.

On the restoration of the Palace, see: F. RAFFI, "Restauri nel Palazzo Ducale di Gubbio", *Italia Nostra*, XVII, Sept.-Oct. 1975, pp. 36–9; P. CIUFERRI, "I restauri nel Palazzo Ducale di Gubbio", *Antiqua*, III, 1976, pp. 54–60; MARTINES, "Il Palazzo Ducale" cit. See also note 11 below. The Ducal Palace has recently (June 1984) been opened to the public to house temporary exhibitions.

[6] For the full text of Cerretani's *Relazione*, cf. C. BUDINICH, *Il Palazzo Ducale d'Urbino*, Trieste, 1904, pp. 129–30.

[7] This important manuscript has recently been discovered by Prof. Bruno CENNI, in the *Archivio di Stato* of Florence (Fondo Urbinate, classe III, F. XXXII, cc. 1–9). For the full text, together with an interesting essay on it, see his booklet: *Un manoscritto inedito per il Palazzo Ducale di Gubbio. Un intervento di diagnostica a stima visiva per il restauro del Palazzo Ducale eugubino, sec. XVII*, Gubbio, 1982.

[8] The first of such accounts is in J. D. PASSAVANT, *Rafael von Urbino und sein Vater Giovanni Santi*, Leipzig, I, 1839, p. 10; it describes the inlays and the ceiling. Two others are quoted in DENNISTOUN, op. cit., I, pp. 172–3; the first of these, due to the Gubbio scholar Luigi Bonfatti, briefly deals with the inlays; the second, by a certain F. C. Brooke, discusses both the inlays and the ceiling in some detail. (Dennistoun could not provide a first-hand account of the study, since, as he explains on p. 172, the Palace was closed when he visited Gubbio in 1843.) Finally, there is the description of the German scholar Paul LASPEYRES, who had seen the room in 1873; it is the most detailed of all, and deals with the intarsias and the ceiling. Cf. "Die Baudenkmale Umbriens. IX Gubbio", *Zeitschrift für Baukunst*, XXXIII, 1883, p. 78.

[9] The decorations were purchased by Prince Lancillotti in 1875, for his villa at Frascati. Sometime later, the Prince sold them to Adolfo Loewi, a Venetian dealer, who in turn sold them to the Swiss magnate Werner Abegg around 1934. However, the plan did not go through. The room was finally sold to the Metropolitan Museum in 1939. Cf. Museum Catalogue, ref. 39.153, cards No. 11–13, and CLOUGH, "Lo studiolo di Gubbio" cit., who, however, states that the dealer was the antiquarian Bardini of Florence.

[10] This floor is on the same level as the courtyard, because the Palace is built on a slope. The mountain rises on the north-western side. For the SW-NE cross-section of the building, see PAPINI, op. cit., III, Fig. XXXV; the drawing is also reproduced in MARTINES, "Il Palazzo Ducale" cit., Fig. 5.

roughly into the middle of the 402 cm. wall. On either side, higher up, are two small embrasured windows, approximately 110 cm. high and 60 cm. wide. Until recently (July 1984) these were entirely blocked. The nature of the filling material used suggests that the bricking in took place some time in the 17th century[11].

The smooth plaster that was laid on the walls during the restoration of the 1970's has also just been removed to reveal the masonry, and the cramps which held the intarsia panels, the paintings and the ceiling. The wooden ceiling was suspended at a height of 5 m. from the present tile floor, as the level of the cramps at the top of the walls indicate. This floor, however, dates from the 17th century. The original brick floor is some 20 cm. beneath it[12].

There was a second, smaller, coffered ceiling; this was fitted in the window niche. The soffit of the doorway is also worth noting: it is an inlaid panel depicting the Montefeltro arms, including the insignia of Gonfalonier of the Holy Roman Church and the letters FE DVX, which incontrovertibly date the decorations after 1474, when the title was awarded, and before 1482, when Federico died[13].

The woodwork has unfortunately reached us in an incomplete state, the main loss being the window section of the niche. This has been replaced by a modern reconstruction[14]. The intarsia designs are similar to those of Urbino. They depict an articulated frieze of cupboards to which correspond below two parallel sequences: one made up of ducal emblems and devices, and another of folding seats. The paraphernalia in the room (books, armour, musical and scientific instruments, etc.) are also essentially the same, though less numerous and more neatly arranged. Only a few items are displayed on the seats. The Theological Virtues, the portrait of Federico, the loggia overlooking the landscape, the squirrel and the basket of fruit – details which feature prominently in Urbino – are absent from the Gubbio decorations as we know them.

Along the top of the intarsia panelling, beginning from the wall to the left of the entrance, run the following distichs:

ASPICIS AETERNOS VENERANDAE MATRIS ALVMNOS
DOCTRINA EXCELSOS INGENIOQVE VIROS
VT NVDA CERVICE CADANT ANTE
. GENV
IVSTITIAM PIETAS VINCIT REVERENDA NEC VLLVM
POENITET ALTRICI SVCCVBVISSE SVAE[15]

[11] This view was communicated to me orally by the architect in charge of the restoration of the Palace, Giovanni Venturini of the *Soprintendenza* of Perugia, and confirmed by Cenni, who has carried out a series of structural examinations of the *studiolo* on behalf of the *Istituto d'arte* of Gubbio. Both will be publishing the results of their investigations very shortly.

[12] This information was kindly supplied to me by Cenni. His figure of 5 m. agrees with the approximate one that can be deduced from LASPEYRES's statement that the wainscoting (268 cm. high) reached half the height of the walls ("Die Baudenkmale" cit., p. 78). DENNISTOUN, quoting Bonfatti, states that the "room is nineteen feet high, but the inlaid work goes only half way up" (*Memoirs* cit., I, p. 172); however the figure of 19′ (579 cm.) must be treated as a gross approximation.

[13] PASSAVANT (op. cit., I, p. 10), PAPINI (op. cit., I, p. 138) and CHASTEL (*Art et humanisme* cit., p. 369) assume that the *studiolo* must have been completed by Guidobaldo, on account of the letters G. BALDO DX inscribed on a mirror, by the large window. The inscription, as will be argued later, was probably intended as a dynastic reference. See also note 30, below.

[14] It would appear that in the 19th century, before its removal from the Palace, the woodwork was in no more complete a state than it is now: the already mentioned accounts say nothing of the decorations of the window section of the niche; the partly mutilated inscription that runs along the upper edge of the intarsias (see below, in the text) is recorded in just as incomplete a form by both Brooke and Laspeyres.

[15] Hans NACHOD has argued that the missing part of the inscription was:

. ORA PARENTIS
DEMISSE POSITO SVPPLICI TERQVE . . .

28

This led Martin Davies to suggest that above it hung the so-called *Liberal Arts*, a series of panels attributed to Justus of Ghent, of which four are known. They are: the *Rhetoric*(?) (157 cm. high × 105.5 cm. wide) and *Music* (155.5×97 cm.) of the National Gallery of London, and the *Dialectic*(?) (150×110 cm.) and *Astronomy* (150×110 cm.), formerly in the Kaiser-Friedrich-Museum of Berlin[16], destroyed in the 2nd World War. These paintings would apply to the inscription since each depicts a bare-headed man in homage before a female figure. The original number of panels is unknown; Davies believed there would have been room in the *studiolo* for "seven – or more"[17].

72

75, 73

74

Though the paintings' original provenance is undocumented[18], their association with the Montefeltro is obvious. In the *Dialectic*(?), the figure in homage is identifiable as Federico: his armorial shield is depicted directly above him. Three of the paintings carry parts of an inscription across the background. The fragmented text reads: ... VX VRBINI MONTISFERETRI AC (on the *Rhetoric*(?)), DVRANTIS COMES (on the *Dialectic*(?)) and ECLESIE CONFALONERIVS (on the *Music*). This was treated by Davies as additional evidence that the allegorical panels came from the Gubbio study, as it echoes part of the inscription beneath the ceiling of its Urbino counterpart[19]. The text also enabled him, with the help of other pictorial evidence, to attempt a reconstruction of the sequence.

Rhetoric(?), Davies argued, must have been placed to the left of *Dialectic*(?), as indicated by the sense of the inscription and the perspective of the thrones. Such common features as the round backs of the thrones and the dark marble in the upper mouldings of the background panelling distinguish these pictures from the other two; further, the two *Trivium* pictures are lit from the left, and the *Quadrivium* ones from the right. The enclosing wall to the right of *Dialectic*(?) shows that this was the last panel of the wall, while the shadow of a throne's arm to the left of *Rhetoric*(?) points to the presence, immediately before it, of another allegory, probably *Grammar*, the third art of the *Trivium*.

72, 73

He has ascribed the lines to the Duke's librarian Federigo Veterano. Cf. "The Inscription in Federigo da Montefeltro's Studio in the Metropolitan Museum: Distichs by his Librarian Federigo Veterano", *Medievalia et Humanistica*, II, 1943, pp. 98–105. Nachod's translation of the full inscription is:

> You see the eternal nurselings of the honourable mother,
> > men exalted by learning and genius
> how they kneel down with bared necks before the face of their parent,
> > humbly and suppliantly bending their knees:
> Reverend piety prevails over justice and no one
> > repents having yielded to his fostermother.

[16] For the suggestion that the *Liberal Arts* come from the Gubbio study, and detailed information on the London panels, cf. M. DAVIES, *Early Netherlandish School, National Gallery Catalogues*, London, 1945, pp. 45–53; pp. 52–9 of the 1955 ed., and pp. 70–8 of that of 1968 to which reference will henceforth be made. See also: idem, *Les primitifs flamands. I. Corpus de la peinture des anciens Pays-Bas méridionaux au quinzième siècle. The National Gallery*, II, Antwerp, 1955, pp. 142–57. For the Berlin panels, cf. *Beschreibendes Verzeichnis der Gemälde im Kaiser-Friedrich-Museum und Deutschen Museum*, Berlin, 1931, pp. 304–6.

[17] *Early Netherlandish School* cit., p. 74. Davies cautiously pointed out that it could not be assumed that the *Arts* were originally seven, since the series sometimes also included Medicine and Architecture.

[18] These paintings were assumed, without any foundation, to have come from Urbino. They were mostly ascribed to the library of the Palace or the room adjacent to it. Cf. DAVIES, *Les primitifs flamands ... The National Gallery* cit., pp. 148, 153–6. The library could not have accommodated the *Liberal Arts* as there was not enough room for them on the walls, between the shelves (which have left marks on the plaster, as recent restoration has revealed) and the vaulted ceiling. The results of the restoration of the library have been outlined by Prof. Dal Poggetto in a paper given at the 1982 conference on Federico: "La Biblioteca del Palazzo di Urbino".

The room adjoining the library is equally unsuitable: it is too large for the panels (13.65×6.25 m.). For a detailed plan, cf. BOMBE, "Justus von Gent in Urbino" cit., p. 129, Fig. 22.

[19] See p. 15 of this monograph.

The arrangement of the other two known pictures proved more difficult to establish. Davies
remarked that *Astronomy* must have been placed to the left: this is shown by the perspective of the
throne, the enclosing wall on the left and the position of the kneeling figure. *Music* could be
ascribed a late place in the sequence on account of the words ECCLESIE CONFALONERIVS
(assuming that the full inscription was like that in Urbino). Davies thought the painting may have
been a centre-piece, or half of a composite one, since its perspective is centralized. He attributed
the termination of the panelling on the right to the presence of a structural or decorative object
separating this panel from the next one. He concluded that the uncertainty concerning the exact
number of pictures in the series made it impossible to tell whether *Astronomy* (which bears no
inscription) immediately preceded *Music*, or whether another panel came between the two.

Davies's suggestion that the *Liberal Arts* originally hung in the Gubbio study has been generally
accepted.[20] Cecil Clough has taken it further; he has claimed that, as well as these panels (which he
believes to have been seven in number), the room accommodated the picture of *Federico,
Guidobaldo and Others Listening to a Discourse*, attributed to Justus of Ghent, now at Hampton
Court[21]; he has also proposed a precise topographic arrangement for all of them[22].

The Hampton Court picture (130 cm. tall × 212 cm. wide) was designed to hang high, as its
perspective indicates. Clough argues that, in its original size and framed, it would have neatly filled
the wall space above the entrance[23]. He points out that the two columns in the foreground of the
picture would have harmonized with the inlaid pilasters that frame the upper half of the doorway
below, and that the background frieze inscription, which reads FEDERICVS DVX VRBINI
MONTIS FE . . ., would have echoed part of that on the *Liberal Arts*, thus paralleling the inscrip-
tion repetition which occurs in the Urbino *studiolo*. Clough believes that the Hampton Court
panel was the highlight of the *studiolo*, and that it depicts the oration delivered by Antonio Bonfini,
in the autumn of 1477 or spring of 1478, on behalf of his client Leonardo Angelo, who had been
dispossessed of his fief of Controguerra in the Kingdom of Naples. Bonfini aimed to convince
Federico to use his influence on the King of Naples, so that the property could be restored[24].
Interpreted in this way, the painting is treated as an implicit celebration of the Prince's appreciation
of Rhetoric, and of his justice.

As for the *Liberal Arts*, Clough allocates the *Trivium* to the long wall to the left of the entrance,
Astronomy to the next one, and *Geometry*, *Arithmetic* and *Music* to the other long wall. So

[20] The claim continues to be made occasionally that the panels come from the Palace of Urbino: cf. BRUSCHI, *Bramante architetto* cit., pp. 84–6 (pp. 21–2 of its English ed.), who ascribes the series to the room next to the library; and DUBOS, op. cit., pp. 22, 38, MAZZINI, op. cit., p. 164, and C. CIERI VIA, "L'idea di microcosmo come forma simbolica nella cultura urbinate del '400", in M. APA ed., *Microcosmo/Macrocosmo*, Urbino, 1984, p. 17, who ascribe it to the library. However, since none of these authors refers to Davies, it is likely that they are unfamiliar with his reconstruction.

[21] On this picture, cf. J. LAVALLEYE, *Juste de Gand, peintre de Frédéric de Montefeltre*, Louvain, 1936, pp. 146–50; J. EECKOUT, *Juste de Gand, Berruguete et la cour d'Urbino*, Gand, 1957, pp. 60–1. The fullest account of this painting is in the forthcoming catalogue *The Early Flemish Pictures in the Collection of Her Majesty the Queen*, pp. 59–65. I am most grateful to the author, Dr. Lorne CAMPBELL, for sending me a paginated copy of the entry in question.

[22] "Federigo da Montefeltro's Private Study" cit., pp. 278–87. The view that the *Liberal Arts* and the Hampton Court panel were in the *studiolo* is confirmed, together with the panels' arrangement, in his paper "Lo studiolo di Gubbio".

[23] It should be noted that the dimensions of the panel given by CLOUGH in "Federigo da Montefeltro's Private Study" cit., p. 281 and the caption of Fig. 12 on p. 286, namely 120 cm. × 210 cm., are inaccurate. My figures are drawn from LAVALLEYE, *Juste de Gand* cit., p. 146, and find confirmation in CAMPBELL, op. cit., p. 60.

[24] Marilyn ARONBERG LAVIN too has argued, independently, that the *Discourse* depicts Bonfini's oration. Cf. "The Altar of Corpus Domini in Urbino: Paolo Uccello, Joos van Ghent, Piero della Francesca", *Art Bulletin*, XLIX, 1967, p. 23. The subject of this painting and the identity of the figures appearing with Federico and Guidobaldo have been much debated. For a full survey of opinions, see CAMPBELL, op. cit., pp. 62–4. Campbell's own view is that the *Discourse* (of which two early copies appear to have existed) does not depict "a specific event but rather [. . .] a generalised image of the learned activities of the Urbino court" (p. 64). Such a view is well substantiated, and I would endorse it.

arranged, and assuming that the missing panels were approximately the same size as the known ones, the series could be easily fitted in the available space. Clough places the *Trivium* panels in the order recommended by Davies, but suggests that *Dialectic*(?), with its portrait of Federico, may in fact be *Rhetoric* (and, obviously, vice-versa), since, if so identified, the picture would reiterate the motif of the Prince paying homage to Eloquence, which he sees obliquely expressed in the Hampton Court panel. His arrangement of the *Quadrivium* panels ignores Davies's cautious considerations on their sequence. Schematically, Clough's reconstruction looks as follows[25]:

NORTH-WEST WALL
(width: 397.5 cm.)

SOUTH-WEST (DOOR) WALL
(width: 286.5 cm.)

| | VX VRBINI MONTISFERETRI AC | DVRANTIS COMES |

FEDERICVS DVX VRBINI MONTIS FE

BONFINI'S ORATION
130×212 cm.

Unknown
[GRAMMAR]

DIALECTIC
157×105.5 cm.

RHETORIC
150×110 cm.

NORTH-EAST WALL
(width: 205 cm.)

SOUTH-EAST (WINDOWS) WALL
(width: 402 cm.)

ECLESIE CONFALONERIVS

ASTRONOMY
150×110 cm.

Unknown
[GEOMETRY]

Unknown
[ARITHMETIC]

MUSIC
155.5×97 cm.

Now, this reconstruction is far from convincing. The very first objection concerns the panels that have been placed on the south-east wall. There simply is not enough room for them because of the presence of the two smaller windows[26]. Davies, who relied on second-hand information about the room, seems not to have been aware of their existence[27]. Clough does refer to these windows, but provides no measurements; we are led to conclude that they would not have interfered with the three paintings[28]. Yet, since the intarsias reached the height of 268 cm., and the small windows are set from a height of approximately 395 cm. (this measurement takes into account the level of the original floor), the three paintings, which must have all been over 155 cm. tall, could obviously not

[25] For a photographic reconstruction, see "Lo studiolo di Gubbio" cit., Fig. 8.
[26] I am grateful to Virginia Tenzer of Brown University (Providence, R. I.), for kindly pointing this out to me, and leading me to question the presence of the *Artes* in the *studiolo* before I was able to visit the Gubbio Palace.
[27] At least, no mention is made of them in *Early Netherlandish School* cit. The acknowledgment that a certain Theodore Rousseau sent him the dimensions of the *studiolo* (ibid., p. 77 note 11) indicates that Davies had not seen the room.
[28] "Federigo da Montefeltro's Private Study" cit., p. 281, and "Lo studiolo di Gubbio" cit. See also the following note.

have fitted into the space between them[29]. They could have been accommodated on that wall only if the embrasured windows were bricked in at the time – which does not seem to be the case, as we have seen. The top part of the large window, which reaches the level of the lower border of the small ones, would also have had to be filled in. It is worth noting that the wing which incorporates the *studiolo* room is one of Federico's additions to the medieval *Palazzo della Guardia*; thus it is unlikely that the alterations were made on the wall shortly after the latter was built. Besides, a *studiolo* needs plenty of light. But even if the small windows and the top of the main one were walled in to accommodate the *Liberal Arts*, Clough's arrangement is unconvincing.

The panels that particularly strike one as being out of place are *Astronomy* and *Music. Astronomy* is unlikely to have occupied by itself the wall that faces the door: its sideways construction, which, as Davies pointed out, calls for a position on the left, would have contrasted sharply with the centralized perspective of the intarsias beneath it. *Music*, on the other hand, which is lit from the right and has a frontal construction, is an improbable occupant of the position to the right of the window wall. We may attempt to shift these panels elsewhere in the room, but the *Trivium* should be kept where Clough has placed it, for its lighting from the left agrees with that of the inlays below; further, since *Grammar* is likely to have carried the beginning of the panels' inscription (most probably, the words FEDERICVS MONFELTRIVS[30]), it would be appropriate if this coincided with the beginning of the carved inscription, on the north-western wall[31]. None of the other possible arrangements of the two *Quadrivium* pictures is, however, entirely satisfactory. *Music* could not occupy the door wall, as it would be lit from the wrong side. It could not be accommodated on the opposite wall for its inscription (ECLESIE CONFALONERIVS) would not follow from that of the preceding panel (DVRANTIS COMES); moreover, its open end on the left would not match the enclosing wall of this picture. *Astronomy* might be placed to the left of the windows wall, with *Music* next to it as a centrepiece: its perspective would be correct, and so would the direction of the light (the painted shadows would be in agreement with those on the intarsias). Such a reconstruction corresponds to that proposed by Bruschi for the room adjoining the library of Urbino[32]; topographically his window is placed elsewhere, but the direction of the light in relation to the panels remains essentially the same. In spite of its advantages it is not faultless, though. *Astronomy* and the unknown panel preceding it (*Arithmetic* or *Geometry*) could in no way accommodate the missing parts of the inscription in their entirety:

SERENISSIMI REGIS SICILIE CAPITANEVS GENERALIS SANCTEQVE ROMANE

We do not, however, have to assume that the paintings' original inscription was like that in Urbino. A more serious problem is the termination of the wall panelling to the right of *Music*. If it is true, as Davies argued reasonably, that a structural or decorative object followed the picture, then there would not have been room for *Geometry* or *Arithmetic* on the same wall.

Given that the four known panels cannot be placed in any visually satisfactory way, and that, in any case, it is extremely unlikely that three *Liberal Arts* hung on the south-eastern wall, Davies's claim, and with it Clough's arrangement, must be rejected. The *studiolo* could have been decorated with another series of paintings, of appropriate dimensions, depicting a similar subject mat-

[29] The photographic reconstruction attached to Clough's conference paper is misleading: it shows that the panels could comfortably fit there, but the schematically-drawn windows have been placed arbitrarily on the wall in question.

[30] DAVIES, misled, like Passavant and Chastel, by the mirror with Guidobaldo's name, did not exclude the possibility that the inscription on the missing *Grammar* might have been GVIDO VBALDVS MONTEFELTRIVS. Cf. *Early Netherlandish School* cit., pp. 73–4.

[31] Some of the shortcomings of Clough's arrangement of the *Liberal Arts* have been pointed out by ELAM, op. cit., pp. 26–7. LIEBENWEIN believes both Davies 's and Clough's reconstructions to be unconvincing (op. cit., p. 99). Neither Elam nor Liebenwein, however, question the presence of the *Arts* in the study.

[32] See note 20, above.

32

ter, for it is undeniable that the inscription along the top of the intarsias applies aptly to the *Liberal Arts* we know.

The possibility that the *Discourse* may have hung on the south-western wall cannot be discounted. 76, 85 The size of the picture, the structure of the composition, the direction of the light and the perspective viewpoint do support such a location. Further, the portrait of Federico wearing the robe of the Order of the Garter would correspond to the Garter depicted directly below him, casually yet prominently hanging out of the latticed cupboard over the door. 86

Ironically, evidence against the presence of the *Discourse* in the study is provided by Clough's own (questionable) deductions. He has assumed that a recently-discovered contract stating that Francesco di Giorgio Martini entrusted a certain Berardino from Gubbio to paint some friezes of a ducal *camera* in September 1477 refers to our *studiolo*, and concluded that by that date the rest of the woodwork (intarsias and ceilings) must have been installed[33]. Now, if it is true, as Clough has

[33] The document, discovered by Piero Luigi MENICHETTI, is here quoted fully from his *Le corporazioni delle Arti e Mestieri medioevali a Gubbio*, Città di Castello, 1980, p. 239:

Die XXII mensis maii [1477] Actum Eug. in supradicta domo mei notarii presentibus testibus in fine presentis contractus descriptis. Spectabilis vir Francischus Georgii de Senis, vice et nomine Ill.mi D.ni N.ri Ducis, etc. locavit et concessit Berardino q. Nannis Petri pictori de Eug. presenti et conducenti, opus infrascriptum videlicet: quod dictus Berardinus teneatur et debeat depingere de colore azurro fino, valoris IIII Ducatorum pro qualibet libra, quomdam fregium in Camere sue Ill. Dom. ad omnes parietes cum licteris aureis, et etiam facere et depingere in tota dicta Camera omnia alia laboreria quod fuit designata in quodam folio aut carte ostenso et demostrato ipsi Berardino per dictum Francischum in presentia dictorum testium et mei notarii, et de coloribus sibi commissis per ipsum Francischum, et cum auro fino in locis dicte Camere secundum quod per dictam designationem apparet in dicto folio; ubicumque aparet color croceus sit aurum cum damaschino alto et basso, cum alio fregio super circumcircha ad omnes parietes, secundum dictam designationem et totum aurum et colores ponere ibi de suo proprio et omnia et singula facere circa predicta que dictus mag. Francischus sibi dixerit ordinasse et designasse et commisisse et quod dictum opus debeat esse approbatum iudicio ipsius Francisci.

Et dictum opus facere et completare promisit per totum mensem septembris proximi futuri.

Et hoc pro mercede septuaginta Ducatorum auri sibi dandorum et solvendorum per prefatum Ill.mum D.num N.um sive per alium pro sua Do. solventem.

Quod pus promisit facere bona fide etc. et ita iuravit ... Presentibus Dommo Sensio Pauli Sensi et Jacopo Pritiani de Senis testibus.

[Gubbio, 22 May [1477]. Drawn up in the above-mentioned house of my notary, and in the presence of the witnesses whose names are listed at the foot of the present contract. The esteemed Francesco di Giorgio da Siena, as proxy for our most illustrious Duke, has awarded the contract for, and commissioned Berardino, son of the late Nanni Pietro, painter of Gubbio, here present and undertaking the contract, to carry out the following work. Namely, that the said Berardino be contracted and [thus] obliged to paint with fine azure worth four ducats a pound, a frieze in the room of his Most Illustrious Lord, on all the walls, with golden letters. He must also carry out and paint in the whole of the abovementioned room all the other pieces of work, as indicated on a sheet or drawing that has been shown and thoroughly explained to Berardino himself by the said Francesco, in the presence of the said witnesses and my notary. He must do this using the colours allotted to him by Francesco himself, and with gold of good quality in the parts of the said room, according to the aforesaid design shown on the aforesaid sheet. Wherever the colour yellow is shown, gold should be used, with *damaschino* (plum colour) above and below together with the other frieze that runs around the top of all the walls, as shown in the aforesaid drawing. [He is expected] to supply all the gold and the [other] colours from his own pocket, and carry out everything including the details concerning the aforesaid works, which the said master Francesco has told him to set in order, draw up and commission. This work is to be judged and approved by Francesco.

[Berardino] has promised to carry out and complete this work in the course of this coming September.

For this he will receive the sum of seventy golden ducats, to be paid to him and settled by our aforenamed Most Illustrious Lord, or by another person on his behalf.

[Berardino] has promised to carry out the work in good faith, etc., and has sworn as follows ... In the presence of the witnesses Dommo Sensi, Paolo Sensi and Jacopo Pritiani of Siena.]

For the claim that the contract concerns the Gubbio study, see CLOUGH, "Lo studiolo di Gubbio" cit. The paper includes, as an Appendix, an edited version of the document.

argued, that the Hampton Court panel depicts Bonfini's oration of late 1477 – early 1478, and was designed to relate specifically to the intarsias and at least one of the other paintings (that depicting Federico in homage), one would have to come to the unlikely conclusion that the decorations were not conceived at the same time[34]. Most scholars (including Clough) in any case agree that the *Discourse* must have been completed around 1479–80, since Guidobaldo looks about eight years old[35].

It is worth noting that the *Discourse* and the *Liberal Arts* are in many ways incompatible[36]: the former is much less tall than the latter; there is little compositional agreement between the two; the inscriptions on the *Discourse* and on the *Rhetoric*(?) echo each other thus making the close proximity of the two panels doubtful[37]; finally, Federico is unlikely to have been depicted twice in the same room[38].

To conclude, the question of the reconstruction of the Gubbio study is far from resolved. The paintings Cerretani refers to in his *Relazione* cannot have included the *Liberal Arts* we know, though the *Discourse* may have been part of the original scheme. Throughout this investigation, any comparison between the decorations of the Urbino and Gubbio *studioli* will be restricted to the woodwork.

5, 6 Clough's assumption that the *camera* the contract refers to must be the *studiolo* is surely rash. The only evidence that supports it is the letter frieze of corresponding colours, but this is hardly sufficient. Blue friezes with gold lettering are not infrequent in works commissioned by Federico (the *Tempietto delle Muse* and the *Cappella del Perdono*, for instance, are both decorated in this way). Blue and gold were, after all, Montefeltro colours; cf. L. NARDINI, *Le imprese o figure simboliche dei Montefeltro e dei Della Rovere*, Urbino, 1931, p. 5.

89 Menichetti's document refers to a second frieze, placed just beneath the ceiling, and there is indeed one in such a place in the *studiolo*. However, Dr. Olga Raggio of the European Sculpture and Decorative Arts Department of the Metropolitan Museum kindly informs me that this frieze is now thought not to have originally belonged to the ceiling in question.

[34] Clough himself has argued that the decorations were probably conceived as a whole. See: "Federico da Montefeltro's Private Study" cit., p. 286.

[35] See CAMPBELL, op. cit., p. 64, for a review of opinions. CLOUGH's own dating is in "Federigo da Montefeltro's Private Study" cit., p. 286.

[36] The points that follow are made by CAMPBELL, op. cit., p. 65. Being mostly concerned with the painting in the Royal Collections, he does not question the presence of the *Liberal Arts* in the study. The incompatibilities between these panels and the *Discourse* lead him to exclude the latter from the room.

[37] As we have seen, Clough compares this repetition to that in the Urbino *studiolo*, so as to treat it as evidence in support of his reconstruction. Yet the analogy is a false one. In Urbino, the inscription reproduced within the context of the right-hand niche on the east side is the fictitious counterpart to the inscription that runs just beneath the actual ceiling of the room. This juxtaposition implies a playful competition between the imaginary and the real (see Chapter IV, below). In Gubbio, the two inscriptions would follow and repeat each other pointlessly within the same pictorial world.

[38] Again, Clough's claim that the repetition endorses his reconstruction is unconvincing. The redundance would be out of keeping with the relative concision which, as will be shown, characterizes the programmes of the *studioli*.

34

[Il cortegiano potrà] eccitarlo [il Principe] [alle virtù] con l'esempio dei celebrati capitani e d'altri omini eccellenti, ai quali gli antichi usavano di far statue di bronzo e di marmo e talor d'oro; e collocarle ne' lochi publici, così per onor di quegli, come per lo stimulo degli altri, che per una onesta invidia avessero da sforzarsi di giungere essi ancor a quella gloria.

Baldassarre Castiglione[1]

III. THE FRIEZE OF FAMOUS MEN[2]

1. *Function and Origin of the Idea*

The habit of decorating interiors of princely and civic buildings with *uomini famosi* was a well-established one, from the middle-ages onwards. There were two main traditions: one of chivalric inspiration, which celebrated men of arms, and is exemplified by the cycle in the so-called *Sala degli Affreschi* of the Palace of Urbino, attributed to Giovanni Boccati, and another which glorified intellectual and moral worth, and is typified by the frescoes painted by Altichiero in the Palace of Francesco il Vecchio da Carrara in Padua, and by Taddeo di Bartolo in the Ante-chapel of Siena's *Palazzo Pubblico*. Clearly, the frieze of heroes in the Urbino *studiolo* belongs to the humanist tradition.

106

[1] *Il libro del Cortegiano* (B. MAIER ed.), Turin, 1981, Book IV, Ch. IX, p. 463.

[2] The panels' authorship is controversial. Most scholars, relying on Vespasiano's contemporary evidence, agree that Justus of Ghent worked on the frieze. The bookseller does not actually name the "maestro solenne" invited from Flanders by Federico, but Justus is recorded in Urbino from 1473 to 1475 (LAVALLEYE, *Le Palais Ducal* cit., pp. 31–7). There he painted the authenticated *Communion of the Apostles*, which shows affinities with the portaits. (On this panel, cf. ibid., pp. 1–43; pp. 90–6 for the affinities.) However the frieze is not generally ascribed exclusively to Justus, for it is stylistically uneven. The identity of the other artist(s) and the precise distribution of the work among the contributors are much debated. One or more of the following are said to have collaborated: Pedro Berruguete, Giovanni Santi, Melozzo da Forlì, Antonio del Pollaiuolo and Donato Bramante.
The most recurrent of such attributions is that of Berruguete. It is not based exclusively on stylistic comparison. A document referred to by Luigi PUNGILEONI, now lost, stated that a "Pietro Spagnolo pittore" was in Urbino in 1477 (cf. *Elogio storico di Giovanni Santi, pittore e poeta, padre del gran Raffaello di Urbino,* Urbino, 1822, p. 49). Pablo DE CESPEDES is frequently reported to have said in his *Discurso de la comparación de la antigua y moderna pintura y escultura,* dated 1604, (S. CANTON ed.), Madrid, 1933, II, p. 16, that Berruguete painted the portraits in the Urbino study. In fact, De Cespedes says the opposite: that the panels are by an artist *other* than him. However, the mention of the artist does imply the existence of a tradition. The presence of a few Castilian words in Albertus Magnus' book (see Appendix B), and of echoes of Montefeltro architecture in a panel attributed to Berruguete (*The Beheading of St. John the Baptist,* in the Church of Santa Maria del Campo, Lerna province) have also been treated by some as evidence that the Spanish artist contributed to the frieze of famous men. For a detailed review of the attributions, see LAVALLEYE, *Le Palais Ducal* cit., pp. 70–95. This should be updated with: R. DUBOS, *Giovanni Santi, peintre et chroniqueur à Urbin au XV^e siècle,* Bordeaux, 1971; A. PARRONCHI, "Prima traccia dell'attività del Pollaiolo per Urbino", *Studi Urbinati,* XLV (new series B), 1971, p. 1188; ROTONDI, "Ancora sullo studiolo" cit., pp. 561–602; C. H. CLOUGH, "Pedro Berruguete and the Court of Urbino: A Case of Wishful Thinking", *Notizie da Palazzo Albani,* III, 1974, pp. 17–24 (also, in reset form with additions, in CLOUGH 1981, item X); A. CHATELET "Pedro Berruguete et Juste de Gand", in *España entre el Mediterraneo y el Atlantico. Actas del XXIII congreso internacional de historia del arte – Granada 1973,* Granada, 1976, I, pp. 335–43; L. CASTELFRANCHI VEGAS, *Italia e Fiandra nella pittura del Quattrocento,* Milan, 1983, pp. 145–8. The question of the authorship is most intricate; it is easy to agree with VERONEE-VERHAEGEN that "when one reviews the various separate attributions that have been proposed for each of the portraits, one can only conclude that the overall picture is one of hopeless confusion." (FRIEDLÄNDER, op. cit., p. 85).

Portrait galleries of the humanist type fulfilled, like much of the edifying literature that was produced from the 13th century onwards (e.g. Dante's *Comedy*, Petrarch's *De viris illustribus*, Boccaccio's *De casibus illustrium virorum*, and Vespasiano's *Vite*), an exemplary function: they were meant to inspire men and lead them to imitate the conduct of the great[3]. This didactic function made friezes of heroes especially suitable to libraries and *studioli*. In Part III of Angelo Decembrio's dialogues *De politia litteraria*, Leonello d'Este states that the ideal library should have, among other things, effigies of gods and heroes[4]. In Filarete's *Trattato di architettura*, Nicodemi, ambassador of the court of Milan in Florence, is reported saying that Piero de' Medici kept in his study

> ...l'effige e le immagine di quanti imperadori e d'uomini degni che stati sieno: chi d'oro e chi d'argento, e chi di bronzo et chi di pietre fine, e chi di marmi e d'altre materie, che sono maravigliose cose a vedere[5].

The idea was suggested by antiquity. A number of classical sources recorded the presence of paintings, busts or full-length statues of illustrious men (often complemented by dedicatory inscriptions) in libraries and other parts of stately buildings[6]. Reference to them by humanists indicates that this practice was consciously imitated. In his preface to Petrarch's *De viris illustribus* (on which the frescoes in the palace of Francesco da Carrara were based), Lombardo della Seta, who completed the work interrupted by the poet's death, rhetorically declares that by adorning the palace with the effigies of illustrious people so that they may be emulated, the custom of the ancients was being

[3] On the portrait cycles and their functions, cf. T. E. MOMMSEN, "Petrarch and the Decoration of the Sala Virorum Illustrium in Padua", *Art Bulletin*, XXXIV, 1952, pp. 95–116 (also in E. F. RICE jr ed., *Medieval and Renaissance Studies*, Ithaca, N.Y., 1959, pp. 131–74); J. ALAZARD, "Sur les hommes illustres", in *Il mondo antico nel Rinascimento*, Florence, 1958, pp. 275–7; N. RUBINSTEIN, "Political Ideas in Sienese Art: the Frescoes by Ambrogio Lorenzetti and Taddeo di Bartolo in the Palazzo Pubblico", *Journal of the Warburg and Courtauld Institutes*, XXI, 1958, pp. 189–207; CHASTEL, *Art et humanisme* cit., pp. 234–6, 248–9, 482; LAVALLEYE, *Le Palais Ducal* cit., pp. 53–4; R. L. MODE, *The Monte Giordano famous men cycle of Cardinal Giordano Orsini and the "Uomini famosi" tradition in fifteenth-century Italian art*, Ph.D. Thesis, 1970, Univ. of Michigan; C. L. JOOST-GAUGIER, "A Rediscovered Series of 'Uomini Famosi' from Quattrocento Venice", *Art Bulletin*, LVIII, 1976, pp. 184–95; L.M. SLEPTZOFF, *Men or Supermen? The Italian Portrait in the Fifteenth Century*, Jerusalem, 1978; C. L. JOOST-GAUGIER, "Giotto's Hero Cycle in Naples: A Prototype of Donne Illustri and a Possible Literary Connection", *Zeitschrift für Kunstgeschichte*, XLIII, 1980, pp. 311–8; idem, "Castagno's humanistic program at Legnaia and its possible inventor", *Zeitschrift für Kunstgeschichte*, XLV, 1982, pp. 274–82; idem, "The History of a Visual Theme as Culture and the Experience of an Urban Center: 'Uomini Famosi' in Brescia", *Antichità viva*, XXII, 4, 1983, pp. 7–17, and XXIII, 1, 1984, pp. 5–14; M. A. CICCARONE, *I cicli degli uomini illustri nel Rinascimento italiano*, Degree Thesis, Rome Univ., 1982–83.

[4] Leonello's view on the contents of his ideal library is worth quoting fully; it will be compared with Alberti's, in the next chapter.

> Intra bibliothecam insuper horoscopium aut sphaeram cosmicam, citharamue habere non dedecet, si ca quandoque delecteris: quae nisi cum uolumus, nihil instrepuit. Honestas quoque picturas, caesurasue, quae uel deorum, uel heroum memoriam repraesentent. Ideoque saepenumero cernere est quibusdam iucundissimam imaginem esse Hieronymi describentis in eremo, per quam in bibliothecis solitudinem & silentium, & studendi scribendique sedulitatem opportunam aduertimus.

> [As well [as books] it is not unseemly to have in the library an instrument for drawing up horoscopes or a celestial sphere, or even a lute if your pleasure ever lies that way: it makes no noise unless you want it to. Also decent pictures or sculptures representing gods and heroes. We often see, too, some pleasant picture of St. Jerome at his writing in the wilderness, by which we direct the mind to the library's privacy and quiet and the application necessary to study and literary composition.]

(M. BAXANDALL, "Guarino, Pisanello and Manuel Chrysoloras", *Journal of the Warburg and Courtauld Institutes*, XXVIII, 1965, p. 196.)

[5] *Trattato di architettura* (A. M. FINOLI and L. GRASSI eds.), Milan, 1972, II, p. 687.

[6] C. V. DAREMBERG and E. SAGLIO eds., *Dictionnaire des antiquités grècques et romaines*, Paris, I, 1877, s.v. "Bibliotheca", p. 708; RUBINSTEIN, op. cit., p. 195 note 104; C. L. JOOST-GAUGIER, "The Early Beginnings of the Notion of 'Uomini Famosi' and the 'De Viris Illustribus' in Greco-Roman Literary Tradition", *Artibus et Historiae*, No. 6, 1982, pp. 97–115.

followed[7]. In Poggio Bracciolini's dialogue *De nobilitate*, Lorenzo de' Medici says that Cicero, Varro, Aristotle and others had effigies of great men in their libraries (and gardens) to ennoble and inspire their owners[8]. Alberti notes in the *De re aedificatoria* that Tiberius had effigies of poets in his library[9].

2. *The Programme*

A careful study of the portraits and their relation to one another reveals a great deal about Federico, 9–36
the culture of his court, and, more generally, about the Renaissance.

A feature of the frieze that stands out immediately is the already-noted grouping of the portraits into two categories: one (corresponding to the lower register) consisting of ecclesiastical personalities, and the other (upper register) of lay ones. There is one apparent intrusion: the twin presence of Dante/Petrarch among the religious heroes. Of the two, Dante, the revered author of the "poema sacro, /al quale ha posto mano e cielo e terra" (*Paradiso*, XXV, 1–2), is the less surprising: from the 14th century onwards, he is often referred to as "theologus"[10]. Raphael, in his *Stanza della Segnatura*, includes him among the theologians of the *Sacrament* as well as among the poets of the *Parnassus*[11]. As for Petrarch, his presence in the register may be explained by the fact that Christianity played a leading part in several of his works (the *Secretum* and the *De otio religioso*, for instance)[12]. It should also be noted that Petrarch held a number of minor ecclesiastical posts[13]. Finally, once agreed that Dante's presence among the theologians is no intrusion, it is possible to argue that Petrarch's traditional iconographic association with the author of the *Comedy* may have influenced his inclusion in the double compartment[14].

The coexistence of the sacred and the profane, the Christian and the pagan, in the frieze of famous men, is calculated: it expresses a syncretistic philosophy, a belief in the complementary nature of ancient and modern values; the same philosophy that the twin rooms beneath the *studiolo*, the

[7] MOMMSEN, op. cit. p. 96 (p. 132 of the re-published ed.).

[8] *Opera omnia*, Basel, 1538, I, p. 65 (quoted in LIEBENWEIN, op. cit., pp. 66, 195 note 107).

[9] *L'Architettura* cit., Book VIII, Ch. IX, vol. II, p. 769. See also Castiglione's remark at the head of this chapter, which, when compared to that of Filarete quoted above, gives a further though indirect confirmation of the extent to which the diffusion of cycles of famous men was influenced by antiquity. Castiglione's *Cortegiano*, the outcome of a close acquaintance with the Urbino court, will frequently be referred to in this monograph, for, though written at the beginning of the 16th century, it codifies ideals that are unlikely to have changed much in a generation.

[10] He is addressed as such, for instance, by Pietro Alighieri, a son of the poet, in his *Super Dantis ipsius genitoris comoediam commentarium* and by Giovanni da Virgilio, in an epitaph which has reached us through Boccaccio's *Trattatello in laude di Dante* (cf. R. ANTONELLI, "L'Ordine domenicano e la letteratura nell' Italia pretridentina", in A. ASOR ROSA ed. *Letteratura italiana*, Turin, I, 1982, pp. 713–4). For a later example, cf. M. Francesco DE' VIERI, detto il VERINO SECONDO, *Discorsi delle Maravigliose Opere di Pratolino*, & *d'Amore*, Florence, 1582, p. 52, who refers to Dante as "Poeta, Filosofo, & Theologo eccellentissimo".

[11] L. DUSSLER, *Raphael*, London-New York, 1971, p. 72, Fig. 123.

[12] T. G. BERGIN, *Petrarch*, New York, 1970, pp. 119–34.

[13] E. H. WILKINS, "Petrarch's Ecclesiastical Career", in idem, *Studies in the Life and Works of Petrarch*, Cambridge, Mass., 1955, pp. 3–32.

[14] By virtue of the fact that they are both Tuscan, near-contemporaries and outstanding literary figures, Dante and Petrarch were frequently represented together. See, for instance, Castagno's frieze of famous men, formerly in the Villa Carducci of Legnaia (now in the Uffizi), where the two are the only figures in the cycle to be depicted engaged in lively discussion, and thus associated. The other figures, including Boccaccio, are portrayed as solitary individuals (M. HORSTER, *Andrea del Castagno*, Oxford, 1980, Figs. 75, 82–3). See also the inlaid portraits of Dante and Petrarch on the shutters of the door leading to the *Sala dei Gigli*, in the Palazzo Vecchio of Florence, executed in 1478 (F. ZERI ed., *Storia dell'arte italiana*, Turin, XI, 1982, Fig. 489).

5,6 *Cappella del Perdono* and *Tempietto delle Muse*, evoke. Paganism played an important role in Urbino. The Duke owned Lodovico Lazzarelli's *De gentilium deorum imaginibus*, a treatise that supported the view that mythology was a kind of poetic religion[15]. Thus, what the *studiolo* decorations express is a picture of universal harmony and wisdom – one that anticipates Raphael's *Stanza della Segnatura*[16].

Another obvious feature of the frieze is the twinning of the heroes according to shared characteristics (mostly their professional status). In the upper register, Plato is coupled with Aristotle (they are both philosophers of seminal importance), Ptolemy with Boethius (authorities on the *Quadrivium*), Cicero with Seneca (moral philosophers), Homer with Virgil (epic poets), Solon with Bartolus (legislators), and Hippocrates with Pietro d'Abano (physicians). In the lower register, Gregory is twinned with Jerome (Doctors of the Church), Ambrose with Augustine (Doctors of the Church), Moses with Solomon (legislators), Thomas Aquinas with Duns Scotus (scholastic theologians), Pius II with Bessarion (humanist prelates), and Dante with Petrarch (Christian poets). The remaining couples (Euclid and Vittorino da Feltre, Albertus Magnus and Sixtus IV) need to be considered apart, for their compatibility is less manifest.

Vittorino, Federico's teacher, is no unsuitable partner to Euclid. Unlike most humanists, he took a professional interest in mathematics, and in geometry in particular, as contemporary accounts stress. A medal by Pisanello celebrates him with the inscription: MATHEMATICVS ET OMNIS HVMANITATIS PATER [Mathematician and father of all culture]. Vittorino gave special prominence to mathematics in his school, and taught it through games[17]. His association with Euclid should therefore be taken as Federico's commemoration of a most special and influential teacher[18].

The association of the medieval philosopher and theologian Albertus Magnus with Sixtus IV, whom present-day historians tend to remember mostly as a shrewd politician, a nepotist and a patron of the arts, is not an unlikely one. The inscription reveres the Pope as a learned philosopher and a theologian (Appendix A, No. 26), and this was far from being unmotivated praise. Before his elevation to the papacy, Sixtus IV had been a Franciscan celebrated for his philosophical treatises and discussions; he had taught philosophy and theology at several Italian universities, and was especially interested in scholastic authors[19].

If we look at the double compartments individually, we note that the position of the two figures in

[15] ROTONDI, *Il Palazzo Ducale* cit., I, p. 332; CHASTEL, *Art et humanisme* cit., p. 360.

[16] On the influence of the Urbino frieze on the *Segnatura*, cf. E. PETERICH, "Gli dei pagani nell'arte cristiana", *Rinascita*, I, 1942, pp. 60–1.

[17] For Vittorino's mathematical interests, cf. W. H. WOODWARD, *Vittorino da Feltre and Other Humanist Educators*, Cambridge, 1897, pp. 7–8, 42–3; BAXANDALL, *Giotto and the Orators* cit., pp. 127–8; P. L. ROSE, *The Italian Renaissance of Mathematics*, Geneva, 1975, pp. 15–25. Vittorino's association with Euclid is probably more than merely symbolically appropriate, for the biographical accounts of two contemporaries, Francesco da Castiglione and Bartolomeo Platina, indicate that he was especially knowledgeable on the geometrician. Cf. E. GARIN ed., *Il pensiero pedagogico dell'Umanesimo*, Florence, 1958, pp. 536 and 670.

[18] Mathematics remained a leading interest of Federico's. See Vespasiano:

Di geometria et d'arismetrica n'aveva buona peritia, et aveva in casa sua uno maestro Pagolo, tedesco, grandissimo filosofo et astrologo. Et di geometria et d'arismetrica aveva bonissima notitia. Et non molto tempo inanzi che si morissi, si fece legere da maestro Pagolo opere di geometria et d'arismetrica, et parlava dell'una et dell'altra come quello che n'aveva piena notitia.

Le vite cit., I, p. 383.

BAXANDALL has argued that Federico's early training in mathematics probably accounts for his appreciation of a 'rationalist' like Piero. Cf. *Giotto and the Orators* cit., pp. 128–133; and *Painting and Experience in 15th Century Italy*, Oxford, 1974, p. 109.

[19] L. D. ETTLINGER, "Pollaiuolo's Tomb of Pope Sixtus IV", *Journal of the Warburg and Courtauld Institutes*, XVI, 1953, p. 255. Appropriately, Sixtus IV's monumental tomb embodies a basically scholastic programme (ibid., pp. 239–74).

38

relation to each other follows, in most cases, a chronological order: the "older" hero is placed on the left-hand section, and the other in the right-hand one.

PLATO	ARIS-TOTLE	PTOLEMY	BOE-THIUS	CICERO	SENECA	HOMER	VIRGIL	EUCLID	VITTO-RINO	SOLON	BARTO-LUS	WINDOW	HIPPO-CRATES	PIETRO D'ABANO
428/7 – 348/7 B.C.	384–322 B.C.	2nd C.	480–524	106–43 B.C.	4 B.C.–65	c. 850 B.C.	70 B.C.–19	3rd C. B.C.	1378–1446	630–560 B.C.	1314–1357		460–377 B.C.	1257–1315
GREGORY	JEROME	AM-BROSE	AUGUS-TINE	MOSES	SOLO-MON	THOMAS AQUINAS	DUNS SCOTUS	PIUS II	BESSA-RION	ALBER-TUS MAGNUS	SIXTUS IV		DANTE	PE-TRARCH
540–604	347–419	339–397	354–430	13th C. B.C.	10th C. B.C.	1224–1274	1265–1308	1405–1464	1403–1472	1200–1280	1414–1484		1265–1321	1304–1374
(NORTH WALL)				(EAST WALL)				(SOUTH WALL)					(WEST WALL)	

This criterion offers, at times, the suggestion of an ideal continuity in the intellectual achievements of the great of ancient and modern times. Thus, Boethius takes inspiration from Ptolemy, Bartolus from Solon, Pietro d'Abano from Hippocrates, and Vittorino from Euclid.

The couples not arranged in a temporal order are: Gregory/Jerome and Pius II/Bessarion. Hierarchical considerations must have prevailed here: Gregory and Pius II are popes, while Jerome and Bessarion merely cardinals[20]. Pius II's position in relation to Bessarion's is chronological if their dates of death, rather than of birth, are considered. The former are likely to have been more meaningful to Federico, since he was personally acquainted with the prelates.

<center>*</center>

Status, interests, and other biographical details of the famous men are expressed through four main "codes": garments, attributes, gestures and inscriptions. These "codes" complement and reinforce one another to give a fuller and more immediate picture of each hero[21].

Garments[22]. The garments worn by the ecclesiastical personalities are the well-codified official ones that qualify their rank and order. Thus, Gregory, Pius II and Sixtus wear tiaras; Ambrose and Augustine, bishop's mitres. All of them are cloaked with the traditional cape fastened at the front with a jewelled clasp. Jerome and Bessarion wear cardinal's hats. Scotus's frock is Franciscan; Thomas Aquinas's and Albertus Magnus's, Dominican. The academic status of the last three is also indicated: they wear doctor's hats.

11, 27, 32
15, 16
12, 28, 24
23, 31

[20] In actual fact Jerome was not a cardinal: the office had not yet been instituted. Having however been a papal secretary (a position later filled by cardinals), he was, from the 14th century onwards, depicted as a cardinal. Cf. L. REAU, *Iconographie de l'art chrétien*, Paris, 1958, II, p. 742.

[21] The codes in question are often crucial to the recognition of the famous men, since their facial features do not always follow conventional iconography. Some of the portraits of the heroes from antiquity seem to have been based on the features of contemporary personalities. BOMBE has remarked, for instance, that Moses resembles the ambassador of the King of Persia depicted talking to Federico in Justus of Ghent's *Communion of the Apostles*, and may therefore have been modelled on him. Cf. "Justus von Gent in Urbino" cit., p. 125; for a detail of the ambassador's portrait, see LAVALLEYE, *Le Palais Ducal* cit., Pl. XVI. The question of the sources of the portraits is complex and to a large extent unresolved. For a few, mostly tentative, suggestions, see E. MICHEL, *Musée national du Louvre. Catalogue raisonné des peintures du Moyen Age, de la Renaissance et des temps modernes. Peintures flamandes du XV^e et du XVI^e siècle*, Paris, 1953, p. 147; CHASTEL, *Art et humanisme* cit., p. 367; LAVALLEYE, *Le Palais Ducal* cit., pp. 56–62.

[22] I am indebted to Stella Mary Newton and Jacqueline Herald for many of the comments on the costumes of the famous men, that follow. I have also found the former's *Renaissance Theatre Costume and the Sense of the Historic Past*, London, 1975, most useful.

The costumes of the Greek and biblical heroes are partly imaginary. Late 15th century artists working in Italy did not lack opportunities to find out what Greek and Oriental garments looked like, but they preferred to rely on the well-established "language" of theatre costumes; the latter were only vaguely based on primary information, but they offered the advantage of being readily understood by the public at large.

A general feature that was associated with garments of the classical period was looseness. Hence the ample and "asymmetrical" mantles, tunics and gowns worn by most of the ancient heroes of the *studiolo*.

It is worth noting that the Greek personalities are depicted as Orientals: Aristotle's turban and Euclid's strip of cloth tied round his head are especially indicative. This is not uncommon in the Quattrocento, and suggests that the Greeks were thought of as "exotic" because they were not Latins[23]. The following standard features denoting exoticism should be pointed out, with regard to the *studiolo* heroes: Moses's and Homer's lavish brocades; Plato's and Moses's short oversleeves; Ptolemy's, Solomon's, Euclid's and Hippocrates's turned-down collars; Aristotles's and Ptolemy's garish buttons; Ptolemy's knotted waist sash; Plato's and Solon's mantle tassels; Aristotle's and Ptolemy's jewels (denoting status as well as exoticism); and finally the unusual brims of Solon's and Hippocrates's hats (pointed in the first case and cut-away in the second).

The Latin heroes (Boethius, Cicero, Seneca and Virgil), the remaining 13th–14th century ones (Bartolus, Pietro d'Abano, Dante and Petrarch) and Vittorino da Feltre all wear various forms of modern academic and official garments. Cicero's costume is that of the Doctor of civil law: scarlet robe dressed with miniver with large hanging sleeves. The padded cap fastened to a broad shoulder band and the coif were features of the lawyer's gear[24]. Bartolus wears a similar costume. Attempts have been made to give several of the above-named personalities garments from earlier periods in order to characterize them as non-contemporary. Some distortions and inaccuracies have ensued. Thus, Boethius wears a combination of an archaic academic cap, turned up with white fur, and the large hood of the mid-fifteenth century, which was fading from fashion in the 1470's; the cap could not have fitted in the hood of the type shown. Seneca's gown too is of an archaic academic type, but the patterned lining of his hood has no precedent, and must have been included to liven up the dress. Dante's sober costume with its two little revers at the neck and the transparent coif reproduces one in use in the 14th and early 15th centuries, but the coif should have had a longer tie; as it is, it cannot have fastened under the chin. Petrarch's gown should have fastened on the right shoulder rather than the left one.

Attributes. All the characters except Moses and Ptolemy are depicted with books, which qualify them as intellectuals. The open books held by Jerome and Albertus Magnus are partly legible. Jerome's text derives from the Psalms, and so does part of Albertus Magnus's. No specific significance needs to be ascribed to them; they were probably chosen simply to characterize the manuscripts as liturgical. Albertus Magnus's text includes some words in Castilian. These may well be, as has been suggested, a reference to his attacks against the Arab commentators of Aristotle (Averroes in particular), whose works had reached Paris via Muslim Spain[25].

[23] In a late 15th century woodcut for Poliziano's *Favola di Orfeo*, one of the guards of the Underworld and Orpheus himself are depicted wearing turbans. So are Pythagoras and Euclid in one of the bas-reliefs of the Campanile of Florence Cathedral; cf. P. D'ANCONA, "Le rappresentazioni allegoriche delle Arti Liberali nel Medio Evo e nel Rinascimento", *L'Arte*, V, 1902, p. 226, for an illustration. But see also Stella Newton's remark that Greek and Oriental garments were not discriminated by 15th century Northern artists since the "emperors of Constantinople [...] followed the Greek rite and must, therefore, have been thought of as, in some respects, descendants of the Greeks" (*Renaissance Theatre Costume* cit., pp. 64–5).

[24] W. N. HARGREAVES-MAWDSLEY, *A History of Academical Dress in Europe*, Oxford, 1963, p. 14; idem, *A History of Legal Dress in Europe*, Oxford, 1963, pp. 5–7, 119, 118, Fig. 3.

[25] For the transcriptions of Jerome's and Albertus Magnus's texts, and the relevant bibliography, see Appendix B.

40

More traditional attributes have also been included. Ptolemy holds an armillary sphere, Moses, his tables with the ten Commandments inscribed in Hebrew, and Euclid, tablet and compasses. Solomon is depicted with a crown and a sceptre; Dante, Petrarch and Homer wear laurel wreaths[26]. Ptolemy's crown, curiously worn over his Oriental headpiece, is inappropriate, for he was not a king. Since he was born in Egypt, and carried out his main work there, he must have been confused with one of the Macedonian Kings of the Ptolemy dynasty who ruled that country from 323 to 30 B.C.[27].

Gestures. These provide information on the identity of several of the heroes. Some are immediately recognisable today: Ambrose's, Augustine's and Sixtus IV's right hands are blessing; Homer feels the book he cannot see; Vittorino and Moses point their forefingers to book and tables respectively – a gesture that is both authoritative and authoritarian, and thus suits the law-giver and the teacher[28]. Jerome holds a page up as if to better collate two passages from a holy text[29].

Much less obvious, because historically and culturally confined, is Aquinas's and Scotus's counting gesture. Its function is to qualify these personalities as Scholastics: the gesture translates graphically their highly systematic reasoning method, based on the enumeration of arguments involving divisions and subdivisions[30]. Boethius too is depicted counting; his gesture should however be interpreted as a reference to his mathematical studies.

A few other gestures in the frieze, those of Plato, Aristotle, Hippocrates, Albertus Magnus, Dante and Petrarch, strike one as possibly significant. If we examine them in the light of the rhetorical gestures described by Quintilian in his *Institutio oratoria* (a work which had considerable influence on Renaissance educationalists, including Vittorino), correspondences will in fact be noted[31]. Petrarch's "OK" sign fits the following extract particularly well:

> Pollici proximus digitus mediumque, qua dexter est, unguem pollicis summo suo iungens, remissis ceteris, est et approbantibus et narrantibus et distinguentibus decorus[32].

[26] Bay became the poet's official attribute especially after Petrarch chose to be crowned with this, rather than ivy and myrtle, on the Capitol in Rome, in 1341. All three plants were used in classical antiquity for poets, but laurel was considered the most exalted, because it was also a motif of victory and triumph. Cf. J. B. TRAPP, "The Owl's Ivy and the Poet's Bays", *Journal of the Warburg and Courtauld Institutes*, XXI, 1958, pp. 227–55.

[27] This confusion was not infrequent. Ptolemy was depicted wearing a crown by Giusto de' Menabuoi in the Cortellieri Chapel of the Church of the Eremitani, in Padua (S. BETTINI, *Giusto de' Menabuoi e l'arte del Trecento*, Padua, 1944, pp. 112–7, Fig. 54); by Andrea da Firenze in the *Cappella degli Spagnoli* in Florence (R. OFFNER and K. STEINWEG, *A Critical and Historical Corpus of Florentine Painting*, Glückstadt, section IV, vol. VI, 1979, p. 25, Pl. I (21)); and by Raphael in the *School of Athens* (DUSSLER, op. cit., p. 73, Pl. 24). Another example is provided by Justus(?)'s *Astronomy*, if it is true, as A. SCHMARSOW (*Melozzo da Forlì*, Berlin–Stuttgart, 1886, p. 87) and LIEBENWEIN (op. cit., pp. 91, 213 note 354) have convincingly argued, that the figure kneeling before the enthroned personification is Ptolemy.

[28] On the pointing index with admonishing function, cf. A. CHASTEL, "Sémantique de l'index", *Storia dell'arte*, No. 40, 1980, pp. 415–7; and idem, "Gesture in Painting: Problems in Semiology", paper read at the Toronto Colloquium of 1983 on *The Language of Gestures in the Renaissance*, forthcoming in the proceedings. Prof. Chastel (whom I wish to thank for kindly sending me a copy of his paper) recalls in both Alberti's recommendation to painters:

... piacemi sia nella storia chi ammonisca e insegni a noi quello che ivi si facci, o chiami con la mano a vedere ...
(*De pictura*, Book I, 42)

[29] A similar gesture is to be found in Van Eyck's *Jerome*: the saint is here depicted with two fingers of his right hand inserted among the pages of the book he is reading. Cf. E. PANOFSKY, *Early Netherlandish Painting*, New York, 1971, I, p. 189; II, Fig. 258.

[30] O. CHOMENTOVSKAJA, "Le comput digital. Histoire d'un geste dans l'art de la Renaissance italienne", *Gazette des Beaux-Arts* (6th series), XX, 1938, pp. 157–72.

[31] There were in the Renaissance other gesture codes too: those of monks bound to silence, dumb men and preachers, for instance; cf. BAXANDALL, *Painting and Experience* cit., pp. 61–71. Given the nature of the portraits, it is especially suitable to turn to Quintilian.

[32] [If the first finger touch the middle of the right-hand edge of the thumb-nail with its extremity, the other fingers being

13
19, 25, 20
35, 36, 21
13

15, 16, 32
21, 26, 19

12

23, 24

14

36

9 Plato's left hand gesture seems to correspond to this description:

> Eadem aliquatenus liberius deorsum spectantibus digitis colligitur in nos et fusius paulo in diversum resolvitur, ut quodammodo sermonem ipsum proferre videatur[33].

10, 33, 31, 35 Aristotle's, Hippocrates's, Albertus Magnus's and Dante's gestures resemble that described in this extract:

> Sunt et illi breves gestus, cum manus leviter pandata. qualis voventium est, parvis intervallis et subadsentientibus humeris movetur, maxime apta parce et quasi timide loquentibus[34].

These gestures do not seem to have a specific meaning within the context of the *studiolo*; the artists' main preoccupation was probably to give the characters in question signs that might render them immediately identifiable as polemicists and dialecticians. These random samples from a learned code of gestures adequately fulfil this purpose.

Inscriptions. Their main function is to name and thus incontrovertibly identify the characters of the frieze. For the rest, they play on the whole a supportive role. The *tituli* state verbally (usually with greater precision and in more detail, thanks to the narrative and argumentative potential of words) what the portraits express iconographically and through their twinning arrangement. At times, however, when the multi-sided nature of a personage needs to be emphasized, the inscription is made to play a complementary role. Thus, Boethius is visually celebrated as an astronomer/

14, 13 mathematician (he is placed next to Ptolemy and depicted counting), but the dedication, through its reference to Varro, who was renowned for his encyclopaedic knowledge (Appendix A, No. 4), hints at the variety of his interests which included all the arts of the *Quadrivium* and philosophy.

17, 18 Cicero's association with Seneca asserts the philosophical interests of both authors; the former's inscription, however, specifically praises him on account of his eloquence (Appendix A, No. 5).

26, 25 Vittorino's location next to Euclid highlights his interest in geometry, but the dedication informs

31 us of his status as humanist teacher (Appendix, A, No. 10). Albertus Magnus is visually presented

32 as a scholastic theologian (he shares a compartment with Sixtus IV), but the inscription praises him for his studies in the natural sciences (Appendix A, No. 25).

<p style="text-align:center">*</p>

It is legitimate to wonder whether the Urbino frieze embodies a more complex programme – one that might explain, other than the division into two rows and the twinning system, the choice of portraits and their arrangement in relation to one another. Cycles of *uomini famosi*, after all, frequently embodied ideological schemes[35]. A number of scholars have looked for such a programme in the *studiolo* – on the whole with disappointing results. Rotondi concludes that:

> relaxed, we shall have a graceful gesture well suited to express approval or to accompany statements of facts, and to mark the distinction between our different points.]

Institutio oratoria, Cambridge, Mass., 1951 (Loeb Classical Library), Book XI, Ch. III, 101, vol. IV, p. 296 (p. 297 for the English translation).

[33] [Slightly greater freedom may be given to the gesture by pointing the fingers down and drawing the hand in towards the body and then opening it somewhat more rapidly in the opposite direction, so that it seems as though it were delivering our words to the audience.]

Op. cit., Book XI, Ch. III, 97, vol. IV, p. 294 (p. 295).

[34] [The following short gestures are also employed: the hand may be slightly hollowed as it is when persons are making a vow, and then moved slightly to and fro, the shoulders swaying gently in unison: this is adapted to passages where we speak with restraint and almost with timidity.]

Op. cit., Book XI, Ch. III, 100, vol. IV, p. 296 (p. 297).

I wish to thank Prof. Reginald Dodwell of Manchester University (who is preparing a full study of gestures in art), for confirming that the *studiolo* gestures are of the Quintilian type, and accepting my specific interpretations of them.

[35] See the literature on the cycles of famous men in note 3, above, for numerous examples.

42

La [...] successione [dei ritratti] non obbedisce a nessun intento specifico. Salvo qualche tradizionale accoppiamento (Dante e Petrarca, Omero e Virgilio, Platone e Aristotile) la presentazione di questi uomini illustri non rispetta in complesso nessun vincolo speciale, essendo state scelte alla rinfusa le immagini degli autori preferiti, dei protettori e degli amici del duca, non trascurando che fossero rappresentati nello studiolo, uomini del Vecchio e del Nuovo Testamento, del mondo greco e di quello latino[36].

Chastel states that the frieze echoes the four-class arrangement (Theology, Philosophy, Poetry and Law) of the ducal library as described by Giovanni Santi in his *Cronaca*[37]. The poet/painter, in fact, also mentions physicians and historians[38]; since these categories too are represented in the frieze, the suggestion is a reasonable one. The scheme would presumably fit the frieze thus:

PHILOSOPHY				HISTORY?		POETRY		PHILOSOPHY		LAW		WINDOW	MEDICINE	
PLATO	ARISTOTLE	PTOLEMY	BOETHIUS	CICERO	SENECA	HOMER	VIRGIL	EUCLID	VITTORINO	SOLON	BARTOLUS		HIPPOCRATES	PIETRO D'ABANO
GREGORY	JEROME	AMBROSE	AUGUSTINE	MOSES	SOLOMON	THOMAS AQUINAS	DUNS SCOTUS	PIUS II	BESSARION	ALBERTUS MAGNUS	SIXTUS IV		DANTE	PETRARCH
(NORTH WALL)				(EAST WALL)				(SOUTH WALL)					(WEST WALL)	

THEOLOGY

Under the general heading of Philosophy, we would include the heroes who specialized in the disciplines of the Liberal Arts. Cicero, author of political letters regarded as a mine of historical information, may, by the skin of his teeth, be treated as a historian. The proposed scheme, how-

[36] *Il Palazzo Ducale* cit., I, p. 342. Rotondi suggests that even the twinning of the figures is in most cases random. This, as I have shown, is untrue. There are, incidentally, no "uomini [...] del Nuovo Testamento" among the heroes.

[37] *Art et humanisme* cit., p. 367. His opinion is endorsed by LIEBENWEIN, op. cit., pp. 93, 210 note 312.

[38] Santi's account of the library goes as follows:

[Federico] principiò con nobile intellecto
 una Biblioteca tanta e tale
 che ad ogni ingegno è altissimo dilecto.
E in tucte facoltà universale
 e vi adunò de libri un numer tanto,
 che ogni chiar spirto li può spiegar tale.
Prima di quel collegio sacro e sancto
 Theologi divoti l'opre tucte
 coperte e ornate di mirabil manto.
E le scripture possa che constructe
 da *Philosophi* antichi al mondo fuoro
 quante hogi se ne trova ivi en reducte,
Le *Istorie* tucte, el sacro consistoro
 de chiar *Poeti*, e i nobili *Legisti*,
 Medici molti in ordine decoro,
Poi de diverse lingue anco ivi ho visti
 Arabi, Greci et venerandi Hebrei,
 libri diversi insiem cum gli altri misti,
Gli ornamenti dei quali io non potrei
 scriver in parte non che intieramente.
(*Cronaca* cit., Book XII, Ch. LIX, 51–7, p. 120; my italics.)

ever, is of limited value; it fails insofar as it does not explain the choice and the order of the heroes. Lavalleye turns to Baldi's and Schrader's accounts of the ducal library in the hope of finding a pattern that might fit the sequence, but concludes that there is not one[39]. The opinion is shared by Heydenreich[40], Elam[41], Liebenwein[42] and, one gathers, Sleptzoff[43]. Yet, a number of clues suggest that the selection of heroes is not totally idiosyncratic, nor their arrangement essentially random[44].

Let us consider the upper row to begin with. One cannot help being struck by the seminal importance of a number of its figures. Plato/Aristotle, Ptolemy, Cicero, Homer/Virgil, Euclid, Solon and Hippocrates are so incontrovertibly authoritative that they can all act as exemplars, the perfect embodiment of their individual disciplines: Logic, Astronomy, Rhetoric, Poetry, Geometry, Law and Medicine respectively[45]. The impression that these characters may have been chosen for their exemplary value is corroborated by the fact that two of the figures hold the traditional attributes of the respective personifications of the *Artes*: Euclid, compasses and tablet, and Ptolemy, the armillary sphere. Cicero, as has been remarked, is specifically praised in the inscription as a rhetorician.

We are encouraged to seek in the remaining figures the representatives of other fundamental disciplines. Boethius, celebrated author of the treatise *De institutione arithmetica*, depicted counting[46], is well qualified to stand for Arithmetic. He is, at the same time, a very apt exponent for Music, having written the *De institutione musica*[47]. Though this art is not specifically mentioned in Boeth-

[39] *Le Palais Ducal* cit., p. 56. The descriptions of the library are quoted in ROTONDI, *Il Palazzo Ducale* cit., I, pp. 469–70, note 245.

[40] "Federico da Montefeltro as a Building Patron" cit., p. 5 (p. 174 of the republished ed.).

[41] *Studioli and Renaissance* cit., p. 24.

[42] *Studiolo* cit., pp. 91–3.

[43] *Men or Supermen?* cit., p. 84.

[44] Only Egon VERHEYEN has claimed that the paintings of the Urbino study embody a scheme. In the introduction to his monograph on Isabella d'Este's *studiolo*, he remarks: "... we may choose to discuss the *studiolo* in the Palazzo Ducale at Mantua or the one in Urbino, but as soon as this decision has been made, we have to accept the cycle of paintings as one unit in which all parts deserve equal attention." Cf. *The Paintings in the 'Studiolo' of Isabella d'Este at Mantua*, New York, 1971, p. 3. His view is, however, purely intuitive.

[45] Aristotle, Ptolemy, Cicero and Euclid normally accompany the personifications of their respective *Artes*, or replace them, in medieval and Renaissance didactic cycles. See their entries in J. HALL, *Dictionary of Subjects and Symbols in Art*, London, 1979 (2nd ed.), where they are said to personify Logic (p. 31), Astronomy (p. 255), Rhetoric (p. 68) and Geometry (p. 117) respectively. For several examples, see J. VON SCHLOSSER, "Giusto's Fresken in Padua und die Vorläufer der Stanza della Segnatura", *Jahrbuch der Kunsthistorischen Sammlungen des allerhöchsten Kaiserhauses*, XVII, 1896, pp. 13–100; D'ANCONA, op. cit., pp. 137–55, 211–28, 269–89, 370–85. On didactic cycles, see also J. SEZNEC, *The Survival of the Pagan Gods*, Princeton, N.J., 1972; M. MEISS, *Painting in Florence and Siena after the Black Death*, Princeton, N.J., 1978. In support of the claim that Ptolemy may have been included in the study (also) as a representative of Astronomy, it is worth recalling that the figure kneeling before the personification of this art in Justus(?)'s Berlin panel is most likely the same personality. Cf. note 27, above.

[46] This gesture is an established attribute of Arithmetic. See the representation of this art on one of the bas-reliefs of Giotto's Campanile, and in the frescoes of the *Cappella degli Spagnoli*. (D'ANCONA, op. cit., pp. 218 and 280 respectively).

[47] Vespasiano states that Federico's library included "tucte l'opere di Boetio, così in loica come in filosofia et in musica" (*Le vite* cit., I, p. 391). He makes no mention of Boethius's mathematical treatise, but this too was in the library of the Palace, as the inventory of the *Fondo Urbinate* shows (cf. ibid., p. 391 note 7). It is worth noting that the *De institutione musica* was in parts closely fashioned on Ptolemy's *Harmonia* (cf. *Dizionario biografico degli italiani*, Rome, XI, 1969, s.v. "Boezio", p. 154); this increases the compatibility of the couple Ptolemy/Boethius, without diminishing the former's essential role as representative of Astronomy. Boethius wrote treatises on the remaining arts of the *Quadrivium* too: Geometry and Astronomy. However, that on the former is almost completely lost, and the other not extant at all. He is therefore unlikely to have been meant as an exponent of these subjects.

ius's inscription, Federico might well have associated this author with Music, since Vittorino had emphasized the study of his musical theories in the curriculum[48]. Bartolus and Pietro d'Abano reinforce Solon's and Hippocrates's respective roles as representatives of Law and Medicine, and suggest themselves as their modern counterparts. Bartolus is by no means a minor figure in his field[49], but the fact that he originated from Sassoferrato, which was part of the Montefeltro state, and that he was the great-uncle of Pierantonio Paltroni, Federico's chancellor and biographer[50], must have at least in part motivated his inclusion in the scheme[51]. Though essentially representing Medicine, Pietro d'Abano may also have been chosen on account of his astrological interests; the inscription, with its reference to "recondite disciplines", endorses such a view (Appendix A, No. 14)[52]. Seneca and Cicero may stand for Moral Philosophy[53]; the inscription of the former hints at his consolatory literature, and thus at his stoicism (Appendix A, No. 6).

To sum up, the upper register seems to embody an almost complete spectrum of the leading intellectual fields of the time: Logic, three of the subjects of the *Studia humanitatis* (Moral Philosophy, Rhetoric, Poetry), all those of the *Quadrivium* (Astronomy, Music, Arithmetic and Geometry), Law and Medicine. The scheme looks as follows:

LOGIC		ASTRO-NOMY	MUSIC ARITH-METIC	MORAL PHILOSOPHY RHETORIC		POETRY		GEOMETRY		LAW			MEDICINE	
PLATO	ARIS-TOTLE	PTO-LEMY	BOE-THIUS	CICERO	SENECA	HOMER	VIRGIL	EUCLID	VITTO-RINO	SOLON	BARTO-LUS	WINDOW	HIPPO-CRATES	PIETRO D'ABANO
(NORTH WALL)				(EAST WALL)				(SOUTH WALL)					(WEST WALL)	

Not only the authoritativeness of several of the characters, but the very range of "professions" that are represented suggests that the series embodies an encyclopaedic type of programme. It should

[48] P. O. KRISTELLER, "Music and Learning in the Early Italian Renaissance", in idem, *Renaissance Thought II*, New York, 1965, pp. 153–4; C. GALLICO, "Musica nella Ca' Giocosa", in N. GIANNETTO ed., *Vittorino e la sua scuola: Umanesimo, pedagogia e arti*, Florence, 1982, pp. 192–4.

[49] Cf. *Dizionario biografico degli italiani*, Rome, VI, 1964, s.v. "Bartolo", pp. 640–69.

[50] See TOMMASOLI's introduction to Paltroni's *Commentari* cit., p. 9.

[51] Bartolus must have been an author especially dear to the Montefeltro household. In his enumeration of the books of Federico's library, Vespasiano mentions works on law in general terms, with the exception of Bartolus, who is referred to by name:

> [Il duca ha voluto] tutte l'opere di ragione civile, testi bellissimi, tutte le letture di Bartolo in cavreti, et molti iscrittori in ragione civili.

(*Le vite* cit., I, p. 390). Later, Vespasiano compares the Prince's judicial competence to Bartolus's (ibid., p. 405).

[52] Astrology was taken very seriously in Urbino, as elsewhere. Federico employed distinguished astrologers at his court: Jacopo da Spira first, and Paolo di Middelburg later. His library was endowed with the works of "tutti gli scritori in astrologia et i comenti loro" (VESPASIANO, op. cit., p. 391). Tommaso da Sarzana (later Nicholas V) asserted in his canon for libraries, which served as a pattern for Federico's and many others (HERSTEIN, op. cit., p. 117), that Pietro d'Abano's astrological works would be fitting for every library (P. KIBRE, "The Intellectual Interests Reflected in Libraries of the 14th and 15th Centuries", *Journal of the History of Ideas*, VII, 1946, p. 286).

The role of astrology at the court of the Montefeltro was stressed in the Gubbio exhibition *Dal Sogno all' Utopia*, and taken up by its organizer, Patrizia CASTELLI, in the paper "Matematici e astrologia alla corte dei Montefeltre", read at the recent (July 1984) Frankfurt Symposium on *Naturwissenschaft und Naturbeobachtung*. The paper is to be published shortly in the proceedings.

[53] On the popularity of Cicero and Seneca as moral philosophers in the Renaissance, cf. P. O. KRISTELLER, "The Moral Thought of Renaissance Humanism", in idem, *Renaissance Thought II* cit., pp. 32–3, 35. The view that Cicero is included in the register with a multiple function, is endorsed by the inscription, which praises him for the variety of his interests (Appendix A, No. 5).

be noted that secular cycles of *uomini famosi* consisted mostly of writers, and political and military leaders[54]. The economical distribution of the heroes in the register (no discipline is represented in more than one double compartment) is another clue that the selection reflects some order.

The sequence of the heroes is not as erratic as may at first appear. The most satisfactory arrangement is that of Cicero/Seneca and Homer/Virgil. It is clearly appropriate that such leading protagonists of the *Studia humanitatis* should be grouped together on the most prominent wall of the study[55].

The facing arrangement of the couples Ptolemy/Boethius and Euclid/Vittorino may also be calculated: it is possible to argue that its purpose is to draw together across the room the representatives of the *Quadrivium*. This type of correspondences is made possible by the smallness of the *studiolo*. As we shall see, the device is used elsewhere in the decorations.

IV, II Solon/Bartolus and Hippocrates/Pietro d'Abano follow each other in the sequence, but are actually separated by the window. Since their respective disciplines, Law and Medicine, were the subject of a controversy known as *disputa delle arti*, which divided opinion on the question of the superiority of one over the other[56], it cannot be excluded that the location of the two pairs was meant to suggest the antagonism between the two professions.

Let us now examine the bottom register of the frieze.

GREGORY	JEROME	AM-BROSE	AUGUS-TINE	MOSES	SOLO-MON	THOMAS AQUINAS	DUNS SCOTUS	PIUS II	BESSA-RION	ALBER-TUS MAGNUS	SIXTUS IV	WINDOW	DANTE	PE-TRARCH
(NORTH WALL)				(EAST WALL)				(SOUTH WALL)					(WEST WALL)	

The selection of religious figures is more dependent on Federico's personal preferences than is that of the lay figures. The inclusion of Pius II, Bessarion and Sixtus IV is indicative. Though far from minor public/cultural figures, their presence is probably largely explainable in terms of the Duke's personal celebration of his illustrious acquaintances. Federico served as a condottiere to both popes, and had frequent contacts with Bessarion, who is addressed in the inscription as "wisest and best of friends" (Appendix A, No. 24)[57]. It is worth noting that Renaissance cycles of famous men tended to exclude contemporary figures.

The presence of Thomas Aquinas and Duns Scotus is a reflection of the Prince's reading preferences. Vespasiano emphasizes considerably in his *Vite* Federico's fondness for these theologians:

> ... volle avere notitia di teologia, la quale è quella in nella quale ogni cristiano debbe fondarsi. Fecesi legere la prima parte di sancto Tomaso, et alcune altre opere delle sua, et era per questo afetionatissimo alla dottrina di sancto Tomaso, parendogli una dottrina chiara come ella era, et molto difendeva la dottrina sua. Quando si parlava o di santo Tomaso o di Schoto, diceva che, bene che Ischoto ne' sua opinioni fussi

[54] MODE, op. cit., p. 203. A survey of 15th and early 16th century Italian biographies of famous men reveals a similar situation: 49% of the personalities honoured were writers, 30% political and military leaders, 10% church dignitaries, 6.5% physicians and 4.5% artists. Cf. E. ZILSEL, *Die Entstehung des Geniebegriffes*, Tübingen, 1926, p. 159 (quoted from MODE, op. cit., pp. 203, 251 note 57).

[55] The eastern wall is the widest in the study, the best lit (the light comes in from the window on the opposite side), and the most striking because of the central pier. It immediately confronts the visitor entering the room from the west door.

[56] L. THORNDIKE, *Science and Thought in the Fifteenth Century*, New York, 1929, pp. 24–58; E. GARIN, *La disputa delle arti nel Quattrocento*. Florence, 1947.

[57] For the relations with the figures named, cf. G. FRANCESCHINI, "Pio II e Federico da Montefeltro", *Atti e Memorie della Deputazione di Storia Patria per le Marche* (8th series), IV, 1964–65, pp. 219–33; C. H. CLOUGH, "Cardinal Bessarion and Greek at the Court of Urbino", *Manuscripta*, VIII, 1964, pp. 160–71 (also, with additions and corrections, in CLOUGH 1981, item VII); J. MONFASANI, "Alexius Celademus and Ottaviano Ubaldini: An Epilogue to Bessarion's Relationship with the Court of Urbino", *Bibliothèque d'Humanisme et Renaissance*, XLVI, 1984, pp. 95–110; TOMMASOLI, *La vita di Federico* cit., index references.

istato sottilissimo, nientedimeno sancto Tomaso era la sua dottrina più chiara. Et volle ancora vedere delle opere di Schoto, che si fece legere il primo, in modo ch' era cosa mirabile a vedere. Il tempo aveva, lo compartiva in modo che ogni cosa gli riusciva, avendo notitia, più che a uno signore non si conveniva, et di filosofia morale et naturale, di poi della Iscrittura Sancta e dei dotori moderni che vanno per via d'argomenti[58].

Albertus Magnus is not an obvious choice; his inclusion suggests that he was one of the "dotori moderni che vanno per via d'argomenti", i.e. the Scholastics, that Federico favoured.

The presence of the four Doctors of the Church among the religious personalities is more predictable, but can also be explained in the light of what Vespasiano asserts:

[Federico] Aveva grandissima notitia della iscrittura sancta, de'dottori antichi, cominciandosi alla Bibia et a tutti e' dottori antichi, come è sancto Ambruogio, Girolamo, sancto Agostino, sancto Gregorio, de' quali aveva voluti tutti l'opere loro[59].

Moses and Solomon, symbols of good rule, express Federico's aspiration to be an enlightened leader[60].

The inclusion of Dante and Petrarch can easily be explained. Dante became a cult figure in the Quattrocento, following his "platonization"[61]. As for Petrarch, his presence in the *studiolo* is appropriate since, as already noted, the idea that solitude was conducive to literary pursuits, was revived from classical antiquity precisely by him.

Having explained the selection of the figures, we may attempt to establish the criteria that govern their sequence.

The appropriateness of the grouping of the four Doctors of the Church on the same wall (the northern one) has already been remarked on. On the wall as a whole, just as in the individual double compartments, two criteria have determined the choice of order of the figures: hierarchy and chronology. When the two conflict, it is hierarchy that gets the upper hand. This explains why Gregory (540–607, pope) and Jerome (347–419, cardinal), precede Ambrose (339–397, bishop) and Augustine (354–430 bishop).

The south wall section too has considerable unity, if we exclude Albertus Magnus: Pius II, Bessarion and Sixtus IV, placed in chronological sequence, were all eminent contemporary humanist figures whom Federico knew personally. Indeed the compatibility of the three heroes is such that we cannot help being puzzled by the discordant presence of the medieval philosopher – even though, as we have already seen, he is an apt partner to the scholastic-minded Sixtus IV. Ideally, the fourth personality too should have been a high-ranking prelate, a humanist and an acquaintance of Federico. One person particularly springs to mind: Paul II (1417–1471). As Pius II's successor and Sixtus IV's predecessor, and as a patron of the arts, he could have fittingly been accommodated in Albertus Magnus's place. The exclusion of Paul II from the frieze is significant. It is probably a reflection of the strained working relations Federico had with this employer, because of political disagreements[62]. It is worth adding that Paul II, in spite of his enthusiasm for

[58] *Le vite* cit., I, pp. 380–1. Federico's interest in scholastic authors was in no way unusual, for scholasticism and humanism co-existed. Cf. P. O. KRISTELLER, "Humanism and Scholasticism in the Italian Renaissance", in idem, *Studies in Renaissance Thought and Letters*, Rome, 1956, pp. 553–83; KIBRE, op. cit., p. 280.

[59] *Le vite* cit., I, pp. 381–2.

[60] Representations of Moses and Solomon recur, with similar emblematic functions, in Federico's famous illuminated Latin Bible (Codexes Urb. Lat. 1 and 2). Cf. A. GARZELLI, *La Bibbia di Federico da Montefeltro*, Rome, 1977, pp. 24, 27, 31–2.

[61] For the cult of Dante in the Renaissance, see CHASTEL, *Art et humanisme* cit., pp. 106–28. Federico owned a preciously illuminated codex of the *Comedy* that was one of the highlights of his library. Cf. L. MICHELINI TOCCI, *Il Dante Urbinate della Biblioteca Vaticana. Codice Urb. Lat. 365*, Vatican City, 1965; of special interest is the chapter "Dante nella storia e nella cultura di Urbino tra medioevo e Rinascimento", pp. 3–45.

[62] TOMMASOLI, *La vita di Federico* cit., pp. 170 ff.

learning, was unpopular among the humanists: following his suppression of the College of Abbreviators and the Roman Academy of Julius Pomponius Laetus – strongholds of pagan humanism – he acquired a reputation as an enemy of letters[63]; as such, he could hardly deserve a place in Federico's Christian-pagan frieze. It is possible that the inclusion of Paul II was originally envisaged in order to give unity to the section and provide a complete list of popes Federico worked for, but that, on second thought, it was decided to replace him with the chronologically and professionally less compatible, but otherwise more acceptable Albertus Magnus.

The location of Gregory, Jerome, Ambrose and Augustine, whom the Renaissance revered also as antique writers and scholars (see below), on the wall facing that which accommodates Pius II, Bessarion and Sixtus IV, may have been calculated to bring together the leading proto-humanist and humanist prelates of the register.

III The placing of Moses/Solomon on the most prominent wall of the study is of interest. These figures have already been interpreted as symbols of enlightened statesmanship. They may, in fact, represent more specifically Justice and Wisdom[64] respectively. This association could have been inspired by the *Nicomachean Ethics*, a text by Aristotle Federico was well acquainted with, and by the *Summa theologica*, the principal work of his favourite scholastic author, since they argue that Justice is the highest moral virtue and Speculative Wisdom the highest intellectual one[65].

II The position of the Dante/Petrarch couple to the right of the window may have been calculated to allow Petrarch to confine the wall that accommodates his beloved Doctors of the Church[66].

The relations between the personalities on the upper register and the corresponding ones below,

[63] L. VON PASTOR, *Storia dei Papi dalla fine del Medio Evo*, Rome, 1961, II, pp. 302–36. See also R. WEISS, *Un umanista veneziano: Papa Paolo II*, Venice-Rome, 1958, pp. 18–23.

[64] Solomon is praised for his wisdom in the inscription (Appendix A, No. 20).

[65] *Nicomachean Ethics*, V, i, 15; VI, vii, 2; X, vii, 1; *Summa theologica*, Ia IIae, quest. 66, art. 3–5. (The latter reference is quoted after RUBINSTEIN, op. cit., p. 183 note 35.) That Federico was well acquainted with Aristotle's *Ethics* is stressed by Vespasiano:

> [Federico] Udì da maestro Lazero l'Etica d'Aristotile con comenti et sanza comenti, et non solo l'udì, ma tutti quegli passi difficili gli disputava, et avendo dato in primo opera a loica, intendeva gli argomenti benissimo, et non solo gli intendeva, ma egli disputava, sendo di prestantissimo ingegno come era. Avendo udita l'Etica più volte tutta intendendola maravigliosamente, in modo che dava fatica al precetore nelle disputationi, udita l'Etica, e non solo intendendola ma sapiendola quasi a mente, si fece legere la Pulitica, et quella vide con grandissima diligentia. Sendo venuto a Firenze nell' acquisto di Volterra, priegò Donato Aciaiuoli che gli piacessi durare fatica, avendo comentata l'Etica, di comentare la Pulitica, et così fece, et mandolla alla sua Signoria.

(*Le vite* cit., I, p. 380.)

The leading role of Justice is stressed by Plato too. In his *Republic*, he argues that this virtue is the highest good (X, xii), and the foundation of the ideal state (IV, xi). The pre-eminence of Justice is frequently echoed in Renaissance literature. Sabadino degli Arienti, in Book VII of his *De triumphis religionis*, calls it "santissima regina" (op. cit., p. 82). In the *Cortegiano*, Ottaviano Fregoso asserts:

> … la giustizia, vergine incorrotta, amica della modestia e del bene, [è] regina di tutte l'altre virtù, perché insegna a far quello che si dee fare e fuggir quello che si dee fuggire; e però è perfettissima, perché per essa si fan l'opere dell'altre virtù, ed è giovevole a chi la possede e per se stesso e per gli altri; senza la quale, come si dice, Iove istesso non poria governare il regno suo.

(op. cit., Book IV, Ch. XVIII, p. 475.)

Later on, Ottaviano states that the administration of justice is the most important of the princely duties:

> … delle cure che al principe s'appartengono la più importante è quella della giustizia; per la conservazion della quale si debbono eleggere nei magistrati i savi e gli approvati omini. [...] Direi come dalla giustizia ancora depende quella pietà verso Iddio, che è debita a tutti, e massimamente ai prìncipi, li quali debbon amarlo sopra ogn'altra cosa ed a lui come al vero fine indrizzar tutte le sue azioni.

(op. cit., Book IV, Ch. XXXII, p. 494.)

[66] Cf. P. P. GEROSA, "La cultura patristica del Petrarca", in idem *L'Umanesimo cristiano del Petrarca*, Turin, 1966, pp.

are also worth investigating. In a few cases the heroes seem to match. Vittorino and Bessarion are 26, 28 both humanists. Pietro d'Abano and Petrarch spent part of their lives in the Padua region[67]. These 34, 36 correspondences are, however, tenuous, and perhaps accidental. The pairing of Augustine with Boethius is more valid, for they were both authorities on Music[68]. Most convincing of all are the 16, 14 vertical links on the east wall. Cicero/Seneca, who were political figures[69] as well as "humanists", 17, 18 can relate to the leaders below, Moses/Solomon, and represent with them *vita activa*; while, on the 19, 20 right-hand side of that wall, Homer/Virgil (Poetry) may be linked to Thomas Aquinas/Duns 21, 22 Scotus (Theology) to collectively stand for *vita contemplativa*. 23, 24

<div align="center">*</div>

The scheme here outlined is not without inconsistencies. Grammar, a key *Trivium* and *Studia humanitatis* subject, normally exemplified in allegorical cycles by Priscian or Donatus, is missing[70]. The disciplines of the top register are not represented systematically by two personalities in each case. A few of the groupings are ideologically unjustifiable (for instance, the couples Euclid/Vittorino and Solon/Bartolus share the same wall, but have little in common). These inconsistencies could be explained by the fact that the organizational criteria that have been pursued are too numerous to be satisfied systematically. To recall the main ones: the professional and internally chronological twinning system, with its difficulties occasioned by the multi-sided personality of most heroes (upper and lower register); the representation, within the restrictive space of seven double compartments, of most of the leading disciplines of the time (upper register); the thoughtful grouping of the characters within individual walls (achieved on the eastern section of the upper register, and on the lower register); the establishment of correspondences across the room (achieved, partially, between the portraits of the north and south walls); and the vertical matching of the figures (achieved in a fully convincing manner only on the east wall). But perhaps it is misleading to talk of "inconsistencies", since a coherent scheme in which all parts are rigorously interrelated was probably never envisaged. Federico's frieze is unlike the frescoes of

156–79. Ideally, Petrarch should have been followed immediately by his favourite Father, Augustine, with whom he had an imaginary dialogue, in the *Secretum*; but the criteria that determined the order of the Fathers did not permit it.

[67] In fact, the association could be an unhappy one: Petrarch is the author of the invectives *Contra medicum*. Unless, of course, the vertical correspondence was meant polemically. Federico owned a copy of Petrarch's treatise; cf. *Le vite* cit., I, p. 391 note 8.

[68] Boethius's interest in Music has already been stressed. Augustine wrote the treatise *De musica*. Carpaccio's portrait of the Saint in his study (Church of S. Giorgio degli Schiavoni, Venice) appropriately includes some well-displayed music books. Cf. H. I. ROBERTS, "St. Augustine in 'St. Jerome's Study': Carpaccio's Painting and its Legendary Source", and E. E. LOWINSKY, "Epilogue: the Music in 'St. Jerome's Study'", *Art Bulletin*, XLI, 1959, pp. 283–97 and 298–301 respectively.

[69] For Cicero's political career, see D. STOCKTON, *Cicero: a Political Biography*, London, 1971; for Seneca's, see M. T. GRIFFIN, *Seneca, a Philosopher in Politics*, Oxford, 1976.
Cicero's inscription states that he was proclaimed Father of his Country (Appendix A, No. 5). This may be treated as a hint that he also has a political role to play in the frieze, since he was given the appellative after he foiled Catiline's conspiracy.

[70] It might however be argued that this subject is implied through the presence of Homer and Virgil, since their works – Virgil's in particular – were treated as models of good writing. See D. COMPARETTI, *Vergil in the Middle Ages*, London, 1966 (reprint of the second ed. of 1908), pp. 24–73, 119–34; especially the following (p. 30): "Vergil [...], embodying as he did the highest development of which the Latin language was capable, was, and was bound to be, the supreme authority on all grammatical questions. He is, as it were, the pole-star of the grammarian, and every one destined for the profession of grammar must steep himself in him. No other Latin writer was made a subject of study by so many grammarians or called forth so many grammatical works." Both Priscian's and Donatus's grammars draw most of their examples from Virgil (ibid., p. 70).

the *Sala della Pace* in Siena or of the *Cappella degli Spagnoli* in Florence, where the images serve the purpose of illustrating a didactic programme and are consequently rigidly disciplined by it. The intention to celebrate Federico's wide-ranging interests and decorate the room in a manner that suited its function seems to have led the person in charge of the project to seek inspiration from encyclopaedic cycles. Hence the incorporation of a near-comprehensive spectrum of disciplines, the choice of several traditional personalities (Aristotle, Ptolemy, Cicero, Moses, Solomon . . .), and the attempt to arrange all the heroes in a meaningful order. This order could not, however, be rigorous, because, as has been shown, the selection partly reflects the preferences of the Prince. The frieze is a mixture of well-established images and personal choices.

It should be stressed that the selection of heroes is most of all the expression of *humanist* admiration; this is as much true of the lower register as it is of the upper one. The devotional/theological aspect in the former is not present to the exclusion of the scholarly one. Such popular but unlearned saints as St. John the Baptist, St. Sebastian, St. Francis of Assisi and St. Catherine of Alexandria were not thought worthy of a place in the frieze[71]; nor were biblical figures, with the exception of Moses and Solomon who, as has been argued, have been included to represent political virtues[72]. The spirit in which the lower tier, in fact the whole cycle, was conceived, is well typified by the Church Fathers. Though the Middle Ages revered them mostly as theologians, the Renaissance regarded them also as ancient writers (they lived before the end of the Roman Empire) and scholars. Typically, Vespasiano refers to them as "dotori antichi"[73]. The Fathers appealed to humanists for, deep-rooted in the classical culture of their time as they were, they could provide with their works a justification to the often frowned-upon syncretism of pagan and Christian traditions[74]. It is worth noting that the inscriptions beneath the portraits of Gregory, Jerome and Ambrose explicitly praise these figures not only for their theological importance, but for their stylistic excellence too (Appendix A, Nos. 15, 16, 17)[75].

Thus, the division between the upper and the lower tiers is not as clear-cut as might originally have appeared. In fact, the presence of other figures of hardly exclusively theological importance such as Pius II, Bessarion, Albertus Magnus, Sixtus IV, Dante and Petrarch, suggests that such a division is, to a considerable extent, a perfunctory one.

<div align="center">*</div>

This chapter cannot be concluded without discussing in some detail the miniature grisaille figures which group the portraits in fours.

[71] These head Peter BURKE's list of most popular saints as represented in Renaissance art. Cf. *Tradition and Innovation in Renaissance Italy*, London, 1974, p. 183.

[72] Solomon is also depicted as the philosopher-king: he holds a book. The absence of unlearned saints and biblical figures from the frieze need not be taken for granted. In the *Stanza della Segnatura*, which probably served as a study or a library, the fresco that illustrates the faculty of Theology includes a host of representatives of the Church Triumphant: St. Peter, Adam, St. John the Evangelist, etc. (cf. DUSSLER, op. cit., pp. 71–3, Pl. 123). For the *Segnatura* as a *studiolo*, cf. CHASTEL, *Art et humanisme* cit., p. 470. For the view that it was a library, cf. J. SHEARMAN, "The Vatican Stanze: Functions and Decoration", *Proceedings of the British Academy*, LVII, 1971, pp. 369–424.

[73] See above, p. 47, second quotation..

[74] On the revival of patristic literature in the Renaissance, cf. P. O. KRISTELLER, "Augustine and the Early Renaissance", in idem, *Studies in Renaissance Thought and Letters* cit., pp. 362–7; C. TRINKAUS, *In our Image and Likeness*, London, 1970, I, pp. 20 ff.

[75] Jerome and Augustine feature fequently in the pictorial genre of the scholar in his study, as already mentioned. Augustine's reputation as a master of rhetoric and classical learning is stressed in Benozzo Gozzoli's fresco cycle in the choir of the Church of S. Agostino, in S. Gimignano (cf. A. PADOA RIZZO, *Benozzo Gozzoli, pittore fiorentino*, Florence, 1972, Fig. 126–49).

On the north wall, a winged figure links Plato/Aristotle with Gregory/Jerome; before him is an eagle – a symbol of authority – displaying, on a shield, Federico's arms.

The second grisaille figure of the north wall, which connects Ptolemy/Boethius to Ambrose/Augustine, holds an armorial shield with the right hand and, very likely, a sceptre in his left hand. This unusual motif may have been meant as an attribute of Philosophy. The context seems to support this interpretation, since the top of the item actually points to the right-hand side of the compartment where Boethius, author of *De consolatione Philosophiae*, is to be found. It is worth noting that it was precisely Boethius who gave a sceptre to Philosophy, in the named work[76].

On the east wall, the grisaille figure that connects Cicero/Seneca to Moses/Solomon is of some interest. Lavalleye describes it as Atlas and suggests that the animal with open jaws "might" be a lion[77]. The combination Atlas/lion is unlikely. The composition, as Rotondi originally noted, represents Hercules slaying the Nemean lion[78]. Needless to say, the evocation of this mythical hero protector of people and guardian of cities, a personification of such active virtues as courage and fortitude, in the very part of the study that accommodates political figures, is extremely appropriate[79].

The miniature figure that groups Homer/Virgil with Thomas Aquinas/Duns Scotus is actually Atlas (he is depicted physically supporting the compartments above). Since some traditions ascribe scholarly traits to him[80], it is appropriate that he should be placed among the representatives of contemplative life, on the eastern wall[81].

The parallels Hercules/active life and Atlas/contemplative life appear to have been established ones. In Cristoforo Landino's *Disputationes Camaldulenses*, which, as will be recalled, was dedicated to Federico, Alberti states in the course of a discussion on the relative merits of the two lives that occupies almost the whole of Book I:

> Fuit sapiens Hercules. At non sibi sapiens; verum sua sapientia omnibus paene mortalibus profuit. Nam maximam orbis partem peragrans horrendas ferat substulit, pernitiosa ac immania monstra perdomuit; crudelissimos tyrannos coercuit; plurimis populis ac nationibus ius liberatemque restituit;

[76] Cf. J. P. MIGNE, *Patrologia Latina*, LXIII, col. 590 (quoted after G. DE TERVARENT, *Attributs et symboles dans l'art profane, 1450–1600*, Geneva, 1958, s.v. "Sceptre", I, col. 337).

[77] *Le Palais Ducal* cit., pp. 58, 59.

[78] *Il Palazzo Ducale* cit., I, p. 353; II, Fig. 360.

[79] For a concise account of the meaning of Hercules, cf. this entry in HALL, op. cit., pp. 147–53 (esp. 147–8). For a fuller treatment, see E. PANOFSKY, *Herkules am Scheidewege*, Leipzig, 1930; M. R. JUNG, *Hercule dans la littérature française du XVIᵉ siècle*, Geneva, 1966; L. D. ETTLINGER, "Hercules Florentinus", *Mitteilungen des Kunsthistorischen Institutes in Florenz*, XVI, 1972, pp. 119–42.
The association of Hercules with cycles of *uomini famosi* was common in the Renaissance. Cf. Sabadino degli Arienti on a room of Belriguardo Palace, in Ferrara:
> ... passiamo in una camera pincta ad homini sapienti, con brevi morali de singular sentencie e con la figura del' antiquo Hercule in campo verde.
(*De triumphis* cit., p. 59).
Hercules is also depicted on the spandrels of the *Camera degli Sposi*, among *tondi* depicting the Caesars, above the portraits of the Gonzagas and the other personalities. Cf. E. TIETZE-CONRAT, *Andrea Mantegna. Le pitture, i disegni, le incisioni*, Florence–London, 1955, Figs. 87–97.

[80] DAREMBERG and SAGLIO eds., op. cit., I, 1877, s.v. "Atlas", pp. 526–8.

[81] A connection may also have been intended between the Heavens that Atlas was condemned to uphold in the well-known myth, and the figures of Homer and Virgil he supports in the frieze, since these poets are praised in the inscriptions for the divinity of their poetry (Appendix A, Nos. 7 and 8).

quod si apud Athlantem praeceptorem suum commoratus ociosae sapientiae tantum operam dedisset, pro Hercule sophistam haberemus ...[82]

25–32, 33–36 The grisaille figures on the remaining walls are too mutilated to permit identification. The drawing
7 of Rotondi's first reconstruction depicts them as caryatids, but this is mere supposition. The small figure on the west wall displays a shield with the full arms of the Prince.

[82] [Hercules was wise, but not for himself; all mortals benefited from his wisdom. In fact, during his peregrinations, which covered large parts of the world, he eliminated horrible wild beasts, tamed pernicious and huge monsters, suppressed the most cruel tyrants, and brought back law and freedom to many peoples and nations. Had he stayed with his tutor Atlas, who was devoted to a purely idle wisdom, we would have had a sophist instead of Hercules.]
"Disputationes Camaldulenses", in E. GARIN ed., *Prosatori latini del Quattrocento*, Milan, 1952, pp. 762, 764.

> … dal tempo de' gientili in qua non ci sono stati simili maestri di lengname, di tarsie e commessi, di tanta arte di prospettiva che con pennello non si farebbe meglio.
>
> Giovanni Rucellai[1]

IV. THE INLAID PANELS[2]

1. *The General Conception of the Decorations*

The visitor entering the room is immediately struck by the trompe-l'oeil effect of the wall decorations. This is achieved through the combination of a highly sophisticated knowledge of perspective with a masterly marquetry technique[3].

41–61

63–65

[1] A. PEROSA ed., *Giovanni Rucellai ed il suo Zibaldone*, London, 1960, I, p. 61.

[2] The authorship of the intarsia designs is undocumented, and much debated. The cartoons have been ascribed to Botticelli (R. LONGHI, *Piero della Francesca*, Milan, 1946 [2nd ed.], p. 123; F. ARCANGELI, *Tarsie*, Rome, 1942, pp. 7–10; PAPINI, op. cit., I, pp. 136–7; CHASTEL, *Art et humanisme* cit., pp. 365–6; CLOUGH, "Federigo da Montefeltro's Private Study" cit., pp. 286–7 [but see the author's subsequent attribution, below]), to Piero (CLOUGH, "Piero della Francesca" cit., p. 285), to Francesco di Giorgio (L. VENTURI, "Studii sul Palazzo Ducale di Urbino", *l'Arte*, XVII, 1914, p. 450; L. SERRA, *Il Palazzo Ducale di Urbino*, Rome, 1930, pp. 470–2; REMINGTON, op. cit., p. 12; SALMI, op. cit., p. 196 note 9), to Antonio del Pollaiuolo (PARRONCHI, op. cit., pp. 1187–9) and to Piero del Pollaiuolo (FERRETTI, op. cit., p. 519 note 13). Rotondi has proposed a composite attribution. He believes that the designs were executed in two main stages: a first one entailing the planning of the general architectural framework of the *studiolo* decorations, and a second one involving the details. He ascribes the general perspective structure to Bramante, who later created similarly complex illusionistic architectures in Lombardy (e.g. the *Casa Panigarola*, in Milan). As far as the details of the inlaid decorations are concerned, some he attributes to Botticelli (Charity, for instance, for it is reminiscent of the *Primavera*), and others to Francesco di Giorgio (e.g. the three-arched loggia, the pilasters of which closely resemble later ones designed by him; the clock and the articulated arrangement of the seats, which would especially accord with his engineering mind). See ROTONDI, *Il Palazzo Ducale* cit., I, pp. 346–56; 462–7; *Francesco di Giorgio nel Palazzo Ducale* cit., pp. 34–7; "Ancora sullo studiolo" cit., pp. 597–602 (pp. 262–5 of the later ed.). The practice of executing intarsia designs in two stages when the composition included an architectural element was not uncommon; see FERRETTI, op. cit., pp. 474–5.

The authorship of the woodwork is also undocumented. It has been attributed to Baccio Pontelli, who trained in Francione's workshop in Florence (ARCANGELI, op. cit., p. 7; ROTONDI, *Il Palazzo Ducale* cit., I, pp. 463–5 note 218; CHASTEL, *Art et humanisme* cit., p. 365; LAVALLEYE, *Le Palais Ducal* cit., p. 70), and to Giuliano da Maiano (PAPINI, op. cit., I, p. 136; G. MARCHINI, *Giuliano da Maiano*, Florence, 1959, p. 44; PARRONCHI, op. cit., p. 1188).

Since this chapter will also deal with the Gubbio intarsias, the bibliography on the attributions is extended to cover these too. The designs have mostly been ascribed to Francesco di Giorgio. Cf. REMINGTON, op. cit., p. 12; CHASTEL, *Art et humanisme* cit., pp. 369, 371; CLOUGH "Lo studiolo di Gubbio" cit. (who, however, had previously thought of Botticelli and Piero; see the works cited above, same page numbers). The master craftsman to whom the execution of the Gubbio intarsias is generally attributed is Baccio Pontelli. Cf. REMINGTON, op. cit., pp. 12–3; CLOUGH, "Federigo da Montefeltro's Private Study" cit., p. 287.

[3] That the sophisticated perspective designs should have been expressed in intarsia form is of little surprise. As CHASTEL has shown, the connections between rationalist artists and *intarsiatori* (also known as *maestri di prospettiva*) were close; cf. "Marqueterie et perspective au XV^e siècle", *La revue des Arts*, III, 1953, pp. 141–54 (now also in idem, *Fables, formes, figures*, Paris, 1978, I, pp. 316–32). The technical reasons behind the association are explained thus: "L'autorité des perspectives brunelleschiennes venait de la structure clairement intelligible qu'elles conféraient à l'espace; elles apportaient en même temps une méthode de construction pratique. L'armature simple des orthogonales et des lignes de fuite convergentes, déterminait par le jeu des 'intersections' un réseau géométrique; ce réseau se résolvait en un jeu de figures élémentaires

61

VII

63

78–88

Illusionistic intarsias were not uncommon from the middle of the 15th century; the choir stalls and sacristy cupboards of the cathedrals of Parma and Modena especially come to mind[4]. The Urbino inlays, however, are far more ambitious, since not only a few details but the whole set of furniture of the room has been simulated.

From the general design point of view, the similarity with contemporary choir stalls and sacristy cupboards is striking. Like these, the Urbino woodwork consists of a compact articulated frieze, with half-open cupboards holding still lives, niches enframing figures, and rows of seats. The similarity may be attributed partly to their shared functions: choir stalls too were places devoted to meditation; while sacristies functioned as libraries and archives since liturgical and administrative books were usually kept there[5].

More specific considerations – practical, illusionistic, decorative and iconographic – also played their part in determining the design of the Urbino "furniture".

The sequence of cupboards needed to be compact, i.e. rationally arranged, with its capacity intensively exploited, because of the tiny size of the room and the large number and variety of items to be displayed. Their uniformly limited depth was necessary to facilitate the perspective illusion; the depiction of such "irregularities" as greatly projecting objects and deep recesses has on the whole been avoided in the *studiolo* for this very reason. Ordinary *studioli* – if the pictures of humanists in

90, 104 their studies that have reached us are anything to go by – were far less compact and structured; but then their contents could be freely spread across the available space; they did not have to be relegated to the walls, or, if bulky, excluded.

It should be added that, though providing an illustration of a study-room's furnishings and paraphernalia, the décor remains essentially an ornamentation: a rich and elegant way of covering bare walls. Hence the copiousness of the motifs. As for the articulations of the frieze, they are a feature necessary for reasons of harmony: to a mathematics-conscious prince like Federico, it must have been important that the inlays related symmetrically to the painted decorations above.

Finally, to anticipate later arguments, it will be pointed out that the highly structured arrangement of the illusionistic furnishings and the items they contain was necessary to permit, or at least facilitate, the incorporation (for us, identification) of an elaborate iconographic programme. The division of the walls into compartments has a classificatory function: it groups the items according to their symbolic meanings.

41, 53, 58 The folding seats that run around three sides of the *studiolo* strike us as unusual, given the private character of the room. This feature too, however, can be accounted for: the seats offered an opportunity for illusionistic virtuosity.

While there is little doubt that the *studiolo* woodwork was influenced by ecclesiastical furnishing, the trompe-l'oeil idea may be ascribed to a much earlier source: antique illusionistic wall painting. As Charles Sterling has shown, such motifs as the still lives in cupboards with doors ajar, the loggia overlooking the landscape, the animals and the fruits can all be traced in Pompeian frescoes; these were obviously unknown in the Renaissance, but a number of similar works (now almost entirely

facile à découper, les carrés du dallage placés normalement à la surface devenant dans l'effet perspectif, des trapèzes, les carrés tournés sur l'angle des losanges, etc. ...; ce que l'on recueillait au terme de la décomposition de l'espace se construisait sur le tableau comme un 'puzzle', c'est-à-dire comme une marqueterie. [...] la fonction unifiante de la perspective exprime bien une pensée mathématique cohérente, mais le procédé d'analyse et de construction qui en résulte est la technique de la marqueterie." (op. cit., pp. 144–5 of the original article, and pp. 321–2 of the republished ed.). On the inlay technique and its development, see also: B. CIATI, *Il significato dell'opera ad intarsio nella cultura e nella società del secondo Quattrocento attraverso l'opera dei fratelli Lendinara*, Degree Thesis, State Univ. of Milan, 1974–75; M. HAINES, *The Intarsias of the North Sacristy of the Duomo in Florence*, Ph. D. Thesis, London Univ., 1975; FERRETTI, op. cit., pp. 457–585.

[4] Cf. ARCANGELI, op. cit., and A. C. QUINTAVALLE, *Cristoforo da Lendinara*, Parma, 1959, for illustrations.

[5] LIEBENWEIN, op. cit., pp. 15–20.

54

lost) could be seen elsewhere, particularly in Rome. Inspiration could equally have come from Greek and Latin descriptions of mural paintings. Clearly, the idea of decorating the study with motifs inspired by antiquity would have had a considerable appeal for Federico[6].

2. *The Upper and Lower Registers*

A close investigation of the designs in the marquetry suggests that they are not the illusionistic representation of a random selection of items. The choice of the motifs and their specific arrangement in relation to one another (and to the portraits above, as will be shown in the final chapter) point to the existence of an underlying programme.

While many of the motifs replace real ones which one might expect to find in a study (e.g. the books, the writing material, the portraits of the Virtues), some are rather unexpected (e.g. the many musical instruments), and others totally out of place (e.g. the armour and the arms). This leads one to believe that such a heterogeneous multitude of items may have been included to draw our attention to Federico's variegated universe. The objects allude to his religious preoccupations (see the Virtues and the book marked BI[BBIA]), to his wide-ranging intellectual pursuits and patronage (books, musical and scientific instruments); and, finally, to his military career and status as a ruler (armour, bâton of command, arms, emblems and devices). Many of the items thus have a celebratory function; they may be taken as a visual parallel to encomiastic biographies, with their enumerations of the ruler's qualities – moral, aesthetic, intellectual and political. An extract taken almost at random from Vespasiano's account of the Duke's life, and compared to the inlaid motifs, illustrates this point:

46, 47, 57, 61

50, 42, 44, 54

> Della musica s'era dilettato assai et intendevane benissimo et del canto et del sono, et aveva una degna capella di musica, dove erano musici intendentissimi, et avevano parecchi giovani che facevano canto et tinore in modo ch'era una degna capella di musica. D'instrumenti non era instrumento che la sua signoria non avessi in casa, et deletavasi assai del suono, et aveva in casa sonatori perfettissimi di più instrumenti...[7].

To this, we may add an extract from the *Cortegiano*:

> [Federico fornì il Palazzo] non solamente di quello che ordinariamente si usa, come vasi d'argento, apparamenti di camere di ricchissimi drappi d'oro, di seta e d'altre cose simili, ma per ornamento v'aggiunse una infinità di statue antiche di marmo e di bronzo, pitture singularissime, instrumenti musici d'ogni sorte; né quivi cosa alcuna volse, se non rarissima ed eccellente[8].

[6] C. STERLING, *Still Life Painting from Antiquity to the Present Time*, New York, 1981 (2nd ed.; the 1st one, dated 1959, is the slightly amplified version of the exhibition catalogue: *La nature morte de l'antiquité à nos jours*, Paris, 1952), pp. 52–3, 161. Similar views are expressed in passing, and apparently independently, by I. BERGSTRÖM, *Dutch Still-Life Painting in the Seventeenth Century*, New York, 1983 (reprint of the British ed. of 1956), pp. 28, 298 note 78. Sterling's claim that Renaissance still lives in general have their source in antiquity is endorsed, with minor reservations, by GOMBRICH in his review of the 1st. ed. of the book; cf. "Tradition and Expression in Western Still Life", in idem, *Meditations on a Hobby Horse*, London, 1963, pp. 95–105 (the essay was originally published in 1961). On the role of antiquity as an inspirer of Renaissance trompe-l'oeil decorations, see also: E. H. GOMBRICH, "The Renaissance Theory of Art and the Rise of Landscape", in idem, *Norm and Form*, Oxford 1971, pp. 107–21 (the essay first appeared in 1953); I. BERGSTRÖM, *Revival of Antique Illusionistic Wall-Painting in Renaissance Art*, Göteborg, 1957.

[7] *Le vite* cit., I, p. 383–4.

[8] CASTIGLIONE, op. cit., Book I, Ch. II, pp. 84–5. The taste for the most rare and outstanding here celebrated is a reference to the already discussed virtue of *magnificentia*. This virtue is well typified in Urbino by the clock. Such devices, at least in their domestic version, were quite rare in the Renaissance, and must have thus had a status symbol value (cf. C. M. CIPOLLA, *Clocks and Culture 1300–1700*, London, 1967, p. 49; E. PANOFSKY, *Problems in Titian, Mostly Icono-graphic*, London, 1969, p. 89).

63

Like these eulogistic extracts, the inlaid decorations may be interpreted rhetorically: the copiousness and the variety of items displayed are the figurative translation of an *amplificatio*[9].

On entering the room from the western door, the visitor is struck by the symmetrical arrangement of two motifs with opposite connotations, on the eastern side: the armour, occupying the left-hand recess, and the lectern with the books in the right-hand one. Such an arrangement seems to express a belief in the complementarity of active and contemplative pursuits[10]. This concept was one of the most common Renaissance *topoi*[11], but its frequent repetition in the *studiolo* suggests that it was especially dear to Federico. It is expressed elsewhere in the intarsias. In the well-displayed music book of the west wall, the following words accompany the score:

> Bella gerit musasque colit Federicus omnium maximus Italiorum Dux foris atque domi ...[12]

They celebrate the Duke for the happy reconciliation of a busy public life (*bella gerit*; *foris*) with a scholarly and private one (*musasque colit*; *domi*). The inlaid portrait in the north wall reiterates the idea, for Federico is depicted armed with a spear and proudly displaying the Collar of the Ermine, but also wearing a humanist robe. That the integration of the two types of life was a major aspiration of Federico's is also attested in contemporary works of celebratory inspiration, such as Vespasiano's biography[13] and Landino's *Disputationes Camaldulenses*, Book I of which deals, as we have seen, with the theme of *vita activa – vita contemplativa*[14].

[9] On this trope, cf. E. R. CURTIUS, *European Literature and the Latin Middle Ages,* London, 1953, pp. 490–4; E. H. GOMBRICH, "The Early Medici as Patrons of Art", in idem, *Norm and Form* cit., pp. 35, 51.

[10] That the symmetrical arrangement armour/lectern suggests the twin concept of active/contemplative life is pointed out by LIEBENWEIN, op. cit., p. 212 note 234.

[11] Cf. F. SCHALK, "Il tema della 'vita activa' e della 'vita contemplativa' nell' Umanesimo italiano", in E. CASTELLI ed., *Umanesimo e scienza politica*, Milan, 1951, pp. 559–65; CURTIUS, op. cit., pp. 178–9. The subject was dealt with in two works of Aristotle's that Federico revered: the *Nicomachean Ethics* (X, vii–ix) and the *Politics* (VII, ii–iii). In the *Cortegiano*, Ottaviano declares that

> [la vita del buon principe deve essere] ordinata di modo che partecipi della attiva e della contemplativa, quanto si conviene per beneficio dei populi.

Op. cit., Book IV, Ch. XXIV, p. 485).

[12] [Federico, the greatest leader of all Italians, outdoors and at home, he fights wars and cultivates the Muses.]
On this song, cf. V. SCHERLIESS, *Musikalische Noten auf Kunstwerken der Italienischen Renaissance bis zum Anfang des 17. Jahrhunderts*, Hamburg, 1972, pp. 58–60, 120–2. For the practice of reproducing musical compositions in inlays, cf. G. REESE, "Musical Compositions in Renaissance Intarsia", in J. L. LIEVSAY ed., *Medieval and Renaissance Studies*, Durham, N.C., 1968, pp. 74–97.

[13] See the following excerpts:

> Avendo detto infino a qui alcuna cosa fatta dal duca d'Urbino circa la disciplina militare [...] parmi al presente dovere dire alcuna cosa della peritia ebe della lingua latina, congiungendola colla disciplina militare, chè difficile è a uno capitano singulare potere far bene e' fatti dell'arme, s'egli non ha la peritia delle lettere, come ebe il duca d'Urbino, perchè le cose passate sono exempro delle presenti.
> (*Le vite* cit., I, p. 379).
> [È stato] infino qui detto di fatti de l'arme, di poi delle lettere coniuncte coll'arme, chè a volere fare uno uomo excellentissimo nella disciplina militare sanza le lettere, non può avere quella peritia la quale ebe la sua Signoria per avere congiunta l'una contro l'altra ...
> (ibid., I, p. 399).

[14] The author writes in the Preface:

> Verum cum librum nostrum eius principis auctoritate honestare placeret, qui omnium quos aetas nostra tulerit utroque illo genere maxime excelleret, quem tibi, illustrissime Federice, conferrem, etsi multum diuque universam Italiam mente ac cogitatione lustrassem, repperi neminem. Nam cum quicumque erectiore quodam ingenio fuerint, aut ita coetum civitatemque coluerint, ut et prudenter monendo et recte agendo non sibi solum verum reliquis quoque profuerint, aut maiori quadam mente praediti, relictis humanis negociis, se ad divinarum rerum contemplationem erexerint, nonne utrumque istorum in te esse cognoscimus?
> [Having decided to embellish my book with the example of that prince of our time who appeared to be excellent in both

56

The interpretation of the decorations cannot stop at this level, which we could call of natural or referential symbolism. Such motifs as the squirrel, the basket of fruit and the cage with the parrots are puzzling: their compatibility with the rest of the décor, on a level of naturalism, and their possible derivation from antique models, are not enough to justify their presence. A humanist may well have kept in his study something to nibble at, or a pet; whether it was customary in the Renaissance to transpose them to an artistic medium for their own sake, is another matter.

Some of the objects in the study are unlikely to have been chosen merely to refer to Federico's varied interests. The mathematical tablet with its characteristic perforation at the top, which we see on the south wall, is too elementary an item to include in order to inform us that the Prince was well versed in the subject it is used for: a book with the inscription PITAGORA would have been more suitable. The motif in question is the standard attribute of the personification of Arithmetic. The mace leaning against the same wall, beneath no less than the personification of Faith, is so fierce a weapon that it is difficult to believe that it has been included in the study simply to suggest that Federico was a successful condottiere: the armour and the bâton of command fulfil this function less truculently. The weapon in question is a well-established symbol of Fortitude. The tambourine on the north side is not an obvious instrument to depict in order to refer to someone's love of music. It corresponds to the attribute of the Muse Erato. Thus, it is legitimate to wonder whether the more "deviant" motifs (and perhaps some of the more ordinary ones as well) may embody hidden meanings.

Art historians have shown that representations of *studioli* are frequently disseminated with items that require to be apprehended on two levels: a purely sensuous one and a symbolic one[15]. Interiors especially lent themselves to the incorporation of symbols, on account of the variety of items that could be accommodated in the rooms.

The practice of using naturalistic motifs for symbolic purposes was indeed a common one from the 15th century onwards. Panofsky[16] has noted how, while in the Middle Ages the non-recognition of the unities of space and time had permitted objects clearly recognizable as symbols to be depicted side by side with straightforward realistic ones, in the Renaissance the development of perspective made the disparity between these levels of reality unacceptable. Pictorial space was increasingly treated as the extension of empirical space and therefore subjected to the same rules. The centuries-old tradition, however, did not disappear:

> ... the world of art could not at once become a world of things devoid of meaning. There could be no direct transition from St. Bonaventure's definition of a picture as that which 'instructs, arouses pious emotions and awakens memories' to Zola's definition of a picture as 'un coin de la nature vu à travers un tempérament'. A way had to be found to reconcile the new naturalism with a thousand years of Christian tradition; and this attempt resulted in what may be termed concealed or disguised symbolism as opposed to open or obvious symbolism[17].

types of life, I could not find anyone to compare with you, most illustrious Federico, though I have searched the whole of Italy for a long time in my thoughts. For do we not recognize that you belong to both sets of individuals: those who have been of a superior intellect or have so cherished the city assembly that they have brought profit by their prudent advice and just actions not only to themselves but also to the others, and those who, endowed with a greater spirituality, leaving human pursuits aside, raised themselves to the contemplation of the divine world?]
("Disputationes" cit., p. 718. There are other references to Federico's dual activities on pp. 722, 762.)

[15] Cf. I. BERGSTRÖM, "Medicina, Fons et Scrinium. A Study in Van Eyckean Symbolism and its Influence in Italian Art", *Konsthistorisk Tidskrift*, XXVI, May 1957, pp. 4–13; ROBERTS, op. cit.; P. W. PARSHALL, "Albrecht Dürer's St. Jerome in his Study: A Philological Reference", *Art Bulletin*, LIII, 1971, pp. 303–5; FRIEDMANN, op. cit.; P. HOWELL JOLLY, "Antonello da Messina's 'Saint Jerome in his Study': An Iconographic Analysis", *Art Bulletin*, LXV, 1983, pp. 238–53.

[16] *Early Netherlandish Painting*, New York, 1971, I, Ch. V.

[17] Ibid., I, p. 141.

Panofsky is of course well aware of the problem that such a practice poses: how are we to know whether a particular item needs decoding or should be taken merely for its face value? He offers the following advice:

> We have to ask ourselves whether or not the symbolical significance of a given motif is a matter of established representational tradition [...]; whether or not a symbolical interpretation can be justified by definite texts or agrees with ideas demonstrably alive in the period and presumably familiar to its artists [...]; and to what extent such a symbolical interpretation is in keeping with the historical position and personal tendencies of the individual master[18].

These recommendations will be borne in mind throughout this investigation.

<p align="center">*</p>

The attempt at deciphering the symbols that may lie hidden in the intarsias will begin with the more usual motifs – those that have already been interpreted as loose signs pointing to Federico's diverse interests, namely: arms and scientific and musical instruments. The possibility will be considered that they may also be conventional signs commonly used to characterize personifications – i.e. attributes. To identify them, reference will be made especially to contemporary allegorical cycles directly associated with, or known in, Urbino. It is in fact reasonable to suppose that the decorations of the study of one of the leading humanist princes of Italy may not simply include a handful of randomly disseminated symbols, but series of systematically organized ones – i.e. that they may embody an iconographic programme. To check the results, reference will also be made to the inlaid decorations of the Gubbio *studiolo*, for the motifs there, though arranged differently, are basically the same as in Urbino – a point which suggests that one basic iconographic programme was devised for both rooms. As we shall see, in both cases the items are thoughtfully arranged – particularly so in Urbino, where humanist advisor and artist(s) appear to have closely cooperated. Unfortunately, the proposed system of verification is handicapped by the slightly incomplete state of the Gubbio woodwork. The area beneath the large window may have originally been veneered with inlays; the window itself may have been hidden by inlaid shutters (like the door that leads to the loggia in the Urbino study). In both cases, the woodwork could have featured iconographically significant motifs.

One theme particularly suggests itself when we look at the decorations: the Liberal Arts[19]. A detailed examination confirms this impression. As the table below shows, a number of Urbino and Gubbio motifs correspond to the attributes of their personifications such as they appear in the following figurative cycles: the so-called *Tarocchi del Mantegna* (a series of cards that had some influence on the arts, and were known in Urbino in Federico's time, as a number of iconographic and stylistic echoes in works connected with the Palace indicate)[20]; the inlaid panels of the door leading from the *Sala delle Udienze* to the *Sala degli Angeli* in the Urbino Palace; and the four Berlin and London paintings of obvious Montefeltro provenance, ascribed to Justus of Ghent.

80

58, 61, 62

92

72–75

[18] Ibid., I, pp. 142–3.

[19] For the popularity of the theme, and its iconography, cf. P. D'ANCONA, op. cit., pp. 137–55, 211–28, 269–89, 370–85; L. H. HEYDENREICH, "La ripresa 'critica' di rappresentazioni medievali delle 'septem artes liberales' nel Rinascimento", in *Il mondo antico nel Rinascimento*, Florence, 1958, pp. 265–73; Ph. VERDIER, "L'iconographie des arts libéraux dans l'art du moyen âge jusqu'à la fin du quinzième siècle", in *Arts libéraux et philosophie au moyen âge*, Montreal-Paris, 1969, pp. 305–55. See also M. W. EVANS, *The Personifications of the Artes from Martianus Capella up to the End of the 14th Century*, Ph. D. Thesis, London Univ., 1970, especially for the iconographic sources.

[20] E. PETERICH, "Gli dei pagani nell'arte cristiana", *La Rinascita*, V, 1942, pp. 61–2 note 2; L. DONATI, "Le fonti iconografiche di alcuni manoscritti urbinati della Biblioteca Vaticana. Osservazioni intorno ai cosiddetti 'Tarocchi del Mantegna'", *La Bibliofilia*, LX, 1958, pp. 48–129. For illustrations of the cards depicting the seven Liberal Arts, cf. A. M. HIND, *Early Italian Engraving*, London, 1938, IV, Pls. 340–5, 348.

The decorations of the Urbino and Gubbio *studioli* have been divided into sections, marked (a) to (t) and (I) to (XIII) respectively, in order to facilitate reference to individual motifs.

	LIBERAL ARTS	TAROCCHI	URBINO DOOR	JUSTUS(?)'s PANELS		URBINO STUDY	GUBBIO STUDY
TRI-VIUM	GRAMMAR	file, drug-jar	book, pupil	[lost]		armed vessel (o)	vessel (V)
	RHETORIC	sword, cuirass, crown, trumpets	not represented	book		—	—
	LOGIC	dragon-snake in veil	two snakes	book		—	—
QUADRI-VIUM	ARITHMETIC	tablet, counting of coins	tablet (with double perforation)	[lost]		tablet (with double perforation) (k)	—
	GEOMETRY	geometrical symbols, landscape	compasses	[lost]		—	dividers (IV)
	MUSIC	swan, organ and other instruments	organ	organ		organ (j) and other instruments	organ (XIII) and other instruments
	ASTRONOMY	sphere, book, rod	sphere, book	sphere		sphere (k)	sphere (X)

The motifs from the Urbino *studiolo* that tally with the attributes appearing in one or more of the named allegorical cycles are: the two-armed vessel (resembling that on one of the sides of the *Tarocchi* card, which is meant to contain medicine for correcting children's pronunciation)[21]; the tablet (with a double perforation, identical to that which we find associated with the personification of Arithmetic on the *Door of the Liberal Arts*); the organ (the most common attribute of Music); and the armillary sphere (an established symbol of Astronomy). Geometry is probably freely referred to through the *mazzocchio*, a motif dear to perspectivists, such as Piero and Uccello[22]. The latter suggestion is not unreasonable, for, as will become increasingly apparent, the

59, 93
94
VIII
92, 54
VIII

[21] R. WITTKOWER, "Grammatica: from Martianus Capella to Hogarth", in idem, *Allegory and the Migration of Symbols*, London 1977, pp. 167–72, esp. p. 169.
[22] B. DEGENHART and A. SCHMITT, *Corpus der italienischen Zeichnungen 1300–1450*, Berlin 1968, Part I, vol. II, p. 524 (for Piero's *mazzocchi*); vol. II, pp. 402–6, and vol. IV, Pl. 283 a, b and d (for Uccello's). For a broad discussion on the *mazzocchio*, cf. M. DALY DAVIES, "Carpaccio and the Perspective of Regular Bodies", in M. DALAI EMILIANI

studiolo decorations are not a mechanical display of conventional symbols. The devisor of the programme has also made use of less codified references and metaphorical images to create an original and poetical work of art. Though the cuirass and the sword, traditional attributes of Rhetoric (they stand for its defensive and attacking functions), are present in the inlays (see (g) and (a)), they are unlikely to have been included with this meaning. The cuirass has already been interpreted as a symbol of active life; as for the sword, it is perhaps more appropriate to treat it as the attribute of Justice, since it is located close to military symbols (see below). It is tempting to argue that Rhetoric has been symbolized instead by the twin motif of the cage with the parrots, and the clock, in (r) and (s). Perhaps it is no coincidence that in his influential manual for painters, *Iconologia*, Cesare Ripa described Eloquence as a woman with three main attributes: a book, an hourglass and a parrot:

> Il libro, e l'orologio [da polvere] [...] è indicio che le parole sono l'istromento dell'eloquente: le quali però devono essere adoperate in ordine e misura del tempo, essendo dal tempo solo misurata l'oratione, e da esso ricevendo i numeri, lo stile, la grazia, e parte dell'attitudine a persuadere.
> Il papagallo, è simbolo dell'eloquente, perché si rende maraviglioso con la lingua e con le parole, imitando l'huomo, nella cui lingua solamente consiste l'essercitio dell'eloquenza[23].

Ripa wrote the first version of his manual in the late 16th century, but the idea of coupling a time-measuring device to a parrot to signify the well-regulated art of Eloquence may have already been "in the air", in uncodified form, in the 15th century. It is equally likely that the designer of the programme associated two obvious individual symbols[24] to create a new metaphor. The temptation to consider the cage with the parrots, and the clock as a single motif is a strong one. Not only are the two items adjacent and somewhat cut off from the others (the door on which they are depicted is set in a slight recess of the wall), they are also formally rather similar: both items consist roughly of a quadrangular base and a triangular top.

Of all the Arts, only Logic has not been found a motif that may suitably refer to it. Its traditional attribute, the snake, is not of course one that can be incorporated in a study unobstrusively. The subject was occasionally symbolized by the book (see Justus's(?) *Dialectic*(?), for instance), but this item is so copiously represented and well integrated in the *studiolo*, that it cannot be ascribed a specific meaning[25]. We should conclude, therefore that Logic is missing[26].

To return briefly to the objects that have been associated with Arithmetic, Geometry, Music and

ed., *La prospettiva rinascimentale*, Florence, I, 1980, pp. 183–97. See especially the following remark, supporting the view that this motif could symbolize Geometry (p. 183): "The mazzocchio is [...] a perspective exercise *par excellence*, and it serves as a hall-mark, a kind of badge whereby the painter manifests his concern for perspective science."

[23] C. RIPA, *Iconologia: overo Descrittione di diverse Imagini cavate dall'antichità, & di propria inventione*, Rome, 1603 (facsimile ed., New York, 1970), s.v. "Eloquenza", p. 127. Ripa mentions an hourglass rather than a clock. He also states that the parrots should be depicted "fuora della gabbia, perché l'eloquenza non è ristretta a termine alcuno, essendo l'offitio suo di saper dire probabilmente qualsivoglia materia proposta..." The lack of a complete correspondence with the details in Urbino does not invalidate my point, for the reasons explained immediately below, in the text.

[24] The clock is a patent symbol of regulation. It is, in fact, one of the established attributes of Temperance (see below, note 42). The parrot was an attribute of Mercury, the God of Eloquence. Cf. TERVARENT, op. cit., s.v. "Perroquet", cols. 303–4.

[25] This is not to say that the books should be taken at face value only, since they also have a status symbol function. Antonio Maria ADORISIO has remarked in a paper entitled "Aspetti tipologici di legature feltresche", read at the 1982 conference on Federico: "Il libro chiuso, il libro oggetto, il libro che si nota perché riccamente coperto, ovvero in ultima analisi la rappresentazione del libro, esprimono la cultura del Signore ed il messaggio di potere a quella affidato. [...] Il libro scolpito, dipinto o intarsiato, raffigurato attraverso l'immagine della sua legatura, continua a ricordare, come i trofei d'armi le vittorie militari, quelle altre vittorie d'umanità che si ottengono attraverso il possesso della sapienza degnamente custodita nei preziosi involucri dei codici."

It is worth noting that Alberti considered books the main ornament of libraries. See the *De re aedificatoria*, Book VIII, Ch. IX (the relevant excerpt is quoted below, p. 77).

[26] The absence of Logic from the proposed scheme need not disquiet us. In a far more conventional *Artes* cycle, the already-

Astronomy, it should be remarked that they are located in two adjacent compartments. This is an important clue, for, clearly, it is appropriate that the Arts of the *Quadrivium* should be arranged together. Such an iconographically satisfactory arrangement is made possible by the nature of the objects in question: the close association of musical and scientific instruments is quite plausible from a naturalistic standpoint.

The motifs identifiable as symbols of two of the *Trivium* subjects are far apart; but then such diverse items as the armed vessel (Grammar) and the parrots and clock group (Rhetoric) are much less compatible in reality.

As the table shows, a few traditional attributes of the Liberal Arts are identifiable in the Gubbio *studiolo* too. Some of them are closely associated with motifs having similar connotations, which fulfil a supportive function: the dividers of Geometry share cupboard (IV) with a square (among other items); directly beneath the sphere of Astronomy in (X) is a quadrant; cupboard (XIII), before which is the organ of Music, encloses a lute, two flutes and a fiddle. As for Grammar, it is tempting to treat the painted armed vessel in (V) as its attribute. Its shape does not correspond to either version of the vessel that appears on the two sides of the *Tarocchi* Grammar, but it is interesting that Remington, who no doubt examined the detail at close range, should refer to it as "albarello", i.e. chemist's jar[27]. Rhetoric could, here too, be symbolized by the parrot, though this is not coupled with a clock – a motif missing altogether from the decorations. The tablet of Arithmetic is also missing. Both motifs could of course have been depicted on the inlaid panel that probably hid the window.

The cupboards enclosing the symbols of Geometry, Music and Astronomy are not grouped together as in Urbino. The scattered arrangement of the motifs seems to suggest that the author (or authors) of the designs relied on the Urbino programme but was incapable of translating it figuratively, and adapting it to the structure of the room, as thoughtfully as his predecessor(s) in Urbino[28] – possibly because he could not avail himself of the cooperation of the humanist responsible for it. The Gubbio study is a less subtle version of its prototype.

The representation of the *Artes* by means of attributes and other symbols only is an idea of great originality and poetical efficacity. No comparable contemporary works are known. The closest equivalents are the friezes of religious items, and tools associated with the various mechanical arts and crafts, inlaid in choir stalls and sacristy cupboards of many northern and central Italian churches. But the seemingly random arrangement of the motifs, and the mostly obvious nature of their symbolism, give these works a rather prosaic character[29].

A figurative conception nearer to that of Urbino and Gubbio but executed at the beginning of the

named *Door of the Liberal Arts*, another *Trivium* subject, Rhetoric, has been sacrificed. The exclusion must have been motivated in this case by reasons of symmetry: the shutters of the door could not have been divided into seven equal parts to accommodate the series of the Arts. One must assume that it is the *Trivium* rather than the *Quadrivium* which has lost a subject, because of the special esteem in which the latter was held in Urbino.

[27] "The Private Study" cit., p. 6. REMINGTON was Curator of the Renaissance and Modern Art Department of the Metropolitan Museum, at the time. For the unusual term "albarello", see R. W. BURCHFIELD ed., *A Supplement to the Oxford English Dictionary*, Oxford, 1972, I, p. 55.

[28] This is a general problem in Gubbio. On the whole here the sections do not interrelate with the strict logic that can be traced in Urbino. For instance, little unites (I), (II) and (III) (the largest and best lit, thus the most important wall in the room), and the facing cupboards (VII) and (IX). Individually, however, most cupboards are thematically coherent, as will be made clear later.

[29] There are no systematic iconographic studies of choir stalls and sacristy cupboards, but it is usually believed that they would yield limited results. See C. DEL BRAVO "La dolcezza dell' immaginazione", *Annali della Scuola Normale Superiore di Pisa. Classe Lettere e Filosofia*, VII, 1977, p. 780; and, with reference to the inlays of the Lendinaras, which we may consider typical, STERLING, op. cit., p. 52, and B. CIATI, "Cultura e società nel secondo Quattrocento attraverso l'opera ad intarsio di Lorenzo e Cristoforo da Lendinara", in DALAI EMILIANI ed., *La prospettiva* cit., I, pp. 210, 214. Ciati contrasts the ecclesiastical inlays with those in Urbino, which she intuitively sees as having "rimandi concettuali e

16th century may be found in the Casa Marta Pellizzari, in Castelfranco Veneto. The main hall of the building, which housed an academy, is decorated with friezes ascribed to Giorgione, consisting of the symbols of the Liberal and Mechanical Arts, interspersed with Latin mottos and portraits of philosophers. Interestingly, a detailed study of these decorations has led Adriano Mariuz to compare them precisely with the Urbino inlays, and note in passing that in both works the Arts are represented exclusively through the attributes of the personifications. In spite of the limitations of its purely intuitive basis, this remark provides additional evidence in support of the claim that the Arts are present in the intarsias[30].

The third enclosure of each of the "regular" walls of the Urbino study is occupied by a Theological Virtue. It is reasonable to suppose that decorations may embody the Cardinal Virtues as well; not simply because the presence of the first usually implies that of the others, but because the Cardinal Virtues are the political ones that rulers traditionally liked to be associated with[31].

Eulogistic literature centred on Federico especially stresses the Cardinal Virtues – though these do not necessarily appear all together, and are sometimes complemented by subsidiary ones. There are many references to them throughout Vespasiano's biography of the Duke. To quote one:

> Venendo alla disciplina militare, che è la prima sua professione, egli è stato istrenuo capitano, quanto ignuno che n'abbia avuto la sua età, et in questo ha adoperata la forza, coniuncta con una grandissima prudentia, et non meno ha vinto col senno che s'abbi fatto colla forza[32].

Castiglione for his part asserts:

> [Il] duca Federico [...] a' dì suoi fu lume della Italia; né mancano veri ed amplissimi testimonii, che ancor vivono, della sua prudentia, della umanità, della giustizia, della liberalità, dell'animo invitto e della disciplina militare[33].

It should also be noted that the wing devoted to Federico of Piero's Uffizi diptych (the side with the Triumph) depicts him with the four Cardinal Virtues[34].

The personified Virtues, all seven of them, are to be found on the inlaid door that leads to the grand staircase landing on the piano nobile of the Urbino Palace. The same are also among the allegorical figures that precede Federico's appearance in the "Preambolo" of Santi's *Cronaca*:

simbolici ben precisi" (p. 210). But for a few iconographic observations on ecclesiastical intarsias, cf. FERRETTI, op. cit., pp. 576–85.

[30] Mariuz's excerpt is worth quoting: "... gli oggetti del fregio [di casa Marta Pellizzari] alludono alle arti liberali e meccaniche (poste, queste ultime, sullo stesso piano delle prime): tema questo che fin dal Trecento ha goduto di una notevole fortuna. Generalmente le Arti, come anche le Virtù, venivano raffigurate in forma di personaggi ideali ciascuno con i suoi attributi specifici, secondo il principio di una 'antropomorfizzazione' dei concetti in cui si perpetuava una tradizione classica. Nel fregio invece (come anche vediamo nello studiolo di Urbino, la cui decorazione era per altro completata da ventotto ritratti di uomini illustri) si fa riferimento alle Arti esclusivamente mediante gli strumenti con cui si esplicano: gli attributi, per così dire, diventano sostantivi svincolandosi per ciò stesso da ogni convenzionale, precostituito sistema di rappresentazione." Cf. "Appunti per una lettura del fregio Giorgionesco di Casa Marta Pellizzari", in *Liceo-Ginnasio Giorgione – Castelfranco Veneto*, 1966, p. 68. On the Castelfranco frieze, see also P. H. HEFTING, "Het Enigma van de Casa Pellizzari", *Nederlands Kunsthistoricsh Jaarboek*, XV, 1964, pp. 67–92, who believes the hall served as a study.

The Urbino frieze anticipates another: that of the *Scala dei Giganti*, in the courtyard of the Ducal Palace of Venice, due to Antonio Rizzo. Many of the motifs here illustrated are esoteric, following the fashion set by Francesco Colonna's *Hypnerotomachia Poliphili*. The frieze includes symbols of arts and crafts, mottos and portraits of illustrious men. Cf. M. MURARO, "La Scala senza Giganti", in M. MEISS ed., *De Artibus Opuscola XL. Essays in Honor of Erwin Panofsky*, New York, 1961, I, pp. 350–70; II, pp. 114–21 (also, in French, in D. ARASSE [presented by], *Symboles de la Renaissance*, Paris, II, 1982, pp. 21–38.)

[31] RUBINSTEIN, op. cit., p. 180.

[32] *Le vite* cit., I, p. 356.

[33] *Il libro del Cortegiano*, cit., Book I, Ch. II, p. 84.

[34] The corresponding part of the diptych devoted to Battista Sforza represents her with the Theological Virtues.

Et qual ha verde et qual ardente gonna,
Qual candida, et qual tien la spada in mano,
Qual spechio et qual dui vasi e qual colonna[35].

In the study itself, an important clue that the Cardinal Virtues may be present is provided by the inscription on the *cartellino* in (b): ·VIRTVTIBVS·ITVR·AD·ASTRA·. Scholars have paid little attention to it, granting it at most a passing reference[36]. The motto seems to declare that "Through the [Theological] Virtues one goes to Heaven". Yet, the obvious nature of such an assertion, which the *cartellino* so exalts, suggests that it may be more meaningful than it looks. The example of the Gubbio study, where, in (IX), the open volume on the lectern displays an excerpt from the *Aeneid* (Book X, ll. 457–91), part of which praises military valour[37], has led me to identify the source of the motto in a line of the same poem:

43

84

Aetheria tum forte plaga crinitus Apollo
desuper Ausonias acies urbemque videbat,
nube sedens, atque his victorem adfatur Iulum :
'macte nova *virtute*, puer : sic *itur ad astra*,
dis genite et geniture deos. iure omnia bella
gente sub Assaraci fato ventura resident;
nec te Troia capit'[38].

(Book IX, ll. 638–44)

In this extract, Apollo congratulates Iulus, Aeneas's son (usually known as Ascanius) for his bravery, recalling that it is precisely through heroic actions that the heights of fame can be reached, and predicts that the future Caesars (*geniture deos*) will descend from him. Given the context from which the *studiolo* inscription has been drawn, it is reasonable to assume that the virtues it refers to are essentially of a military nature. Appropriately, beneath the *cartellino* hangs a dagger, and next to it a cloth with the Order of the Garter. The military meaning of VIRTVTIBVS need not exclude the moral one: the Garter, with its motto HONI SOIT QUI MAL Y PENSE, is, after all, also a symbol of all-defying Virtue. The indirect reference to Aeneas's son may be taken as a celebration of Guidobaldo, and thus of the dynastic continuity of the Montefeltro. The "quotation" also implies that such a line has God's approval, since it is a divinity (Apollo) who blesses Ascanius[39].

43, 44

[35] *Cronaca* cit., Ch. V, 38, p. 10. Green ("verde"), red ("ardente") and white ("candida") are the colours of Hope, Charity and Faith respectively. Cf. RIPA, op. cit., s.v. "Speranza", p. 669; "Carità", p. 63; "Fede", p. 149. "spada", "spechio", "dui vasi" and "colonna" are the attributes of Justice, Prudence, Temperance and Fortitude respectively (see below).

[36] ROTONDI, *Il Palazzo Ducale* cit., I, p. 338; CHASTEL, *Art et humanisme* cit., p. 365; LIEBENWEIN, op. cit., p. 90.

[37] The full passage deals with Pallas's last combat. Before killing him with a spear, Turnius seeks the moral support of Alcides (Ulysses), who answers his call with the following initial words (ll. 467–9):

'stat sua cuique dies; breve et inreparabile tempus
omnibus est vitae; sed famam extendere factis,
Hoc virtutis opus.'

['Each has his day appointed; short and irretrievable is the span of life to all: but to lengthen fame by deeds – that is valour's task.']

(*Aeneid VII–XII; The Minor Poems*, Cambridge, Mass., 1966 [Loeb Classical Library], p. 202, for the Latin text and p. 203 for the English transl.). F. C. BROOKE (quoted by DENNISTOUN, op. cit., I, p. 173 note 1) is probably right in believing that the long quotation of the *studiolo* was motivated only by these lines.

[38] [Then it chanced that in the realm of sky long-haired Apollo, cloud-enthroned, was looking down on the Ausonian lines and town, and thus he addresses triumphant Iülus: 'A blessing, child, on thy young *valour*! So *man scales the stars*, O son of gods and sire of gods to be! Rightly shall all wars, that fate may bring, sink beneath the house of Assaracus to rest; nor can Troy contain thee!']

(*Aeneid VII–XII* cit., pp. 156 and 157; my italics).

[39] It is worth noting that in 1464 Pius II had granted Federico the right to hand down the title of Vicar-Apostolic (received

Encouraged by the cryptic reference to military valour on the *cartellino*, we may proceed to seek the Cardinal Virtues. First of all, we shall attempt to identify the more established symbols of these personifications. To this end, reference will be made to three figurative cycles: Piero's diptych, the already-mentioned *Door of the Virtues*, and the appropriate *Tarocchi*[40]. (See the scheme on the page facing.) As we have seen, Faith, Hope and Charity are represented in Urbino as straightforward personifications. The sword and the mace are probably meant to represent Justice and Fortitude respectively, for they are their well-established attributes[41]. It is worth repeating that the very presence of the mace in a *studiolo*, and its location beneath the niche of Faith are indications that it should be taken at more than its face value. Temperance may be symbolized by the clock – a motif suggestive of a well-regulated life[42]. As for Prudence, it is probably represented by the squirrel, on account of the animal's well-known provision-making habits[43]. In fact, Liebenwein, considering the latter motif in the context of the entire inlaid decorations of the east side, offers an all-encompassing interpretation: the prudent ruler (squirrel), enriched by the experience and humanity derived from his active/contemplative pursuits (symmetrical niches), provides for the well-being (basket of fruit) of his state (landscape)[44]. It is a plausible interpretation. The prominence given to Prudence in the *studiolo* would be in keeping with the emphasis placed on this Virtue by Renaissance moral treatises, which tended to associate it with *vita activa*[45]. In Vespasiano's biography of Federico, the terms "prudentia" and "prudente" recur quite frequently, especially in connection with the Prince's political activities[46]. The fruit motif may refer more specifically to *amor proximi* (the earthly

in 1447 by Nicholas V) to his legitimate sons and grandsons; this in effect sanctioned the establishment of his dynasty. I should also add in support of my interpretation of the motto on the *cartellino* that the Urbino portrait of Federico and Guidobaldo contains an explicit reference to the papal endorsement of the right of succession: the word PO[N]TIFEX engraved on the heir's sceptre. (My attention was drawn to this detail by ROSEMBERG's paper.) For a clear illustration of the detail, cf. LAVALLEYE, *Le Palais Ducal* cit., Pl. CCII.

[40] HIND, op. cit., IV, Pls. 353–9.

[41] It should be noted that the sword in the Urbino double portrait too has been interpreted as a symbol of justice. See ROSEMBERG, op. cit.

[42] TERVARENT, op. cit., s.v. "Horloge", I, col. 220. Cf. also L. WHITE jr., "The Iconography of 'Temperantia' and the Virtuousness of Technology", in T. K. RABB and J. E. SIEGEL eds., *Action and Conviction in Early Modern Europe*, Princeton, N.J., 1969, pp. 197–219. As one can see from the table on the next page, Temperance is traditionally symbolized by two vessels, which refer to the watering down of wine. The possibility that the vessels in (o) may have been depicted in order to represent this virtue must be excluded: the large vessel on the top shelf has already been interpreted as a probable symbol of Grammar; that next to it is hardly suited to contain water or wine. As for the vessel on the lower shelf, this seems to have been intended essentially to hold the book upright.

[43] The squirrel is featured with the meaning of wisdom and prudence in the emblem of the Ugolini family of Castrocaro (Forlì), who are documented since the 13th century. Cf. G. GUELFI, *Vocabolario araldico ad uso degli Italiani*, Milano, 1897, s.v. "Scoiattolo", p. 235. Today the squirrel is used with similar meanings by insurance groups, banks, etc., in their publicity. It appears for instance in the logos of the British insurance company NPI (*National Provident Institution*) and of the French savings bank *Caisse d'Epargne*.
CALVESI, op. cit., p. 13, suggests that the squirrel eating a nut may be a symbol of transience, since this motif appears in some Roman sarcophagi with the likely meaning of time eroding human existence. I find his interpretation unconvincing, since it conflicts with the earthly rather than metaphysical character of the other motifs on the east wall (see the text, immediately below).

[44] *Studiolo* cit., pp. 211–2 note 334.

[45] R. DE MATTEI, "Sapienza e prudenza nel pensiero politico italiano dall'Umanesimo al secolo XVII" and F. SCHALK, "Il tema della 'vita activa' e della 'vita contemplativa' nell' Umanesimo italiano", in E. CASTELLI ed., *Umanesimo e scienza politica*, Milan, 1951, pp. 129–37 and 564–5 respectively; E. F. RICE Jr., *The Renaissance Idea of Wisdom*, Cambridge, Mass., 1958, Ch. II. A leading source was the *Nicomachean Ethics* (VI, v ff.), a work well known to Federico, as we have seen.

[46] *Le vite* cit., I, pp. 356 (mentioned three times), 357, 360 (twice), 361 (twice) 363, 367, 368, etc.

VIRTUES		TAROCCHI	URBINO DOOR	PIERO'S DIPTYCH	URBINO STUDY	GUBBIO STUDY
THEO-LOGICAL VIRTUES	FAITH	cross, chalice, dog	cross, chalice	cross, chalice	cross, chalice (l)	—
	HOPE	joined hands, burning phoenix	joined hands, crown	(not visible)	joined hands, crown (c)	—
	CHARITY	pelican, flaming heart, bag of fruit	flame, child	pelican	flame, child (p)	—
CARDINAL VIRTUES	TEMPERANCE	two vessels, dog(?) looking at mirror	two vessels	(not visible)	—	—
	JUSTICE	sword, scales, crane	sword	sword, scales	sword (a)	sword (VI)
	PRUDENCE	two-faced figure, mirror, dragon-snake, compasses	mirror, snake	two-faced figure, mirror	—	mirror (IX)
	FORTITUDE	broken column, mace, armour, lion	mace	broken column	mace (l)	mace (VI)

aspect of Charity; the other being *amor Dei*). It appears as its attribute in a number of representations of *Caritas*: in the Arena Chapel frescoes and in the *Tarocchi* for instance[47]. It is worth noting

[47] On this virtue and its iconography, cf. E. WIND, "Charity – The Case History of a Pattern", *Journal of the Warburg and Courtauld Institutes*, I, 1937–38, pp. 322–30; R. FREYHAN, "The Evolution of the Caritas Figure in the Thirteenth and Fourteenth Centuries", *Journal of the Warburg and Courtauld Institutes*, XI, 1948, pp. 68–86.
The Urbino fruit motif finds a parallel in Cranach's panel of Cardinal Albrecht in his study (1525). Here is depicted, placed on an isolated stool and foregrounded, a plate full of a variety of fruits. The obviously symbolic intention behind the picture as a whole (Albrecht is portrayed as St. Jerome, hence the lion), and the additional presence of the dog, a probable allusion

104

that the Urbino basket includes, just like the bowl of earthly goods that Giotto's personification holds, some pomegranates. The detail is significant, for this fruit which, when ripe, opens itself to offer its sweet seeds, is, alone, in turn, a probable symbol of Charity[48]. That the basket of fruit may stand for Charity (or the human part of it) is also suggested by the presence of this Virtue in personified form on the opposite wall; interestingly, this figure is depicted on the door that leads to the loggia overlooking the landscape. The singling out of *amor proximi* is justified by the context: only the human/social part of Charity is of relevance to the political metaphor the devisor of the scheme seems to have wanted to express on the east wall[49].

The basket of fruit lends itself to additional, related meanings that can only enrich the above image. If we treat the motif as the naturalistic adaptation of the cornucopia, we may interpret it as a symbol of Plentiness, Liberality, Public Happiness, Peace, Concord and Good Fortune[50]. The pomegranates alone, in turn, may stand for Concord[51].

To seek support for the claim that the Cardinal Virtues may be present in the Urbino inlays, we will turn again to the Gubbio study. Justice may be symbolized by the sword, Fortitude by the mace, and Prudence by the mirror (the idea being that the prudent man sees himself as he really is). The latter item is appropriately placed near the *Aeneid* with the lines referring to military virtues. Temperance has no suitable symbol.

The mirror, being a well-established attribute of Prudence, is a less poetical symbol than the Urbino squirrel. The inscription engraved round its edge, however, makes it more interesting. As will be shown later, in the Urbino inlays words are never indiscriminately applied to images: the thoughtful union of the two elements gives rise to playful conceits. This happens with the Gubbio detail in question: the name of Federico's son, most unusually abbreviated as ·G· BA LDO DX[52]

to Faith (cf. FRIEDMANN, op. cit., p. 208; P. REUTERSWÄRD, "The Dog in the Humanist's Study", *Konthistorisk Tidskrift*, L, 1981, pp. 53–69), suggest that the plate of fruit may be a disguised symbol of *Caritas proximi*.

[48] LEVI D'ANCONA, op. cit., s.v. "Pomegranate", p. 317, No. 10. In Padua and in Urbino respectively, one and two splitting pomegranates are emphatically turned towards the onlooker. The *Door of the Virtues* supports my interpretation, for the panels with the personifications and Hercules are framed by stylized branches with open pomegranates. The other side of the door too, depicting the *Triumphs*, another moral/allegorical theme, is similarly decorated. (To my knowledge, the pomegranate motif does not appear on any of the other doors of the Palace.) For the use of decorative motifs with symbolic functions, cf. E. H. GOMBRICH, *The Sense of Order*, Oxford, 1979, pp. 217–50.

[49] Federico's Charity towards his subjects is another quality contemporary celebratory literature stresses considerably. See W. TOMMASOLI, "Spirito umanistico e coscienza religiosa in Federico da Montefeltro", paper read at the 1982 conference on Federico.

[50] TERVARENT, op. cit., s.v. "Corne d'abondance", I–V, cols. 116–8. The concepts the basket of fruit evoke are closely linked. On the relation between Charity and Concord, cf. RIPA, op. cit., s.v. "Carità" (p. 63):

Senza carità un seguace di Christo è come un armonia dissonante d'un Cimbalo discorde, e una sproportione (come dice S. Paolo), però la carità si dice esser cara unità, perché con Dio, e con gl' huomini ci unisce in amore, e in affettione, che accrescendo poi i meriti, col tempo ci fa degni del Paradiso.

For the links between Plentiness and Charity, see D. G. WILKINS, "Donatello's Lost 'Dovizia' for the Mercato Vecchio: Wealth and Charity as Florentine Civic Virtues", *Art Bulletin*, LXV, 1983, pp. 401–23, esp. 416–22.

A good example of a basket of fruit used as an attribute of Plentiness is to be found in the *Città ideale* (1490's(?)) of the Walters Art Gallery of Baltimore. The motif is held, together with a cornucopia, by one of the four allegorical figures that top the columns in the square. On this panel see F. ZERI, *Italian Paintings in the Walters Art Gallery*, Baltimore, Md., 1976, I, pp. 143–51 (Pl. 72). In the very Palace, the fruit motif seems to have been depicted with the same meaning on the lintel of the so-called *Porta della Guerra*, which faces the grand staircase on the piano nobile. Wolfram PRINZ has in fact argued that it is "un' allusione all' abbondanza, frutto del buon governo del Duca". Cf. "Simboli e immagini di pace e di guerra nei portali del Rinascimento: la Porta della Guerra nel Palazzo di Federico da Montefeltro", paper presented at the 1982 conference on Federico.

[51] See RIPA, op. cit., s.v. "Concordia" (p. 81) and "Concordia degl' Antichi" (p. 82).

[52] As far as I know, Guidobaldo was never shortened as "G. Baldo", nor "Baldo". Vespasiano refers to him each time as "Guido" (*Vite* cit., I, pp. 355, 402, 412, 413; II, p. 447). See also Ariosto: "Quivi non era Federico allora,/ né l'Issabetta, né 'l

on a motif frequently used to represent Prudence, seems to have been meant to express the oxymoron *Baldo/Prudente*[53]. This would explain the engraving of the name on as awkward a place as the circular border of the mirror.

The Theological Virtues are not present in personified form in the Gubbio study. A search for disguised symbols proves unproductive because of the unsatisfactory nature of most of the traditional attributes of these Virtues: the overtly liturgical cross and chalice of Faith could not have a place among the paraphernalia of a secular room; the praying hands of Hope do not lend themselves to objectization, nor do the flame and suckling child of Charity. These reasons probably explain why in Urbino the Virtues in question have been depicted in personified form. It is tempting to conclude that the Theological Virtues have not been included in the Gubbio decorations. Had they been wanted, they could have been represented as in Urbino. Perhaps the designer feared that the three niches would have encumbered the airy and ordered arrangement he had in mind: the Gubbio study is considerably less crowded and untidy than its Urbino counterpart. It should also be recalled that chroniclers, biographers and panegyrists tended to associate their heroes especially with the Cardinal Virtues, rather than the others – possibly because the Theological ones were so essential that they could be taken for granted.

The blatant display of a range of musical instruments appears like an invitation to regard them as symbols. These motifs one cannot help associating with the Muses. We shall see how far they correspond to the attributes of the personifications in question as they appear in the *Tarocchi*[54], Lazzarelli's *De imaginibus Deorum*[55], and the extant panels that once decorated the *Tempietto delle Muse*[56].

As the table overleaf shows, the system of correspondences is not complete. The musical motifs from the Urbino study that may be treated as symbols are: for Urania the sphere (and the astrolabe, in the same compartment); for Euterpe the flutes; for Terpsichore the lira da braccio (which belongs to the viol family)[57]; for Erato the tambourine; and for Polyhymnia the organ.

VIII

45, 56

41, 54

In the Gubbio study, the following motifs may have been intended as attributes: for Urania the sphere (and the quadrant, in the same compartment); for Euterpe the flutes; for Thalia the rebec (a small instrument of the viol family)[58]; for Melpomene the horn; for Terpsichore the cittern (guitar family)[59]; for Erato the tambourine; and for Polyhymnia the organ.

83, 85

79, 81

78, 85

buon Guido v'era,/ né Francesco Maria, né Leonora" (*Orlando Furioso*, XLIII, 148). Castiglione calls him "Guid' Ubaldo" and "Guido" (*Il Cortegiano* cit., pp. 69, 85, and 70 respectively). In a medal coined circa 1482, the name appears as GVIDVB. DVX. VRB. (cf. G. F. HILL, *A Corpus of Italian Medals of the Renaissance Before Cellini*, London, 1930, vols. I and II, No. 308). Clearly, it is especially appropriate to compare the medal with the mirror because the problems of fitting an inscription concisely and circularly are identical.

[53] For the Renaissance belief in the *coincidentia oppositorum*, see R. L. COLIE, *Paradoxia Epidemica. The Renaissance Tradition of Paradox*, Princeton, N.J., 1966; E. WIND, *Pagan Mysteries of the Renaissance*, London, 1968 (2nd ed.), pp. 85–112; and M. T. JONES-DAVIES ed., *Le paradoxe au temps de la Renaissance*, Paris, 1982.

My interpretation of the mirror and its inscription is supported by the celebrated Shakespearean line: "The better part of valour is discretion" (*Henry IV – Part One*, V, iv, 120). And since the conceits of the past often re-emerge, rooted as they are in the depths of our collective unconscious (CURTIUS, op. cit., pp. 104–5), it may not be inappropriate to back the interpretation further by referring to an advertisement which appeared in Italian periodicals in spring 1979: it depicted a lion wearing a motorcyclist's crash helmet Nava (this being the advertised product), and carried the slogan: ANCHE I PIÙ CORAGGIOSI SONO PRUDENTI.

[54] HIND, op. cit., IV, Pls. 330–8.

[55] ROTONDI, *Il Palazzo Ducale* cit., II, Fig. 388.

[56] Ibid., II, Figs. 391–8. These panels are now in the Galleria Corsini of Florence.

[57] For this identification, cf. WINTERNITZ, op. cit., London, 1967, Pl. 52a. For the family it belongs to, ibid., p. 87.

[58] For its identification, cf. ibid., Pl. 53c. The rebec is an early viol; cf. E. BLOM ed., *Grove's Dictionary of Music and Musicians*, London, 1966, VII, p. 69.

[59] For its identification, cf. WINTERNITZ, op. cit., Pl. 53a. For its belonging to the guitar family, cf. *Grove's Dictionary* cit., II, p. 312.

MUSES	TAROCCHI	DE IMAGINIBUS DEORUM	TEMPIETTO PANELS	URBINO STUDY	GUBBIO STUDY
URANIA (Astronomy)	compasses, sphere	compasses, sphere	(not extant)	sphere (k)	sphere (X)
EUTERPE (Lyric Poetry)	(double) flute	(double) flute	(not extant)	flutes (b)	flutes (XIII)
CLIO (History)	swan	swan	(no attribute)	–	–
THALIA (Comedy and Pastoral Poetry)	small viol	(not represented)	long horn	–	rebec (I)
MELPOMENE (Tragedy)	horn	horn	horn	–	horn (I)
TERPSICHORE (Dancing and Song)	guitar	guitar	viol	lira da braccio (k)	cittern (IV)
ERATO (Lyric and Love Poetry)	tambourine	tambourine	tambourine	tambourine (a/b)	tambourine (III)
POLYHYMNIA (Sacred Song)	organ	organ	organ	organ (j)	organ (XIII)
CALLIOPE (Epic Poetry)	trumpet	trumpet	trumpet	–	–

Thalia's and Melpomene's traditional instruments are not present in Urbino. Calliope's trumpet is missing from both *studioli*, and so (understandably) is Clio's swan. These absences should not necessarily lead us to conclude that the musical instruments have been randomly chosen and scattered. A clue that militates against such a conclusion is the prominent display in both studies of the tambourine. This unsophisticated instrument, unlike flutes, viols, lutes and organs, is not an obvious one to depict to express someone's fondness of music. It is tempting to suggest that it was included mostly for symbolic purposes.

This impression is corroborated by the fact that in Gubbio the tambourine, the attribute of Erato, Muse of Lyric and Love Poetry, shares a cupboard with another well-known symbol of the latter discipline, the harp[60], and with a music book which once had inscribed a song based on a love poem by Leonardo Giustinian:

[60] This instrument sometimes accompanies Apollo, the God of poetry (cf. R. RENSCH, *The Harp*, New York, 1969, p. 53; WIND, *Pagan Mysteries* cit., Fig. 95; E. BATTISTI, "Non chiare acque", in SCAGLIONE ed. *Francis Petrarch* cit., p. 338), and Orpheus (BATTISTI, op. cit., p. 339). It also features in pictures of lovers (RENSCH, op. cit., pp. 53–4, Pl.

O rosa bella, o dolce anima mia,
Non mi lassar morire, in cortesia.
Ay lasso me dolente, dezo finire
Per ben servire e lealmente amare?

O dio d'amor, che pena è questa, amare
Ve' ch'io mor' tutt'ora per questa iudea.
Soccorrimi oramai del mio languire,
Cor del cor mio, non mi lassar penare[61].

Another clue is provided by the presence of the horn in the Gubbio study. Remington[62] and 79
Winternitz[63]call it a "hunting horn". Now Federico, like most of his contemporaries, is quite
likely to have indulged in such a sport; however, a reference to it in a *studiolo* would have been
inappropriate. The horn may thus have been included to represent the Muse of Tragedy. In
Urbino, the book inscription [SE]NACA, in (e), could replace the horn as a symbol for Mel- 47
pomene, for the philosopher was also a highly influential tragic playwright[64]. Thalia (Comedy and
Pastoral Poetry) may be represented in Urbino through the Ovidian quotation which, as will be
argued later, the Cupid-with-lantern motif on the lectern in (i) seems to embody[65]. The absence of 52, 51
Calliope's traditional heroic attribute, the trumpet, may be justified in the light of Vespasiano's
claim that the Prince cared little for this instrument:

> [Federico] diletavasi più d'instrumenti sotili che de' grossi, trombe et instrumenti grossi non se ne
> dilettava molto, ma organi et istrumenti sotili gli piacevano assai[66].

This Muse may have been symbolized instead, in Urbino, by the books marked O[M]E[RO] and 47
[VIR]GILIO and by the Virgilian near-quotation on the *cartellino*, and in Gubbio, by the open 43
volume on the lectern, displaying the verses from Book X of the *Aeneid*[67]. No adequate substitute 84
can be found for Thalia's swan. This Muse is most probably missing.

In conclusion, it will be stressed that the absence of some well-established attributes, and the
excessive number and variety of instruments depicted, prevent one from claiming with any reason-
able certainty that the theme of the Muses is present in the *studioli*. It is however worth recalling
that the goddesses of creative inspiration, whom Cicero considered as especially suitable for lib-

16a). See also the entry "Arpa", in S. BATTAGLIA, *Grande dizionario della lingua italiana*, Turin, 1961, I, p. 676, where
the instrument is said to figuratively represent poetry.

[61] REMINGTON, op. cit., pp. 7–8. For a full study of this composition, see N. PIRROTTA, "Ricercare e variazioni su
'O rosa bella'", in idem, *Musica tra Medioevo e Rinascimento*, Turin, 1984, pp. 194–212.

[62] "The Private Study", cit. p. 6.

[63] *Musical Instruments* cit., p. 121.

[64] In the decorations of the library of the Badia of Fiesole which, as Alberto Avogadro informs us in a rhymed description,
depicted the Muses accompanied by their historical representatives, Melpomene was associated with Seneca. Cf. E. H.
GOMBRICH, "Alberto Avogadro's Descriptions of the Badia of Fiesole and of the Villa of Careggi", *Italia medioevale e
umanistica*, V, 1962, pp. 219, 225 (Fol. 38 r, 15–6).

[65] Ovid accompanied Thalia in the library decorations of the Badia, according to Avogadro. Cf. ibid., pp. 219, 225 (Fol.
38 r, 13–14).

[66] *Le vite* cit., I, p. 384. Wind instruments came to be regarded as vulgar in the Renaissance because they distorted facial
features. Humanists often referred to the myth of Minerva who threw her *aulos* away because it puffed the player's cheeks.
Cf. W. H. KEMP, "Some notes on Music in 'Il libro del Cortegiano'", in C. H. CLOUGH ed., *Cultural Aspects of the
Italian Renaissance – Essays in Honour of Paul Oskar Kristeller*, Manchester, 1976, p. 359 and pp. 367–8 note 53. Perhaps
Melpomene's horn has been excluded form the Urbino study for the same reason.

[67] In Avogadro's poem, Calliope is described as dancing with Virgil. Cf. GOMBRICH, "Alberto Avogadro's Descrip-
tions" cit., pp. 219, 225 (Fol. 38 r, 11–2). The association of Homer and Virgil with Calliope was to be codified by Ripa. He
describes the Muse thus (*Iconologia* cit., p. 349):

> Giovane ancor' ella, e haverà cinta la fronte di un cerchio d'oro, nel braccio sinistro terrà molte ghirlande di lauro, e con la
> destra mano tre libri, in ciascun de' quali apparirà il proprio titolo, cioè in un Odissea, nell' altro Ilias, e nel terzo Eneide.

60 raries[68], are referred to in Federico's Urbino study in one of the songs ("Bella gerit, musasque colit ..."), and that their portraits are known to have decorated Leonello's Belfiore study in Ferrara, and Guidobaldo's in Urbino. Moreover, in the "Preambulo" of Santi's *Cronaca*, they precede (along with the Virtues and other allegorical figures) Federico's appearance[69].

V, 58, 65 The fife and drum we find relegated at one end (t) of the Urbino west wall are clearly meant not to be confused with the other instruments. They are military band instruments[70], obliquely pointing out Federico's exploits as an army leader. The Order of the Ermine hanging from one of the drawers, and the Garter in the middle register contribute to give the whole section military overto-

V, 42 nes. The ducal sword is appropriately depicted nearby, in the adjoining section (a).

81 In Gubbio, fife and drum are less clearly cut off from the other musical instruments. However, the cupboard that encloses them (V) is adjacent to that which contains parts of a suit of armour and the

80, 82 mace (VI).

 A number of other motifs in the inlays lend themselves to symbolic interpretations. The bundle of

44 rods in (b) is another likely allusion to Concord[71]. The arrangement of the dagger and of the *cartellino*

43 with its hidden reference to valour directly above the rods suggests that the latter specifically refers to military concord[72]. Two fasces are prominently displayed in Gubbio too, in (x). Both are appropri-

83 ately depicted by the twice-repeated ducal arms boasting the eagle of authority.

47, 81 An hourglass and a candle share one compartment in Urbino and in Gubbio ((d) and (IV) respec-

 tively). Both items are perhaps meant as symbols of transience – i.e. vanities[73].

41, 53, 58 The wheel-like motifs incorporated in the framework of the seat-stands are a possible reference to

[68] *Ad familiares*, VII, 23. For a concise account of the significance of the Muses since antiquity, cf. EÖRSI, op. cit., pp. 30–4.

[69] *Cronaca* cit., Ch. V, 35, p. 10.

[70] J. BLADES, *Percussion Instruments and their History*, London, 1970, pp. 209–10. The same combination of instruments is represented on the jambs of the already mentioned *Porta della Guerra*. Cf. ROTONDI, *The Ducal Palace* cit., Figs. 110, 113, 115.

[71] HALL, op. cit., s.v. "Fasces", p. 119. Hall's bundle of rods inlcudes an axe; the latter, however, was not an indispensable part of the attribute. One of Ripa's personifications of "Concordia" simply holds "un fascio di verghe strettamente legato" (*Iconologia* cit., p. 81). It should be noted that the designer has attempted to camouflage the bundle of rods (a

44 symbolic item with no literal meaning) by placing it, half hidden, near a similar motif with a purely practical function: a bunch of wax candle-lighters (*cerini*).

41, 46 [72] In the adjacent compartment (c), we find Hope joining her hands. The proximity of this figure to the fasces may not be accidental, for her gesture is one of the attributes of Ripa's "Concordia Militare" (op. cit., p. 80):

> Donna che tenghi con la destra mano un rostro di nave, sopra del quale vi è un' insegna militare, e in mezo d'essa, cioè in mezo dell'asta, vi sono due mani giunte, come quando si dà la fede, con lettere che dicono:
> CONCORDIA EXERCITVVM
> Le due mani nella guisa che dicemmo dimostrano la Concordia, l'insegna e il rostro gl'Eserciti.

Ripa relies on a coin of Emperor Nerva, as he himself notes (ibid.); this source may have been known in Federico's time.

[73] TERVARENT, op. cit., s.v. "Chandelle qui se consume", col. 70; and "Sablier", VI, cols. 330–1. It is perhaps to these items that CHASTEL refers when he claims that in the Urbino study are included "les symboles de la caducité et de la mort" (cf. *Art et humanisme* cit., p. 365). CALVESI (op. cit., p. 13) too interprets the hourglass as a symbol of time passing; he notes that this motif appears with books in the frieze of Casa Marta Pellizzari, near two inscriptions proclaiming: VMBRE

96(a) TRANSITVS EST TEMPVS NOSTRVM. SOLA VIRTVS CLARA ETERNAQVE HABETVR. [Our time is the passing of a shadow. Only virtue is held famous and everlasting.]

84 In the study of Gubbio, the theme of transience is expressed in the passage from the *Aeneid* reproduced in (IX): see ll. 467–8, quoted in note 37.

In fact, this theme is implicit in all the still lives that are featured in the two *studioli*. As GOMBRICH has argued, "every painted still life has the *vanitas* motif 'built in' as it were, for those who want to look for it. The pleasures it stimulates are not real, they are mere illusion. Try and grasp the luscious fruit or the tempting beaker and you will hit against a hard cold panel. The more cunning the illusion the more impressive, in a way, is this sermon on semblance and reality. Any painted still life is *ipso facto* also a *vanitas*." ("Tradition and Expression" cit., p. 104.) This idea can be extended to every representation of

Fortune. The presence, on the front of the stands, of the stylized olive motif, which can symbolize Virtue[74], makes the suggestion especially plausible, for Fortune and Virtue were frequently associated. The relations between them were variously interpreted: these concepts were sometimes seen as antagonists (either one or the other finally triumphed), sometimes as allies. It is the latter view, echoing the well-known Ciceronian line "Duce virtute comite Fortuna" [Fortune follows the tracks of Virtue][75], that the proximity of the olive motif to the wheel seems to proclaim in Urbino.

There are no wheels in the Gubbio room. The olive motifs are present, but as ornaments to the sides of the lattice-work beneath the middle register; they are half-hidden by the seats. At most we may attribute to them a general meaning of Peace and Virtue.

78, 80, 85

The ornamental vegetal design on the back of the seat flap against which the mace rests, in (l), also includes a stylized multiple olive motif[76]. Such a detail is "unnatural" since the vegetal pattern on to which it has been "grafted" does not at all resemble the leaves of an olive plant; it is also unexpected because none of the other back flaps in the study include such a motif, though the basic ornamental design is the same (cf. (a), (d) and (o)). It is therefore possible to argue that the olive "branch" has been used here to counteract the brutality of the mace (which, inevitably, has a literal meaning as well as a symbolic one), and reassure us that the Prince only fights for Peace. This ideal, recommended by Aristotle in his *Politics* (VII, xiii, 8), recurs frequently in Renaissance eulogistic writing, and may thus be treated as a *topos*. The following excerpt, drawn from Landino's *Disputationes*, refers to Federico:

54, 56

42, 47, 59

> Non te fugit, qui de vita sociali atque civili scripserunt, rem totam in pacis ac belli studia divisisse, et illam propter se expetendam, hoc autem minime propter se, sed ut ad eam redire liceat sumendum demonstrant[77].

reality. See COLIE, op. cit., pp. 274–5, and, with reference to photography, S. SONTAG, *On Photography*, Harmondsworth, 1979, pp. 15, 70, and R. BARTHES, *Camera Lucida*, New York, 1981, pp. 78 ff.

[74] M. LEVI D'ANCONA, *The Garden of the Renaissance*, Florence, 1977, s.v. "Olive", pp. 261–71.

[75] For Cicero's quotation (from *Ad familiares*, X, 3) and its echoes in the Renaissance, cf. R. WITTKOWER, "Chance, Time and Virtue", in idem, *Allegory* cit., pp. 101–3; PANOFSKY, *The Iconography of Correggio's Camera di San Paolo*, London, 1961, pp. 63–4. The latter work offers a conveniently brief account of attitudes to *Fortuna* from antiquity to the Renaissance (pp. 60–6). See also: H. R. PATCH, *The Goddess Fortuna in Medieval Literature*, London, 1967, and L. GALACTEROS DE BOISSIER, "Images emblématiques de la Fortune. Eléments d'une typologie", in Y. GIRAUD ed., *L'emblème à la Renaissance*, Paris, 1982, pp. 79–125.

That Federico believed in both *Virtus* and *Fortuna* is indicated by a letter of reply, dated 1472, to Bartolomeo Scala, Chancellor of the Florentine Republic: the Prince rejects the flattering assertion that his successful military operation in Volterra was due exclusively to his *virtus*, and acknowledges the contribution of *Fortuna*. See P. ALATRI ed., *Federico da Montefeltro. Lettere di Stato e d'arte (1470–1480)*, Rome, 1949, No. 79.

[76] These "olives" are identical in shape and size to those that decorate the front of each stand, though they are not shaded. The motifs on the flaps have a more abstract character than the others, hence their flatness. 56

[77] [It has not escaped you that those who have written about social and civic life have divided the whole subject into peacetime and war-time endeavours, pointing out that the first must be sought for their own sake, and the other not for themselves at all but only to recover the first.]

"Disputationes" cit., p. 718. The idea is stressed a little later (p. 720):

Illud [...] et aequi et iniqui fateantur necesse est, te adversarii iniuria lacessitum invitum in certamen descendisse, et iustissimis causis impulsum rem magno consilio suscepisse, maiori animo perfecisse, victoria demum clementissime usum esse, ut iam omnes intelligere potuerint te nihil quam pacem maluisse, qui in bello nihil nisi tranquille egeris.

[... it is necessary that the just and the unjust should admit that you involved yourself in wars unwillingly, instigated by the offences of the enemy; only after careful pondering, urged by the fairest reasons, did you embark on an enterprise which you ran in a magnanimous way, using victory with the greatest clemency so that everybody might understand that there was nothing you liked better than peace, since even in war you conducted yourself in a peace-loving spirit.]

See also what Vespasiano has to say about Federico's attempts to pacify the Florentines, who had employed him, with the people of Volterra:

51 The Cupid motif that tops the lectern in (i) is puzzling. It does not appear on any of the lecterns depicted in representations of humanists in their studies. It is tempting to suggest that a functional motif such as the lantern may have led the designer of the scheme to add to it the Cupid figure, in order to express a conceit. In a seminal work on *imprese*, Mario Praz tells us of a device of Scève's consisting of a lantern with the words "celer ne le puis", and of its derivative, a 17th century Dutch love emblem representing Love placing a lantern in a niche, with the motto "Ie ne le puis celer". He claims that their source is Ovid's *Heroides*:

> – quis enim bene celat amorem?
> Eminet indicio prodita flamma suo.
>
> (XII, ll. 37–8)

He notes that the passage was "proverbial", and draws our attention to the following lines from Petrarch's *canzone* "Ben mi credea":

> Chiusa fiamma è più ardente; e se pur cresce
> In alcun modo più non può celarsi.
>
> (CCCVI, ll. 66–7)[78]

Now, the possibility that either Ovid or Petrarch may have inspired the pictorial detail in the *studiolo* cannot be excluded. The figurative translation of a literary quotation would, after all, not be unparalleled in the Palace. As Chastel has argued, the monumental chimney-piece of the *Sala della Iole*, depicting on either side Hercules and Iole, is based on a line from Dante's *Comedy*:

> quando Iole nel core ebbe rinchiusa
>
> *Paradiso* IX, 102

He believes that the erudite reference to Hercules's burning passion for Iole was probably meant to celebrate Federico's marriage to Battista Sforza[79]. If this is so, similarly, the image of Love's repressed yet unconcealable fire which the Cupid and lantern detail perhaps expresses, could refer to the Countess, who had died in 1472, i.e. roughly at the time when, as Rotondi has convincingly argued, the *studiolo* decorations were probably begun[80]. The beloved Battista was worthy of such a

Gli uomini dell'arme si dolevano della sua Signoria, dicendo: 'signore, e' c'era venuta una grande ventura da potere istarci più d'un anno, e la S.V. cerca de fare l'accordo per levarsi questo aviamento delle mani, et mandarci allo spedale, la S.V. doverebe prestar favore a' vostri soldati, et voi fate l'oposito'. Il duca gli pareva ogni dì mille, che questo acordo si facessi, perchè di sua natura era volto alla via della pace.
(*Le vite* cit., I, p. 372).

Federico's aspiration to moralize war is expressed in the *Sala di Jole* of the Palace. The door that leads to the bedchamber of the Duke depicts Mars, the God of war, together with Hercules, the virtuous hero. On its back, one of the mottos inscribed asserts: MELIVS TE VINCI VERA DICENTEM QVAM VINCERE MENTIENTEM [It is better to be defeated telling the truth, than to win deceiving]. My attention was drawn to these details by Claudia CIERI VIA's paper "Ipotesi di un percorso funzionale e simbolico nel Palazzo Ducale di Urbino attraverso le immagini", presented at the 1982 conference on Federico.
The theme of the delicate relations between war and peace seems to be expressed also in a medal struck for Federico by
109 Clemente da Urbino in 1468. Its reverse depicts an eagle (symbol of Jupiter and of the Montefeltro), on whose wings a sword and a cuirass (war), and an olive branch and a brush (peace) balance each other under the influence of the planetary signs of Mars, Jupiter and Venus. The inscription along its border reads: MARS · FERVS · ET · SVMHVM · TANGENS · CYTHEREA · TONANTEM · DANT · TIBI · REGNA · PARES · ET · TVA · FATA · MOVENT. [Wild Mars and the Cytherean Venus, touching the most high god of Thunder, equally contribute to your power and direct your destiny]. See F. SANGIORGI, *Iconografia federiciana*, Urbino, 1982, p. 100.

[78] M. PRAZ, *Studies in 17th Century Imagery*, Rome, 1963, pp. 92–3. Ovid's lines translate as follows:
[– who can well hide love?
Its flame shines forth its own betrayer.]
Heroides and Amores, Cambridge, Mass., 1963 (Loeb Classical Library), p. 145.

[79] *Art et humanisme* cit., p. 360.

[80] "Ancora sullo studiolo" cit., pp. 593–601 (pp. 262–5 of the later ed.).

celebration, since, as has been remarked, she played a prominent role in Urbino. A quotation from a classical work celebrating great women (the *Heroides*) would have been considered an appropriate way of commemorating her. The possibility that Petrarch may have been the source of the image is equally plausible. Battista's *Triumph of Chastity*, on one wing of Piero's diptych, was, after all, inspired by a work of that poet: the *Trionfi*[81]. [99]

The presence of the useful but rather prosaic brush among volumes that include the Bible, Cicero and Seneca in cupboard (e) comes as a surprise at first. The implement is, in fact, another indication of the designer's eagerness to insert disguised symbols in the naturalistic context of the decorations. The brush is, most likely, a camouflaged ducal device, the *pennacchio*, which we see so frequently reproduced in the Palace decorations. It also appears, in miniature form, on the capital to the left of the cupboard in question – a reminder, perhaps, that the brush on the books should not be taken too literally. As a ducal device, it is probably a reference to the cleansing of the stain of Federico's illegitimate birth, granted to him by Martin V[82]. Within the context of the cupboard, this symbol of purity agrees with the Bible and Scotus's text ([SCO]TO) because they are both religious works, and with Cicero's and Seneca's volumes because these authors were moral philosophers. Another miniature brush is depicted on the capital of the pilaster between (a) and (b). If it is not totally accidental, this motif may have been introduced here because one of the themes of cupboard (b) is that of the Virtues[83]. The brush is present in Gubbio as an ordinary object in (II), and as an *impresa* in (IV). [47] [41] [78, 81]

The portrait of Federico with the lance in (f), to which we have already ascribed the meaning of active/contemplative life, needs to be lingered on, for it embodies further concepts. That the Prince should have been provided with so simple and ineffective a weapon as a spear merely to allude to his military activities seems somewhat strange; a more sophisticated and fearful one would have been more appropriate. This consideration leads one to believe that the spear may have a specific symbolism. A similar weapon is held by Charles V in the equestrian portrait painted by Titian, now in the Prado; Panofsky has interpreted it as an attribute of the *Miles Christianus* (e.g. St. George and St. Michael), and as a classical symbol of supreme authority (Roman emperors carried a *hasta* on ceremonial and triumphal occasions)[84]. Both meanings would fit Federico's portrait. With regard to the first, it will be recalled that Federico had offered his services to three Popes, and could therefore consider himself as defender of the Christian Faith. As for the second meaning, contemporary celebratory literature implies that Federico (like most Renaissance princes) aspired to emulate the great captains of antiquity[85]. [105]

[81] Battista seems to have been celebrated posthumously in other works. Marilyn ARONBERG LAVIN has argued that the woman and child depicted in Justus's *Communion of the Apostles* was meant as a memorial to the Countess. Cf. "The Altar of Corpus Domini in Urbino", *Art Bulletin*, XLIX, 1967, pp. 18–9. Piero's diptych, with its idealized portrait of Battista, now tends to be dated shortly after her death. See: P. HENDY, *Piero della Francesca and the Early Renaissance*, London, 1968, p. 137; ROTONDI, *The Ducal Palace* cit., p. 55 (in the earlier Italian ed. he had dated the panel 1465); BATTISTI, *Piero della Francesca* cit., I, p. 357; CLOUGH, "Federigo da Montefeltro's Artistic Patronage" cit., pp. 722, 732 note 31. [98, 99]

[82] NARDINI, op. cit., p. 13. The brush, complemented by the motto MERITO ET TEMPORE [justly and seasonably] was also one of Lodovico il Moro's favourite *imprese*, and carried implications of the cleansing of Italy. The same motif appears as a disguised symbol of purity in a number of works. Cf. I. BERGSTRÖM, "On Religious Symbols in European Portraiture of the XVth and XVIth Centuries", in E. GARIN *et al.*, *Umanesimo e esoterismo*, Padua, 1960, pp. 341–2 note 16.

[83] Other miniature devices have been depicted on the capitals of the north wall. They are: the spires (between (b) and (c)) and the grenade (between (c) and (d)). Their meanings will be discussed later. In the context of this wall, these motifs seem to have no functions other than general ornamental and celebratory ones. [41, 46] [41]

[84] PANOFSKY, *Problems in Titian* cit., pp. 85–7, Figs. 97–103. For a detailed account of the spear as a symbol of authority in antiquity, cf. A. ALFÖLDI, "'Hasta – summa Imperii'. The Spear as Embodiment of Sovereignty in Rome", *American Journal of Archaeology*, LXIII, 1959, pp. 1–27, Pls. 1–10.

[85] Vespasiano declares in his *Vite*:

The second interpretation of the spear is also supported by an anecdote told by Pius II in his *Commentarii*, suggesting that Federico had an archaeological interest in classical weapons. In his account of a meeting with the Duke by the river Aniene in July 1461, the Pope, after a description of the spectacular display of the arms and other equipment of the ducal cavalry, notes:

> Federicus qui multa legisset interrogare Pontificem an prisci duces aeque ac nostri temporis armati fuissent. Pontifex et in Homero et in Virgilio genus omne armorum inveniri descriptum dicere, quibus nostra utitur aetas et alia multa quae obsoluerunt. Poetas, etsi fingunt aliqua, ea tamen plerumque describere, quae in usu aliquando fuerunt, neque prorsus a vero discedere[86].

The spear is also an attribute of Minerva, and thus a symbol of Wisdom or, more generally, of Virtue[87]. This interpretation (which does not exclude the others) supports Liebenwein's view that 41 Federico, depicted full-length on the same level and in the same size as the personified Virtues, is presented as the exemplary embodiment of the *homo virtuosus*[88].

105 The Duke's spear points downwards. This unusual detail is featured in a number of Roman imperial coins. It is especially Mars who is depicted holding his weapon in this way; sometimes he grasps an olive branch as well, with his other hand, and is surrounded by the inscription MARTI PACIFERO [To Mars, the bringer of peace] or MARS PACATOR [Mars, the pacifier][89]. The

> Egli [Federico] cominciò molto giovane a militare, imitando Iscipione Africano ...

(op. cit., I, p. 355).

Alberti is reported saying, in Landino's *Disputationes*:

> [Federicus] suae aetatis duces sine controversia superat, et cum omni antiquitate contendit ...
>
> [[Federico] no doubt surpasses the leaders of his age, and competes with those from the whole of antiquity ...]

(Latin quotation from: op cit., p. 762).

See also the recollections of Francesco Prendilacqua, a former school-mate of Federico's at Vittorino's school:

> Africani vero vitam legens, cum illum prima aetate Imperatorem factum cognovisset, indoluisse primo fertur, mox ad Victorinum conversus poetae carmen verbis paulum mutatis dixisse:
>
> 'en erit unquam Illa dies mihi, qua liceat mea cernere facta?'
>
> Interrogatus quidnam doleret: Scipio, inquit, adolescens exercitum duxit; ego paulo immaturior nondum milites aut castra vidi. At praeceptor discipulum consolatus: nolo te Scipionem, sed Alexandrum, respondit; fuit enim, ut tu, principis filius, et ipse princeps clarissimus.
>
> [It is said that, as he was reading the life of Africanus, when he learned he had been a general when he was very young, [Federico] felt distressed at first, but then turned to Vittorino to recite the song of the Poet, modifying the words a little: 'Will the day when I can contemplate my deeds ever come for me?'
>
> Asked why he grieved, he replied: 'Scipio led armies when he was just a boy; yet I, who am only slightly younger than he was, have not yet seen either soldiers or camps'. But his master consoled him: 'I do not wish you to become Scipio, but Alexander: like you, he was the son of a prince, and a prince himself.']

Latin text from: "De Vita Victorini Feltrensis Dialogus", in E. GARIN ed., *Il pensiero pedagogico dell' Umanesimo*, Florence, 1958, p. 612. A footnote by the editor explains that the verses quoted freely by young Federico refer to the *Aeneid*, VIII, 516. On this biographical source, see P. ZAMPETTI, "Federico da Montefeltro e Vittorino da Feltre", in GIANNETTO ed., *Vittorino e la sua scuola* cit., pp. 255–61.

For further references, see F. ERSPAMER, "Il 'lume della Italia': alla ricerca del mito feltresco", paper presented at the 1982 conference on Federico.

[86] [Federigo, who was well read, asked the Pope whether the captains of antiquity had been armed as ours were. The Pope answered that in Homer and Vergil could be found descriptions of every kind of weapon which our age used and many others which had gone out of fashion. He said that although poets invented some things, still as a rule they described things which have at some time been in use and do not depart entirely from the truth.]

"Commentarii rerum memorabilium", in GARIN ed., *Prosatori latini* cit., pp. 674, 676. Transl. from L. C. GABEL ed., *Memoirs of a Renaissance Pope. The Commentaries of Pius II*, London, 1960, p. 190.

[87] TERVARENT, op. cit., s.v. "Lance", col. 230.

[88] LIEBENWEIN, op. cit., p. 90.

[89] See H. MATTINGLY *et al.*, *Coins of the Roman Empire in the British Museum*, London, 1965–1975, 6 vols., types index, s.v. "Spear" and "Mars". PACATOR is sometimes abbreviated PACAT and PAC. Dr. David Shotter, of the

aureus of Severus Alexander reproduced here is one example. The same spear motif occurs in two [108] Quattrocento cycles of famous men: Taddeo di Bartolo's frescoes in the Ante-chapel of Siena's [106] *Palazzo Pubblico*[90], and Castagno's, formerly in *Villa Carducci*. In the first case it is the Roman [107] general Scipio Africanus Major, included in the cycle as a representative of Magnanimity, who holds his weapon upside down, and in the other Tomyris, the queen of a Central Asian tribe, who bravely resisted the invasion of Cyrus the Great (her inscription appropriately praises her as the liberator of her people)[91]. These antique and modern examples suggest that Federico's reversed spear is intended to celebrate him according to the *topos* already seen of the virtuous hero who fights only with peaceful intentions.

The same motif may be given another interpretation. It could be a sign of mourning inspired by an episode from the *Aeneid*: Pallas's funeral. The Trojans, Etruscans and Arcadians who attend it are, in fact, described as carrying their spears pointed to the ground (Book XI, ll. 88–93). If this is the source of Federico's reversed weapon, the motif must be regarded as a reference to Battista's death. Clearly, this interpretation is not compatible with the previous ones[92].

The illusionistic loggia overlooking the countryside on the east wall, and its counterpart in reality [VII, 62] on the opposite wall, also need to be commented upon. These details fulfil first of all a practical function: that of relieving the room from an otherwise claustrophobic character[93]. They are also rich in cultural implications.

The possibility that the fictional landscape may have been inspired by ancient prototypes has already been mentioned[94]. It must be added that, through the well-established identification of natural beauty with creative leisure, both views suggest the concept of *vita contemplativa* which the whole room embodies. The figure of Petrarch comes to mind again, for he was the first modern [90] to consider natural spots with their idyllic peace (contrasted with the rush and discomfort of the city) as the proper setting for the repose and intellectual stimulation of the man of letters[95].

The illusionistic landscape is, to some extent, idealized: the lake or river in the foreground charac- [VII]

Classics and Archaeology Department of Lancaster University, has kindly confirmed my interpretation, and added, quoting Cicero, *De officiis*, II, viii, 27, that the spear was planted in the ground to indicate that the war booty was put up for sale, and that peace had therefore been imposed on the enemy.

[90] RUBINSTEIN, op. cit., pp. 189–207, esp. pp. 191–2, 196.

[91] See HORSTER, op. cit., pp. 29, 32. Federico's portrait seems to have been directly inspired by Castagno's *Tomyris*, for [105, 107] the two have striking formal similarities: both figures hold the spear in a mannered fashion with the right hand, while gathering the heavily-folded robe with the left one.

[92] WESTFALL, op. cit., p. 37, connects Federico's reversed spear with the Virgilian lines, but draws no conclusions.

[93] The illusionistic vista is not a redundant addition, in this respect. Without it, when the shutters of the real loggia were closed, the dado of intarsias would have given the study the appearance of a golden, but still oppressive prison; an impression which the window on the west wall could not have eliminated because of its high location.

[94] Cf. pp. 54–5. See especially Pliny's and Vitruvius's descriptions of mural paintings (from: *Historia naturalis*, XXXV, 116–7, and *Architectura*, VII, 5 respectively), quoted in English and commented on by GOMBRICH in "The Renaissance Theory of Art and the Rise of Landscape" cit., pp. 112–4, 119–20.

[95] The cult of nature was to be taken up by humanists such as Lorenzo de' Medici, Poliziano, Alberti and Ficino. It led to the fashion of the country-house (the Medici villas of Careggi, Fiesole and Cafaggiolo, for instance, were conceived as places of humanist *otium* and *studium*), and to the rise of a bucolic literature (e.g. Sannazzaro's *Arcadia*). The literature on the Renaissance cult of nature is vast. The following works offer general accounts of the issue: A. R. TURNER, *The Vision of Landscape in Renaissance Italy*, Princeton, 1974 (2nd ed.), esp. Ch. X; RUPPRECHT, op. cit.; L. PUPPI, "L'ambiente, il paesaggio e il territorio", in G. PREVITALI ed., *Storia dell'arte italiana*, Turin, IV, 1980, pp. 43–100; G. VENTURI, "'Picta poësis': ricerche sulla poesia e il giardino dalle origini al Seicento", in C. DE SETA ed., *Storia d'Italia. Annali*, Turin, V, 1982, pp. 682–703. On Petrarch's attitude to nature, see: M. BISHOP, *Petrarch and his World*, London, 1964, esp. Chs. VIII and X; TURNER, op. cit., pp. 194–5; THOMASON, op. cit., Ch. I; VENTURI, "'Picta poësis'" cit., pp. 682–6.

terizes it as a *locus amoenus*[96]. At the same time the vista reflects features of the countryside in which Urbino is set: the gentle hills dotted with vegetation allude to the Apennines. By indicating a specific topographic location, the view functions (as already mentioned in connection with the squirrel) as a reference to the territories over which the Montefeltro ruled, and thus constitutes a symbol of self-glorification[97].

To conclude this section on nature, the significance of the real landscape's interaction with the *studiolo* and the two cubicles directly beneath it should be noted. As Rotondi has argued, the western part of the Palace, that between the turrets, was planned as a "sacred" area, in which nature contributes to the exaltation of universal values: those of Humanity, Faith and Poetry[98].

62, 5, 6 and

3

*

Winternitz has remarked that the inlaid decorations, through the masterly use of linear perspective, express the interconnection between the creative arts and the sciences in the 15th century:

> Both art and science in the 'quattrocento' drew their inspiration from one strong impulse: the tendency toward rationalization, sweeping through all branches of natural science, aiming at calculation and control of nature by establishing its laws. The basic structure of nature was to be found in simple numerical formulas. This conception of natural science swept the artists along with it, but they were themselves pioneers in its development; in portraying nature 'correctly' they hoped to capture its secrets. Art was research into nature, the artist an experimental scientist, the canons of nature the canons of rules

[96] On this *topos*, cf. CURTIUS, op. cit., pp. 183–202. Alberti recommended similar vistas for their restorative and therapeutic values in the section on domestic decorations of his *De re aedificatoria*:

> Hilarescimus maiorem in modum animis, cum pictas videmus amoenitates regionum et portus et piscationes et venationes et natationes et agrestium ludos et florida et frondosa.
> [Our minds are cheered beyond measure by the sight of paintings depicting the delightful countryside, harbours, fishing, hunting, swimming, the games of shepherds – flowers and verdure.]

The psychological effect of landscapes is emphasized a few lines later:

> Aquarum spectare fontes pictos et rivulos maiorem in modum fabricitantibus conferet. Experiri hoc licet: si quando per noctem somnus cubantem frustrabitur, tunc limpidissimas, quas uspiam videris, aquas fontium rivorum aut lacus ubi mente repetere institeris, illico vigiliarum illa siccitas humectatur irrepitque sopor, quoad dulcissime obdormiscas.
> [Those who suffer from fever are offered much relief by the sight of painted fountains, rivers and running brooks, a fact which anyone can put to test; for if by chance he lies in bed one night unable to sleep, he need only turn his imagination on limpid waters and fountains which he had seen at one time or another, or perhaps some lake, and his dry feeling will disappear all at once and sleep will come upon him as the sweetest of slumbers.]

(Latin quotations from *L'Architettura* cit., Book IX, Ch. IV, vol. II, pp. 805, 807. English translations from GOMBRICH, "The Renaissance Theory of Art and the Rise of Landscape" cit., p. 111.)

[97] See TURNER, op. cit., p. 198: "[A function of the painted landscape] was to indicate the geographical location of the villa, or to boast of the lands possessed by the land-owner. Not only was the geography described, but often its venerability was suggested. [...] The desire to suggest a specific topography partially explains much of the Renaissance landscape painting."

98, 99 The use of landscape as self-advertisement is especially evident in Piero's Uffizi diptych: the Apennines fill the backgrounds to the half-length portraits of Federico and his spouse, and the Triumphs on the other side. An interesting point made by BATTISTI about this panel lends further support to the political interpretation of the *studiolo* landscape. He has argued that the view from above carries implications of domination, and remarked that the idea is consciously expressed by Pius II in his *Commentarii*: speaking in the third person, the pope informs us that in May 1463 he climbed *Monte Cavo*, along the ancient Roman road, and from there "maritimam contemplatus plagam a Terracina usque ad Argentarium montem omne littus Ecclesiae metatus est oculis." ["gazed at the seashore and surveyed all the coast belonging to the Church from Terracina to Monte Argentario."]. Cf. *Piero della Francesca* cit., I, pp. 358, 519 note 490; translation after *Memoirs of a Renaissance Pope* cit., p. 321.

[98] *Il Palazzo Ducale* cit., I, p. 336 (*The Ducal Palace* cit., p. 79).

of 'correct' artistic creation. Art was thus a sort of science, a body of knowledge dealing with the basic relations between phenomena, visible or audible[99].

Such motifs as the musical and scientific instruments and the arms depicted in the marquetry allude, according to Winternitz, to the rational foundation of harmony, astronomy and warfare respectively.

With regard to harmony, his view is endorsable, since the Pythagoreans had discovered that it was determined by certain arithmetical relations, for instance those of the lengths of strings or air columns producing sounds. It was this theoretical basis that enabled music to affect other disciplines (architecture in particular). The laws of musical consonances inspired architectural theory from Vitruvius to Palladio[100].

The suggestion that the astronomical instruments in the *studiolo* are an oblique reference to the "harmony of tones in the proportions of the planets and their orbits"[101] is less convincing. Perhaps they should be seen more simply as expressive of a generalized mathematical humanism. Alberti stressed their suitability in a library:

VIII

> Bibliothecis ornamento in primis erunt libri et plurimi et rarissimi, praesertim ex docta illa vetustate collecti. Ornamento etiam erunt mathematica instrumenta cum caetera tum 'iis' similia, quae fecisse Possidonium ferunt, in quibus septem planetae propriis motibus movebantur; quale etiam illud Aristarchi, qui in tabula ferrea orbis descriptionem et provincias habuisse praedicant artificio eleganti[102].

Perhaps the clock too fulfils, like the astronomical instruments, a mathematical function. It is, after all, known to have interested "rationalist" scholars. Vasari tells us that Brunelleschi,

63

> ... avendo preso pratica con certe persone studiose, cominciò a entrar colla fantasia nelle cose de' tempi e de' moti, de' pesi e delle ruote, come si possan far girare e da che si muovono; e così lavorò di sua mano alcuni oriuoli buonissimi e bellissimi[103].

Winternitz's contention that the arms (the sword, the dagger and the mace?) are also reminders of an aspiration to rationalize the environment is unconvincing. While it is true that "war became a topic of scientific speculation and was subjected to conventional and technical rules, the rules of correct warfare"[104], the possibility that such concepts may have crossed the designer's mind are remote.

42, 44, 54

[99] WINTERNITZ, op. cit., p. 122. Again, the author refers to the Gubbio intarsias, but his observations are extendable to the Urbino ones.

[100] Ibid., pp. 124–5. On mathematical aesthetics, cf. also R. WITTKOWER, "The Problem of Harmonic Proportion in Architecture", *Architecture Principles in the Age of Humanism*, London, 1962, pp. 101–42; BAXANDALL, *Painting and Experience* cit., pp. 94–102; G. L. HERSEY, *Pythagorean Palaces*, Ithaca, N.Y.–London, 1976.

[101] WINTERNITZ, op. cit., p. 125.

[102] [... the main ornament of libraries is the number and variety of books; these have to be quite rare, and chosen giving preference to the most learned men of antiquity. Another ornament is constituted by mathematical instruments: those resembling the one which, according to tradition, Posdonius built, in which the seven planets performed their revolutions; or that of Aristarco, who, we are told, traced a plan of the whole world with all its provinces, on an iron table – a most ingenious and attractive work.]
(Latin quotation from *L'Architettura* cit., Book VIII, Ch. IX, vol. II, pp. 767, 769). This view is partly echoed by Leonello d'Este: see the excerpt from Decembrio's dialogue *De politia litteraria*, quoted on p. 36, note 4 of the present volume.

[103] VASARI, *Le Vite* (G. MILANESI ed.), Florence, 1906, II, p. 330.

[104] *Musical Instruments* cit., p. 51.

3. *The Middle Register*

The devices and emblems represented in the middle register of the intarsias deserve special attention: they function as much more than a generalized celebration of the Prince.

These symbols have clearly not been arranged according to a recurring pattern. Neither have simpler formal criteria, such as symmetry and variety, been considered: a few of such motifs are repeated (the tongues of fire, in (b) and (n); the ostrich, in (e) and (q); the ermine, in (c) and (p)), while others (the brush and the twin spires) have been excluded. Since it is unlikely that, in such a carefully-designed décor, the princely symbols were chosen and arranged totally at random, a different type of scheme has been sought in the frieze. The investigation has shown that the arrangement of the devices and emblems was determined by the nature of the motifs directly above them: i.e. the items in the cupboards.

The essential lay-out of the Urbino intarsia decorations is as follows:

books	"j'ai pris amour.." other books, Garter, *cartellino*, fasces, dagger	HOPE	hourglass, candle, Virgil, Homer, other books	Scotus, Bible, Cicero, Seneca, other books, brush	portrait of Federico	NORTH WALL
///////	tongues of fire	ermine	///////	ostrich	grenade	
a	b	c	d	e	f	

armour, bâton		landscape, squirrel, basket of fruit	lectern, hourglass, books	EAST WALL
laurel	laurel	abstract patterns		
g		h	i	

organ	astronomical instruments, tablet, rosary, inkpot, books, *mazzocchio*	FAITH	latticed door	SOUTH WALL
pomegranates	crane	///////		
j	k	l	m	

empty cupboard	"bella gerit...", another book, vessels	CHARITY	chess-board (?), pawns, books	parrots	clock	scroll, fife & drum, Ermine	WEST WALL
tongues of fire	///////	ermine	ostrich	lattice-work		Garter	
n	o	p	q	r	s	t	

Let us take the ermine with the motto NON MAI, to begin with. Since, according to popular tradition, this animal prefers to die rather than soil its immaculate fur, it symbolized purity[105]. It is therefore appropriate that this *impresa* should be located beneath the personifications of Hope (c) and Charity (p). One can reasonably assume that the ermine lies, hidden by the seat-flap, beneath Faith (l) too.

The ostrich with a nail in its beak is a symbol of tenacity: it is in fact accompanied by the motto

[105] NARDINI, op. cit., p. 14.

78

ICAN VERDAIT EN CROCISEN, which has been interpreted as the corruption of the German "Ich kahn verdant ein gros Eisen" [I can digest a large piece of iron]. The device belonged originally to Guidantonio, Federico's father, and commemorated his reappropriation of the Montefeltro territories after a long exile[106]. This motif too may be connected to the contents of its cupboards (e) and (q). The ostrich accords with the book marked TVLIO, for Cicero, despite his exile, did not lose his moral strength and combativity. Seneca, as a stoic (this philosophic trait is alluded to in his inscription, as will be recalled), is especially apt to figure immediately above a symbol of tenacity. As for cupboard (q), it is significant that its door should be open at an angle that allows us to see, apart from the ubiquitous books, only some pawns (lower shelf) and what looks like a chessboard (upper shelf). The game of chess lends itself to comparisons with warfare: it involves two antagonistic sides of which the strongest wins[107]. The analogy could explain why a symbol of tenacity has been placed beneath this cupboard.

The emblem of the tongues of fire, complemented by the gothic initials "f d" (*federicus dux*) stands for glory[108]. As such, it is appropriate that it should be located beneath cupboard (b), which includes such items as the cloth with the Garter, the *cartellino* referring (also) to military valour, and the dagger. One of the two broken strings of the lute in the same section conspicuously curls itself before the flame emblem. Since a lute with a broken string traditionally symbolized Discord[109], it may be argued that the association of the instrument with the emblem hints at the Prince's triumph in wars. This likely symbol of Discord should be linked with and contrasted to the fasces of (internal) Concord, placed in the cupboard above. It should be noted that by the lute with the broken strings, on both sides of the emblem, is a vegetal motif which, as argued below, probably represents Concord. Thus the antithesis Concord/Discord seems to have been suggested twice in this section.

Flames had (and have) amorous connotations. By virtue of this additional meaning, the motif in the emblem can simultaneously agree with the book displaying the following love song:

> Jay pris amor a may devise pur conquerir joyeusete, heureux seray en celeste se pujs venir a mon emprise...[110]

Significantly, the first line actually states that love has been adopted as a device. Both the flames motif and the song are likely references to Divine Love. A Christian virtue (Hope) is appropriately adjacent.

The tongues of fire are also present beneath the empty cupboard (n). Since, as we shall see, all the other motifs in the middle register relate to the corresponding cupboards, it is legitimate to wonder what function the emblem may fulfil in this section. The cupboard in question is the only one in the study to be vacant: this leads one to believe that its very emptiness may be iconographically significant. Recalling that the *studiolo* was probably begun very shortly after Battista's death, it is tempting to suggest that the empty compartment may be a poetical reference to her loss. This would explain the choice of the emblem: the tongues of fire could symbolize Federico's unceasing love for his departed wife. The illusionistic transparent glass hanging from the capital between (n) and (o), and "covering" part of the empty cupboard, could support such an interpretation. This

[106] Ibid., p. 8. The motto has been quoted in the text as spelt by Nardini, but it appears in other forms. In (e) it reads IHC ANVORDAIT EN CROCISEM, and in (q) IH ANVORDA EN CROCISEM.

[107] H. J. R. MURRAY, *A History of Chess*, Oxford, 1913, p. 750. The game of chess continues to symbolize conflicting ideologies, and the triumph of one over the other. See the political importance that was attributed by public opinion to the Spassky v. Fisher and Karpov v. Korchnoi chess matches.

[108] NARDINI, op. cit., pp. 16–8.

[109] HALL, op. cit., s.v. "Lute", p. 197.

[110] On this song, cf. SCHERLIESS, op. cit., pp. 58, 116–20; REESE, "Musical Compositions" cit., pp. 76–80; B. DISERTORI, "Prime versioni a tre voci della canzone 'J'ay prins amours'", in idem, *La musica nei quadri antichi*, Calliano (Trento), 1978, pp. 41–8.

material was one of the symbols of the Incarnation (essentially because light can pass through it leaving it intact)[111]. It cannot be excluded that it has been used in the study with this meaning with reference to Battista, given that she was believed to have borne Guidobaldo through supernatural

99 intercession. It is worth recalling that in Piero's diptych, the Countess's triumphal cart is drawn by the white unicorns of Chastity. Philip Hendy has rightly remarked that the Countess is there represented "like a Virgin of the Annunciation, eyes lowered upon a book in her lap"[112]. Both the *Communion of the Apostles* and the Brera altarpiece contain, as has been argued convincingly, references to Battista's "miraculous" pregnancy[113]. The very fact that cupboard (n) is locked may be another virginal reference: the *porta clausa*[114]. The cupboard in question is relegated to a rather

58 dark part of the room: it is set on one side of the low-ceilinged recess that encloses the south door. This location gives it the awesome overtones of a little votive chapel. It is therefore tempting to conclude that within the vivacious décor of the *studiolo*, the designer has created a quiet corner for contemplation, dedicated to the memory of Battista.

49, 50 The laurel emblem, represented twice in (g), is a symbol of military glory[115]. As such it suitably accompanies the armour and the bâton of command.

58, 65 The depiction of the Order of the Garter in (t) is appropriate, for above, among the motifs that point to Federico's military career, is another title: the Collar of the Ermine.

54, 56 The *impresa* of the crane, which appears in (k), normally celebrates vigilance, for this bird, according to a well-known legend, keeps itself awake, and thus ready to oppose the nocturnal raids of its enemies, by holding a leg up with a stone in its claws[116]. Clearly, the quality of watchfulness is not relatable to the predominantly mathematical character of the cupboard above. The crane (along with ruler and compasses) appears in Ripa's *Iconologia* as an attribute of "Consideratione" (i.e. Calculation). The author explains, quoting Alciati, and suggesting that the reason was a familiar one, that this bird regulates the altitude of its flight by carrying a stone in its claws[117]. The idea

[111] For a full discussion of this symbol, see M. MEISS, "Light as Form and Symbol in Some Fifteenth-Century Paintings", in idem, *The Painter's Choice*, New York, 1976, pp. 3–18. See also PANOFSKY, *Early Netherlandish Painting* cit., I, p. 144.

[112] *Piero della Francesca* cit., p. 40.

[113] See ARONBERG LAVIN, "The Altar of Corpus Domini" cit., pp. 18–9; M. MEISS, "'Ovum Struthionis': Symbol and Allusion in Piero della Francesca's Montefeltro Altarpiece", and "La Sacra Conversazione di Piero della Francesca. Extracts", in idem, *The Painter's Choice* cit., pp. 105–29 (esp. 116–7) and p. 146 respectively; K. CLARK, *Piero della Francesca*, 1969 (2nd ed.), p. 68.

[114] For the sources of this motif, see HARTT's account in F. HARTT, G. KENNEDY and G. CORTI, *The Chapel of the Cardinal of Portugal at San Miniato in Florence (1434–1459)*, Philadelphia, Pa., 1964, pp. 123–4. It is worth noting that the closed door is featured in a work by Piero: the *Annunciation* of the *Story of the Cross* cycle, in Arezzo.

41
58 Other cupboards in the study are locked: that in (a), those on the right-hand side of the central pier, and to the left of the slight recess that accommodates the west door. However, their closed shutters are probably meant here to distract our attention from the contents of the cupboards: the heaps of nondescript books are of no specific iconographic interest.

[115] See p. 41, note 26.

[116] NARDINI, op. cit., pp. 15–6; H. M. VON ERFFA, "'Grus vigilans'. Bemerkungen zur Emblematik", *Philobiblon*, I, 1957, pp. 286–308.

[117] Cf. RIPA, op. cit. (p. 85):
Donna che nella sinistra mano tiene un regolo, nella destra un compasso e ha a canto una grue volante con un sasso in un piede.
[…]
La grue si può adoprare in questo proposito lecitamente, e per non portare altre auttorità, che possino infastidire, basti quella dell' Alciato, che dice in lingua nostra così:
'Pittagora insegnò, che l'huom dovesse
Considerar con ogni somma cura
L'opera, ché egli fatta il giorno havesse

80

could have been known in Federico's time. It should be noted that on both sides of the *Tarocchi* card devoted to "Geometria", a wading bird that may well be a crane is represented in the foreground of the landscape (which hints at surveying). 95

The *impresa* of the bursting grenade in (f) symbolizes, according to Nardini, defensive rather than aggressive warfare: the bomb does not explode unless provoked. It is a plausible interpretation[118]. 41, 48

It also suits the portrait above: as we have seen, Federico's downward-pointing lance suggests peaceful intentions. 105

Finally, the cushion in (j) needs to be considered, for the stylized bursting pomegranates that figure on it, among the abstract vegetal patterns, fulfil a function similar to that of the *imprese* and emblems. Treated as a symbol of Concord, the pomegranates relate well to the organ, this being the principal attribute of Music, and thus the very embodiment of Harmony. 54, 55

The *pennacchio* device is missing; but it was not, from the functional point of view, a vital one to include in this register. Purity in Urbino is effectively alluded to by the more established symbol of the ermine. The exclusion of the twin-spires motif is more surprising: if, as Nardini claims, it stands for war-time and peace-time activities[119], it could have effectively been inserted in (o), to accord with the music book displaying the song "Bella gerit, musasque colit . . .". 59, 60

The symbols in the middle register fulfil an important function: that of summarizing the dominant themes of the corresponding cupboards. They state concisely what the items above tend to express in redundant or "diluted" form. They incidentally indicate that, behind the apparently random selection and scattered arrangement of paraphernalia, lies an ordered scheme.

Turning to the Gubbio decorations to seek confirmation for the system of vertical correspondences claimed for the Urbino ones is of limited help: here more than one type of criterion appears to have determined the choice and sequence of the emblems and devices.

(For a schematic representation of the Gubbio decorations, see overleaf.)

Several of the emblems and devices accord with the motifs above. The spires appropriately accompany the book, the dagger and the fife and drum, in (V), since the first item may be associated with peace, and the others with war. The tongues of fire, as a heraldic symbol of military glory, agree with the armour and the mace in (VI). The crane may have been inserted in (VII) for the banal reason that, like the parrot above, it is a bird. The laurel, which symbolizes both poetic and military glory, accords especially well with the *Aeneid*, placed on the nearby lectern in (IX). To explain the presence of the ducal arms with their eagles, beneath cupboard (X), which encloses the sphere and the quadrant, we may turn to Ripa: he asserts that the eagle is an attribute of Astronomy because, like the stars, this bird is remote from us and thus difficult to grasp[120]. 81 / 82, 80 / 83, 84 / 83

S'ella eccedeva il dritto, e la misura,
E quella, che da far pretermettesse.
Ció fa la grue, che 'l volo suo misura
Onde ne' piedi suol portar un sasso
Per non cessar o gir troppo alto o basso'.

[118] Op. cit., p. 12. I am not convinced by WIND's claim that, as a concealed force ready to be released at the right time, the grenade symbolized "heroic prudence"; cf. *Pagan Mysteries* cit., pp. 108–10.

[119] NARDINI's laborious explanation goes as follows: "*Spira, spirale e spiritale* sono termini per indicare una cosa che ha spirito, che ha a significare la folgore. È innegabile che la folgore abbia spirito e vita dalla elettricità che ne determina l'azione. Herone Alessandrino ideò dei meccanismi che si muovevano con l'azione dell'acqua e del fuoco e che da lui vennero distinti con il nome di spiritali. In questa impresa, una spira sta ad indicare le azioni di guerra del duca Federico, e l'altra quelle di pace. Sono unite fra di loro da una funicella, perchè queste azioni si debbono ad una sola persona." (op. cit., p. 18).

[120] Cf. *Iconologia* cit., s.v. "Astrologia" (p. 28):

Donna vestita di color celeste, con una corona di stelle in capo, porterà alle spalle l'ali, nella destra mano terrà uno scettro, nella sinistra una sfera, e à canto un'aquila.

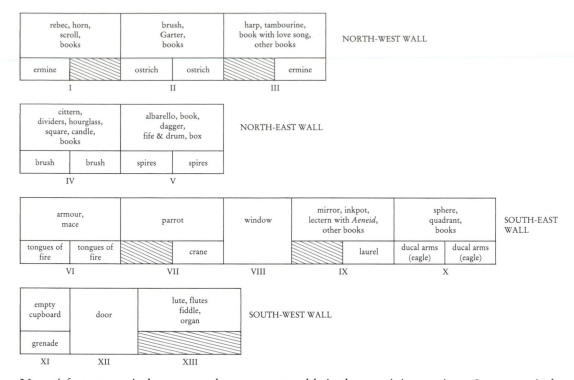

No satisfactory vertical correspondences are traceable in the remaining sections. Symmetry is the criterion that seems to have determined the choice and arrangement of the devices on the north-west wall (I, II, III), as the turning of the ostriches towards each other in the mid section, and the presence of the ermine at both ends indicate[121]. The remaining symbols (the brush and the grenade) were probably used randomly. Variety – or the wish to display as many of the ducal *imprese* and emblems as possible – seems to have been a dominant criterion in Gubbio: though the number of cupboards is smaller than in Urbino, the range of symbols is more extensive. It should also be noted that, with the exception of the ermine in the "symmetrical" wall, none of these motifs is used in more than one section.

4. *Words and Images*

The role of words in Renaissance works of art is usually taken for granted and thus rarely investigated; or else inscriptions are studied out of context[122]. With regard to the Urbino *studiolo*, most scholars have made only fleeting references to the *tituli* beneath the portraits of the illustrious men,

[…]

Et depingesi di color celeste, perché nel Cielo stanno fisse le stelle, e di là su esercitano la forza loro, e per mostrare difficultà dell'apprensioni per la tanta lontananza le si fanno l'ali, le quali ancora sovente non bastano, e per questo medesimo vi si fa l'aquila.

[121] Indeed symmetry has affected other parts of the decorations of this wall: the *mazzocchio* placed in the middle of the seats row and the Garter hanging roughly in the centre of the cupboard above echo the decorative roundel in the middle register; the arrangement of the seat flaps is symmetrical.

[122] Among the few works that deal with the interaction between words and images in Renaissance art, the following are especially interesting: D. A. COVI, *The Inscriptions in Fifteenth Century Florentine Painting*, Ph. D. Thesis, Inst. of Fine Arts, New York Univ., 1958, and the article based on part of it, "Lettering in Fifteenth Century Florentine Painting", *Art*

though, as argued earlier, these inscriptions play an important role in the frieze. They have paid even less attention to the thoughtful association of words and images in the inlaid decorations. Generally speaking, words act as reminders that the room is the refuge of a cultivated person. Many of the motifs (the books, the astronomical instruments, etc.) are expressive of intellectuality, but being images, they are immediately apprehensible by anyone. Words more specifically suit a study because, being conventional (i. e. learned) signs, they denote literacy to a literate élite. It is no coincidence that there are more words in the *studiolo* than in any other part of the Ducal Palace.

All the inscriptions on the dado of intarsias are "internal": they have not been imposed on the pictorial space in which cupboards, etc. are to be found, but are an integral part of it[123]. Words, in the inlays, make a casual appearance on open music books, accompanying scores (e.g. "Bella gerit..."), within *imprese*, as mottos (e.g. NON MAI); on the back of books, to indicate their authors (e.g. TVLIO), on a *cartellino*, as a maxim (·VIRTVTIBVS·ITVR·AD·ASTRA·), etc. They are foreshortened whenever required by the context, as the letters FEDE printed on the ink-pot in (k), and part of the inscription that runs along the top of the illusionistic recess in (i) (...BINI.MONTISF...) show. Some words are partly screened by objects ([VIR]GILIO, O[M]E[R]O, [SE]NACA, BI[BBIA] and [SCO]TO[124]).

The script differentiation in the *studiolo* is not arbitrary, but fulfils iconographic functions[125]. Most of the inscriptions are in Roman capitals, a style of lettering which the 15th century, with its interest in antiquity, was eager to revive. The solemn and dignified appearance of these characters (they were associated with inscriptions on monuments) rendered them appropriate for celebratory and "literary" contexts, whatever the language involved. Hence the use of Roman capitals for [VIR]GILIO[126], NON MAI, BI[BBIA][127], ·VIRTVTIBVS·ITVR·AD·ASTRA·, and IHC ANVORDAIT EN CROCISEM.

The inscription on the organ, IVHAИI CASTELAИO, also in classical lettering, needs to be commented upon. It was originally thought that it referred to the name of the leading *intarsiatore* of the study. De Fabriczy has instead shown that an organ bearing the same name is listed in the inventory of Lorenzo de' Medici's collection in the *Palazzo di via Larga*, and concluded that

Bulletin, XLV, 1963, pp. 1–17; J. SPARROW, *Visible Words*, Cambridge, 1969; M. WALLIS, "Inscriptions in Paintings", *Semiotica*, IX, 1973, pp. 1–28.

[123] This is in keeping with the artistic developments of the Renaissance. COVI ("Lettering" cit., pp. 12–5) and WALLIS (op. cit., pp. 3–4) remark that, while in the Middle Ages inscriptions were not normally connected to the narrative space of works of art, the main underlying concern being a didactic-devotional one, in the Quattrocento, with the rise of a more sensuous attitude to the depicted reality, they tended to be included "naturally" within such a space. These arguments of course run parallel to those of Panofsky's on the 15th century habit of camouflaging symbols.

[124] The interpretation of [...]TO as [SCO]TO requires an explanation. Since the book inscriptions appearing in twos on the bottom shelves of (d) and (e) correspond to some of the twin figures in the painted frieze (Homer/Virgil and Cicero/ Seneca), it is reasonable to suppose that the remaining ones too, on the top shelf of (e), may somehow echo some of the portraits above. BI[BBIA] can represent both Moses and Solomon, while [...]TO can refer to the only famous man in the study with the corresponding radical ending: Scotus. This author was, notably, one of Federico's favourites. The claim made by some scholars that [...]TO stands for [TACI]TO (cf. P. GHERARDI, "Lo studiolo di Federico III, 2° Duca d'Urbino", *Il Raffaello*, I, 1869, p. 66; MORACHIELLO, op. cit., p. 97) is unfounded. Other scholars have ignored the issue altogether, by referring only to the easily decipherable inscriptions (e.g. ROTONDI, *Il Palazzo Ducale* cit., I, p. 338; MICHELINI TOCCI, *Le tarsie* cit., back of 13th illustration).

[125] In this too, the Urbino decorations follow contemporary trends. COVI has shown that, unlike the medieval artist, who used the current script irrespective of the motif or the part of the picture on which the inscription was placed, and of the nature of the text, the Renaissance artist was aware of the connotations of the different styles of lettering, and used the latter accordingly. Cf. "Lettering" cit., pp. 13–7.

[126] It is surprising to find this and the other inscriptions on the books in Italian: one would expect them to be in Latin, like those of the painted frieze.

[127] *Studiolo* cit., p. 212 note 341.

Castelano must have been one of the most reputed organ makers of his time[128]. Thus what the "signature" in elegant Roman capitals[129] has done is turn a mere instrument into a prestigious *objet d'art*.

43, 60 The lettering of the words accompanying the scores on the music books is in humanistic script. The reason is a hierarchical one: this script (along with Gothic minuscules) tended to be used for book and scroll inscriptions not drawn from classical sources.

64 The text on the scroll in (t) is indecipherable, and most likely simulated. Perhaps the scroll is meant to allude to a military document (a *condotta*, for instance), since it is located in a section which

V, 58, 65 includes titles and other military motifs[130].

Writing contributes considerably to the leading aesthetic feature of the inlaid decorations: their playfulness. A number of word-games, some manifest, some well concealed may be traced.

V, 58 Section (t) accommodates a set of six drawers. Some are partly pulled open; one has been taken out

65 and placed on the side table. Four of the drawers visibly carry a label each on the front, with the

64 letters RI, DV, X, CO respectively. The top drawer is partly hidden by the scroll, the second one by a cloth on which the Collar of the Ermine has been placed. The arrangement is as follows:

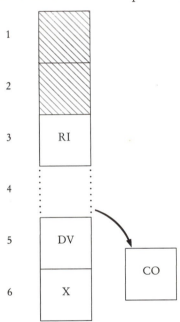

The word DVX, formed by the sequence of the 5th and 6th drawers of the set, leads one to expect the Prince's name. Our expectation is met by the obvious clues RI and CO. The syllables FE and DE are, no doubt, supposed to be on the partly-hidden top two drawers. The reconstructed phrase is of course: [FE][DE]RICO DVX[131].

A more complex word-play, inextricably dependent on an image, is provided by the letters FEDE

[128] Untitled review of E. MÜNZ's, *Les collections des Médicis au XVe siècle*, in *L'Arte*, I, 1888, p. 187.

[129] The reversal of the diagonal in the letter N (И) is, incidentally, of no iconographic significance: it is a corruption not uncommon in Quattrocento art. Cf. M. MEISS, "Towards a More Comprehensive Renaissance Paleography", in idem, *The Painter's Choice* cit., pp. 171–2.

[130] I am grateful to Dr. Gino Corti for kindly examining the text on the scroll, and offering the suggestions which I here repeat.

[131] This Italian-Latin hybrid is odd. It should of course be FEDERICVS DVX (Latin, nominative), or FEDERICO DVCE (Latin, dative), or FEDERICO DVCA (Italian).

inscribed on the four visible sides of the top of the ink-pot in (k). Since this implement has eight sides, we may speculate that the letters RICO are implied, to obtain FEDE[RICO][132]. The apparently accidental view of those sides of the ink-pot that allow us to read FEDE is an ingenious stratagem aimed at justifying the naming of the crucial Virtue of Faith without infringing naturalistic canons.

The play does not end here, for it should be noted that pen and ink-pot are attributes of the four Evangelists[133]. The religious element in the lower half of cupboard (k) is corroborated by the rosary. The personification of Faith is, most appropriately, present in the adjoining compartment (l).

The play on words FEDE/FEDERICO is of a type much favoured by Ficino[134]. In fact, by some happy coincidence, Ficino's dedication of his translation of Aristotle's *Politics* to the Duke contains a flattering pun not unlike that on the ink-pot: "Fideregus/fide regia"[135]. The *studiolo* pun need not of course be ascribed directly to the neo-Platonic philosopher, but to the tradition he set.

The decorations appear to boast an even more complex and obscure word-play: one in which visible letters play no part at all, and in which two apparently secondary elements – an *impresa* and a stylized motif – are involved. The bomb device in (f) presents formal similarities with the vegetal pattern on the pedestals that articulate the middle register of the inlays: the spherical shell, the spurting flames, the symmetrically undulating ribbons find a parallel in the "globe" of the fruit, with its drooping end and swaying stalk. Since the vegetal motif that articulates the lower band is an identifiable plant (the olive, as we have seen), it is reasonable to expect the other also not to be imaginary. The fruit in question is in fact a pomegranate[136]. In order to make the visual pun possible, the artist has represented the fruit at that time of its growth when it does resemble a grenade. The visual pun is closely tied to the linguistic one: both grenade and pomegranate were referred to as "granata"[137].

The pomegranate motif does not of course decorate the articulations of the middle register purely to permit the pun in (f); it should be related to the olive branch motif that correspondingly articulates the lower register: together, these translate symbolically the well-established twin ideal of *Pax et Concordia*[138].

The playful associations of words and images we find in Urbino, and the encomiastic functions they fulfil (they are all more or less directly centred on the Prince) bring to mind *imprese* and emblems; not so much the relatively simple ones of the Quattrocento, but those full of esoteric wit and erudition that delighted especially the 16th and 17th centuries[139].

[132] The word-play FEDE/FEDERICO was probably more immediately apprehensible in Federico's time than it is nowadays. BAXANDALL has noted how the Renaissance eye was especially predisposed to, and delighted in, gauging and seeking geometrical forms where these were merely hinted at (*Painting and Experience* cit., pp. 86–93); cf. esp. the part on Niccolò da Tolentino's hat, pp. 89, 91). The prompt perception of the top of the ink-pot as an eight-sided solid heightened the expectation of four other letters, and this led the 15th century onlooker to the word-play.

[133] HALL, op. cit., s.v. "Writer", pp. 344–5.

[134] See WIND, *Pagan Mysteries* cit., p. 72: "It was part of Ficino's epistolary style to embellish the names of his friends with puns – puns of an oracular or diagnostic jocularity, as if the nature of the man could be extracted from his name (quite possibly a mannerism adopted from Plato)."

[135] CHASTEL, *Art et humanisme* cit., p. 359.

[136] I am grateful to Mr. Green of the Royal Botanic Gardens of Kew, for identifying the motif.

[137] The pomegranate's full name in Italian was "melagranata"; "granata" was its ellipsis. Cf. BATTAGLIA, *Grande dizionario* cit., VI, 1970, p. 1033 No. 2; ibid., No. 5 for "granata" meaning "grenade".

[138] RUBINSTEIN, op. cit., pp. 186–7. For the association of Peace and Concord in literary works connected with Urbino, cf. LANDINO, op. cit., p. 718, and SANTI, op. cit., "Preambulo", Ch. IV, 9, p. 9. In the latter, Peace and Concord are accompanied by Charity.

[139] PRAZ, *Studies in 17th Century Imagery* cit. With their jocular and puzzling nature, some of the details in the Urbino study anticipate in particular the *imprese* that decorated Isabella d'Este's *camerini* in the Palace of Mantua. See, for instance, the number XXVII, which, read in the local dialect as "vinti sete", was meant as a witty reference to her defeated enemies.

The inclusion of playful elements in the *studiolo* need not surprise us: puns, witticisms and riddles were considered a manifestation of intelligence in the Renaissance. Castiglione states in the *Cortegiano*:

> ... tra l'altre piacevoli feste e musiche e danze che continuamente si usavano, talor si proponeano belle questioni, talor si faceano alcuni giochi ingeniosi ad arbitrio or d'uno or d'un altro, ne' quali sotto varii velami spesso scoprivano i circonstanti allegoricamente i pensier sui a chi più loro piaceva. Qualche volta nasceano altre disputazioni di diverse materie, o vero si mordea con pronti detti; spesso si faceano imprese, come oggidì chiamiamo; dove di tali ragionamenti maraviglioso piacere si pigliava per esser, come ho detto, piena la casa di nobilissimi ingegni[140].

Later, in the middle of a lengthy discussion on the subject of word-play and witticism, Bernardo Accolti is reported as saying:

> Delle facezie adunque pronte, che stanno in un breve detto, quelle sono acutissime, che nascono dalla ambiguità, benché non sempre inducano a ridere, perché più presto sono laudate per ingeniose che per ridicule[141].

The witty puzzles alleviate the otherwise sober character of the *studiolo* decorations. They also suggest that the spirit of the occupier of the room, when tired, could be restored through them[142]. That the Urbino *studiolo* was not meant for serious study only is indicated by the presence of the
V chessboard(?) and the pawns[143].

5. *Illusionism and Play*

The lifelikeness that has been aimed at in the marquetry designs is total. Care has been taken to include the temporal dimension too. This is expressed in various ways: through the general untidi-
V, VI, 58 ness of the room, suggesting that the Prince has just used the items that are scattered about and will
VII come back at any moment, as well as the nature of certain items, such as the living animals (squirrel,
63, VII, 47 parrots), the perishable fruits, the lit candle, the hourglass through which the sand is seen flowing,
63 and the clock.

The main aesthetic function of the illusionism is wit. Colie has remarked that the word "recreation" appropriately means "relaxation" as well as "remaking" and "imitation"[144]. Clearly, the trompe-l'œil is not a true deception, since the onlooker is aware of the "trickery", and is all too happy to go along with it[145].

While the decorations as a whole are playful, a few details are especially worth commenting on for their wit.

Cf. M. PRAZ, "The Gonzaga Devices", in D. S. CHAMBERS and J. MARTINEAUD eds., *Splendours of the Gonzaga*, Milan, 1981, p. 66.

[140] CASTIGLIONE, op. cit., Book I, Ch. V, p. 89.

[141] Ibid., Book II, Ch. LVIII, p. 280.

[142] The therapeutic function of play is stressed in Alberti's *Profugiorum ab Aerumna* ([C. GRAYSON ed.], *Opere volgari*, Bari, 1966, II, pp. 178–81), for instance. For the role of witticism and other intellectual play in the Renaissance, see G. LUCK, "Vir Facetus: a Renaissance Ideal", *Studies in Philology*, LV, 1958, pp. 107–21 (mostly on Pontano's treatise *De Sermone*); M. C. CLIFF, *The Intellectual Game in Italian Renaissance Culture 1400–1600*, M. Phil. Thesis, London Univ., 1974; various authors, *La lettre, la figure, le rébus dans la poétique de la Renaissance*, special issue of the *Revue des Sciences humaines*, No. 179, 1980, part III. For playfulness in art, cf. P. BAROLSKY, *Infinite Jest – Wit and Humor in Italian Renaissance Art*, Columbia–London, 1978.

[143] The presence of a game of chess in a study is not unusual: Piero de' Medici kept one in his *scrittoio*. Cf. LIEBENWEIN, op. cit., p. 76.

[144] *Paradoxia* cit., pp. 311–2.

[145] BRUSCHI, *Bramante architetto* cit., p. 82; J. BAUDRILLARD, *Le trompe-l'œil* (pamphlet published by the *Centro internazionale di semiotica e linguistica* of Urbino), Urbino, 1977, p. 5.

86

The oblong glass that hangs from the top of the pilaster between (n) and (o), as well as for the symbolic meaning already seen, may have been included in the decorations to playfully impress the onlooker: clearly, the representation of as smooth and transparent a material as glass, in one as rough and opaque as wood, is the paradox of illusionism pushed to the extreme[146]. 59

The preoccupation with naturalism has led the authors of the designs to compete with actual reality. The onlooker entering the study is confronted with a number of double motifs, and is almost challenged to guess which is the real and which is the illusionistic. Thus, the inlaid loggia in (h) faces the real one, which reveals itself when the door in (p) is opened. The lectern in (i) probably echoed an actual one used by Federico[147]. The inscription in (i) reflects that beneath the ceiling. In some instances, reality and illusion are made to interrelate: the real draughts entering the room through the door in (p) make the pages of the simulated book in (q) flap; the illusionistic latticed shutters on the right-hand side of the central pier can be opened: behind them are real cupboards. 49 — 58, 62, 52 — 52, II, III, IV — 58, V — 49

There are also a few simple illusionistic tricks related to anamorphosis. The lira da braccio and the lute depicted in (k) change form when we look at the wall at close range, moving from left to right, but only to give the impression that their necks follow us. The same applies to the projecting flute in (b)[148]. 54, 56 — 41, 45

Some other play involving illusion is clearly meant to appeal to, and delight, only the more alert onlooker. All the motifs in the upper portion of the marquetry at first sight appear as the simulation of a three-dimensional reality. This, in fact, is not true of all the compartments. Though, by analogy with the items in the cupboards, one is tempted to regard the personifications of the Virtues as solid, they and their niches have been meant as two-dimensional. To view them from an objective angle, they are illusionistic representations of perspective pictures, or images within images. This Chinese-box treatment is revealed by two elements: the hovering crown of Hope (which excludes the possibility that this figure may be a statue), and the patterned frames enclosing the compartments with the niches (these frames are unlike the simple ones surrounding the cupboards). It should be noted that the effigy of Federico, in (f), is to be considered as a statue rather than a painting, since its frame is identical to those of the cupboards. Thus, the whole inlaid frieze embodies, within its fictional world, two levels of reality: a first one constituted by the furniture with its implements, the animals, the fruits and the statue of Federico; and a second by the perfectly-integrated *imprese* and emblems, and the illusionistic pictures of the Virtues. Such cerebral play is worthy of the perspective tradition of Urbino[149]. 41, 54, 58 — 46, 57, 61 — 46 — 105

On the question of the viewer's predisposition in the perception of a work of art, see E. H. GOMBRICH, *Art and Illusion*, Oxford, 1960, Part III.

[146] On the question of the artist's challenge of the constraints imposed by the material, see GOMBRICH, *The Sense of Order* cit., Ch. III; esp. the following remark: "There are examples in the history of all crafts of this desire to press against the limitations of the material as far as is humanly possible and to put the victory of mind over matter to test. [...] The more recalcitrant the material the greater the triumph." (p. 65).

[147] ROTONDI claims that such a lectern must have been placed in the right-hand recess of the east wall: he has discovered that the cushion in (j) is the back of a folding bench which can be pulled down like a seat, while the cupboard beside it in (k) swings out and could have supported the lectern itself (cf. *Il Palazzo Ducale* cit., I, p. 455 note 204; *Francesco di Giorgio nel Palazzo* cit., pp. 34, 108–9). While I cannot think of an alternative function for the details in question, I find it difficult to believe that the lectern was located in such a confined and remote space. It is more likely to have been placed in the centre of the room, facing the real loggia – i.e. in the best-lit place in the *studiolo*. 49 — 52 — V

[148] F. LEEMAN, *Hidden Images. Games of perception. Anamorphic Art. Illusion*, New York, 1976, p. 32, Figs. 13–6. This optical effect is discussed by GOMBRICH in *Art and illusion* cit., pp. 96, 97 (Fig. 80), 234.

[149] For the representation of different levels of reality within the same figurative space, from the Quattrocento onwards, and its connection with the advances in perspective, see S. SANDSTRÖM, *Levels of Unreality*, Uppsala, 1963.

V. THE CEILING[1]

66 The ceiling decorations too are worthy of some iconographic comments, for the choice and arrangement of the symbols incorporated in the octagonal coffers are not haphazard.

It should be noted, first of all, that the emblems and devices have been arranged so that they may be easily "read" by the visitor who enters the room from the west door. This reinforces the claim that the east side is the most important one in the study, for the onlooker has to confront it before raising his head to the ceiling to read the symbols.

The selection of motifs on the ceiling closely adheres to that in the middle register of the marquetry. In both parts are depicted the ermine, the crane, the ostrich, the grenade, the Order of the Garter, the tongues of fire and the laurel; the twin spires and the brush have been excluded from both. Only the Order of the Ermine (as opposed to the device of the ermine) is present in the ceiling but not in the middle register; however it is prominently displayed in the portrait of the Prince in

105, V (f), and among the drawers in (t). The above suggests that the overall decorations were conceived coherently and interactively.

As for the arrangement of the individual symbols, the criteria adopted are of three types: formal, thematical and hierarchical.

An obvious formal feature is symmetry. The two diagonals and the axes mirror each other internally[2]. The top and bottom rows are reflections of each other. In fact, these might be treated as internally symmetrical too, on account of the considerable formal affinity of the crane and the ostrich, which are represented on the same scale (though not only here).

The most important motifs have been allocated privileged places. The flame emblems, with their blatant reference to the Prince (the monogram "f d") and their heraldic meaning of glory, occupy the corners; while the Collars of the Ermine and the Garters, which also carry the monogram and are hierarchically more important than the devices and the emblems, make up most of such prominent parts as the axes of the ceiling. Only the device of the ermine, beginning and ending the vertical axis, intrudes: other than being merely an *impresa*, it is formally discordant (its design is non-concentric). It should be noted, however, that it is thematically linked to its adjacent title: the Collar of the Ermine.

Finally, it may be suggested that the flame emblem has been made to confine (diagonally) with the bomb *impresa*, because the two symbols have fire in common; while the crane and the ostrich have been placed adjacently (again diagonally) in the south-eastern and north-western parts of the ceiling because they are both birds. The crane, the ermine and the ostrich, in the top and bottom rows, suit one another's company because they are all animals.

The presence of almost the entire range of Federico's titles, emblems and devices on the highest part of the room is appropriate. It may be treated as a visual translation of the motto on the

43 *cartellino*: ·VIRTVTIBVS·ITVR·AD·ASTRA·.

89 The Gubbio ceiling does not permit us to verify the iconographic points argued above, for its octagonal coffers incorporate not ducal symbols, but hanging rosettes.

[1] Though undocumented, the authorship of the coffered ceiling is generally attributed to the *bottega* of the da Maiano brothers, who executed a similar one for the *Sala dell' Udienza* in the Palazzo Vecchio in Florence. Cf. SALMI, op. cit., p. 119; PAPINI, op. cit., I, p. 136; ROTONDI, *Il Palazzo Ducale* cit., I, pp. 465–6 note 219.

[2] Because the south-western corner of the ceiling is cut off, a symbol had to be sacrificed, but we can safely assume that the emblem of the tongues of fire would have otherwise occupied the missing part.

... se le parole che usa il scrittore portan seco un poco, non dirò di difficultà, ma d'acutezza recondita, e non così nota come quelle che si dicono parlando ordinariamente, dànno una certa maggior autorità alla scrittura e fanno che 'l lettore va più ritenuto e sopra di sé, e meglio considera e si diletta dello ingegno e dottrina di chi scrive; e col bon giudizio affaticandosi un poco, gusta quel piacere che s'ha nel conseguire le cose difficili.

Baldassarre Castiglione[1]

... certain phenomena tend to vanish if we approach them without ceremony. To call a spade a spade may be a very good habit, but there would be no sense in pretending that discourse is confined to the nature of spades.

Edgar Wind[2]

VI. CONCLUSION

Painting, inlays and ceiling form a co-ordinated interacting complex. These parts harmonize both formally and ideologically.

Some of the connections have already been pointed out. The portraits on the north and east walls relate symmetrically to the intarsias below; while the range of titles, emblems and devices featured in the ceiling essentially reflects that depicted in the middle register of the intarsias. The books marked [VIR]GILIO and O[M]E[R]O, and TVLIO and [SE]NACA, figuring in twos in cupboards (d) and (e), echo the choice and the adjacent arrangement of the upper set of figures of the east wall. Those marked [SCO]TO and BI[BBIA], in cupboard (e), correspond to the portraits of Scotus, Moses and Solomon, also on the east wall. The actual sequences, however, do not coincide: SCO[TO] / BI[BBIA] differ from Moses/Solomon, [...] / Duns Scotus; so do [VIR]GILIO / O[M]E[R]O, TVLIO / [SE]NACA from Cicero/Seneca, Homer/Virgil[3]. Furthermore, the inscriptions are not located on the same side as the portraits they refer to. However, the two-tier cupboards parallel the double register of portraits; and just as above the religious personalities have been segregated from the lay ones, in the cupboards the volumes of Virgil, Homer, Cicero and Seneca occupy a different level from that in which one finds Duns Scotus and the Bible. The order of the levels is, however, inverted. In echoing part of the painted frieze (however inaccurately from a topographic standpoint[4]), the inscriptions fulfil an emphatic func-

[margin notes: 47 / 22, 21, 17, 18 / 47 / 24, 19, 20 / 47]

[1] *Il libro del Cortegiano* cit., Book I, Ch. XXX, p. 136.
[2] "The Eloquence of Symbols", *Burlington Magazine*, XCII, 1950, p. 349.
[3] I have listed the book inscriptions following what seems to me the most plausible orders: for the upper shelf (e), left to right; for the lower shelves (d) and (e), top to bottom.
[4] This "inaccuracy" was probably intended to give the echoes a less contrived and obvious character. The calculated spontaneity with which some of the authors in the upper frieze reappear in the inlays brings to mind a well-known extract from the *Cortegiano*, in which "sprezzatura" (effortlessness) is described as the basic principle underlying grace and 'true art':
... avendo io già più volte pensato meco onde nasca questa grazia, lasciando quelli che dalle stelle l'hanno, trovo una regola universalissima, la qual mi par valer circa questo in tutte le cose umane che si facciano o dicano più che alcuna altra, e ciò è fuggir quanto più si pò, e come un asperissimo e pericoloso scoglio, la affettazione; e, per dir forse una nova parola, usar in ogni cosa una certa sprezzatura, che nasconda l'arte e dimostri ciò che si fa e dice venir fatto senza fatica e quasi senza pensarvi. Da questo credo io che derivi assai la grazia; perché delle cose rare e ben fatte ognun sa la difficoltà, onde in esse la facilità genera grandissima maraviglia; e per lo contrario il sforzare e, come si dice, tirar per i capelli dà

tion, as well as a unifying one: they refer to all the characters but one (Thomas Aquinas) of the leading wall of the study[5].

Further iconographic relations between the painted frieze and the inlays may be traced. If the claim made earlier that the upper register of portraits includes the representatives of most of the Liberal Arts is correct, then these can be tied to the inlaid motifs that have been interpreted as symbols of the same set of disciplines. It might not be a coincidence that Euclid is placed directly above the *mazzocchio* and the other mathematical items in (k). Some of the portraits relate more convincingly to the appropriate motifs below. Cicero/Seneca and Moses/Solomon, symbols of enlightened statesmanship, are located on the very wall that accommodates the political metaphor of the squirrel, the basket of fruit and the landscape. It should also be remarked that these figures correspond to the recess with the armour-*vita activa*, just as Homer/Virgil and Thomas Aquinas/Duns Scotus correspond to that with the lectern-*vita contemplativa*.

The basic idea behind this scheme is not new. From the Middle Ages onwards, didactic cycles frequently depicted personifications of abstractions accompanied by their historical representatives[6]. The Spanish Chapel frescoes are an obvious example. The decorations of the *studiolo* may be treated as their poetical development. Instead of being rigidly twinned to the heroes, the personifications of abstractions have been reduced to their essence (the symbols), and loosely connected to them.

The adoption of symbols alone rather than full personifications in the intarsias (the Theological Virtues are an exception) has permitted the illustration of a richer programme, because more wall space has been made available and multiple levels of meaning could be ascribed to the motifs. Most of all, it has provided the decorations with their leading aesthetic feature – esotericism. The symbols (as well as the *imprese* and the classical allusions) express cryptically, for the delight of the *cognoscenti*, what could have been stated plainly. The taste for the refinedly obscure was rife in Renaissance courts, as the excerpt from the *Cortegiano* prefacing this chapter indicates. It matters little that the quotation refers to literature, for *acutezza recondita* was a quality much sought after in the visual arts as well. It is in the wake of this tradition that Paolo Giovio was to recommend that *imprese* – with which Renaissance works of art can be related – though not unpenetrable, should be inaccessible to the average man:

> Sappiate adunque, M. Lodovico mio, che l'inventione ò vero impresa [...] bisogna [...] ch'ella non sia oscura, di sorte ch'abbia mistero della Sibilla per interprete a volerla intendere, nè tanto chiara, ch'ogni plebeo l'intenda[7].

The authorship of the programme of the decorations is unknown, but Federico is most likely to have played a part in its formulation. He may have suggested the main themes (Liberal Arts, Virtues, Muses(?), the ideal of the two lives, etc.) to a court humanist, and asked him to develop a detailed programme from them. That even learned patrons relied on professional advisors is amply

somma disgrazia e fa estimar poco ogni cosa, per grande ch'ella si sia. Però si pò dir quella esser vera arte che non pare esser arte; né più in altro si ha da poner studio, che nel nasconderla: perché se è scoperta, leva in tutto il credito e fa l'omo poco estimato.

(Op. cit., Book I, Ch. XXVI, pp. 127–8).

[5] These correspondences have escaped all scholars. MICHELINI TOCCI does seem to have pondered over the selection of inscriptions, only to come to no conclusions: "Sui tagli di alcuni libri si leggono dei titoli: TVLIO (Tullio), (SE)NACA, (VIR)GILIO. Sono nomi famosissimi, scritti lì a caso e in volgare dall'artista, e non vogliono designare le letture preferite del duca: dovrebbe vedervisi, infatti, e in primo piano, *l'Etica* di Aristotele, la sua lettura quotidiana, il suo vero *livre de chevet*." (*Le tarsie dello studiolo* cit., back of 13th illustration). The above exemplarily illustrates the piecemeal way in which scholars have examined the decorations of the room.

[6] See the literature cited on p. 44 note 45.

[7] *Dialogo dell'imprese militari et amorose*, Lyons, 1559, p. 8. The extract is quoted and commented on in PANOFSKY, *The Iconography of Correggio's Camera* cit., pp. 1, 5, 30.

proven. It is known, for instance, that, though it was Leonello d'Este's idea to have the Muses represented in the Belfiore *studiolo*, the full iconographic programme was devised by Guarino da Verona[8]. Isabella d'Este frequently turned to Paride da Ceresara for the *invenzioni* she wanted to have pictorially translated[9].

The choice of many of the famous men is probably due to the Prince. The inclusion of his acquaintances and favourite authors suggests it. Federico's name appears in nineteen of the twenty-eight inscriptions to express gratitude, reverence, etc. By extension, Lavalleye concludes that the whole selection was made directly by the patron[10]. Yet, if we accept that part of the frieze embodies a programme, then a number of "choices" must have been determined by it. This is the case with Plato/Aristotle (Logic), Ptolemy (Astronomy) and Homer/Virgil (Poetry), for instance. If it was Federico's idea to have the Liberal Arts, etc. in the programme, then it would be more correct to say that he was responsible for the selection of some of the illustrious men indirectly.

The thoughtful topographic arrangement of the portraits and of the motifs in the inlays suggests that the devisor of the programme worked hand in hand with the artists. To conclude, it is reasonable to suppose that the Urbino decorations may be the result of a three-fold collaboration between patron, humanist adviser and artists[11].

It is worth stressing that, though the general programme consists essentially of a series of allegorical concepts and traditional ideals, the decorations cannot be termed didactic, for they lack a comprehensive philosophical system. They should be seen instead as the visual counterpart of eulogistic treatises, with their wealth of biographical data inextricably tied to *topoi* celebrating the ruler. This in no way diminishes the interest of the Urbino decorations, for, though the basic subject matter is, to some extent, a banal one (like that of most contemporary panegyrics), it has been treated most imaginatively.

As has already been remarked, the *studiolo* must have been shown to illustrious visitors, thus fulfilling a propaganda function. Clearly, for *magnificentia* to be of any political consequence, works of art needed to be displayed rather than secretely treasured. Federico did not keep coins and antiques in his study, as Piero de' Medici and Isabella d'Este did, but the perspective inlays are outstanding enough to guarantee ravished admiration. The portraits of the famous men do not impress us as much as the Mantegnas, the Perugino or the Correggios that decorated the *studiolo* of the Marchioness of Mantua, but Federico must have been proud to possess, and thus eager to show, these panels painted "con un maraviglioso artificio" by a "maestro solenne" invited all the way from Flanders[12]. The originality of the overall iconographic conception would have delighted the more subtle guest.

In a rhymed description of the Palace, the local poet Antonio di Francesco da Mercatello, known as il Temperanza, referred to the study of Urbino as the highlight of the building:

[8] A letter by Guarino to Leonello, with the iconographic suggestions for a cycle of the Muses, was first related to the *studiolo* of Belfiore Palace by BAXANDALL. Cf. "Guarino, Pisanello, Chrysoloras" cit., pp. 186–7.

[9] VERHEYEN, op. cit., passim.

[10] *Le Palais Ducal* cit., pp. 89–90.

[11] Who the humanist in question may be is a matter of pure speculation. A number of scholars were associated with the Montefeltro household (cf. FRANCESCHINI, *Figure del Rinascimento urbinate* cit., pp. 119–47; CLOUGH, "Federigo da Montefeltro's Patronage of the Arts" cit., pp. 133–7). LAVALLEYE has suggested that Veterano, Federico's scriptor and librarian, may be responsible for the *tituli* beneath the portraits in the Urbino study, on account of the fact that he produced the epigrams for the ducal library (*Le Palais Ducal* cit., p. 90). This suggestion is not unreasonable: NACHOD, op. cit., pp. 98–105, has argued that Veterano is the likely author of the Latin distichs that run along the upper end of the wainscoting of the Gubbio study. Clearly, though, it would be far-fetched to extend the hypothesis that the ducal librarian may have written the *tituli* for the Urbino *studiolo* to the whole programme of the decorations.

[12] VESPASIANO, op. cit., I, p. 384. It should be noted that the Flemish master is the only artist Vespasiano mentions in his *Vita*; even Piero is ignored.

78, 80, 83, 85

Se io potessi volentier voria
nominare ogni cosa . . .
E 'l studio che di tutti passa il segno[13].

It is praise that, from a more detached and academic standpoint, we would fully endorse: more than any single work of art from Urbino, the *studiolo* embodies the aesthetic, intellectual and moral achievements and aspirations of its outstanding patron.

[13] ROTONDI, *Il Palazzo Ducale* cit., I, pp. 291–2, 433 note 124. The *studiolo* is still the room of the Palace that impresses visitors most.

Nineteenth- and early twentieth-century accounts suggest that the *studiolo* of Gubbio too was traditionally regarded as the highlight of the building. Though unable to see the room, DENNISTOUN refers to it as "the most interesting feature of the palace" (op. cit., I, p. 173 note 1). JACKSON, op. cit., p. 196, notes: "This cabinet was one of the attractions which had drawn me to Gubbio, but I sought in vain for any trace of it." (Some dated drawings included in the volume indicate that he visited the town in 1888.) See also McCRACKEN's quotation prefacing Chapter II of this monograph.

APPENDIX A

Inscriptions beneath the famous men[1]

1. Platoni Atheniensi, humanae divinaeq[ue] philosophiae antistiti celeberrimo, Fed[ericus] dicavit ex observantia.
[To Plato of Athens, most famous high priest of human and divine philosophy, Federico dedicated this out of reverence.]
2. Aristoteli Stagiritae, ob philosophiam rite exacteq[ue] traditam, Fed[ericus] posuit ex gratitudine.
[To Aristotle of Stagira, for the philosophy handed down in the proper and exact manner, Federico placed this out of gratitude.]
3. Cl[audio] Ptolomaeo Alexandrino, ob certam astrorum dimensionem, inductasq[ue] orbi terrarum lineas[2], vigiliis laboriq[ue] aeterno Fed[ericus] dedit.
[To Claudius Ptolemy of Alexandria, for his precise measurement of the stars, and because he imposed lines on the earth[2], for his observations and everlasting toil Federico gave this.]
4. L[ucio][3] Boetio ob cuius commentationes Latini M[arcus] Varronis scholas non desiderant[4], Fed[ericus] Urb[ini] princeps pos[uit].
[To (Anicius Manlius Severinus) Boethius, on account of whose treatises the Latins do not feel the lack of the productions of Varro's leisure[4], Prince Federico of Urbino placed this.]
5. M[arco] Tullio Ciceroni, ob disciplinarum varietatem, eloquentiaeq[ue] regnum Fed[ericus] D[ux] dic[avit] P[atri] P[atriae] P[osuit] ex persuasione.
[To Marcus Tullius Cicero, proclaimed Father of his Country, for the variety of his learned activities and his command of eloquence, Duke Federico dedicated this out of (Cicero's) persuasiveness.]
6. Annaeo Sanecae Corduben[si] cujus praeceptis animus liberatur perturbationibus, excoliturq[ue] tranquillitas, Fed[ericus] erexit.
[To Annaeus Seneca of Cordoba, by whose precepts the spirit is freed from worries and calm cultivated, Federico erected this.]
7. Homero Smirnaeo, cujus poësin ob divinam disciplinarum varietatem[5] omnis aetas admirata est, assecutus nemo post, gratitudo pos[uit].
[To Homer of Smyrna, whose poetry, on account of the divine variety of its teachings[5], has been admired by every age, and equalled by no one afterwards, gratitude placed this.]

[1] Schrader's inscriptions are here listed as edited by LAVALLEYE (*Le Palais Ducal* cit., pp. 101–4). It should be noted that a comparison with the panels' extant texts indicates that Schrader's transcription is slightly inaccurate.
For early editions of the inscriptions, see Nathan CHYTRAEUS, *Monumenta selectiora inscriptionum recentium variorum in Europa itinerum deliciae*, Herborn, 1594, pp. 134–7, and Franciscus SWEERTIUS, *Selectae Christiani orbis deliciae ex urbibus, templis, bibliothecis et aliunde*, Cologne, 1608, pp. 129–32. Both Sweertius and Chytraeus rely on Schrader but list the inscriptions in an arbitrary order.
The dedications were also edited by BOMBE; cf. "Justus von Gent in Urbino" cit., pp. 118–22.
[2] The lines in question are those marking regions, and refer to Ptolemy's *Geography*.
[3] The initial "L" is a mistake, and so is Lavalleye's interpretation of it as "Lucius", since Boethius was called Anicius Manlius Severinus.
[4] Probably a reference to Varro's (lost) *Disciplinarum Libri IX*, an encyclopaedia of the Liberal Arts.
[5,7] "ob divinam disciplinarum varietatem" (inscription No. 7), "poeseos divinitate" and "furori sublimi" (inscription No. 8) express the neo-Platonic belief that high poetry is directly inspired by God. On the notion of *furor sublimi*, cf. E. R. CURTIUS, *European Literature and the Latin Middle Ages*, London, 1953, pp. 474–5; A. CHASTEL, *Marsile Ficin et l'art*, Paris, 1976 (2nd ed.), pp. 129–35; M. KEMP, "From 'Mimesis' to 'Fantasia': the Quattrocento Vocabulary of Creation, Inspiration and Genius in the Visual Arts", *Viator*, VIII, 1977, pp. 384–7.

8. Pup[lio] Vergilio Maroni Mantuano, ob illustrata numeris heroicis Rom[anorum] incunabula imperii[que] poeseos[6] divinitate Fed[ericus] dedit furori sublimi[7].
[To Publius Virgil Maro of Mantua, for making famous the origins of the Romans in heroic verses, and for the divinity of his poetry of Empire[6], Federico dedicated this to his sublime madness[7].]
9. Euclidi Megaren[si][8], ob comprehensa terrae spacia lineis centroq[ue] Fred[ericus] dedit, invento exactissimo.
[To Euclid of Megara[8], because he grasped the spaces of the earth by means of lines and the compass, Federico gave this for a most precise invention.]
10. Victorino Feltrensi, ob humanitatem literis exemploq[ue] traditam, Fred[ericus] praeceptori sanctiss[imo] pos[uit].
[To Vittorino of Feltre, very holy teacher, for communicating culture by his writings and example, Federico placed this.]
11. Soloni, ob leges Atheniens[ibus] traditas Rom[anarum] tabularum seminario sanctiss[imo][9], Fed[ericus] pos[uit] ex studio bene instituendorum civium.
[To Solon, because he handed down the laws of the Athenians, most holy source of the Tables of the Romans[9], Federico placed this out of enthusiasm for educating his citizens well.]
12. Bartholo Sentinati, acutissimo legum interpreti aequissimoq[ue], Fed[ericus] pos[uit] ex merito et justitia.
[To Bartolus of Sassoferrato, very acute and just interpreter of the laws, Federico placed this in accordance with his merit and justice.]
13. Hippocrati Coo, ob salubritatem humano generi datam, brevibusq[ue] demonstratam comprehensionibus, bonae posteritatis valetudo dicat.
[To Hippocrates of Cos, because he gave health to mankind and set it out in his aphorisms, the health of a fortunate posterity dedicates this.]
14. Petro Apono, medicorum arbitro aequiss[imo] ob remotiorum disciplinarum studium[10] insigne, Fed[ericus] poni cur[avit].
[To Pietro of Abano, the most fair-minded judge of physicians, on account of his distinguished study of the more recondite disciplines[10], Federico caused this to be erected.]
15. Gregorio, in coelum relato, ob morum sanctitatem, librorum quoq[ue] elegantiam testatam, gratitudo christiana memor erexit.
[To Gregory, taken up to Heaven, for his holy habits and the well-known elegance of his works, mindful Christian gratitude placed this.]
16. Hieronymo, ob fidei christianae praecepta, doctrina elegantiaq[ue] illustrata, Fed[ericus] aeternitatis gratia pos[uit].
[To Jerome, because he expressed the precepts of the Christian faith with learning and elegance, Federico placed this for the sake of eternity.]
17. Ambrosio, ob spretos fasces consulares[11], susceptum christianum nomen et ornatum latini sermonis jucunditate Fed[ericus] pos[uit].
[To Ambrose, for spurning the emblems of consular office[11], for adopting the name of Christianity, and adorning it with the beauty of Latin speech, Federico placed this.]

[6] "imperii poeseos" refers to the theme, expressed in the *Aeneid* (esp. Book VI, ll.851–3), that Rome's destiny is to govern the Empire.
[8] "Megaren[si]" is a well-established mistake: Euclid was often confused with the philosopher Eukleides of Megara, Plato's contemporary.
[9] A reference to the XII Tables containing Roman law.
[10] A likely reference to Pietro d'Abano's interest in astrology and the occult. Cf. L. THORNDIKE, *History of Magic and Experimental Science*, New York–London, 1923, II, pp. 888–913.
[11] Ambrose gave up the governorship of Aemilia-Liguria to which he was promoted in 370, to become Bishop of Milan in 374.

18. Augustino, ob sublimem doctrinam coelestiumque V. V. [-erborum *or* -irtutum] indagationem luculentissimam, post[eri] edecti (*sic*) f[ieri] c[uraverunt].

[To Augustine, for his sublime doctrine and for his distinguished search for celestial words (*or*: virtues), his well-educated[12] descendants caused this to be put up.]

19. Moysae Judaeo, ob populum servatum divinisq[ue] ornatum legibus posteritas christiana pos[uit].

[To Moses the Jew, for saving the people and providing them with divine laws, Christian posterity placed this.]

20. Solomoni, ob insigne sapientiae cognomen, Fed[ericus] homini divino p[oni] c[uravit].

[To Solomon, a divine man, because of his great name for wisdom Federico placed this.]

21. Thomae Aquin[ati], cujus divinitas philosoph[iae] theolog[iae]q[ue] commentationibus ornata est, dic[at] ob virtutem egregiam.

[To Thomas Aquinas, whose divinity was adorned with philosophical and theological treatises, (Federico) dedicated this for his outstanding virtue.]

22. Scoto, ob sublimes cogitationes, coelestiumq[ue] V.V. [-erborum *or* -irtutum] assectationes accuratiss[imas], Fed[ericus] doctori acutiss[imo] pos[uit].

[To Duns Scotus, most shrewd doctor, for his sublime thoughts and most diligent investigations of heavenly words (*or*: virtues), Federico set this up.]

23. Pio II Pontif[ici] Max[imo], ob imperium auctum armis, ornatumq[ue] eloquentiae signis, Fed[ericus] pos[uit], magnitudini animi laboribusq[ue] assiduis.

[To Pope Pius II, because he increased his realms by war and adorned it with the marks of eloquence, Federico set this up to his magnanimity and unceasing labours.]

24. Bessarioni, Graeci Latini[que] conventus pacificatori[13], ob summam gravitatem doctrinaeq[ue] excellentiam, Fed[ericus] amico sapientiss[imo] optimoq[ue] posuit.

[To Bessarion, the peace-maker of the Graeco-Latin Conference[13], and wisest and best of friends, for his outstanding authority and excellence of teaching, Federico placed this.]

25. Alberto Magno, ob res naturales aemulatione Aristotelica perquisitas, immensis voluminibus posteritati curae s[anctissi]mae bene m[erenti] pos[uit].

[To Albertus Magnus, because he investigated the natural phenomena in emulation of Aristotle, in immense volumes, as a most holy concern for posterity Federico set this up for one who deserved it well.]

26. Xysto IIII Pontif[ici] Max[imo], ob philosophiae theologiaeq[ue] scientiam ad pontificatum traducto dic[at] benignitati immortali.

[To Pope Sixtus IV, because of his knowledge of philosophy and theology when he became Pope, (Federico) dedicated this to his undying kindness.]

27. Danti Antignio[14], ob propagatos numeros poëticamq[ue] varia doctrina populo perscriptam, posita benem[erenti].

[To Dante Alighieri, who deserves well on account of the verses he produced and the poetry he wrote for the people, with diverse learning, this was set up.]

28. Petrarchae, ob acerrimum ingenium, suaviss[imae]q[ue] ingenuitatis doctrinam, posteritatis laeticia lususque dicavere b[ene]m[erenti].

[To Petrarch, who deserved well for his very keen intellect and the most delightful candour of his learned activities, the merry playfulness of posterity placed this.]

[12] Reading "edocti".

[13] A reference to his role in the Council of Ferrara-Florence, in which he supported the union with the Greek Church.

[14] "Antignio" is a surprising corruption of "Alighieri", and so is the word actually on the panel: "Antigerio".

APPENDIX B

Texts on the books of the famous men.

12 The text on Jerome's book reads as follows (its sources are given on the right)[1].

Folio 1, left-hand column:

Line	1: Deus: in: nomine tuo: salvum: me	Psalm 53, verses 3–4
	2: [Coram?]: Deo: verrute (sic): tua: judica: me	
	3: Auribus: percipes: verba oris	
	4: Mei: / / Juravit: Dominus: et non	109, verse 4
	5: Paenitebit: eum: et: tu: es sacer-	
	6: dos: in eternum: / / Secundum magnam	50, verse 1
	7: Misericorcordiam (sic): tuam/ /	
	8: De torrente in: via: via (sic) bibet	109, verse 7
	9: Et: propterea: et: exaltabit: ca-	
	10: Caput. / / Memoria: eterna: erit	111, verse 7
	11: Justus: ab auditione: mala:	
	12: Non timebit. / / et ...	42, verse 3
	13: Tua: et: veritatem: tuam:	
	14: ... ipsa: me deduxerunt.	

The words on the remaining lines are illegible.

Folio 1, right-hand column:
Only the words "Deus" (line 1), "Deus meus" (line 6) and "Dominus meus" (line 7) are distinguishable.

Folio 2, left-hand column, second paragraph:

Line	1: Deus in:	
	2: rum	
	3: : / / bene	Psalm 117, verse 26
	4: dictus: qui: venit:	
	5: in: nomine: Domini	
	6: Bene [diximus]	

Folio 2, right-hand column:
Only the words "illuminans" (first paragraph, line 2) and "erunt imper ..." (second paragraph, line 1) can be distinguished.

31 The following text is discernible on Albertus Magnus's manuscript[2].

[1] The transcription and the indication of the sources are drawn from J. LAVALLEYE, *Juste de Gand, peintre de Frédéric de Montefeltre*, Louvain, 1936, pp. 131–2.

[2] Reproduced from LAVALLEYE, *Le Palais Ducal* cit., pp. 67–8. J. ALLENDE SALAZAR has remarked that the text on the second folio is Castilian, and treated this as evidence that the cycle of famous men was painted by Berruguete. Cf. "Pedro Berruguete en Italia", *Archivo español de arte y arqueologia*, II:, 1927, p. 135. F. J. SANCHEZ CANTON has argued in a review of a study by Lavalleye, in *Archivo español de arte y arqueologia*, XXVI, 1933, pp. 147–8, that the phrase "mundo malo mundo falso" echoes a line from the *Doctrinal de privados fecho a la muerte del Maestre de Santiago don*

Folio 1, first paragraph:
Line 1: Dominus Psalm 30, verse 6
 2: : michi non est
 3: : in: manus:
 4: tuas Domine comendo spiritum
 5: meum: redemiste m[e]
 6: Domine: Dominus (*sic*): verit[atis]:
 7: Amen.amen.alel[uia] [ale-]
 8: luia.

Folio 1, second paragraph:
Line 1: Domine Deus ...
 2: Mundum ...

Folio 2
Line 1: mundo: malo: mundo: falso
 2: de: todo: bien: me
 3: quien: trae ...
 4: miror: hustado [?]
 5: trae: grande
 6: por ande
 7: porque

Solon and Augustine too hold books with legible scripts. However, with the exception of a "patri" 29, 16
on Solon's manuscript (folio 2, line 2), no words can actually be made out[3].

Alvaro de Luna, the major work of Inigo LOPEZ DE MENDOZA, who died in 1458.
For the interpretation of the Castilian text as a reference to Albertus Magnus's stand against the Hispano-Arab commentators of Aristotle, mentioned before (p. 40), see LAVALLEYE, *Juste de Gand* cit., pp. 130–1.
[3] I am grateful to Dr. Gino Corti of the Harvard Center for Italian Renaissance Studies in Florence, for kindly examining these texts for me. His conclusion is that they were meant to have only a semblance of Latin.

BIBLIOGRAPHY

Primary Sources

P. ALATRI ed.	*Federico da Montefeltro. Lettere di Stato e d'Arte (1470–1480)*, Rome, 1949.
L. B. ALBERTI	*L'Architettura* (G. ORLANDI ed.), Milan, 1966, 2 vols.
L. B. ALBERTI	*Profugiorum ab Aerumna*, in C. GRAYSON ed., *Opere volgari*, Bari, 1966, II, pp. 105–83.
ARISTOTLE	*Nicomachean Ethics*, Cambridge, Mass., 1962 (Loeb Classical Library).
ARISTOTLE	*Politics*, Cambridge, Mass., 1959 (Loeb Classical Library).
B. BALDI	*Della vita e de' fatti di Federigo di Montefeltro, duca di Urbino (1604)* (F. ZUCCARDI ed.), Rome, 1824, 3 vols.
B. BALDI	*Descrizione del Palazzo Ducale di Urbino*, in idem, *Memorie concernenti la città di Urbino*, Rome, 1724 (facsimile ed., Bologna, 1978).
V. DA BISTICCI	*Le vite* (A. GRECO ed.), Florence, 1970–76, 2 vols.
A. BRUSCHI C. MALTESE M. TAFURI and R. BONELLI eds.	*Scritti rinascimentali di architettura*, Milan, 1978.
B. CASTIGLIONE	*Il libro del Cortegiano* (B. MAIER ed.), Turin, 1981.
P. DE CESPEDES	*Discurso de la comparación de la antigua y moderna pintura y escultura* (S. CANTON ed.), Madrid, 1933, II.
D. S. CHAMBERS ed.	*Patrons and Artists in the Italian Renaissance*, London, 1970.
N. CHYTRAEUS	*Monumenta selectiora inscriptionum recentium variorum in Europa itinerum deliciae*, Herborn, 1594.
CICERO	*Letters to his Friends*, Cambridge, Mass., 1959 (Loeb Classical Library), 3 vols.
FILARETE	*Trattato di Architettura* (A. M. FINOLI and L. GRASSI eds.), Milan, 1972, 2 vols.
G. GAUGELLO DELLA PERGOLA	*De vita et morte ill.mae. D. Baptistae Sfortiae Comitissimae Urbini* (A. CINQUINI ed.), Rome, 1905.
SER GUERRIERO DA GUBBIO	*Cronaca 1350–1472* (G. MAZZATINTI ed.), Città di Castello, 1902.
C. LANDINO	"Disputationes camaldulenses. De vita activa et contemplativa", in E. GARIN ed., *Prosatori latini del Quattrocento*, Milan, 1952, pp. 716–91.
N. MACHIAVELLI	*Opere di Niccolò Machiavelli* (E. RAIMONDI ed.), Milan, 1966.
G. MUZIO	*Historia de' fatti di Federico da Montefeltro, duca di Urbino*, Venice, 1605.
OVID	*Heroides and Amores*, Cambridge, Mass., 1963 (Loeb Classical Library).
P. PALTRONI	*Commentari della vita et gesti dell' illustrissimo Federico Duca d'Urbino* (W. TOMMASOLI ed.), Urbino, 1966.
PIUS II	"Commentarii rerum memorabilium", in E. GARIN ed., *Prosatori latini del Quattrocento*, Milan, 1952, pp. 663–87.
PIUS II	*Memoirs of a Renaissance Pope. The Commentaries of Pius II* (L. C. GABEL ed.), London, 1960.
PLATO	*The Republic*, Cambridge, Mass., 1963 (Loeb Classical Library), 2 vols.
PLINY THE YOUNGER	*Letters*, Cambridge, Mass., 1951 (Loeb Classical Library), 2 vols.
F. PRENDILACQUA	"De Vita Victorini Feltrensis Dialogus", in E. GARIN ed., *Il pensiero pedagogico dell'Umanesimo*, Florence, 1958, pp. 552–667.
QUINTILIAN	*Institutio oratoria*, Cambridge, Mass., 1951 (Loeb Classical Library), 4 vols.
C. RIPA	*Iconologia: overo Descrittione di diverse Imagini cavate dall' antichità, & di propria inventione*, Rome, 1603 (facsimile ed., New York, 1970).
G. RUCELLAI	*Giovanni Rucellai e il suo Zibaldone* (A. PEROSA ed.), London, I, 1960.
G. SABADINO DEGLI ARIENTI	*Art and Life at the Court of Ercole I d'Este: The 'De triumphis religionis' of Giovanni Sabadino degli Arienti* (W. K. GUNDERSHEIMER ed.), Geneva, 1972.
G. SABADINO DEGLI ARIENTI	*Gynevera. De le clare donne* (C. RICCI and A. BACCHI DELLA LEGA eds.), Bologna, 1969 (reprint of the 1887 ed.).

98

G. Santi	*Federigo di Montefeltro duca di Urbino. Cronaca* (H. Holtzinger ed.), Stuttgart, 1893.
L. Schrader	*Monumentorum Italiae, qua hoc nostro saeculo et a Christianis posita sunt*, Hemelstadt, 1592.
F. Sweertius	*Selectae Christiani orbis deliciae ex urbibus, templis, bibliothecis et aliunde*, Cologne, 1608.
G. Vasari	*Le Vite* (G. Milanesi ed.), Florence, 1906, 9 vols.
M. F. de' Vieri, detto Il Verino Secondo	*Discorsi delle Maravigliose Opere di Pratolino, & d'Amore*, Florence, 1582.
Virgil	*Aeneid VII–XII. The Minor Poems*, Cambridge, Mass., 1966 (Loeb Classical Library).

Secondary Sources

A. M. Adorisio	"Aspetti tipologici di legature feltresche". Paper read at the 1982 conference on Federico, forthcoming in the proceedings.
J. Alazard	"Sur les hommes illustres", in *Il mondo antico nel Rinascimento*, Florence, 1958, pp. 275–7.
A. Alföldi	"'Hasta – Summa Imperii'. The Spear as Embodiment of Sovereignty in Rome", *American Journal of Archaeology*, LXIII, 1959, pp. 1–27.
J. Allende Salazar	"Pedro Berruguete en Italia", *Archivo español de arte y arqueologia*, III, 1927, pp. 133–8.
M. V. Alpatov	"Allegory and Symbolism in Italian Renaissance Painting", *Diogenes*, XIX, 1971, pp. 1–25.
P. D'Ancona	"Le rappresentazioni allegoriche delle arti liberali nel Medio Evo e nel Rinascimento", *L'Arte*, V, 1902, pp. 137–55, 211–28, 269–89, 370–85.
R. Antonelli	"L'Ordine domenicano e la letteratura nell' Italia pretridentina", in A. Asor Rosa ed., *Letteratura italiana*, Turin, I, 1982, pp. 681–728.
F. Arcangeli	*Tarsie*, Rome, 1942.
M. Aronberg Lavin	"The Altar of Corpus Domini in Urbino: Paolo Uccello, Joos van Ghent, Piero della Francesca", *Art Bulletin*, XLIX, 1967, pp. 1–24.
M. Aronberg Lavin	"Piero della Francesca's Montefeltro's Altarpiece: A Pledge of Fidelity", *Art Bulletin*, LI, 1968–69, pp. 367–71.
A. Bacchiani	"I quadri Barberini passati allo Stato e lo 'studiolo' del Duca d'Urbino", *Giornale d'Italia*, 31. 5. 1934.
G. Baldassarri	"Alle origini del mito feltresco: la 'Vita di Federico' di Vespasiano da Bisticci". Paper read at the 1982 conference on Federico, forthcoming in the proceedings.
R. Barthes	*Camera Lucida*, New York, 1981.
E. Battisti	"Non chiare acque", in A. Scaglione ed., *Francis Petrarch, Six Centuries Later. A Symposium*, Chapel Hill–Chicago, 1975 pp. 305–39.
E. Battisti	*Piero della Francesca*, Rome, 1971, 2 vols.
J. Baudrillard	*Le trompe-l'œil* (pamphlet published by the *Centro internazionale di semiotica e linguistica* of Urbino), Urbino, 1977.
M. Baxandall	*Giotto and the Orators*, Oxford, 1971.
M. Baxandall	"Guarino, Pisanello and Manuel Chrysoloras", *Journal of the Warburg and Courtauld Institutes*, XXVIII, 1965, pp. 183–204.
M. Baxandall	*Painting and Experience in 15th Century Italy*, Oxford, 1974.
L. Becherucci and C. Gnudi	*Mostra di Melozzo e del Quattrocento romagnolo*, Forlì, 1938.
L. Benevolo	"Il palazzo e la città". Paper presented at the 1982 conference on Federico, forthcoming in the proceedings.
T. G. Bergin	*Petrarch*, New York, 1970.
I. Bergström	*Dutch Still-Life Painting in the Seventeenth Century*, New York, 1983 (reprint of the British ed. of 1956).
I. Bergström	"Medicina, Fons et Scrinium. A Study in Van Eyckean Symbolism and its Influence in Italian Art", *Konsthistorisk Tidskrift*, XXVI, May 1957, pp. 1–20.
I. Bergström	"On Religious Symbols in European Portraiture of the XVth and XVIth Centuries", in E. Garin *et al.*, *Umanesimo e esoterismo*, Padua, 1960, pp. 335–43.

I. Bergström	*Revival of Antique Illusionistic Wall-Painting in Renaissance Art*, Göteborg, 1957.
D. Bernini ed.	*Palazzo ducale di Urbino. Storia di un Museo*, Urbino, 1977.
S. Bettini	*Giusto de' Menabuoi e l'arte del Trecento*, Padua, 1944.
B. Biagetti	"Una nuova ipotesi intorno allo studio e alla cappella di Niccolò V nel Palazzo Vaticano", *Atti della Pontificia accademia romana d'archeologia – Memorie*, III, 1932–33, pp. 205–14.
M. Bishop	*Petrarch and his World*, London, 1964.
J. Blades	*Percussion Instruments and their History*, London, 1970.
E. Blom ed.	*Grove's Dictionary of Music and Musicians*, London, 1954–61, 10 vols.
W. Bombe	"Justus von Gent in Urbino: das Studio und die Bibliothek des Herzogs Federigo da Montefeltre", *Mitteilungen des Kunsthistorischen Institutes in Florenz*, III, 1909, pp. 111–36.
W. Bombe	"Die Kunst am Hofe Federigos von Urbino", *Monatshefte für Kunstwissenschaft*, V, 1912, pp. 456–74.
W. Bombe	"Una ricostruzione dello Studio del duca Federigo ad Urbino", *Rassegna Marchigiana*, VIII, 1929, pp. 73–88.
W. Bombe	"Une reconstitution du studio du Duc Frédéric d'Urbin", *Gazette des Beaux-Arts*, IV, 1930, pp. 266–75.
S. Bongi	*Di Paolo Guinigi e delle sue ricchezze*, Lucca, 1871.
E. Borsook	"A Florentine 'scrittoio' for Diomede Carafa", in M. Barash and L. F. Sandler eds., *Art the Ape of Nature. Studies in Honor of H. W. Janson*, New York, 1981, pp. 91–6.
C. Del Bravo	"La dolcezza dell' immaginazione", *Annali della Scuola Normale Superiore di Pisa. Classe Lettere e Filosofia*, VII, 1977, pp. 759–99.
C. M. Brown	"'Lo insaciabile desiderio nostro de cose antique'. New documents on Isabella d'Este's collection of antiquities", in C. H. Clough ed., *Cultural Aspects of the Italian Renaissance – Essays in Honour of Paul Oscar Kristeller*, Manchester, 1976, pp. 324–53.
A. Bruschi	*Bramante architetto*, Bari, 1969.
A. Bruschi	*Bramante*, London, 1977.
C. Budinich	*Il Palazzo Ducale d'Urbino*, Trieste, 1904.
C. Budinis	"Progetto di restauro del Palazzo Ducale di Gubbio – Relazione tecnica", *Bollettino d'Arte*, XI, 1934, pp. 527–34.
W. A. Bulst	"Die Ursprüngliche Innere Aufteilung des Palazzo Medici in Florenz", *Mitteilungen des Kunsthistorischen Institutes in Florenz*, XIV, 1970, pp. 369–92.
P. Burke	*Tradition and Innovation in Renaissance Italy*, London, 1974.
G. Cairo	*Dizionario ragionato dei simboli*, Bologna, 1967.
M. Calvesi	"Vita e morte nello studiolo di Federico da Montefeltro", *Corriere della Sera*, 8. 7. 1973, p. 13.
E. Calzini	"L'Apollo e le Muse dello 'studiolo' del duca di Urbino", *L'Arte*, XI, 1908, pp. 225–9.
L. Campbell	*The Early Flemish Pictures in the Collection of Her Majesty the Queen* (forthcoming).
L. Castelfranchi Vegas	*Italia e Fiandra nella pittura del Quattrocento*, Milan, 1983.
P. Castelli	"Matematici e astrologia alla corte dei Montefeltre". Paper read at the 1984 Frankfurt symposium on *Naturwissenschaft und Naturbeobachtung*, forthcoming in the proceedings.
B. Cenni	*Un manoscritto inedito per il Palazzo Ducale di Gubbio. Un intervento di diagnostica a stima visiva per il restauro del Palazzo Ducale eugubino, sec. XVII*, Gubbio, 1982.
A. Chastel	*Art et humanisme à Florence au temps de Laurent le Magnifique*, Paris, 1982 (3rd ed.).
A. Chastel	"Gesture in Painting: Problems in Semiology". Paper read at the 1983 Toronto colloquium on *The Language of Gestures in the Renaissance*, forthcoming in the proceedings.
A. Chastel	"Les marqueteries en trompe-l'œil des 'studioli' d'Urbin et de Gubbio", *Art et décoration*, XVI, Febr. 1950, pp. 13–7.
A. Chastel	"Marqueterie et perspective au XVe siècle", *La revue des Arts*, III, 1953, pp. 141–54. (Also in idem, *Fables, formes, figures*, Paris, 1978, I, pp. 316–32.)
A. Chastel	"Marqueterie, géometrie et perspective", in idem, *Renaissance méridionale. Italie 1460–1500*, Paris, 1965, pp. 244–63.

A. Chastel	*Marsile Ficin et l'art*, Paris, 1976 (2nd ed.).
A. Chastel	"Sémantique de l'index", *Storia dell'arte*, No. 40, 1980, pp. 415–7.
A. Chastel	"The Studiolo", in idem, *The Myth of the Renaissance, 1420–1520*, Geneva, 1969, pp. 167–9.
A. Chatelet	"Pedro Berruguete et Juste de Gand", in *Actas del XXIII Congreso Internacional de Historia del Arte: España entre el Mediterraneo y el Atlantico*, Granada, 1976, I, pp. 335–43.
L. Cheles	"La decorazione dello studiolo di Federico da Montefeltro a Urbino: problemi ricostruttivi", *Notizie da Palazzo Albani*, X, 1981, pp. 15–21.
L. Cheles	"The Inlaid Decorations of Federico da Montefeltro's Urbino 'Studiolo': An Iconographic Study", *Mitteilungen des Kunsthistorischen Institutes in Florenz*, XXVI, 1981, pp. 1–46.
L. Cheles	"Federico Dux", *F.M.R.*, 12, 1983, pp. 108–20.
L. Cheles	"The 'Uomini Famosi' in the 'Studiolo' of Urbino: an Iconographic Study", *Gazette des Beaux-Arts*, CII, 1983, pp. 1–7.
O. Chomentovskaja	"Le comput digital. Histoire d'un geste dans l'art de la Renaissance italienne", *Gazette des Beaux-Arts* (6th series), XX, 1938, pp. 157–72.
M. G. Ciardi Duprè Dal Poggetto and P. Dal Poggetto eds.	*Urbino e la Marche prima e dopo Raffaello*, Florence, 1983.
B. Ciati	"Cultura e società nel secondo Quattrocento attraverso l'opera ad intarsio di Lorenzo e Cristoforo da Lendinara", in M. Dalai Emiliani ed., *La prospettiva rinascimentale*, Florence, I, 1980, pp. 201–14.
B. Ciati	*Il significato dell'opera ad intarsio nella cultura e nella società del secondo Quattrocento attraverso l'opera dei fratelli Lendinara*, Degree Thesis, State Univ. of Milan, 1974–75.
M. A. Ciccarone	*I cicli degli uomini illustri nel Rinascimento italiano*, Degree Thesis, Rome Univ., 1982–83.
C. Cieri Via	"L'idea di microcosmo come forma simbolica nella cultura urbinate del '400", in M. Apa ed., *Microcosmo/Macrocosmo*, Urbino, 1984, pp. 16–7.
C. Cieri Via	"Ipotesi di un percorso funzionale e simbolico nel Palazzo Ducale attraverso le immagini". Paper read at the 1982 conference on Federico, forthcoming in the proceedings.
C. M. Cipolla	*Clocks and Culture 1300–1700*, London, 1967.
P. Ciuferri	"I restauri nel Palazzo Ducale di Gubbio", *Antiqua*, III, 1976, pp. 54–60.
K. Clark	*Piero della Francesca*, London, 1969 (2nd ed.).
M. C. Cliff	*The Intellectual Game in Italian Renaissance Culture 1400–1600*, M. Phil. Thesis, London Univ., 1974.
C. H. Clough	"Cardinal Bessarion and Greek at the Court of Urbino", *Manuscripta*, VIII, 1964, pp. 160–71. (Also, with additions and corrections, in idem, *The Duchy of Urbino in the Renaissance*, London, 1981, item VII.)
C. H. Clough	*The Duchy of Urbino in the Renaissance*, London, 1981.
C. H. Clough	"Federigo da Montefeltro's Artistic Patronage", *Journal of the Royal Society of Arts*, CXXVI, 1978, pp. 718–34. (Also, with additions and corrections, in idem, *The Duchy of Urbino in the Renaissance*, London, 1981, item IX.)
C. H. Clough	"Federigo da Montefeltro: the Good Christian Prince", *Bulletin of the John Rylands University Library of Manchester*, LVII, 1984, pp. 293–348.
C. H. Clough	"Federigo da Montefeltro's Patronage of the Arts, 1468–1482", *Journal of the Warburg and Courtauld Institutes*, XXXVI, 1973, pp. 129–44. (Also, with additions and corrections, in idem, *The Duchy of Urbino in the Renaissance*, London, 1981, item VIII.)
C. H. Clough	"Federico da Montefeltro's Private Study in his Ducal Palace of Gubbio", *Apollo*, LXXVI, 1967, pp. 278–87.
C. H. Clough	"The Library of the Dukes of Urbino", *Librarium*, IX, 1966, pp. 101–5, 192. (Also, with additions and corrections, in idem, *The Duchy of Urbino in the Renaissance*, London, 1981, item VI.)
C. H. Clough	"Pedro Berruguete and the Court of Urbino: a Case of Wishful Thinking", *Notizie da Palazzo Albani*, III, 1, 1974, pp. 1–10. (Republished, in reset form with additions, in idem, *The Duchy of Urbino in the Renaissance*, London, 1981, item X.)

C. H. CLOUGH | "Piero della Francesca – Some Problems of his Art and Chronology", *Apollo*, XCVIII, 1970, pp. 278–89.

C. H. CLOUGH | "The Relations between the English and Urbino Courts, 1474–1508", *Studies in the Renaissance*, XIV, 1967, pp. 202–18. (Also, with additions and corrections, in idem, *The Duchy of Urbino in the Renaissance*, London, 1981, item XI.)

C. H. CLOUGH | "Sources for the Economic History of the Duchy of Urbino, 1474–1508", *Manuscripta*, X, 1966, pp. 3–27.

C. H. CLOUGH | "Lo studiolo di Gubbio". Paper read at the 1982 conference on Federico, forthcoming in the proceedings.

C. H. CLOUGH | "Towards an Economic History of the State of Urbino at the Time of Federigo da Montefeltro and of his Son, Guidobaldo", in L. DE ROSA ed., *Studi in memoria di Federigo Melis*, Naples, 1978, III, pp. 469–504. (Also, with additions, in C. H. Clough, *The Duchy of Urbino in the Renaissance*, London, 1981, item III.)

R. L. COLIE | *Paradoxia Epidemica. The Renaissance Tradition of Paradox*, Princeton, N.J., 1966.

D. COMPARETTI | *Vergil in the Middle Ages*, London, 1966 (reprint of the 2nd ed. of 1908).

A. CONTI | "Le prospettive urbinati: tentativo di un bilancio ed abbozzo di una bibliografia", *Annali della Scuola Normale Superiore di Pisa*, VI, 1976, pp. 1193–1234.

F. COSSTICK | "Federico da Montefeltro, Duke of Urbino, K. G.", *Report of the Society of the Friends of St. George and the Garter*, VI, 1980–81, pp. 65–9.

D. A. COVI | *The Inscriptions in Fifteenth Century Florentine Painting*, Ph. D. Thesis, Institute of Fine Arts, New York University, 1958.

D. A. COVI | "Lettering in Fifteenth Century Florentine Painting", *Art Bulletin*, XLV, 1963, pp. 1–17.

E. R. CURTIUS | *European Literature and the Latin Middle Ages*, London, 1953.

F. CUSIN | *La personalità storica dei duchi di Urbino*, Urbino, 1970.

M. DALY DAVIES | "Carpaccio and the Perspective of Regular Bodies", in M. DALAI EMILIANI ed., *La prospettiva rinascimentale*, Florence, 1980, I, pp. 183–200.

C. V. DAREMBERG and E. SAGLIO eds. | *Dictionnaire des antiquités grècques et romaines*, Paris, 1877–1919, 5 vols.

M. DAVIES | *Early Netherlandish School. National Gallery Catalogues*, London, 1945, 1955 and 1968.

M. DAVIES | *Les primitifs flamands. I. Corpus de la peinture des anciens Pays-Bas méridionaux au 15e siècle. The National Gallery*, Antwerp, 1953.

M. DAZZI | *Leonardo Giustinian, poeta popolare d'amore*, Bari, 1934.

B. DEGENHART and A. SCHMITT | *Corpus der Italienischen Zeichnungen, 1300–1450*, Berlin, 1968, Part I, vols. II and IV.

J. DENNISTOUN | *Memoirs of the Dukes of Urbino* (E. HUTTON ed.), London, 1909, 3 vols (first published in 1851).

B. DISERTORI | "Prime versioni a tre voci della canzone 'J'ay prins amours'", in idem, *La musica nei quadri antichi*, Calliano (Trento), 1978, pp. 41–8.

L. DONATI | "Le fonti iconografiche di alcuni manoscritti urbinati della Biblioteca Vaticana. Osservazioni intorno ai cosiddetti 'Tarocchi del Mantegna'", *La Bibliofilia*, LX, 1958, pp. 48–129.

R. DUBOS | *Giovanni Santi, peintre et chroniqueur à Urbin au XVe siècle*, Bordeaux, 1971.

L. DUSSLER | *Raphael*, London-New York, 1971.

J. EECKOUT | *Juste de Gand, Berruguete et la cour d'Urbino*, Gand, 1957.

C. ELAM | *Studioli and Renaissance Court Patronage*, M. A. Report, Courtauld Institute of Art, London Univ., 1970.

A. K. EÖRSI | "Lo studiolo di Leonello d'Este e il programma di Guarino da Verona", *Acta Historiae Artium Academiae Scientiarum Hungaricae*, XXI, 1975, pp. 15–52.

H. M. VON ERFFA | "'Grus vigilans'. Bemerkungen zur Emblematik", *Philobiblon*, I, 1957, pp. 286–308.

F. ERSPAMER | "Il 'lume della Italia': alla ricerca del mito feltresco". Paper read at the 1982 conference on Federico, forthcoming in the proceedings.

L. D. ETTLINGER | "Hercules Florentinus", *Mitteilungen des Kunsthistorischen Institutes in Florenz*, XVI, 1972, pp. 119–42.

L. D. ETTLINGER | "Pollaiuolo's Tomb of Pope Sixtus IV", *Journal of the Warburg and Courtauld Institutes*, XVI, 1953, pp. 239–74.

M. W. Evans *The Personifications of the Artes from Martianus Capella up to the End of the 14th Century*, Ph. D. Thesis, London Univ., 1970.

C. de Fabriczy Untitled review of E. Münz's *Les collections des Médicis au XVe siècle*, in *L'Arte*, I, 1888, pp. 185–8.

C. Ferguson *Signs and Symbols in Christian Art*, New York, 1961.

M. Ferretti "I maestri di prospettiva", in F. Zeri ed., *Storia dell'arte italiana*, Turin, XI, 1982, pp. 458–585.

F. P. Fiore "Francesco di Giorgio a Gubbio". Paper read at the 1982 conference on Federico, forthcoming in the proceedings.

G. Franceschini *Documenti e regesti per una storia del Ducato di Urbino*, Urbino, 1982, 2 vols.

G. Franceschini *Figure del Rinascimento urbinate*, Urbino, 1959.

G. Franceschini *I Montefeltro*, Varese, 1970.

G. Franceschini "Pio II e Federico da Montefeltro", *Atti e Memorie della Deputazione di Storia Patria per le Marche* (8th series), IV, 1964–65, pp. 219–33.

G. Franceschini "Quattordici brevi di Pio secondo a Federico da Montefeltro", in D. Maffei ed., *Enea Silvio Piccolomini – Papa Pio II*, Siena, 1968, pp. 133–75.

C. Franzoni "'Rimembranze d'infinite cose'. Le collezioni rinascimentali di antichità.", in S. Settis ed., *Memoria dell'antico nell'arte italiana*, Turin, I, 1984, pp. 299–360.

A. D. Fraser Jenkins "Cosimo de' Medici's Patronage of Architecture and the Theory of Magnificence", *Journal of the Warburg and Courtauld Institutes*, XXXIII, 1970, pp. 162–70.

R. Freyhan "The Evolution of the Caritas Figure in the Thirteenth and Fourteenth Centuries", *Journal of the Warburg and Courtauld Institutes*, XI, 1948, pp. 68–86.

M. J. Friedländer *Early Netherlandish Painting* (N. Veronee-Verhagen ed.), Leyden-Brussels, 1968, III.

H. Friedmann *A Bestiary for Saint Jerome. Animal Symbolism in European Religious Art*, Washington, 1980.

L. Galacteros de Boissier "Images emblématiques de la Fortune", in Y. Giraud ed., *L'emblème à la Renaissance*, Paris, 1982, pp. 79–125.

C. Gallico "Musica nella Ca' Giocosa", in N. Giannetto ed., *Vittorino e la sua scuola: Umanesimo, pedagogia e arti*, Florence, 1982, pp. 189–98.

E. Garin ed. *La disputa delle arti nel Quattrocento*, Florence, 1947.

E. Garin ed. *Il pensiero pedagogico dell'Umanesimo*, Florence, 1958.

A. Garzelli *La Bibbia di Federico da Montefeltro*, Rome, 1977.

P. P. Gerosa "La cultura patristica del Petrarca", in idem, *L'Umanesimo cristiano del Petrarca*, Turin, 1966, pp. 156–79.

P. Gherardi "Lo studiolo di Federico III, 2° Duca d'Urbino", *Il Raffaello*, I, 1869, pp. 65–7.

E. Giovagnoli *Gubbio nella storia e nell'arte*, Città di Castello, 1932.

E. H. Gombrich "Alberto Avogadro's Descriptions of the Badia of Fiesole and of the Villa of Careggi", *Italia medioevale e umanistica*, V, 1962, pp. 217–29.

E. H. Gombrich *Art and illusion*, Oxford, 1960.

E. H. Gombrich "The Early Medici as Patrons of Art", in idem, *Norm and Form*, Oxford, 1971 (2nd ed.), pp. 35–57.

E. H. Gombrich "The Renaissance Theory of Art and the Rise of Landscape", in idem, *Norm and Form*, Oxford, 1971 (2nd ed.), pp. 107–21.

E. H. Gombrich *The Sense of Order*, Oxford, 1979.

E. H. Gombrich *Symbolic Images*, London, 1972.

E. H. Gombrich "Tradition and Expression in Western Still Life", in idem, *Meditations on a Hobby Horse*, London, 1963, pp. 95–105.

M. T. Griffin *Seneca, a Philosopher in Politics*, Oxford, 1976.

G. Guelfi *Vocabolario araldico ad uso degli Italiani*, Milan, 1897.

M. Haines *The Intarsias of the North Sacristy of the Duomo in Florence*, Ph. D. Thesis, London Univ., 1975.

J. Hall *Dictionary of Subjects and Symbols in Art*, London, 1979 (2nd ed.).

W. N. Hargreaves-Mawdsley	*A History of Academical Dress in Europe*, Oxford, 1963.
W. N. Hargreaves-Mawdsley	*A History of Legal Dress in Europe*, Oxford, 1963.
F. Hartt, G. Corti and C. Kennedy	*The Chapel of the Cardinal of Portugal at San Miniato in Florence (1434–1459)*, Philadelphia, Pa., 1964.
P. H. Hefting	"Het enigma van de Casa Pellizzari", *Nederlands Kunsthistorisch Jaarboek*, XV, 1964, pp. 67–92.
D. Heikamp	"Lo 'scrittoio di Piero'", in *Il tesoro di Lorenzo il Magnifico*, II, *I vasi*, Florence, 1974, pp. 47–51.
P. Hendy	*Piero della Francesca and the Early Renaissance*, London, 1968.
G. L. Hersey	*Pythagorean Palaces*, Ithaca, N.Y. – London, 1976.
S. R. Herstein	"The Library of Federico da Montefeltro, Duke of Urbino", *The Private Library*, IV, 1971, pp. 113–28.
L. H. Heydenreich	"Federico da Montefeltro as a Building Patron. Some Remarks on the Ducal Palace of Urbino", in *Studies in Renaissance and Baroque Art Presented to Anthony Blunt on his 60th Birthday*, London, 1967, pp. 1–6. (Also in idem, *Studien zur Architektur der Renaissance: Ausgewählte Aufsätze*, Munich, 1981, pp. 170–9.)
L. H. Heydenreich	"La ripresa 'critica' di rappresentazioni medievali delle 'Septem artes liberales' nel Rinascimento", in *Il mondo antico nel Rinascimento*, Florence, 1958, pp. 265–73.
G. F. Hill	*A Corpus of Italian Medals of the Renaissance Before Cellini*, London, 1930, 2 vols.
A. M. Hind	*Early Italian Engraving*, London, 1938, 4 vols.
U. Hoff	"Meditation in Solitude", *Journal of the Warburg and Courtauld Institutes*, I, 1937–38, pp. 292–4.
C. Hope	"Artists, Patrons, and Advisers in the Italian Renaissance", in G. F. Lytle and S. Orgel eds., *Patronage in the Renaissance*, Princeton, N.J., 1981, pp. 293–343.
M. Horster	*Andrea del Castagno*, Oxford, 1980.
P. Howell Jolly	"Antonello da Messina's 'Saint Jerome in his Study': an Iconographic Analysis", *Art Bulletin*, XLV, 1983, pp. 238–53.
T. Jackson	*A Holiday in Umbria*, London, 1917.
M. T. Jones-Davies ed.	*Le paradoxe au temps de la Renaissance*, Paris, 1982.
C. L. Joost-Gaugier	"Castagno's humanist program at Legnaia and its possible inventor", *Zeitschrift für Kunstgeschichte*, XLV, 1982, pp. 274–82.
C. L. Joost-Gaugier	"The Early Beginnings of the Notion of 'Uomini Famosi' and the 'De Viris Illustribus' in Greco-Roman Literary Tradition", *Artibus et Historiae*, No. 6, 1982, pp. 97–115.
C. L. Joost-Gaugier	"Giotto's Hero Cycle in Naples: A Prototype of Donne Illustri and a Possible Literary Connection", *Zeitschrift für Kunstgeschichte*, XLIII, 1980, pp. 311–8.
C. L. Joost-Gaugier	"The History of Visual Theme as Culture and the Experience of an Urban Center: 'Uomini Famosi' in Brescia", *Antichità viva*, XXII, 4, 1983, pp. 7–17; XXIII, 1, 1984, pp. 5–14.
C. L. Joost-Gaugier	"A Rediscovered Series of 'Uomini Famosi' from Quattrocento Venice", *Art Bulletin*, LVIII, 1976, pp. 184–95.
M. R. Jung	*Hercule dans la littérature française du XVIe siècle*, Geneva, 1966.
R. Jungblut	*Hieronymus, Darstellung und Verehrung eines Kirchenvaters*, Tübingen, 1967.
Kaiser Friedrich Museum, Berlin	*Beschreibendes Verzeichnis der Gemälde im Kaiser-Friedrich-Museum und Deutschen Museum*, Berlin, 1931.
A. Katzenellenbogen	*Allegories of the Virtues and Vices in Medieval Art*, New York, 1964 (2nd ed.).
M. Kemp	"From 'Mimesis' to 'Fantasia': the Quattrocento vocabulary of creation, inspiration and genius in the visual arts". *Viator*, VIII, 1977, pp. 347–98.
W. H. Kemp	"Some Notes on Music in Castiglione's 'Il libro del Cortegiano'", in C. H. Clough ed., *Cultural Aspects of the Italian Renaissance – Essays in Honour of Paul Oskar Kristeller*, Manchester, 1976, pp. 354–69.
P. Kibre	"The Intellectual Interests Reflected in Libraries of the Fourteenth and Fifteenth Centuries", *Journal of the History of Ideas*, VII, 1946, pp. 257–97.

P. O. Kristeller	"Augustine and the Early Renaissance", in idem, *Studies in Renaissance Thought and Letters*, Rome, 1956, pp. 355–72.
P. O. Kristeller	"Humanism and Scholasticism in the Italian Renaissance", in idem, *Studies in Renaissance Thought and Letters*, Rome, 1956, pp. 553–83.
P. O. Kristeller	"The Modern System of the Arts", in idem, *Renaissance Thought II. Papers in Humanism and the Arts*, New York, 1965, pp. 163–227.
P. O. Kristeller	"The Moral thought of Renaissance Humanism", in idem, *Renaissance Thought II. Papers in Humanism and the Arts*, New York, 1965, pp. 20–68.
P. O. Kristeller	"Music and Learning in the Early Italian Renaissance", in idem, *Renaissance Thought II. Papers in Humanism and the Arts*, New York, 1965, pp. 142–62.
P. Laspeyres	"Die Baudenkmale Umbriens. IX Gubbio", *Zeitschrift fuer Baukunst*, XXXI, 1881, pp. 82–7; XXXII, 1882 pp. 66–82; XXXIII, 1883, p. 78.
J. Lavalleye	*Juste de Gand, peintre de Frédéric de Montefeltre*, Louvain, 1936.
J. Lavalleye	*Les primitifs flamands. I. Corpus de la peinture des anciens Pays-Bas méridionaux au 15ᵉ siècle. Le Palais Ducal d'Urbin*, Brussels, 1964.
F. Leeman	*Hidden Images. Games of Perception. Anamorphic Art. Illusion*, New York, 1976.
M. Levey	*Painting at Court*, London, 1971.
M. Levi d'Ancona	*The Garden of the Renaissance*, Florence, 1977.
W. Liebenwein	*Studiolo. Die Entstehung eines Raumtyps und seine Entwicklung bis um 1600*, Berlin, 1977.
R. Longhi	*Piero della Francesca*, Milan, 1946 (2nd ed.).
G. Hulin de Loo	*Pedro Berruguete et les portraits d'Urbin*, Brussels, 1942.
E. E. Lowinsky	"Epilogue: the Music in 'St. Jerome's Study'", *Art Bulletin*, XLI, 1959, pp. 298–301.
O. Lucarelli	*Memorie e guida storica di Gubbio*, Città di Castello, 1888.
G. Luck	"Vir Facetus: a Renaissance Ideal", *Studies in Philology*, LV, 1958, pp. 107–21.
A. Lugli	*Naturalia et Mirabilia. Il collezionismo enciclopedico nelle Wunderkammern d'Europa*, Milan, 1983.
A. de Maddalena	"Federico Dux", *F.M.R.*, 12, 1983, pp. 97–107.
C. Maltese	"Federico da Montefeltro e la civiltà urbinate del Rinascimento", *Notizie da Palazzo Albani*, XI, 1982, pp. 21–31.
G. Marchini	"Il Palazzo Ducale di Urbino", *Rinascimento*, IX, 1958, pp. 43–78.
G. Marchini	"Aggiunte al Palazzo Ducale di Urbino", *Bollettino d'Arte*, XLV, 1960, pp. 73–80.
G. Marchini	*Giuliano da Maiano*, Florence, 1959.
A. Mariuz	"Appunti per una lettura del fregio giorgionesco di Casa Marta Pellizzari", in *Liceo – Ginnasio Giorgione – Castelfranco Veneto*, 1966, pp. 49–70.
G. Martines	"La costruzione del Palazzo Ducale di Gubbio: invenzione e preesistenze". Paper read at the 1982 conference on Federico, forthcoming in the proceedings.
G. Martines	"Francesco di Giorgio a Gubbio in tre documenti d'archivio rinvenuti e trascritti da Piero Luigi Menichetti", *Ricerche di storia dell'arte*, XI, 1980, pp. 67–70.
G. Martines	"Il Palazzo Ducale di Gubbio: un brano sepolto della città medievale, un' ipotesi per Francesco di Giorgio", *Ricerche di storia dell'arte*, VI, 1977, pp. 89–99.
R. de Mattei	"Sapienza e prudenza nel pensiero politico italiano dall'Umanesimo al secolo XVII", in E. Castelli ed., *Umanesimo e scienza politica*, Milan, 1951, pp. 129–43.
H. Mattingly *et al.*	*Coins of the Roman Empire in the British Museum*, London, 1965–1975, 6 vols.
F. Mazzini	*I mattoni e le pietre di Urbino*, Urbino, 1982.
L. McCracken	*Gubbio, Past and Present*, London, 1905.
R. McKeon	"The Transformation of the Liberal Arts in the Renaissance", in B. S. Levy ed., *Developments in the Early Renaissance*, Albany, N.Y., 1972, pp. 158–223.
M. Meiss	"Light as Form and Symbol in Some Fifteenth-Century Paintings", in idem, *The Painter's Choice*, New York, 1976, pp. 3–18.
M. Meiss	"'Ovum Struthionis': Symbol and Allusion in Piero della Francesca's Montelfeltro Altarpiece", in idem, *The Painter's Choice*, New York, 1976, pp. 105–29.
M. Meiss	*Painting in Florence and Siena after the Black Death*, Princeton, N.J., 1978.
M. Meiss	"La Sacra Conversazione di Piero della Francesca. Extracts", in idem, *The Painter's Choice*, New York, 1976, pp. 142–7.

M. Meiss — "Toward a More Comprehensive Renaissance Palaeography", in idem, *The Painter's Choice*, New York, 1976, pp. 151–75.

P. L. Menichetti — *Le corporazioni delle Arti e Mestieri medioevali a Gubbio*, Città di Castello, 1980.

E. Michel — *Musée national du Louvre. Catalogue raisonné des peintures du Moyen Age, de la Renaissance et des temps modernes. Peintures flamandes du XV^e et du XVI^e siècle*, Paris, 1953.

L. Michelini Tocci — *Il Dante urbinate della Biblioteca Vaticana. Codice Urbinate Latino 365*, Vatican City, 1965.

L. Michelini Tocci — *Pittori del Quattrocento ad Urbino e a Pesaro*, Pesaro, 1968.

L. Michelini Tocci — *Le tarsie dello studiolo di Urbino*, Pesaro, 1968.

R. L. Mode — *The Monte Giordano famous men cycle of Cardinal Giordano Orsini and the "Uomini famosi" tradition in fifteenth-century Italian art*, Ph. D. Thesis, Univ. of Michigan, 1970.

T. E. Mommsen — "Petrarch and the Decoration of the Sala Virorum Illustrium in Padua", *Art Bulletin*, XXXIV, 1952, pp. 95–116. (Also in E. F. Rice jr. ed., *Medieval and Renaissance Studies*, Ithaca, N.Y., 1959, pp. 131–74.)

J. Monfasani — "Alexius Celademus and Ottaviano Ubaldini: an Epilogue to Bessarion's Relationship with the Court of Urbino", *Bibliothèque d'Humanisme et Renaissance*, XLVI, 1984, pp. 95–110.

P. Morachiello — *Programmi umanistici e scienza militare nello Stato di Federico da Montefeltro*, Macerata Feltria, 1972.

L. Moranti — *Bibliografia Urbinate*, Florence, 1959.

M. and L. Moranti — *Il trasferimento dei 'Codices Urbinates' alla Biblioteca Vaticana*, Urbino, 1981.

M. Muraro — "La Scala senza Giganti" in M. Meiss ed., *De Artibus Opuscola XL. Essays in Honor of Erwin Panofsky*, New York, 1961, I, pp. 350–70; II, pp. 114–21. (Also, in French, in D. Arasse [presented by], *Symboles de la Renaissance*, Paris, II, 1982, pp. 21–38.)

H. J. R. Murray — *A History of Chess*, Oxford, 1913.

H. Nachod — "The Inscription in Federigo da Montefeltro's Studio in the Metropolitan Museum: Distichs by his Librarian Federigo Veterano", *Medievalia et Humanistica*, II, 1943, pp. 98–105.

L. Nardini — *Le imprese o figure simboliche dei Montefeltro e dei Della Rovere*, Urbino, 1931.

G. Neerman — "Il ritratto di Federico di Montefeltro e di Guidobaldo e il problema di Pedro Berruguete", in M. G. Ciardi Duprè dal Poggetto and P. Dal Poggetto eds., *Urbino e le Marche prima e dopo Raffaello*, Florence, 1983, pp. 88–90.

S. M. Newton — *Renaissance Theatre Costume and the Sense of the Historic Past*, London, 1975.

R. Offner and K. Steinweg — *A Critical and Historical Corpus of Florentine Painting*, Glückstadt, Section IV, vol. VI, 1979.

M. O'Loughlin — *The Garlands of Repose*, Chicago–London, 1978.

H. Olsen — *Urbino*, Copenhagen, 1971.

M. L. D'Otrange Mastai — *Illusion in Art*, New York, 1975.

A. Padoa Rizzo — *Benozzo Gozzoli, pittore fiorentino*, Florence, 1972.

E. Panofsky — *Early Netherlandish Painting*, New York, 1971, 2 vols.

E. Panofsky — *Herkules am Scheidewege*, Leipzig, 1930.

E. Panofsky — *The Iconography of Correggio's Camera di San Paolo*, London, 1961.

E. Panofsky — *Problems in Titian, Mostly Iconographic*, London, 1969.

R. Papini — *Francesco di Giorgio architetto*, Florence, 1947, 3 vols.

A. Parronchi — "Prima traccia dell'attività del Pollaiolo per Urbino", *Studi Urbinati* (new series B), XLV, 1971, pp. 1176–93.

P. W. Parshall — "Albrecht Dürer's St. Jerome in his Study: A Philological Reference", *Art Bulletin*, LIII, 1971, pp. 303–5.

J. D. Passavant — *Rafael von Urbino und sein Vater Giovanni Santi*, Leipzig, 1839, 3 vols.

L. von Pastor — *Storia dei Papi dalla fine del Medio Evo*, Rome, 1943–63, 16 vols.

H. R. Patch — *The Goddess Fortuna in Medieval Literature*, London, 1967.

H. Perruchot — *Montefeltro, Duc d'Urbin*, Paris, 1960.

E. Peterich — "Gli dei pagani nell'arte cristiana", *La Rinascita*, V, 1942, pp. 47–71.

N. Pirrotta	"Ricercare e variazioni su 'O rosa bella'", in idem, *Musica tra Medioevo e Rinascimento*, Turin, 1984, pp. 194–212.
A. Pöllman	"Von der Entwicklung des Hieronymus-typus in der älteren Kunst", *Benediktinische Monatschrift*, II, 1920, pp. 438–522.
M. Praz	"The Gonzaga Devices", in D. S. Chambers and J. Martineaud eds., *Splendours of the Gonzaga*, Milan, 1981. pp. 65–72.
M. Praz	*Studies in 17th Century Imagery*, Rome, 1963.
W. Prinz	"Simboli ed immagini di pace e di guerra nel Rinascimento: la Porta della Guerra nel Palazzo di Federico da Montefeltro". Paper read at the 1982 conference on Federico, forthcoming in the proceedings.
L. Pungileoni	*Elogio storico di Giovanni Santi, pittore e poeta, padre del gran Raffaello di Urbino*, Urbino, 1822.
L. Puppi	"L'ambiente, il paesaggio e il territorio", in G. Previtali ed., *Storia dell'arte italiana*, Turin, IV, 1980, pp. 43–100.
A. C. Quintavalie	*Cristoforo da Lendinara*, Parma, 1959.
D. Radcliff-Umstead	"Petrarch and the Freedom to be Alone", in A. Scaglione ed., *Francis Petrarch, Six Centuries Later. A Symposium*, Chapel Hill-Chicago, 1975, pp. 236–48.
F. Raffi	"Restauri nel Palazzo Ducale di Gubbio", *Italia nostra*, XVII, 1975, pp. 36–9.
G. Reese	"Musical Compositions in Renaissance Intarsia", in J. L. Lievsay ed., *Medieval and Renaissance Studies*, Durham, N.C., 1968, pp. 74–97.
P. Remington	"The Private Study of Federigo da Montefeltro", *Bulletin of the Metropolitan Museum of Art*, XXXVI, 1941, pp. 3–13.
R. Rensch	*The Harp*, New York, 1969.
L. Renzetti	"Lo studiolo di Federico da Montefeltro nel Palazzo ducale di Urbino", *Urbinum*, VI, 1934, pp. 16–9.
P. Reuterswärd	"The Dog in the Humanist's Study", *Konsthistorisk Tidskrift*, L, 1981, pp. 53–69.
E. F. Rice Jr.	*The Renaissance Idea of Wisdom*, Cambridge, Mass., 1958.
B. Ridderbos	*Saint and Symbol. Images of Saint Jerome in Early Italian Art*, Groningen, 1984.
J. B. Riess	*Political Ideals in Medieval Italian Art*, Ann Arbor, Mich., 1981.
H. I. Roberts	"St. Augustine in 'St. Jerome's Study': Carpaccio's Painting and its Legendary Source", *Art Bulletin*, XLI, 1959, pp. 283–97.
P. L. Rose	*The Italian Renaissance of Mathematics*, Geneva, 1975.
C. M. Rosemberg	"The Double Portrait of Federico and Guidobaldo de Montefeltro: Power, Wisdom, and Dynasty". Paper read at the 1982 conference on Federico, forthcoming in the proceedings.
P. Rotondi	"Ancora sullo studiolo di Federico da Montefeltro nel Palazzo Ducale di Urbino", *Restauri nelle Marche – Testimonianze, acquisti e recuperi*, Urbino, 1973, pp. 561–602. (Also in *Studi Bramanteschi*, Rome, 1974, pp. 255–65).
P. Rotondi	*Il Palazzo Ducale di Urbino*, Urbino, 1950, 2 vols.
P. Rotondi	*The Ducal Palace of Urbino*, London, 1969.
P. Rotondi	*Francesco di Giorgio nel Palazzo Ducale di Urbino*, Novilara, 1970.
N. Rubinstein	"Political Ideas in Sienese Art: the Frescoes by Ambrogio Lorenzetti and Taddeo di Bartolo in the Palazzo Pubblico", *Journal of the Warburg and Courtauld Institutes*, XXI, 1958, pp. 179–207.
B. Rupprecht	"Villa. Zur Geschichte eines Ideals", *Probleme der Kunstwissenschaft*, II, 1966, pp. 210–50.
H. Saalman	"The Ducal Palace of Urbino", *Burlington Magazine*, CXIII, 1971, pp. 46–51.
M. Salmi	*Piero della Francesca e il Palazzo Ducale di Urbino*, Florence, 1945.
S. Sandström	*Levels of Unreality*, Uppsala, 1963.
F. Sangiorgi	*Iconografia federiciana*, Urbino, 1982.
F. Schalk	"Il tema della 'vita activa' e della 'vita contemplativa' nell' Umanesimo italiano", in E. Castelli ed., *Umanesimo e scienza politica*, Milan, 1951, pp. 559–66.
V. Scherliess	*Musikalische Noten auf Kunstwerken der Italienischen Renaissance bis zum Anfang des 17. Jahrhunderts*, Hamburg, 1972.

A. Schiapparelli *La casa fiorentina e i suoi arredi nei secoli XIV e XV* (M. Sframeli and L. Pagnotta eds.), Florence, 1983, 2 vols. (first published in 1908).

J. von Schlosser "Giusto's Fresken in Padua und die Vorläufer der Stanza della Segnatura", *Jahrbuch der Kunsthistorischen Sammlungen des allerhöchsten Kaiserhauses*, XVII, 1896, pp. 13–100.

A. Schmarsow *Melozzo da Forlì*, Berlin–Stuttgart, 1886.

R. van Schoute *Le Musée national du Louvre. Corpus de la peinture des anciens Pays-Bas méridionaux au 15ᵉ siècle*, vol. II (forthcoming).

R. Scrivano "Le biografie di Federico". Paper read at the 1982 conference on Federico, forthcoming in the proceedings.

L. Serra *Il Palazzo Ducale di Urbino*, Rome, 1930.

J. Seznec *The Survival of the Pagan Gods*, Princeton, N.J., 1972.

J. Shearman "The Vatican Stanze: Functions and Decoration", *Proceedings of the British Academy*, LVII, 1971, pp. 369–424.

R. de la Sizeranne *Le verteux condottiere Federigo da Montefeltro*, Paris, 1927 (Italian transl.: *Federico di Montefeltro: capitano, principe, mecenate (1422–1482)* [C. Zappieri ed.], Urbino, 1978).

L. M. Sleptzoff *Men or Supermen? The Italian Portrait in the Fifteenth Century*, Jerusalem, 1978.

G. Solari *Ventidue storie dei duchi di Urbino tra il sole e la luna*, Milan, 1973.

S. Sontag *On Photography*, Harmondsworth, 1979.

J. Sparrow *Visible Words*, Cambridge, 1969.

J. Sterling *Still Life Painting from Antiquity to the Present Time*, New York, 1981 (2nd ed.).

D. Stockton *Cicero: a Political Biography*, London, 1971.

C. Stornajolo *I ritratti e le gesta dei duchi d'Urbino nelle miniature dei codici vaticano-urbinati*, Milan, 1914.

A. Strümpell "Hyeronimus im Gehäuse", *Marburger Jahrbuch für Kunstwissenschaft*, II, 1925–26, pp. 173–252.

G. de Tervarent *Attributs et symboles dans l'art profane, 1450–1600*, Geneva, 1958–64 (1 vol. + suppl.).

D. R. Thomason *'Rusticus'. Reflections of the Pastoral on Renaissance Art and Literature*, M. Phil. Thesis, London Univ., 1968.

L. Thorndike *History of Magic and Experimental Science*, New York–London, 1923–58, 8 vols.

L. Thorndike *Science and Thought in the Fifteenth Century*, New York, 1929.

E. Tietze-Conrat *Andrea Mantegna. Le pitture, i disegni, le incisioni*, Florence–London, 1955.

W. Tommasoli "Spirito umanistico e coscienza religiosa in Federico da Montefeltro". Paper read at the 1982 conference on Federico, forthcoming in the proceedings.

W. Tommasoli *La vita di Federico da Montefeltro, 1422–1482*, Urbino, 1978.

A. Tormey and J. Farr Tormey "Renaissance Intarsia: the Art of Geometry", *Scientific American*, CCXLVII, 1982, pp. 116–22.

J. B. Trapp "The Owl's Ivy and the Poet's Bays", *Journal of the Warburg and Courtauld Institutes*, XXI, 1958, pp. 227–55.

G. Trease *The Condottieri*, London, 1970.

C. Trinkaus *In our Image and Likeness*, London, 1970, 2 vols.

A. R. Turner *The Vision of Landscape in Renaissance Italy*, Princeton, N.J., 1974 (2nd ed.).

F. Ugolini *Storia dei Conti e dei Duchi d'Urbino*, Florence, 1859, 2 vols.

Various authors *La lettre, la figure, le rébus dans la poétique de la Renaissance*, special issue of the *Revue des Sciences humaines*, No. 179, 1980, part III.

A. Veca *Inganno e realtà. Trompe-l'œil in Europa*, Bergamo, 1980.

A. Veca *Vanitas. Il simbolismo del tempo*, Bergamo, 1981.

A. Venturi "L'ambiente artistico urbinate nella seconda metà del Quattrocento", *L'Arte*, XX, 1917, pp. 259–93; XXI, 1918, pp. 26–43.

A. Venturi *L'arte a S. Girolamo*, Milan, 1924.

G. Venturi "'Picta poësis': ricerche sulla poesia e il giardino dalle origini al Seicento", in C. de Seta ed., *Storia d'Italia. Annali*, Turin, V, 1982, pp. 663–749.

L. Venturi "Studii sul Palazzo Ducale di Urbino", *L'Arte*, XVII, 1914, pp. 415–73.

Ph. Verdier "L'iconographie des Arts Libéraux dans l'art du moyen âge jusqu'à la fin du quinzième siècle", in *Arts libéraux et philosophie au moyen âge*, Montreal–Paris, 1969, pp. 305–55.

E. Verheyen *The Paintings in the Studiolo of Isabella d'Este at Mantua*, New York, 1971.

R. Villari *Le corti italiane*, Milan, 1977.

M. Wackernagel *The World of the Florentine Renaissance Artist* (A. Luchs ed.), Princeton, N.J., 1981 (originally published in 1938).

D. L. Wagner ed. *The Seven Liberal Arts in the Middle Ages*, Bloomington, Ind., 1983.

M. Wallis "Inscriptions in Paintings", *Semiotica*, IX, 1973, pp. 1–28.

R. Weiss *Un umanista veneziano: Papa Paolo II*, Venice–Rome, 1958.

C. W. Westfall "Chivalric Declaration: the Palazzo Ducale in Urbino as a Political Statement", in H. A. Millon and L. Nochlin eds., *Art and Architecture in the Service of Politics*, Cambridge, Mass., 1978, pp. 20–45.

L. White Jr. "The Iconography of 'Temperantia' and the Virtuousness of Technology", in T. K. Rabb and J. E. Siegel eds., *Action and Conviction in Early Modern Europe*, Princeton, N.J., 1969, pp. 197–219.

D. G. Wilkins "Donatello's Lost 'Dovizia' for the Mercato Vecchio: Wealth and Charity as Florentine Virtues", *Art Bulletin*, LXV, 1983, pp. 401–23.

E. H. Wilkins "Petrarch's Ecclesiastical Career", in idem, *Studies in the Life and Works of Petrarch*, Cambridge, Mass., 1955, pp. 3–32.

E. Wind "Charity – The Case History of a Pattern", *Journal of the Warburg and Courtauld Institutes*, I, 1937–38, pp. 322–30.

E. Wind "The Eloquence of Symbols", *Burlington Magazine*, XCII, 1950, pp. 349–50.

E. Wind *Pagan Mysteries of the Renaissance*, London, 1968 (2nd ed.).

E. Winternitz *Musical Instruments and their Symbolism in Western Art*, London, 1967.

R. Wittkower "Chance, Time and Virtue", in idem, *Allegory and the Migration of Symbols*, London, 1977, pp. 97–106.

R. Wittkower "Grammatica: from Martianus Capella to Hogarth", in idem, *Allegory and the Migration of Symbols*, London, 1977, pp. 167–72.

R. Wittkower "The Problem of Harmonic Proportion in Architecture", in idem, *Architecture Principles in the Age of Humanism*, London, 1962 (3rd ed.), pp. 101 ff.

W. H. Woodward *Vittorino da Feltre and Other Humanist Educators*, Cambridge, 1897.

P. Zampetti *Federico da Montefeltro e la civiltà urbinate del Rinascimento*, Urbino, 1982.

P. Zampetti "Chi era Federico da Montefeltro?", *Notizie da Palazzo Albani*, XI, 1982, pp. 6–12.

P. Zampetti "Federico da Montefeltro e Vittorino da Feltre", in N. Giannetto ed., *Vittorino e la sua scuola: Umanesimo, pedagogia e arti*, Florence, 1982, pp. 255–61.

P. Zampetti *Paintings from the Marches*, London, 1971.

F. Zeri *Italian Paintings in the Walters Art Gallery*, Baltimore, Md., 1976, 2 vols.

E. Zilsel *Die Entstehung des Geniebegriffes*, Tübingen, 1926.

LIST OF ILLUSTRATIONS

114

SOURCES OF THE ILLUSTRATIONS

Photos:

Justus of Ghent(?)'s *Federico, Guidobaldo and Others Listening to a Discourse* (Fig. 76) is reproduced by gracious permission of H. M. Queen Elizabeth II.

A. C. L., Brussels: Figs. 9–40.

Alinari, Florence: Fig. 92.

Archivio di Stato, Florence: Fig. 69.

Author: Fig. 62.

British Museum: Fig. 108.
Reproduced by courtesy of the Trustees of the British Museum.

Fondazione Giorgio Cini, Venice: Fig. 96 (a,b,c).

Foto Grassi, Siena: Fig. 106.

Fotomero, Urbino: Fig. 1.

Foto Moderna, Urbino: Pls. II, III, IV.

Gianfranco Gavirati, Gubbio: Figs. 67, 71.

After C. GNUDI, *Giotto*, Milan, 1958: Fig. 101.

Hessisches Landesmuseum, Darmstadt: Fig. 104.

Massimo Listri: Pls. I, V, VI, VII, VIII.
Reproduced by kind permission of Franco Maria Ricci Editore, Milan.

The Mansell Collection, London: Fig. 3.

Metropolitan Museum of Art, New York (Rogers Fund 1939): Figs. 78–89.

Museo Civico, Padua: Fig. 90.

National Gallery, London: Figs. 72, 75.
Reproduced by courtesy of the Trustees, The National Gallery, London.

Paolo Monti, Milan: Figs. 43, 44, 50, 51, 56, 60, 61, 100.

Soprintendenza per i Beni Artistici e Storici di Firenze: Figs. 98, 99, 107, 109.

Soprintendenza per i Beni Artistici e Storici delle Marche. Urbino: Figs. 41, 42, 45, 46, 47, 48, 49, 52, 53, 54, 55, 57, 58, 59, 63, 64, 65, 66, 93, 97, 105.

Staatliche Museen, East Berlin: Figs. 73, 74.

Walters Art Gallery, Baltimore: Fig. 102.

Prints:

After A. M. HIND, *Early Italian Engraving*, London, 1938, IV: Figs. 94, 95.

After A. POLIZIANO, *Poesie italiane* (S. ORLANDO ed.), Milan, 1976: Fig. 91.

Graphics:

The plan of the Gubbio *studiolo*, Fig. 70, was kindly supplied by its author, Prof. Bruno Cenni.

After W. BOMBE, "Justus von Gent in Urbino", *Mitteilungen des Kunsthistorischen Institutes in Florenz*, III, 1909: Fig. 4.

After A. BRUSCHI, *Bramante architetto*, Bari, 1969: Fig. 77.

After R. PAPINI, *Francesco di Giorgio architetto*, Florence, 1946, III: Fig. 68.

After P. ROTONDI, *Il Palazzo Ducale di Urbino*, Urbino, 1950: Figs. 2, 7.

After P. ROTONDI, "Ancora sullo studiolo di Federico da Montefeltro nel Palazzo Ducale di Urbino", in *Restauri nelle Marche – Testimonianze, acquisti e recuperi*, Urbino, 1973: Fig. 8.

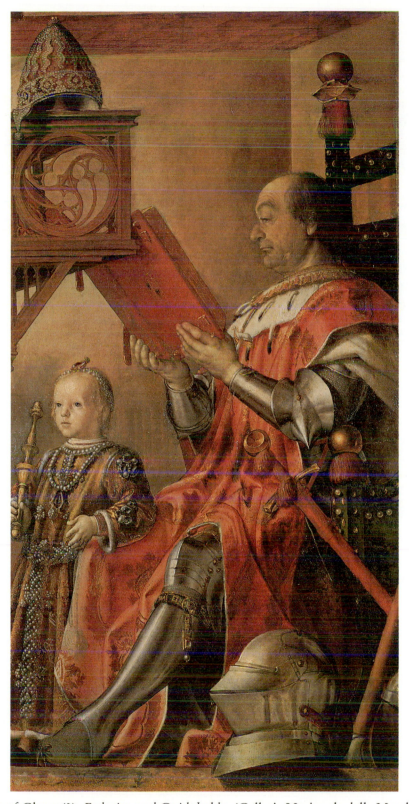

Pl. I. Justus of Ghent (?), *Federico and Guidobaldo*. (Galleria Nazionale delle Marche, Urbino.)

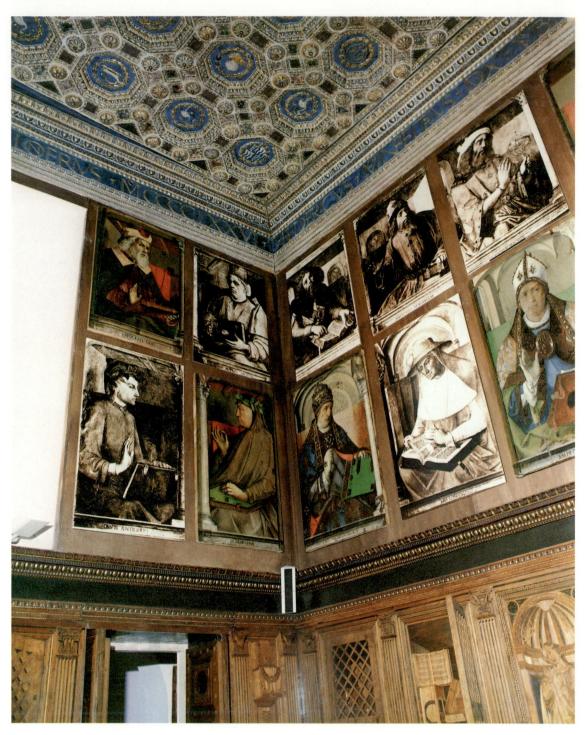

Pl. II. Studiolo of Urbino. *Famous Men*. View of the west and north walls.

118

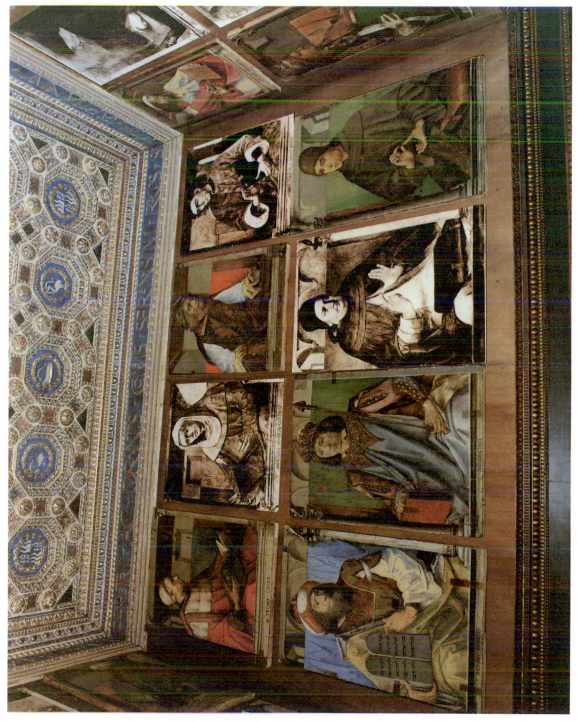

Pl. III. Studiolo of Urbino. *Famous Men*. East wall.

119

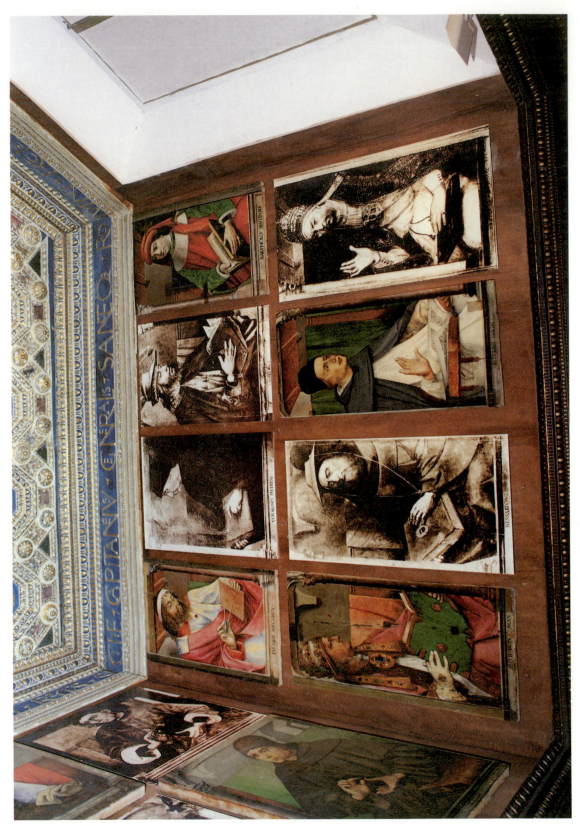

Pl. IV. Studiolo of Urbino. *Famous Men.* South wall.

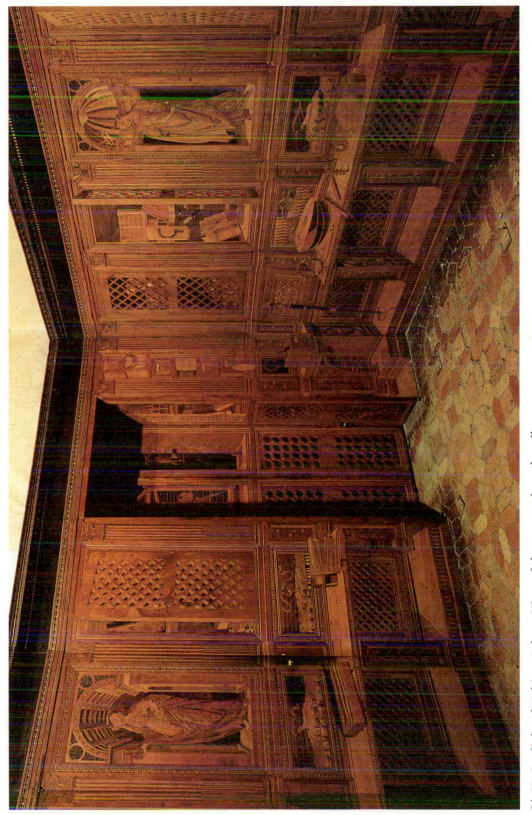

Pl. V. Studiolo of Urbino. Inlays. View of the west and north walls.

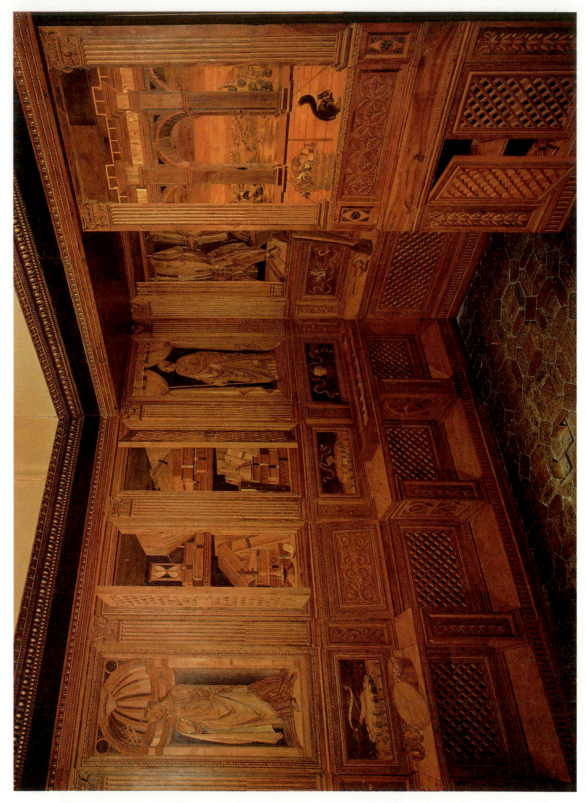

Pl. VI. Studiolo of Urbino. Inlays. View of the north and east walls.

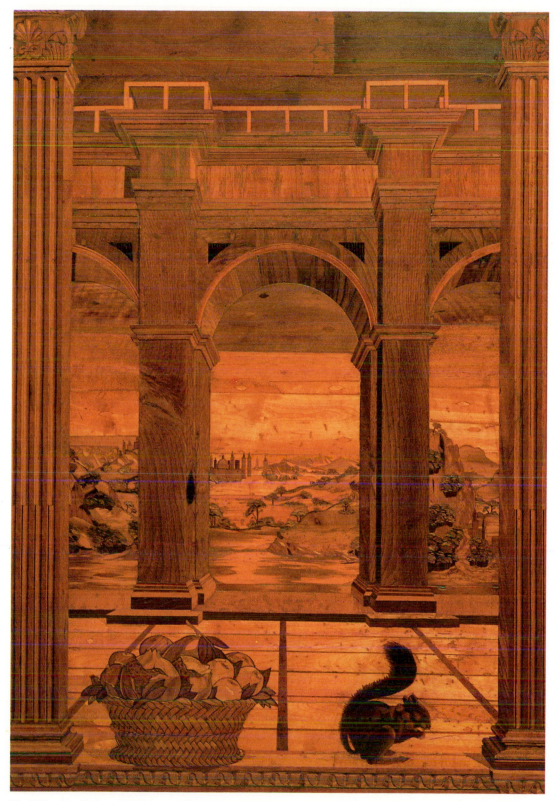

Pl. VII. Studiolo of Urbino. Inlays. Detail from the east wall.

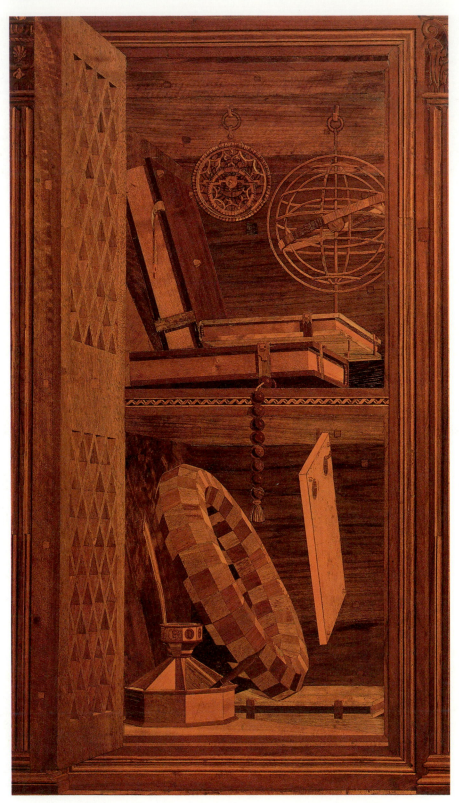

Pl. VIII. Studiolo of Urbino. Inlays. Detail from the south wall.

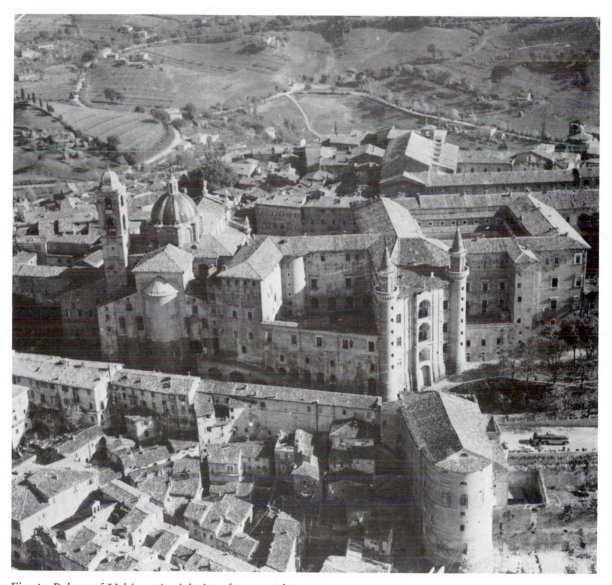

Fig. 1. Palace of Urbino. Aerial view from north-west.

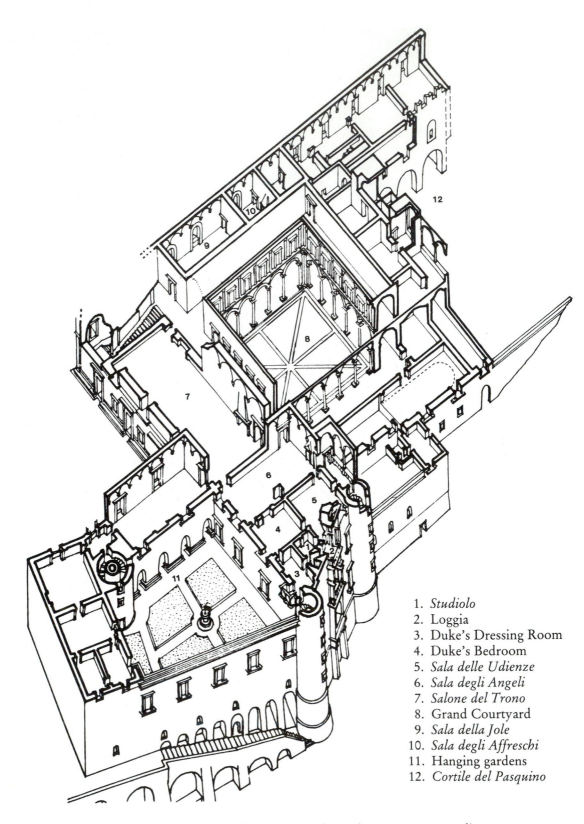

1. *Studiolo*
2. Loggia
3. Duke's Dressing Room
4. Duke's Bedroom
5. *Sala delle Udienze*
6. *Sala degli Angeli*
7. *Salone del Trono*
8. Grand Courtyard
9. *Sala della Jole*
10. *Sala degli Affreschi*
11. Hanging gardens
12. *Cortile del Pasquino*

Fig. 2. Palace of Urbino. Axonometric projection, drawn by Renato Bruscaglia.

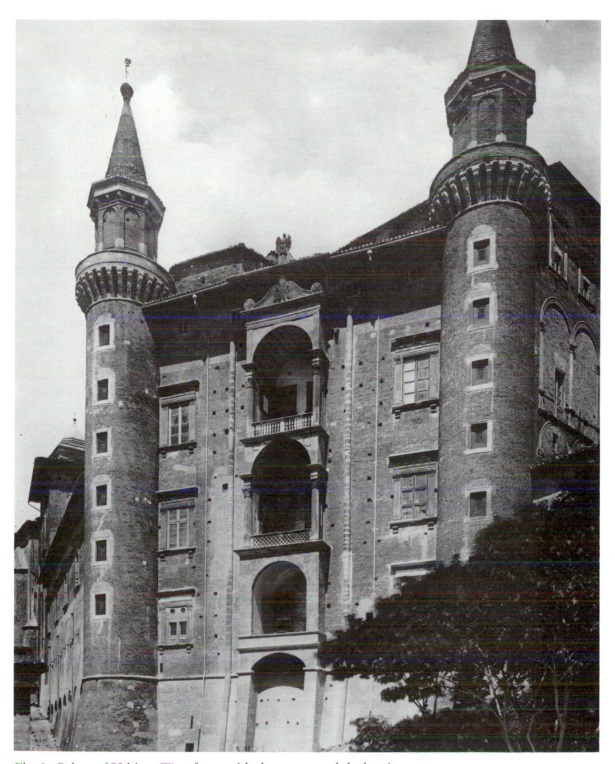

Fig. 3. Palace of Urbino. West front with the towers and the loggias.

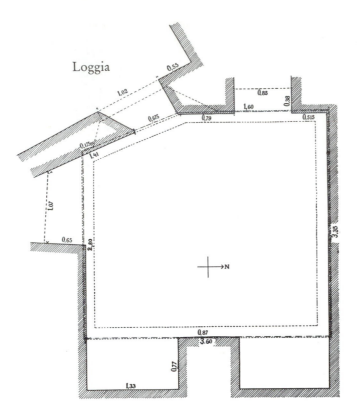

Loggia

Fig. 4. Studiolo of Urbino. Plan, drawn by Marzia Ubaldini.

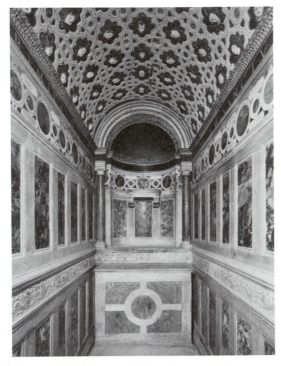 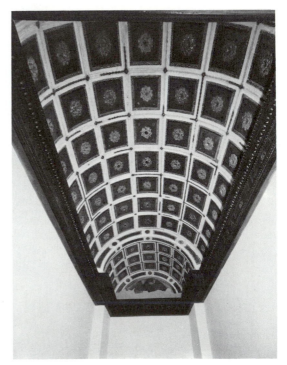

Figs. 5–6. *Cappella del Perdono* and *Tempietto delle Muse*, situated side by side directly beneath the studiolo, on the ground floor.

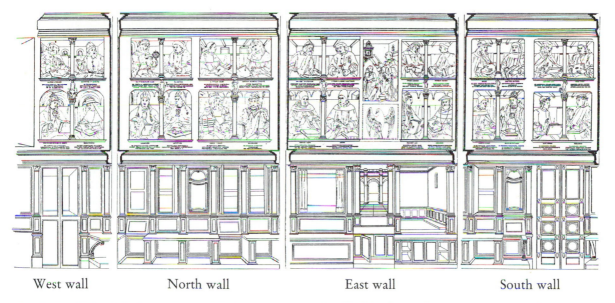

West wall North wall East wall South wall

Fig. 7. Studiolo of Urbino. Rotondi's first reconstruction (1950), drawn by Renato Bruscaglia.

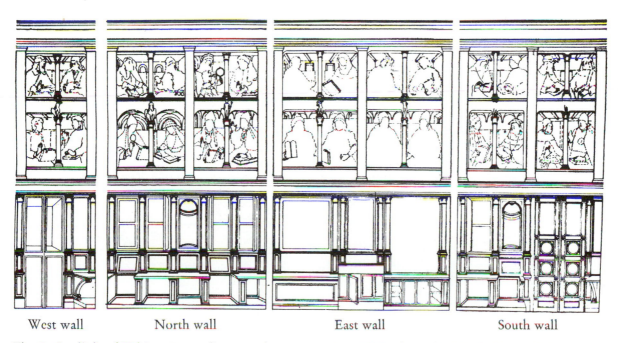

West wall North wall East wall South wall

Fig. 8. Studiolo of Urbino. Rotondi's second reconstruction (1973), drawn by Nicola Costantini.

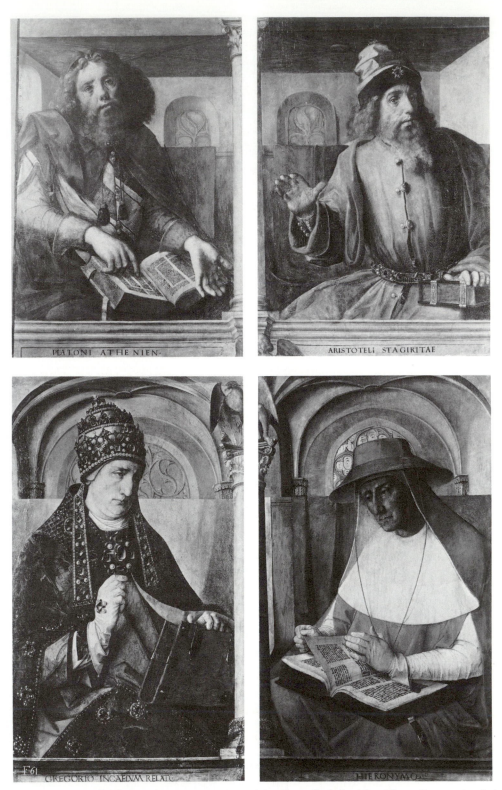

Figs. 9–12. Justus of Ghent (?), *Famous Men*. North wall, left side. *Plato* (Louvre), *Aristotle* (Louvre), *Gregory* (studiolo), *Jerome* (Louvre).

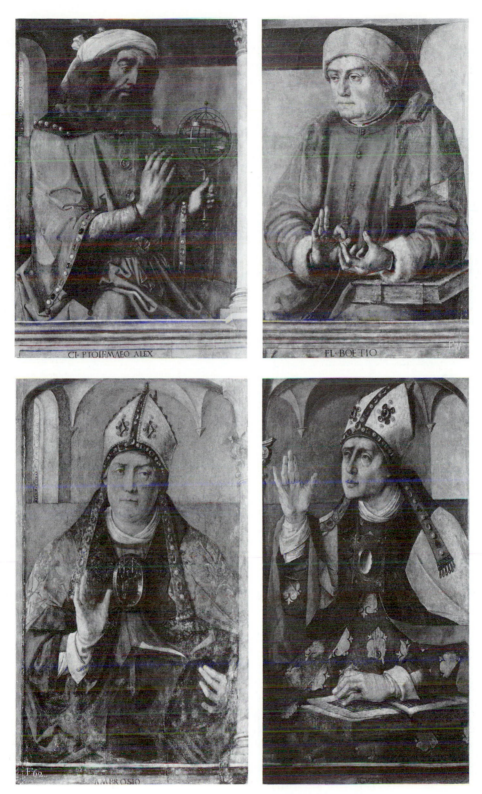

Figs. 13–16. Justus of Ghent (?), *Famous Men*. North wall, right side. *Ptolemy* (Louvre),
Boethius (studiolo), *Ambrose* (studiolo), *Augustine* (Louvre).

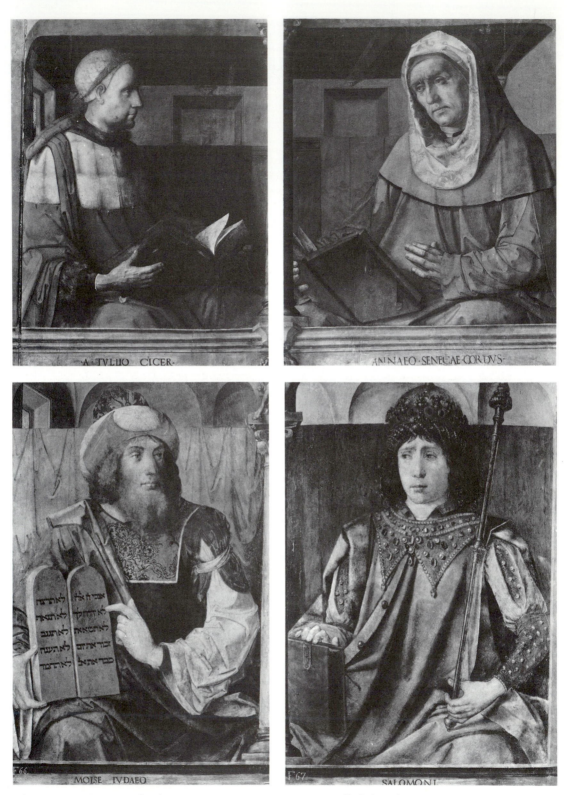

Figs. 17–20. Justus of Ghent (?), *Famous Men*. East wall, left side. *Cicero* (studiolo), *Seneca* (Louvre), *Moses* (studiolo), *Solomon* (studiolo).

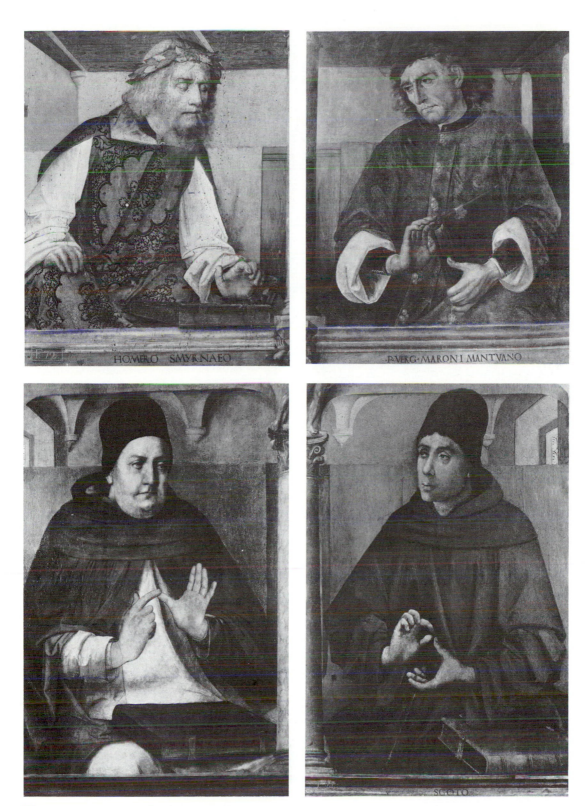

Figs. 21–24. Justus of Ghent (?), *Famous Men*. East wall, right side. *Homer* (studiolo), *Virgil* (Louvre), *Thomas Aquinas* (Louvre), Duns Scotus (studiolo).

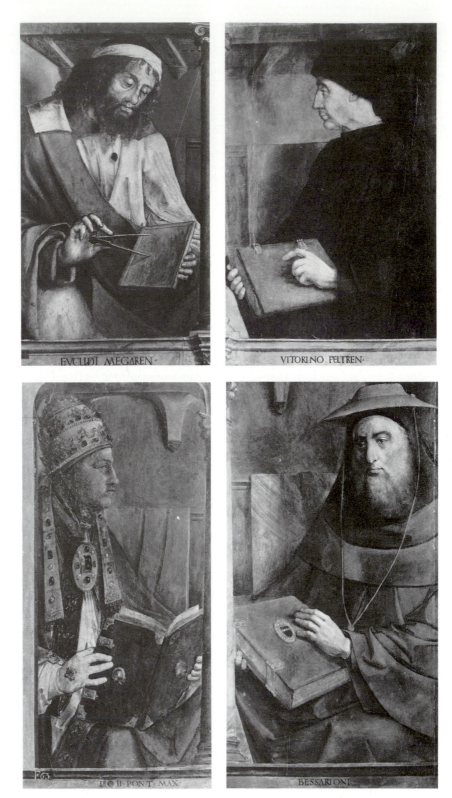

Figs. 25–28. Justus of Ghent (?), *Famous Men*. South wall, left side. *Euclid* (studiolo), *Vittorino da Feltre* (Louvre), *Pius II* (studiolo), *Bessarion* (Louvre).

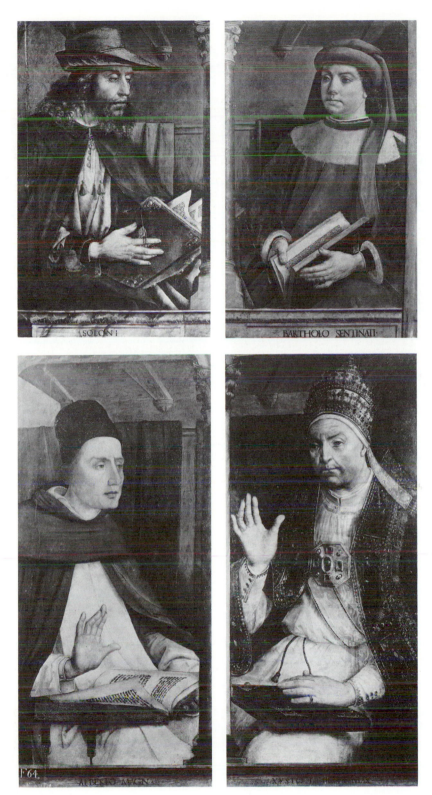

Figs. 29–32. Justus of Ghent (?), *Famous Men*. South wall, right side. *Solon* (Louvre), *Bartolus* (studiolo), *Albertus Magnus* (studiolo), *Sixtus IV* (Louvre).

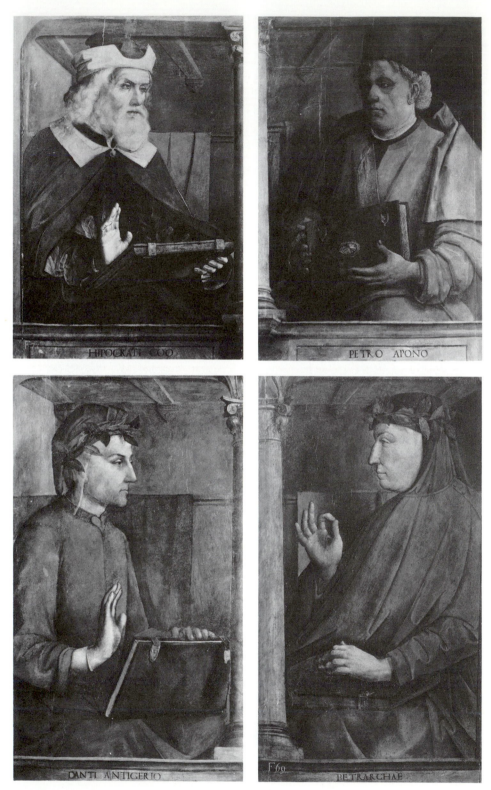

Figs. 33–36. Justus of Ghent (?), *Famous Men*. West wall, right side. *Hippocrates* (studiolo), *Pietro d'Abano* (Louvre), *Dante* (Louvre), *Petrarch* (studiolo).

Fig. 37. Justus of Ghent (?), *Famous Men*. North wall, left side. Detail of the grisaille figure with eagle and ducal emblem, linking Plato, Aristotle, Gregory and Jerome (as reconstructed by Lavalleye).

Fig. 38. Justus of Ghent (?), *Famous Men*. North wall, right side. Detail of the grisaille figure with sceptre and ducal emblem, linking Ptolemy, Boethius, Ambrose and Augustine (as reconstructed by Lavalleye).

Fig. 39. Justus of Ghent (?), *Famous Men*. East wall, left side. Detail of the grisaille motifs identified as Hercules and the lion, linking Cicero, Seneca, Moses and Solomon (as reconstructed by Lavalleye).

Fig. 40. Justus of Ghent (?), *Famous Men*. East wall, right side. Detail of the grisaille figure identified as Atlas, linking Homer, Virgil, Thomas Aquinas and Duns Scotus (as reconstructed by Lavalleye).

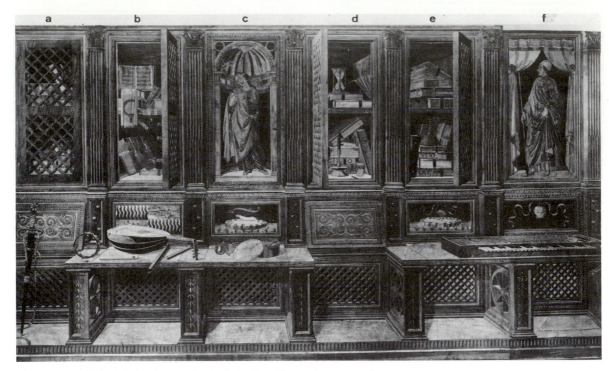

Fig. 41. Studiolo of Urbino. Inlays. North wall (sections a to f).

138

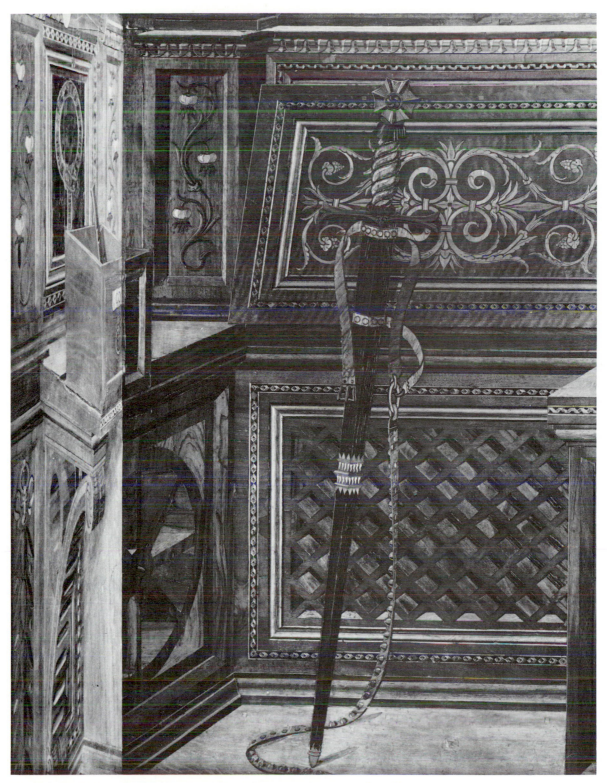

Fig. 42. Studiolo of Urbino. Inlays. Detail from section a, north wall.

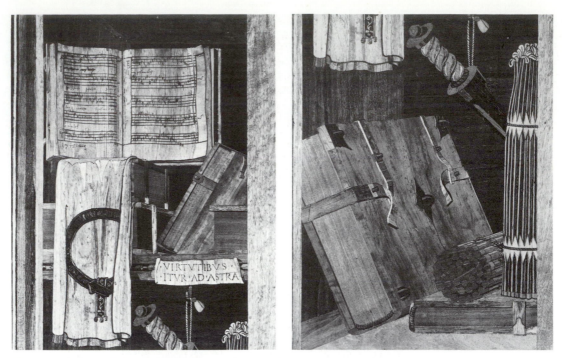

Figs. 43–44. Studiolo of Urbino. Inlays. Details from section b, north wall.

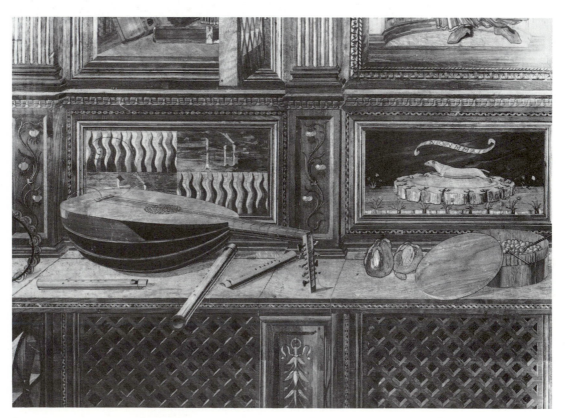

Fig. 45. Studiolo of Urbino. Inlays. Detail from sections b and c, north wall.

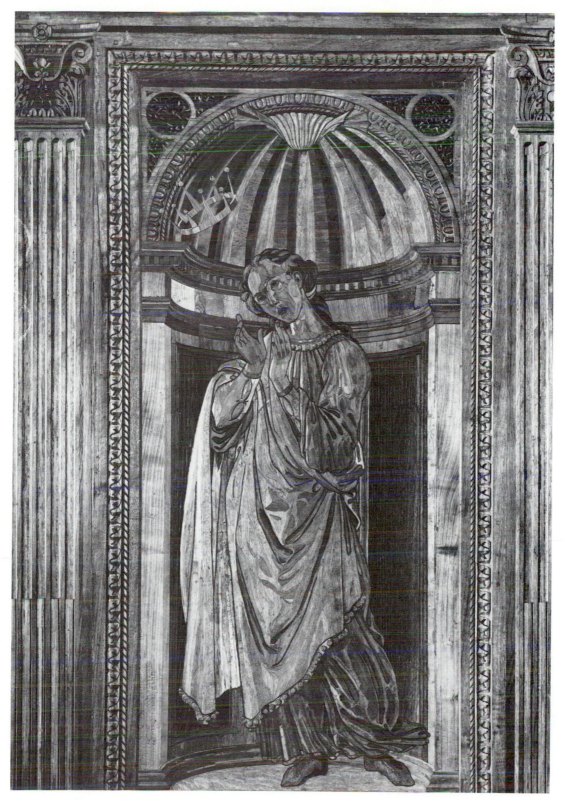

Fig. 46. Studiolo of Urbino. Inlays. Detail from section c, north wall, showing Hope.

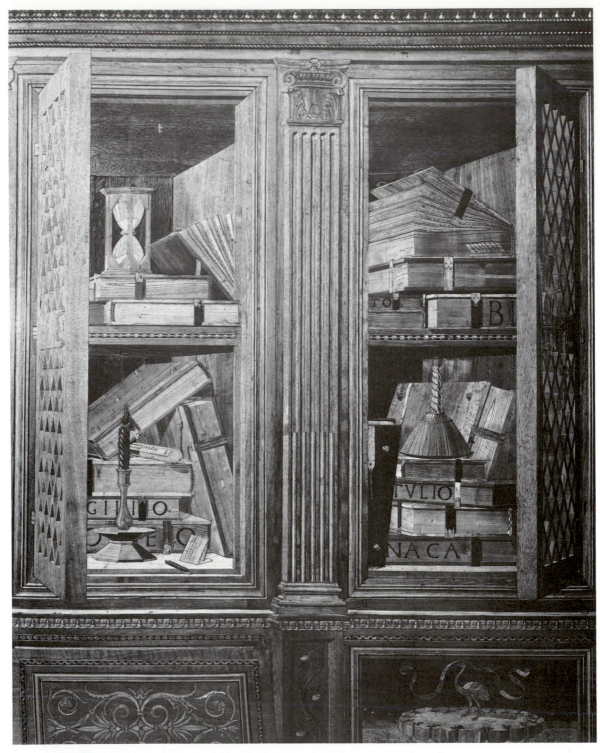

Fig. 47. Studiolo of Urbino. Inlays. Detail from sections d and e, north wall.

142

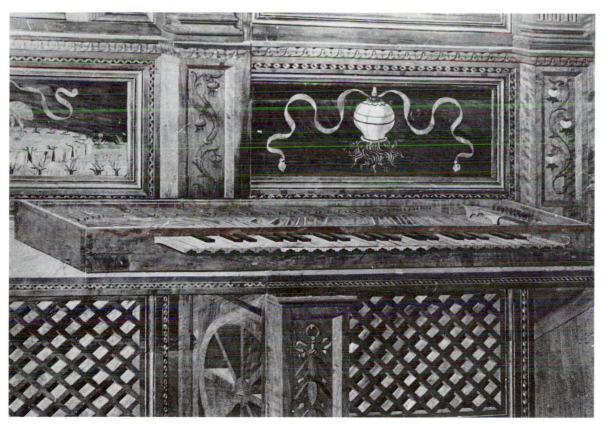

Fig. 48. Studiolo of Urbino. Inlays. Detail from sections e and f, north wall.

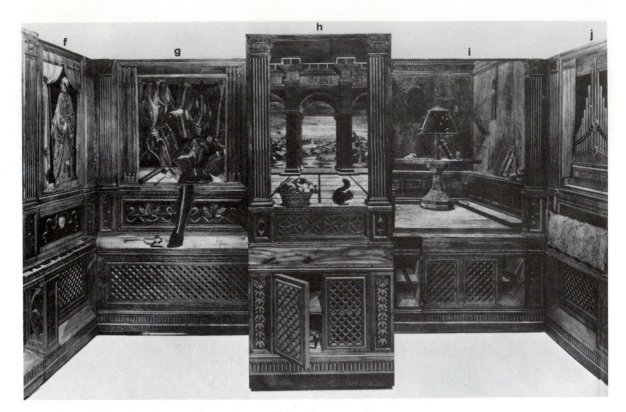

Fig. 49. Studiolo of Urbino. Inlays. East wall (sections g to i).

144

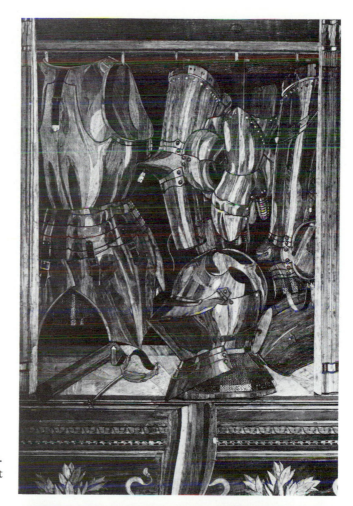

Fig. 50. Studiolo of Urbino. Inlays. Detail from section g, east wall.

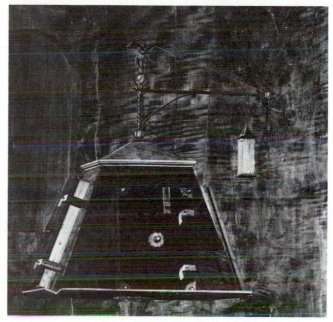

Fig. 51. Studiolo of Urbino. Inlays. Detail from section i, east wall, showing a Cupid with a lantern on top of a lectern.

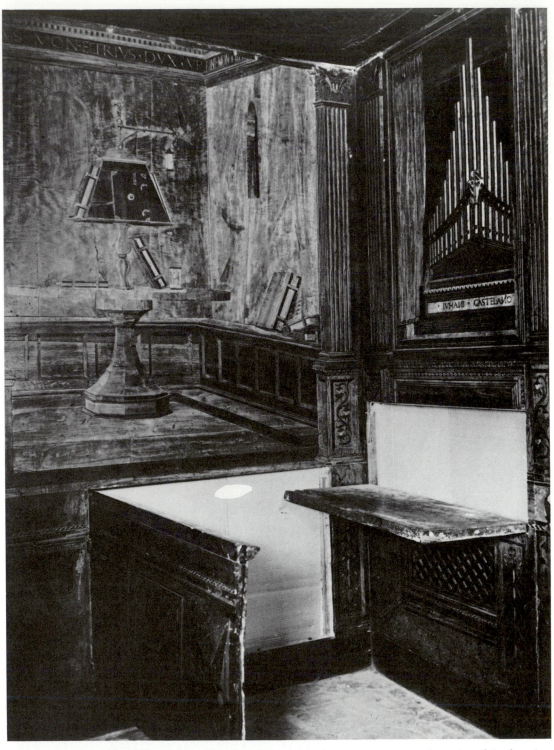

Fig. 52. Studiolo of Urbino. Inlays. View of the south-east corner, sections i and j, showing folding panels.

146

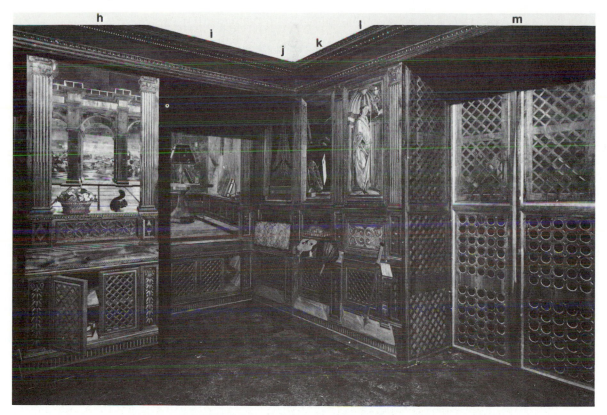

Fig. 53. Studiolo of Urbino. Inlays. View of the east and south walls (sections h to m).

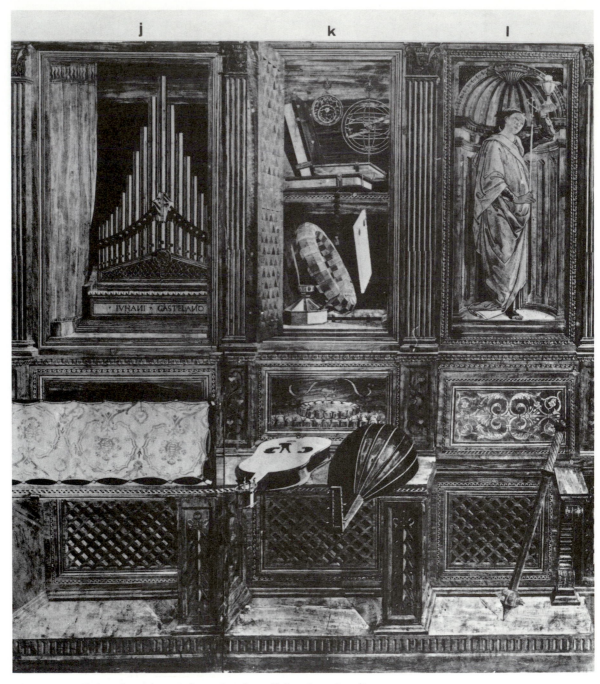

Fig. 54. Studiolo of Urbino. Inlays. South wall (sections j to l).

148

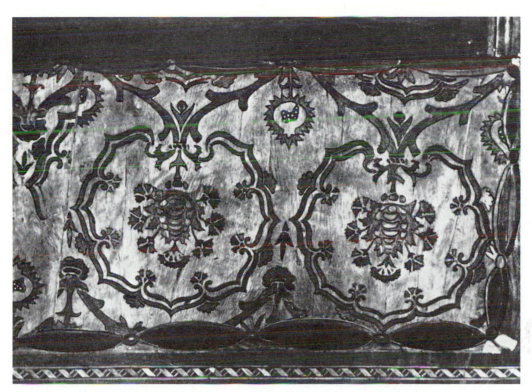

Fig. 55. Studiolo of Urbino. Inlays. Detail from section j, south wall, showing a cushion with vegetal patterns.

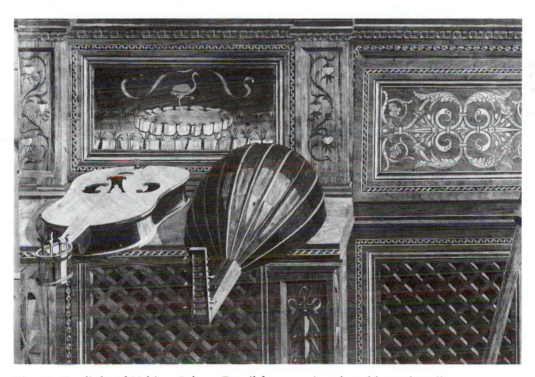

Fig. 56. Studiolo of Urbino. Inlays. Detail from sections k and l, south wall.

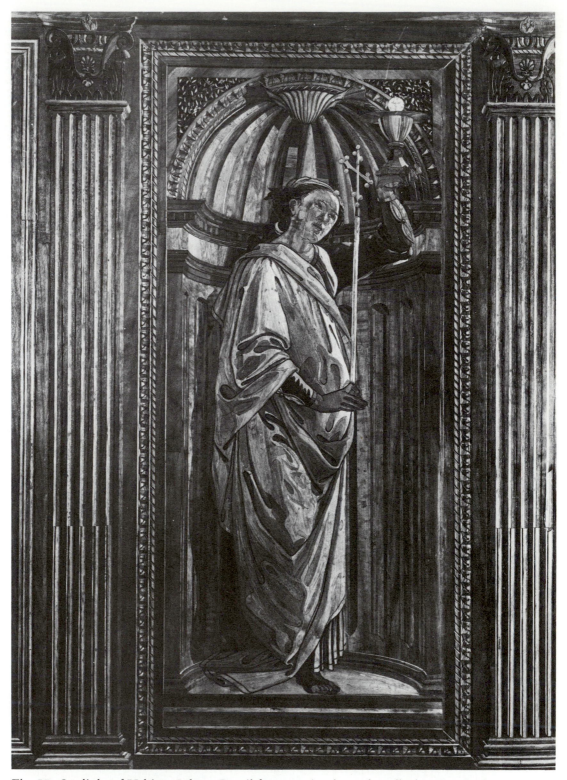

Fig. 57. Studiolo of Urbino. Inlays. Detail from section l, south wall, showing Faith.

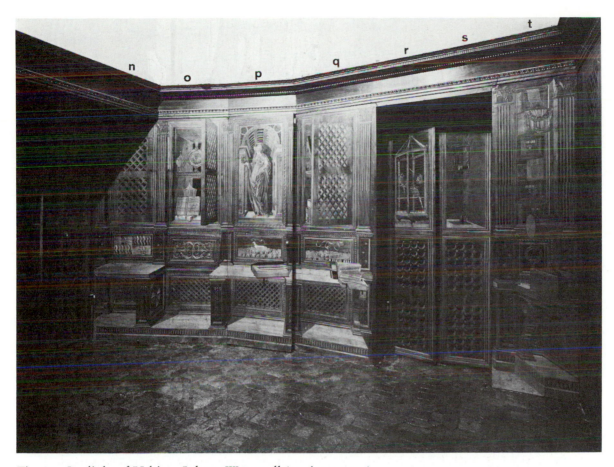

Fig. 58. Studiolo of Urbino. Inlays. West wall (sections n to t).

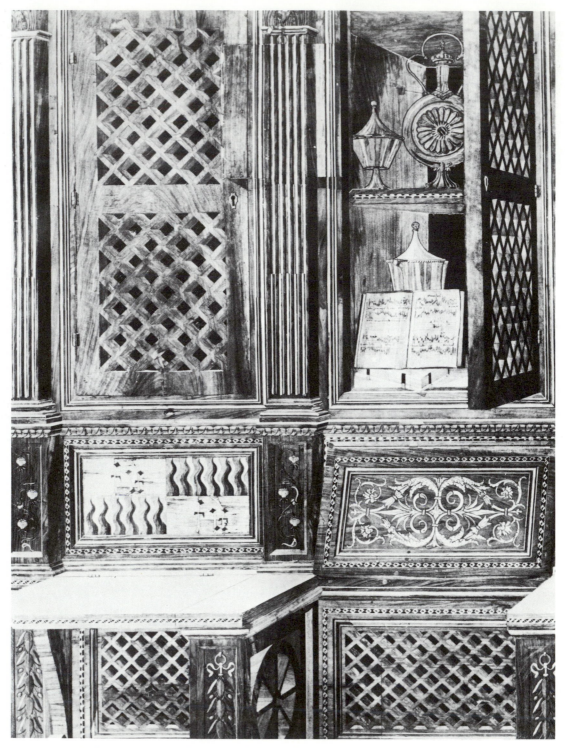

Fig. 59. Studiolo of Urbino. Inlays. Detail from the west wall, showing sections n and o.

152

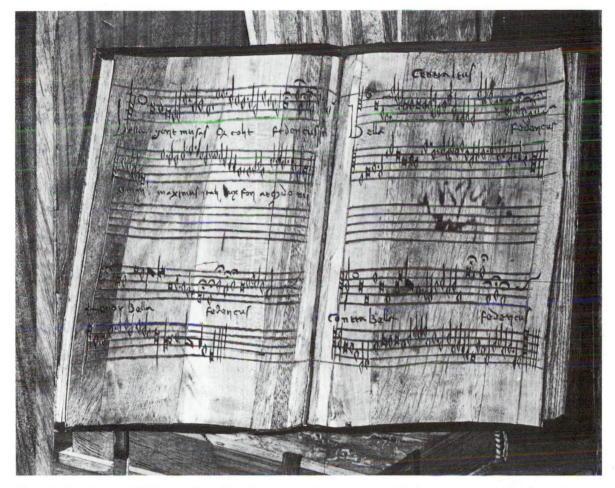

Fig. 60. Studiolo of Urbino. Inlays. Detail from section o, west wall, showing a music book.

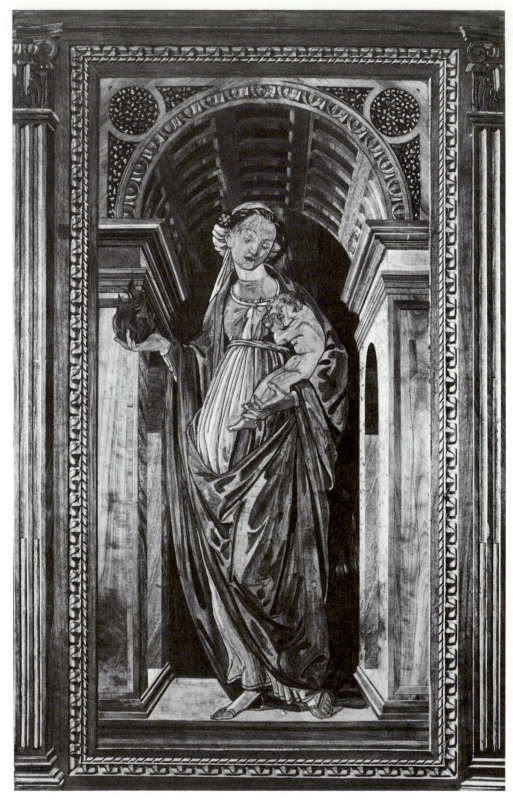

Fig. 61. Studiolo of Urbino. Inlays. Detail from section p, west wall, showing Charity.

Fig. 62. Studiolo of Urbino. View from the loggia. The door is camouflaged with the intarsia designs of section p.

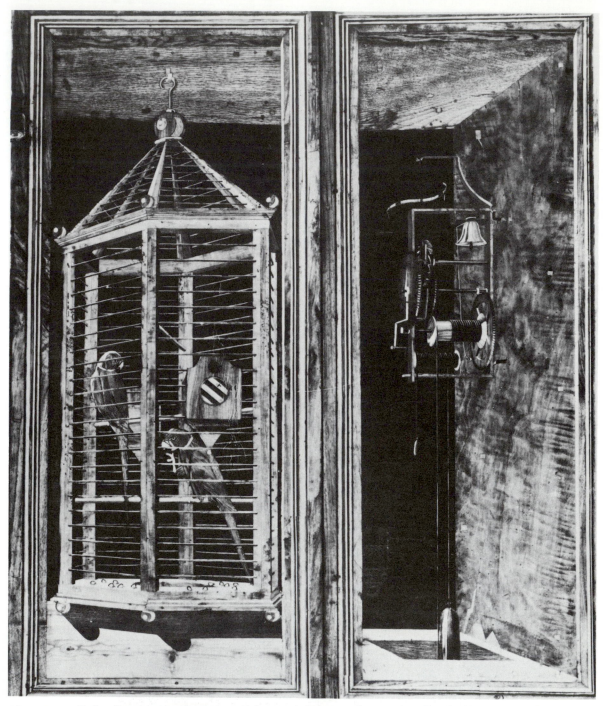

Fig. 63. Studiolo of Urbino. Inlays. Detail from sections r and s, west wall, which correspond to the shutters of the door leading to the Duke's dressing room.

156

Fig. 64. Studiolo of Urbino. Inlays. Detail from section t, west wall, showing a scroll.

Fig. 65. Studiolo of Urbino. Inlays. Detail from section t, west wall.

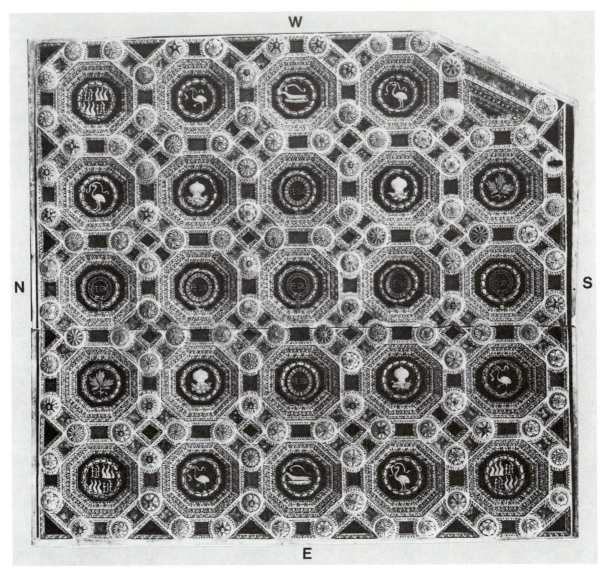

Fig. 66. Studiolo of Urbino. Coffered ceiling.

158

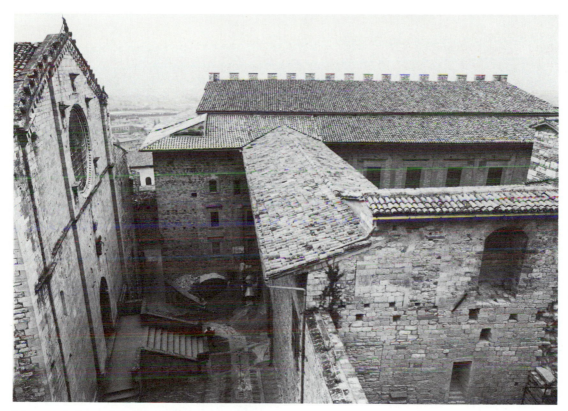

Fig. 67. Palace of Gubbio. View from north-east.

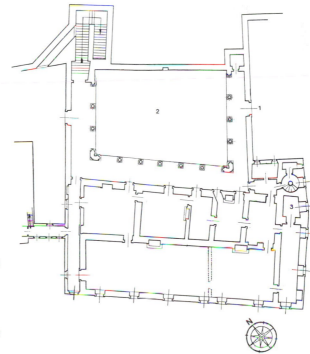

1. Main entrance
2. Courtyard
3. *Studiolo*

Fig. 68. Palace of Gubbio. Plan of the
 piano nobile.

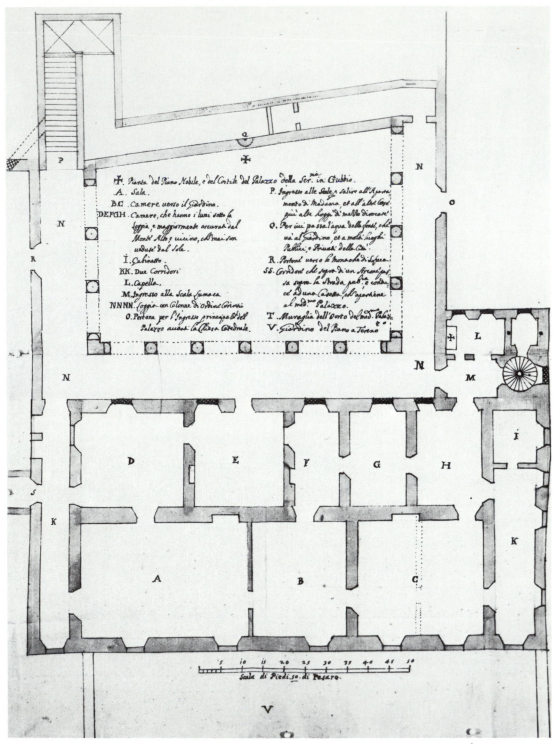

Fig. 69. Palace of Gubbio. 17th century plan of the piano nobile. From the *Relazione sopra il Palazzo della Ser[enissi]ma Duchessa Vittoria [della Rovere] in Gubbio*. (Archivio di Stato, Florence, Fondo Urbinate, Classe III, F. XXXII).

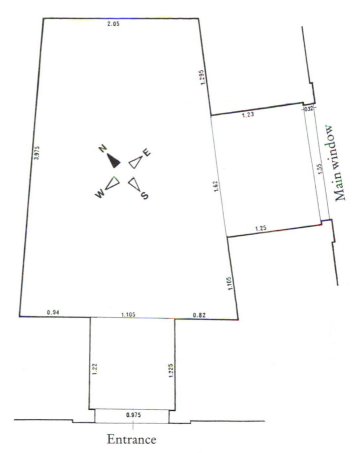

2.05

1.295

1.23

0.12

Main window

3.975

1.62

1.55

N

E

W

S

1.25

1.105

0.94 1.105 0.82

1.22 1.225

0.975

Entrance

Fig. 70. Studiolo of Gubbio. Plan, drawn by Bruno Cenni. The measurements were taken before the recent removal of the plaster from the walls.

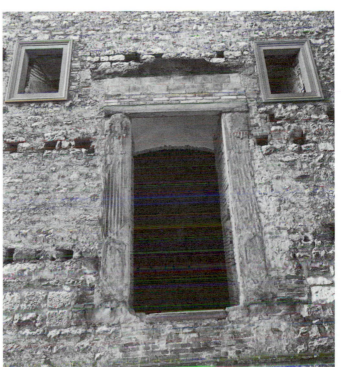

Fig. 71. The three windows of the studiolo of Gubbio, as seen from the outside.

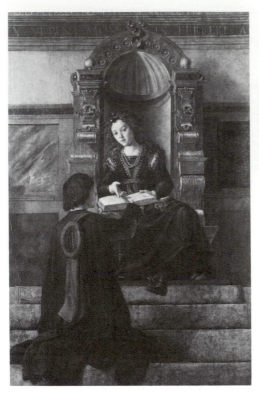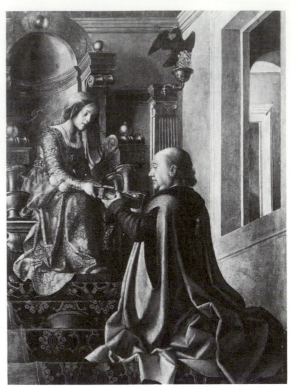

Fig. 72. Justus of Ghent (?), *Rhetoric* (?). (National Gallery, London.)

Fig. 73. Justus of Ghent (?), *Dialectic* (?). (Formerly in the Kaiser-Friedrich-Museum, Berlin; destroyed.)

162

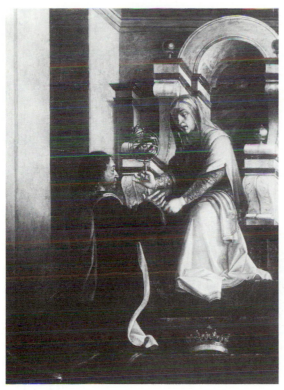 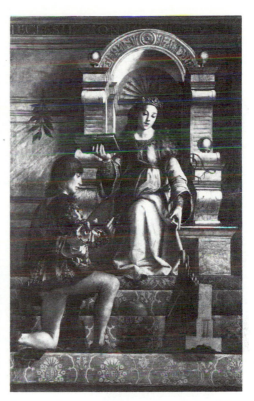

Fig. 74. Justus of Ghent (?), *Astronomy*. (Formerly in the Kaiser-Friedrich-Museum, Berlin; destroyed.)

Fig. 75. Justus of Ghent (?), *Music*. (National Gallery, London.)

Fig. 76. Justus of Ghent (?), *Federico, Guidobaldo and Others Listening to a Discourse*, circa 1479–80. (Hampton Court Palace.)

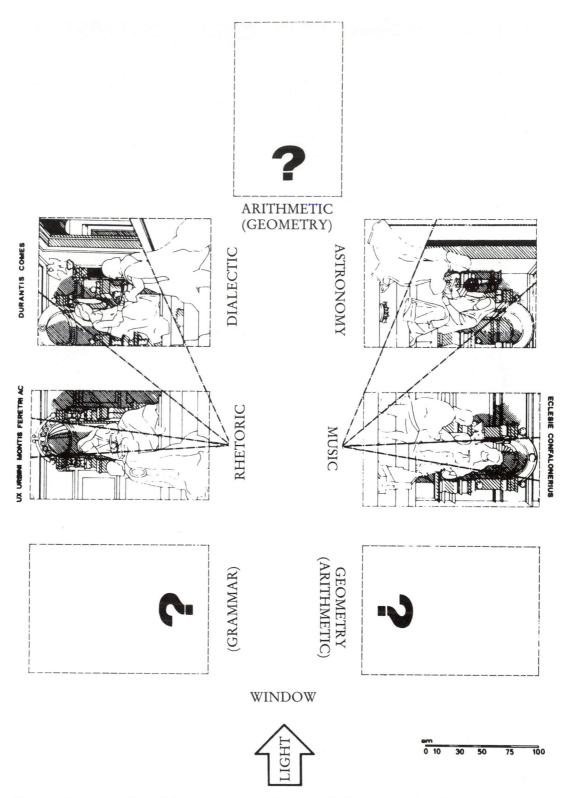

Fig. 77. Reconstruction of the arrangement of Justus of Ghent's (?) *Liberal Arts*, proposed by Bruschi for the room adjacent to the library, in the Palace of Urbino.

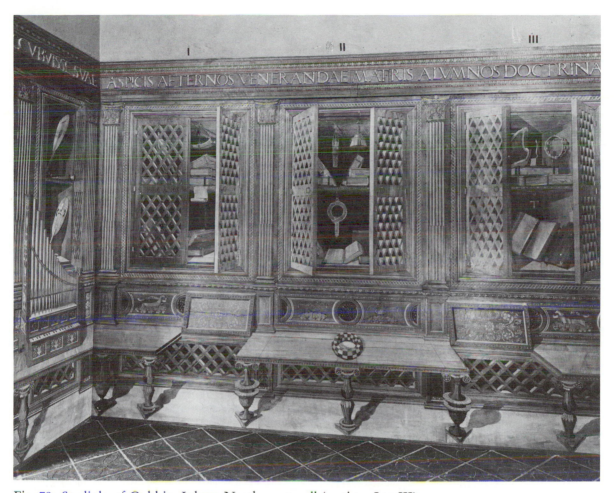

Fig. 78. Studiolo of Gubbio. Inlays. North-west wall (sections I to III).

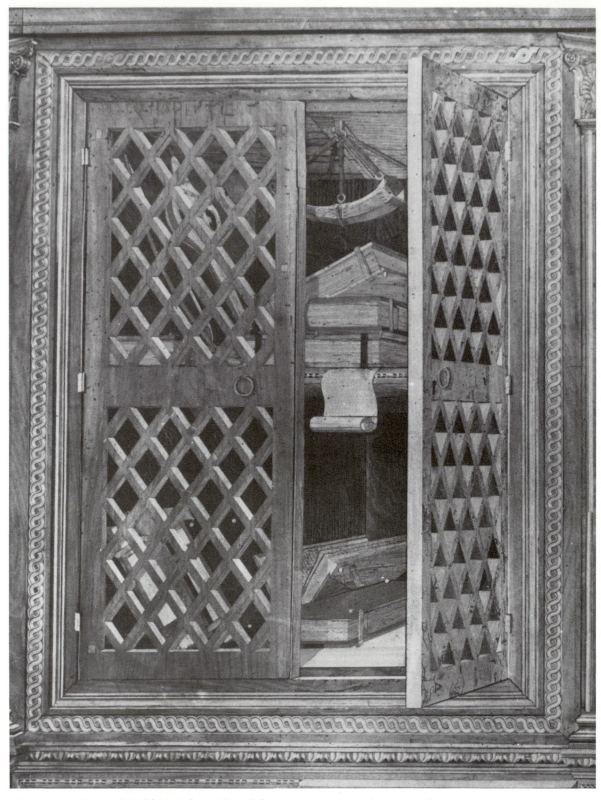

Fig. 79. Studiolo of Gubbio. Inlays. Detail from section I, north-west wall.

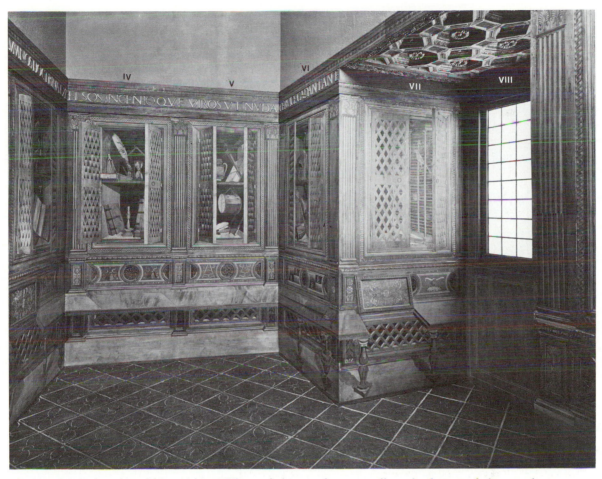

Fig. 80. Studiolo of Gubbio. Inlays. View of the north-east wall, and of part of the south-east one showing the window niche (sections IV to VIII).

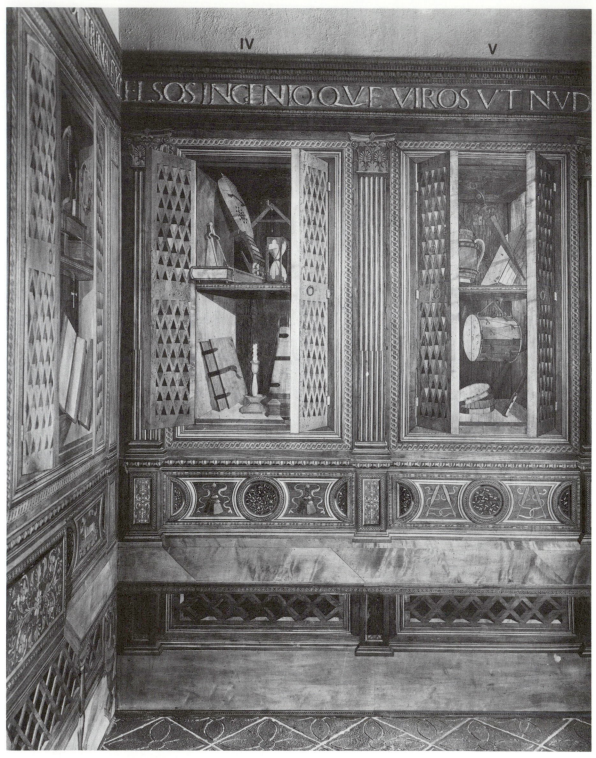

Fig. 81. Studiolo of Gubbio. Inlays. North-east wall (sections IV and V).

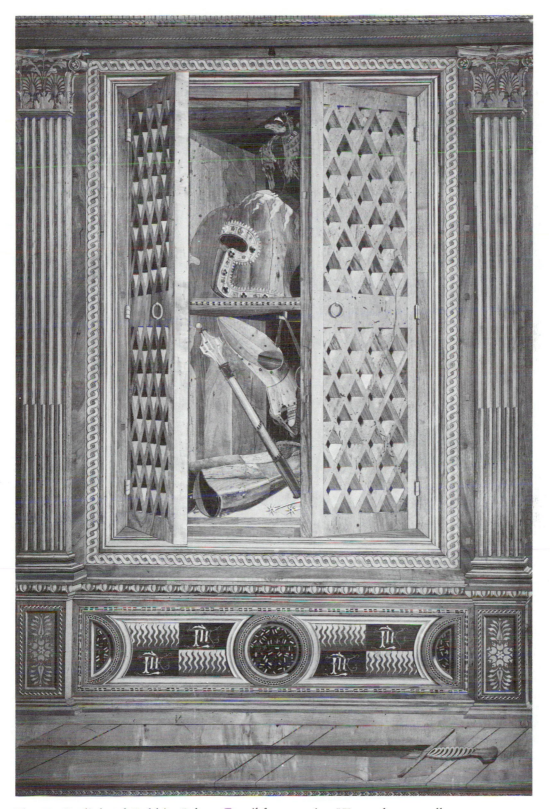

Fig. 82. Studiolo of Gubbio. Inlays. Detail from section VI, south-east wall.

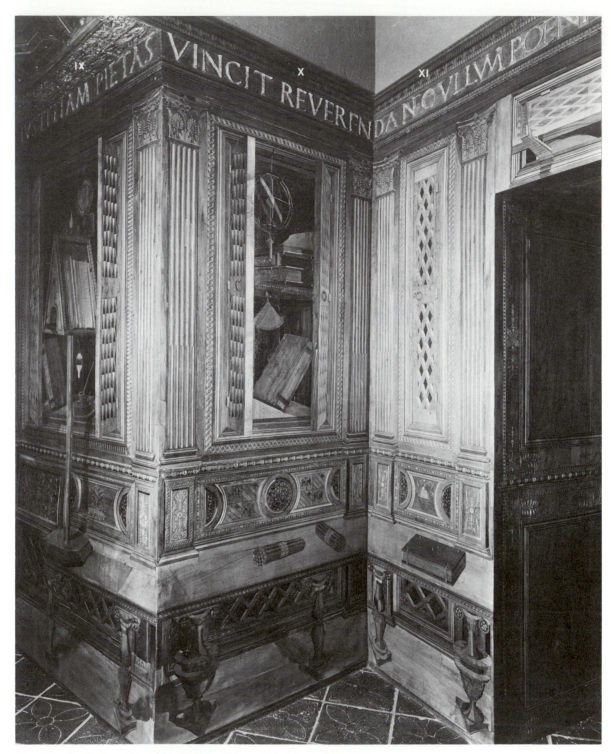

Fig. 83. Studiolo of Gubbio. Inlays. View of sections IX to XI.

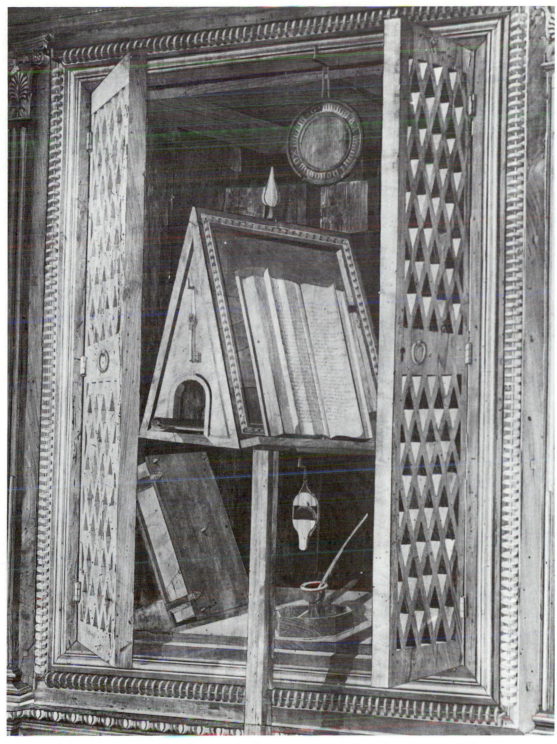

Fig. 84. Studiolo of Gubbio. Inlays. Detail from section IX of the window niche, showing a lectern with Virgil's *Aeneid*, and a mirror with the inscription G. BALDO DX.

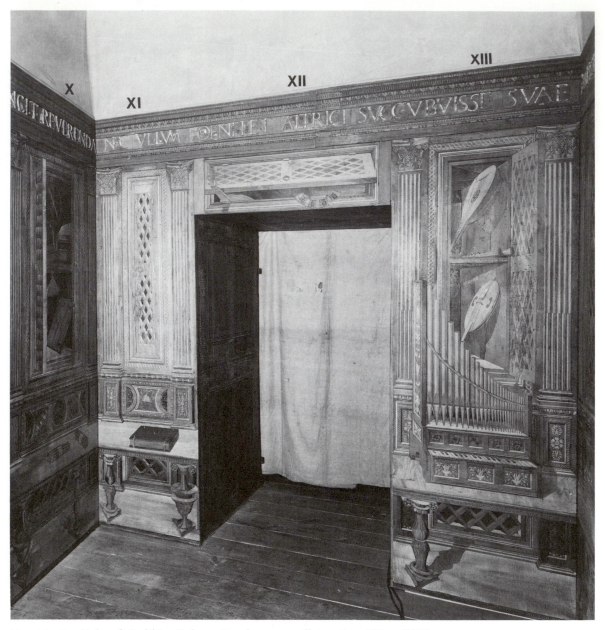

Fig. 85. Studiolo of Gubbio. Inlays. South-west wall (sections XI to XIII).

172

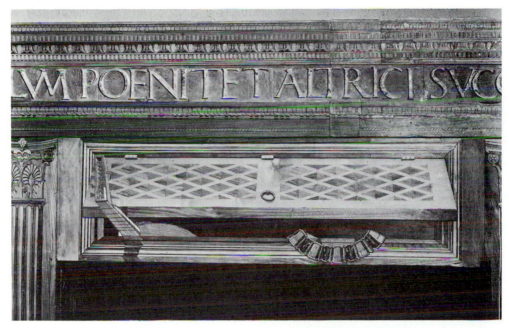

Fig. 86. Studiolo of Gubbio. Inlays. Detail from section XII, south-west wall, showing, on the right, the Garter.

Fig. 87. Studiolo of Gubbio. Inlays. Door (inside), south-west wall.

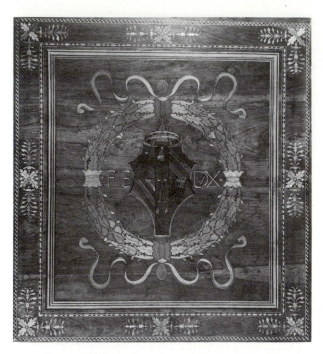

Fig. 88. Studiolo of Gubbio. Inlays. Door soffit with ducal insignia, south-west wall.

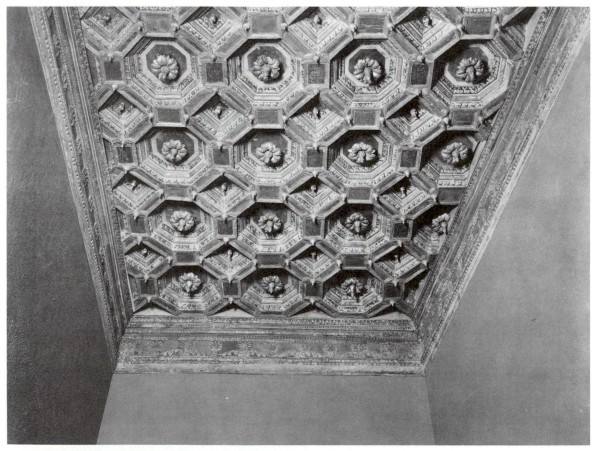

Fig. 89. Studiolo of Gubbio. Coffered ceiling.

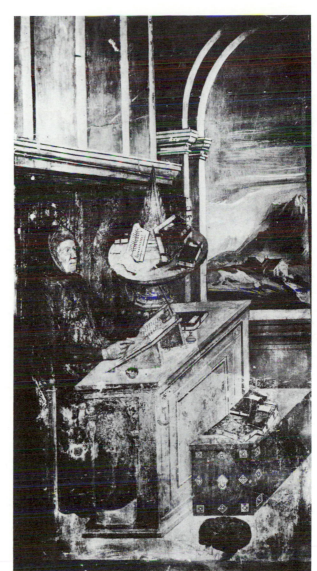

Fig. 90. Altichiero (?), *Petrarch in his Study*, late 14th century, partly repainted in the 16th and 17th centuries. *Sala Virorum Illustrium*, Palace of Francesco il Vecchio da Carrara, Padua (now the University Assembly Hall).

Fig. 91. *Orpheus in the Underworld.* Wood engraving, from a late 15th century edition of Angelo Poliziano's *Favola di Orfeo*, published by Tubini, Veneziano and Ghirlandi.

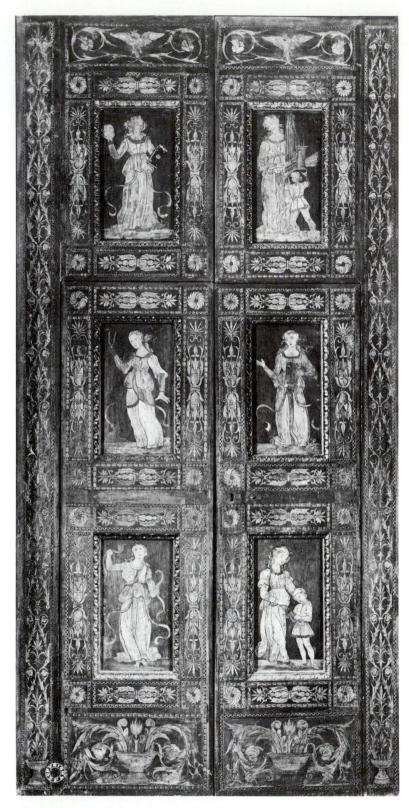

Fig. 92. *Door of the Liberal Arts*, Palace of Urbino.

Fig. 93. Studiolo of Urbino. Inlays. Detail from section o, west wall.

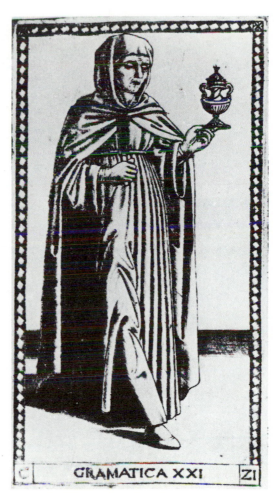

Fig. 94. *Grammar*, from the series of the so-called *Tarocchi del Mantegna*, circa 1465.

Fig. 95. *Geometry*, from the series of the so-called *Tarocchi del Mantegna*, circa 1465.

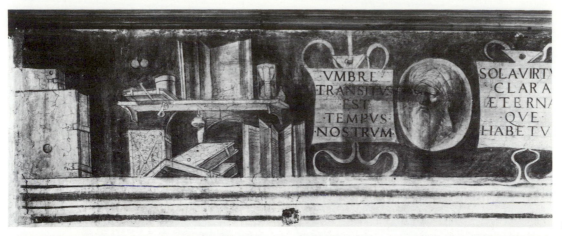

a

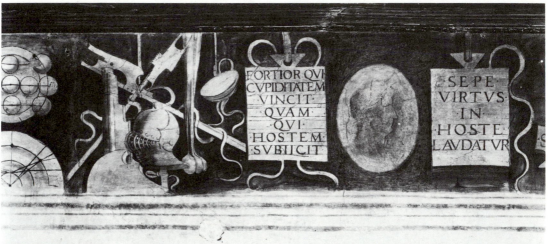

b

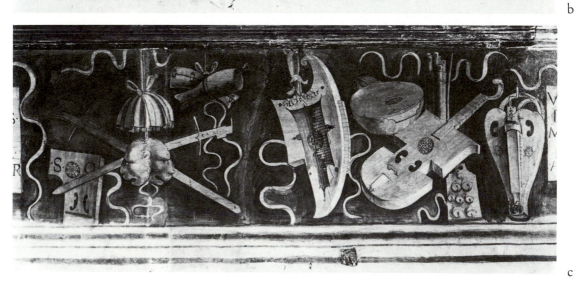

c

Fig. 96. Giorgione(?), *Frieze of the Liberal Arts*, circa 1505, Casa Marta-Pellizzari, Castelfranco Veneto. Details.

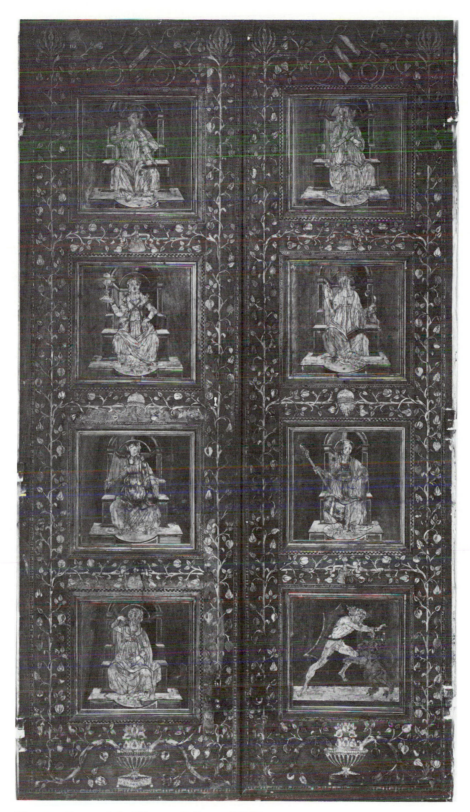

Fig. 97. *Door of the Virtues*, Palace of Urbino.

Fig. 98. Piero della Francesca, *Triumph of Federico*, 1473 (?). (Uffizi, Florence.) Detail. Sitting before Federico are the Cardinal Virtues.

Fig. 99. Piero della Francesca, *Triumph of Battista*, 1473 (?). (Uffizi, Florence.) Detail. Sitting before Battista are the Theological Virtues.

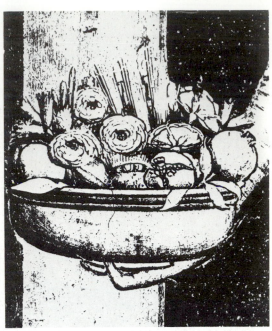

Fig. 100. Studiolo of Urbino. Inlays. Detail from section h, east side.

Fig. 101. Giotto, *Charity*, Scrovegni Chapel, Padua, circa 1306. Detail showing the attribute of *Caritas proximi*.

Fig. 102. Central Italian School, *Città Ideale*, 1490's (?). Detail showing *Abbondanza*. (Walters Art Gallery, Baltimore.)

Fig. 103. *Concordia*. From C. Ripa, *Iconologia*, Rome, 1603.

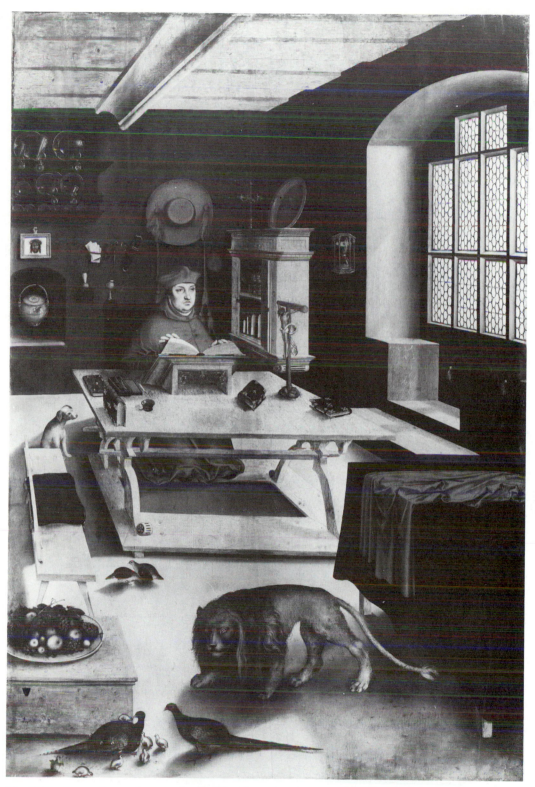

Fig. 104. Lucas Cranach, *Cardinal Albrecht in his Study*, 1525. (Hessisches Landesmuseum, Darmstadt.)

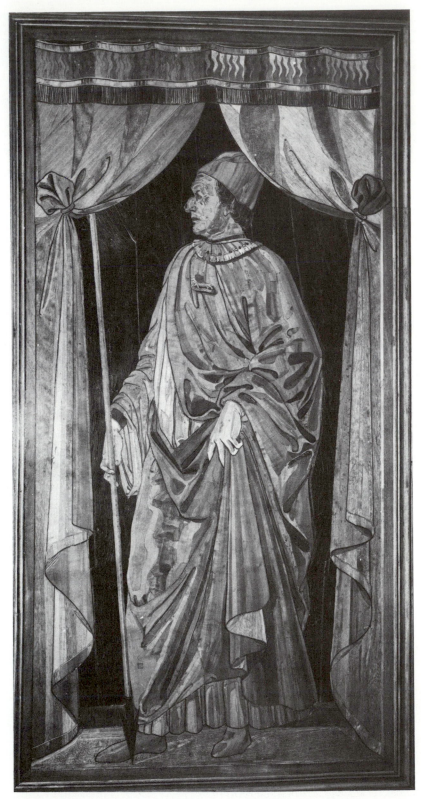

Fig. 105. Studiolo of Urbino. Detail from section f, north wall, showing Federico.

Fig. 106. Taddeo di Bartolo, *Famous Men*, 1414. Ante-Chapel, Palazzo Pubblico, Siena. Detail showing Curius Dentatus, Furius Camillus and Scipio Africanus.

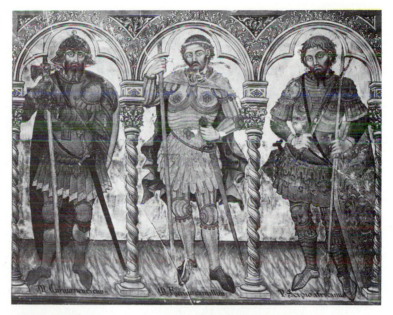

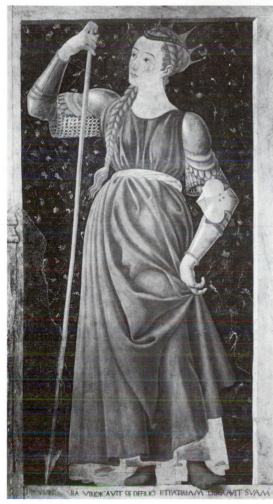

Fig. 108. Coin of Severus Alexander (verso), depicting Mars with a reversed spear and an olive branch. The inscription reads: MARTI PACIFERO.

Fig. 107. Andrea del Castagno, *Famous Men*, circa 1450. Detail showing Queen Tomyris. (Uffizi, Florence. Formerly in Villa Carducci, Legnaia.)

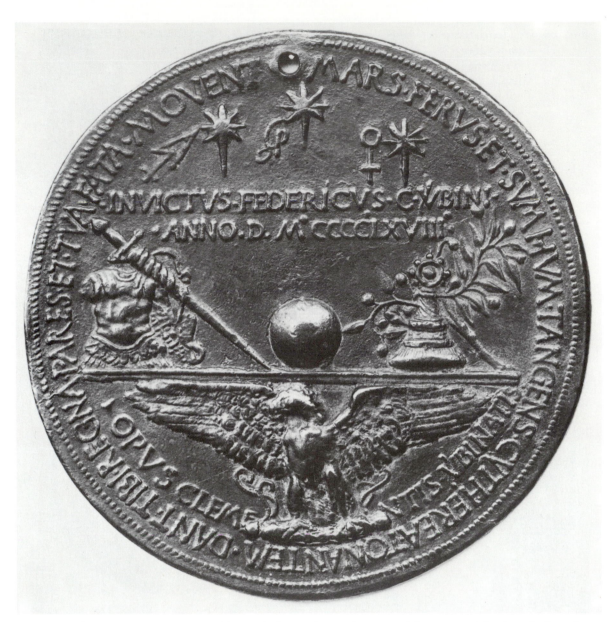

Fig. 109. Clemente da Urbino, medal struck for Federico da Montefeltro, 1468. The inscription along the border reads: MARS · FERVS · ET · SVMHVM · TANGENS · CYTHEREA · TONANTEM · DANT · TIBI · REGNA · PARES · ET · TVA · FATA · MOVENT ·

186

INDEX

Mariano Taccola · De machinis

The engineering treatise of 1449
Introduction, Latin texts, descriptions of engines and technical commentaries by
GUSTINA SCAGLIA
Facsimile of Codex Latinus Monacensis 28800 in the Bayerische Staatsbibliothek, München, with additional reproductions from Codex Latinus 7239 in the Bibliothèque Nationale, Paris, from MS 136 in the Spencer Collection New York Public Library, from Codex Latinus 2941 in the Biblioteca Nazionale Marciana, Venezia.
Volume 1 (text): 1971. 4°. 181 pages.
Volume 2 (facsimile): 1971. 4°. 200 facsimile pages.
Both volumes bound in full cloth. DM 480.– (ISBN 3-920153-05-7)

Writing about engineering went through one of its decisive stages, on the way from the ancient treatise to the modern textbook, during the fifteenth century. Mariano Taccola of Siena is a key figure in this development, and his DE MACHINIS of 1449 culminates a lifetime devoted to the composition of countless engine drawings and technical texts. It is a record of machines for civil and military engineering, hydraulics, mills and tunnels. The autograph DE MACHINIS was only recently discovered. With remarkable ingenuity and realistic force, Taccola clarified the complex form of engines in optical unity perhaps for the first time. His originality of mind and artistic skill also led him to formulate devices for interconnecting drawings and texts and to classify engines perhaps for the first time.

Taccola became famous; the Sienese nicknamed him Archimedes. He was secretary at the leading institution of learning, the *Studio* of Siena. He met King Sigismund and was named *comes palatinus*. He showed his drawings only to a select few, among them Brunelleschi, with whom he discussed engineering questions. He experimented in technology to develop new and improved machines. Taccola's DE MACHINIS, which owes some parts to Vegetius, may have been inspired by Kyeser's BELLIFORTIS but surpasses it in artistic refinement.

DE MACHINIS is a compendium of engines. It illustrates the traditions of the early fifteenth century in Italy as the Middle Ages fade away. In the Renaissance, the manuscripts were known to artists, yielding material of technical knowledge to Francesco di Giorgio Martini, the Ghiberti, Leonardo da Vinci and other men. Illustrious persons in history collected the manuscripts, beginning with the *condottiere* Colleoni, the Turkish rulers in Constantinople who may have had one from Sigismondo Malatesta, the Nani of Venice and Andrea Tessier of Venice, Heinrich Count Daun, and Count Wilczek.

The first part of this edition considers Taccola's life, the composition of his book, and the whereabouts of Taccola as he composed DE MACHINIS. Another part is a description and history of the autograph and of each of its copies. The edition includes a technical and stylistic commentary about Taccola's engine drawings and texts, and it is accompanied by a transcription of the Latin texts. This facsimile edition of DE MACHINIS, which uses folios from manuscript copies when pages are missing from the autograph, is a reconstruction of the original form.

DE MACHINIS in copy form was rediscovered in 1797, along with Leonardo's engineering work, by Giambattista Venturi, a century after a French ambassador acquired the copy for the royal library in Paris. During this time and later the autograph was treasured by its owner in Austria, who was unaware that scholars were searching for the original Taccola. The adventures and sojourn of the manuscript in Italy and Austria came to an end when it was acquired by the Bayerische Staatsbibliothek in Munich.

DR. LUDWIG REICHERT VERLAG · TAUERNSTR. 11 · 6200 WIESBADEN

Mariano Taccola · De ingeneis

Liber Primus Leonis, Liber Secundus Draconis
Books I and II, *On Engines*, and Addenda (*The Notebook*)
Taccola's Introduction, Drawings of Engines and Latin Texts, Descriptions of Engines in English Translation, the *Liber ignium* of Marcus Graecus, and Editorial Notes on Technology in Renaissance Italy.
By GUSTINA SCAGLIA, FRANK D. PRAGER (†), ULRICH MONTAG
Facsimile of Codex Latinus Monacensis 197, part II, in the Bayerische Staatsbibliothek, München, with additional reproductions from Add. 34113 in the British Library, London, and from the Codex Santini in the Collection of Avv. Santini, Urbino.
Volume 1 (text): 1984. 4°. 196 pages with 16 illustrations. DM 180.–
Volume 2 (facsimile): 1984. 4°. 272 facsimile pages. DM 620.–
Both volumes bound in full cloth. DM 800.– (ISBN 3-88226-170-6)

Mariano Taccola was the first Renaissance writer who clearly illustrated and described technical devices. With remarkable ingenuity and realistic force, Taccola clarified the complex form of engines in optical unity. His originality of mind and artistic skill also led him to formulate devices for interconnecting drawings and texts. No earlier, illustrated descriptions of technical devices are known, and among the later ones few are as suggestive and informative as Taccola's sequence of illustrations.
He did not claim these specific devices as his inventions, but he evidently impressed his followers by his clear teaching. In fact – Taccola's notebook gives us the impression that it originated in a world where only rumors were known about the achievements of ancient technology. That many of these things became clearer in Taccola's time is definitely due to his curiosity, resourcefulness, and persuasion.
This ist the first time that Taccola's fascinating treatise "De ingeneis" can be presented as full facsimile. The text volume contains a short biography of Mariano Taccola, the history of his "Notebook", a description of its contents as well as an article on Taccola's importance for science and technology during the Renaissance.
Each of the 272 facsimile pages is explained in detail. Taccola's Latin description of the machines and devices are transcribed and translated into English.
Drawings of certain technical devices which have been developed after models from Taccola's "Notebook" are included in an appendix.

DR. LUDWIG REICHERT VERLAG · TAUERNSTR. 11 · 6200 WIESBADEN